Surinam

Switi Sranan

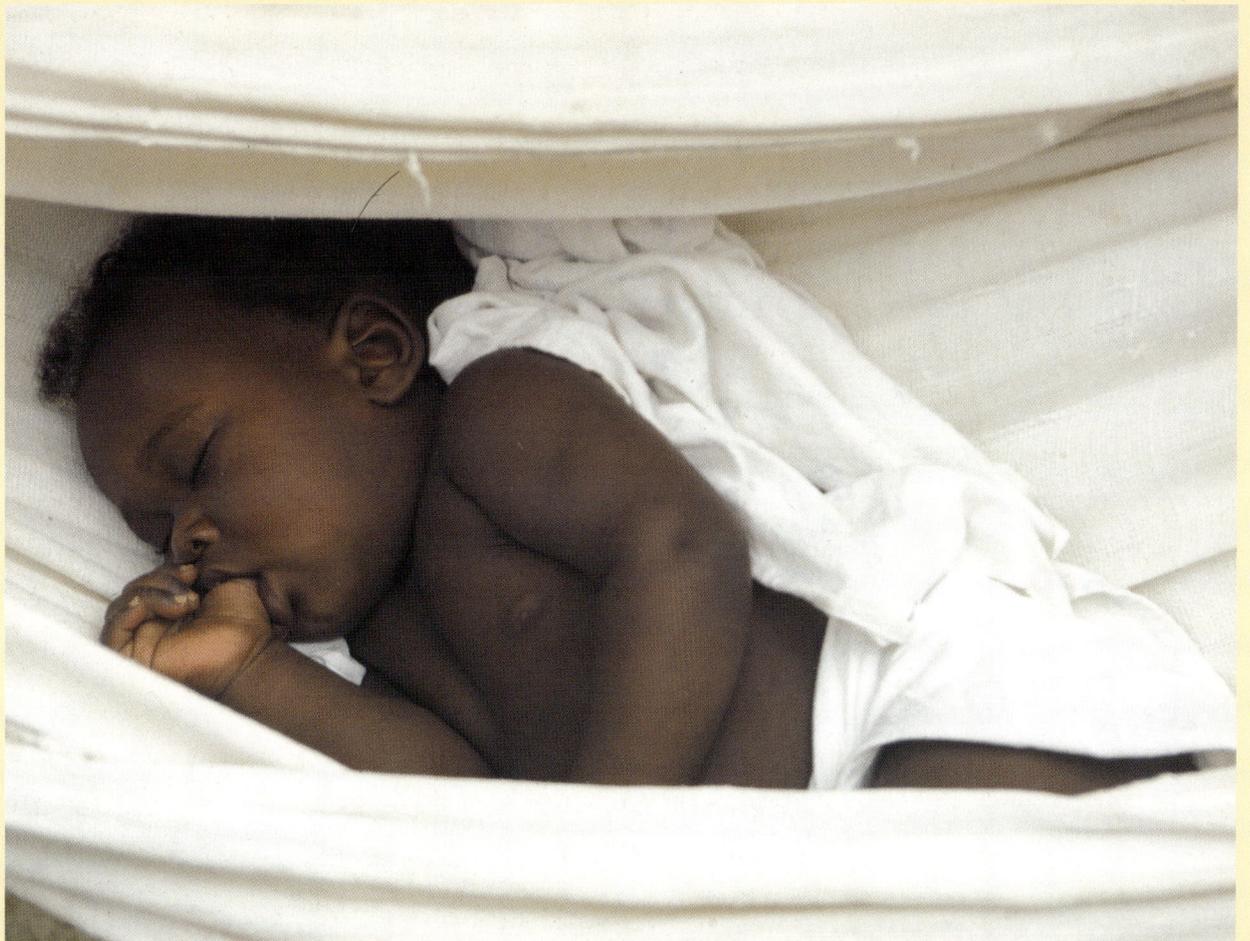

photography

Karin Anema
Toon Fey
N. Martin Heyde
Willem Kolvoort
Henk Lutchman
Joke van der Peet
Frans Schellekens
Erik Sok
Roy Tjin

archives Royal Tropical Institute (KIT)
archives Drenthe

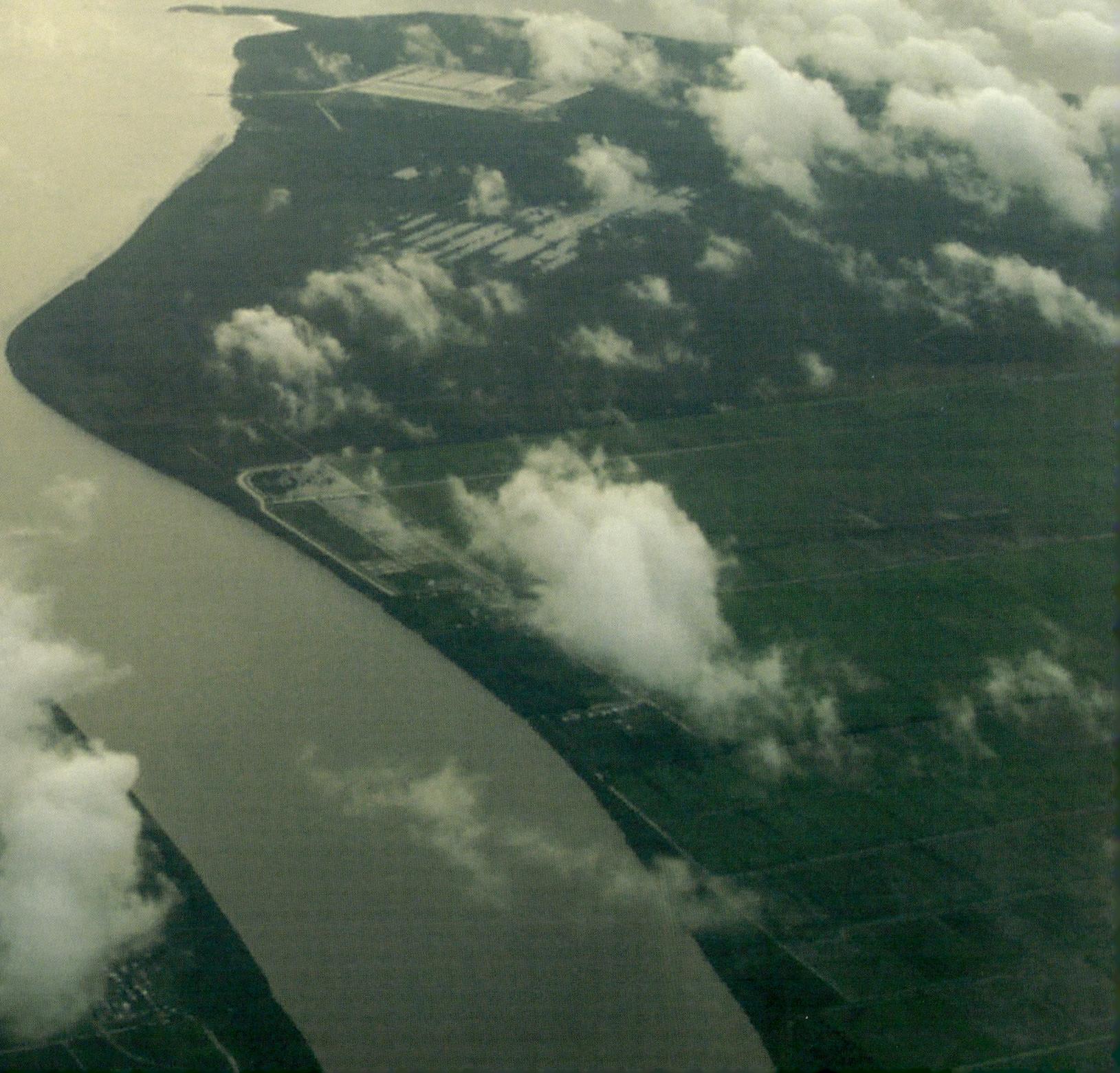

Surinam

Switi Sranan

Toon Fey

Dedicated to Louisa, born around 1820 in Boven
Suriname, slave number unknown.

photography
FRONT COVER:
Rainforest.
WILLEM KOLVOORT
FRONT COVER, INSET:
Surinam River.
TOON FEY
BACK COVER:
Zeelandia Road.
TOON FEY
PAGE 1:
Child in hammock.
TOON FEY
PAGE 2/3:
Where the Surinam River and the Commewijne River meet.
ERIK SOK
PAGE 4/5:
Faya lobi.
TOON FEY
PAGE 6/7:
Surinam River.
TOON FEY
PAGE 8/9:
View of the Van Stockum Mountains from the Voltzberg.
WILLEM KOLVOORT
PAGE 160:
People waiting.
FRANS SCHELLEKENS

© 2003 KIT Publishers, Amsterdam / Uitgeverij Uniepers,
Abcoude / Toon Fey, Heukelum

original idea: Smulders Print & Video, Amsterdam / Toon Fey
consultant: drs. H.T.J. Lutchman, Henry Strijk
picture research: Peter Smulders
English translation & editing: Lightsound Amsterdam
(M. Poysden, H. Waagen, M. Wilmans)
graphic design: Erik Sok / Uniepers
editor: Ingrid Smeets
editorial co-ordination: Annemarie van Gijn, Ellen Hooijen /
Uniepers

Place names are spelled according to the new map of Surinam
by drs. H.T.J. Lutchman, B.A., Amsterdam and Aart J. Karssen,
Nordhorn (BRD).

ISBN 90 6832 530 2

CONTENTS

Many other titles on Surinam precede this book. However, we felt that a book such as this would still have a place. Surinam has hitherto been exclusively portrayed by the foreign media as problematic. Visitors to Surinam often have great difficulty reconciling this reputation with their own experiences.

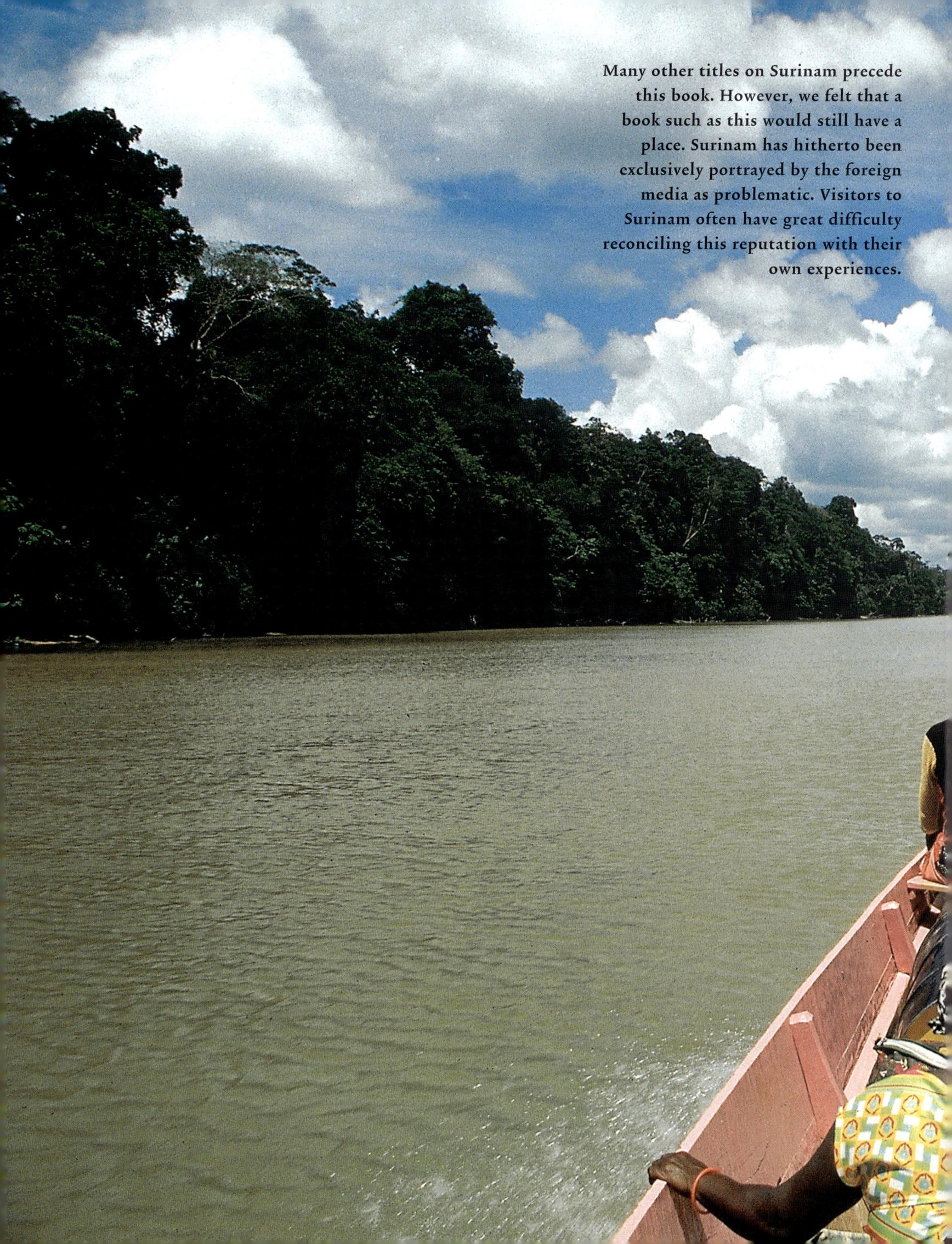

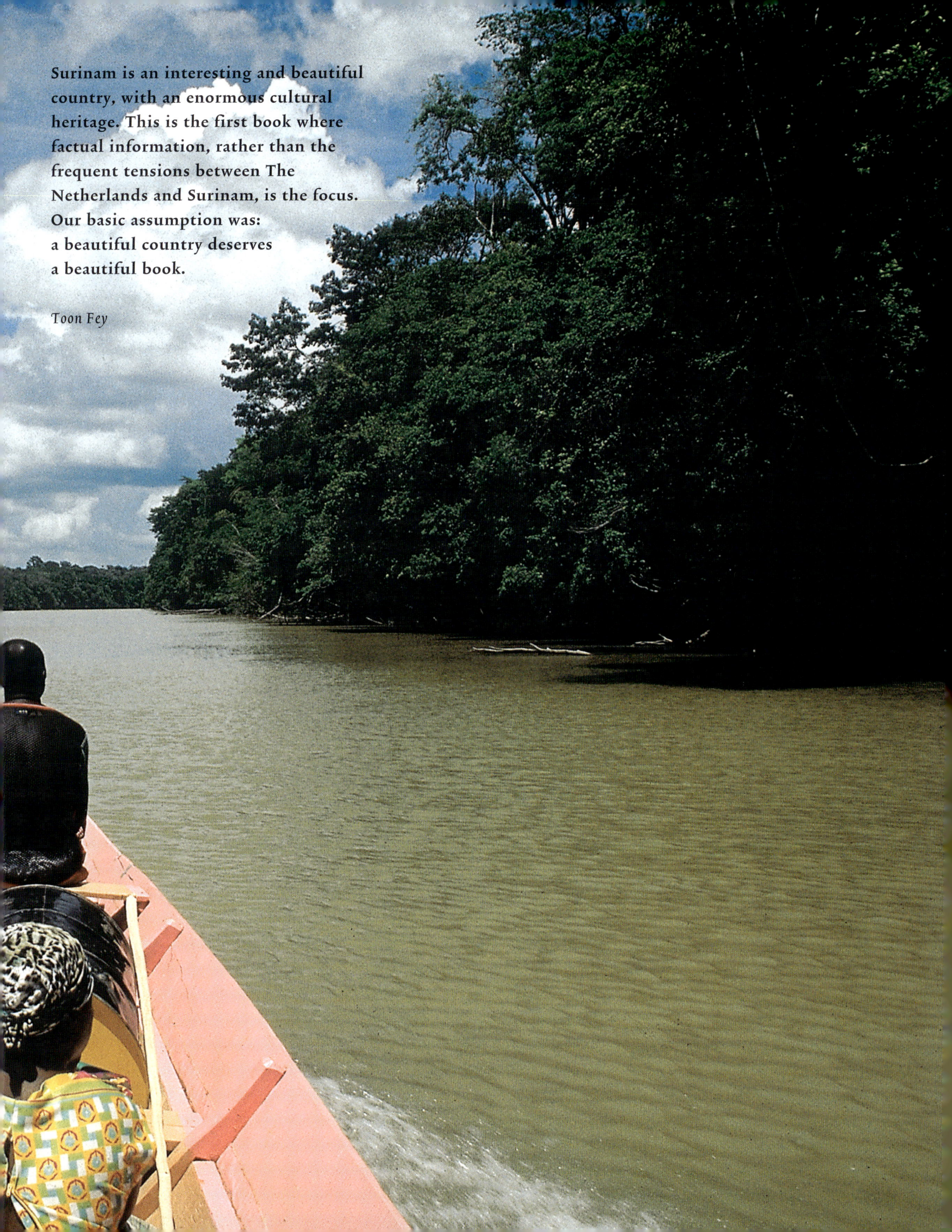

Surinam is an interesting and beautiful
country, with an enormous cultural
heritage. This is the first book where
factual information, rather than the
frequent tensions between The
Netherlands and Surinam, is the focus.
Our basic assumption was:
a beautiful country deserves
a beautiful book.

Toon Fey

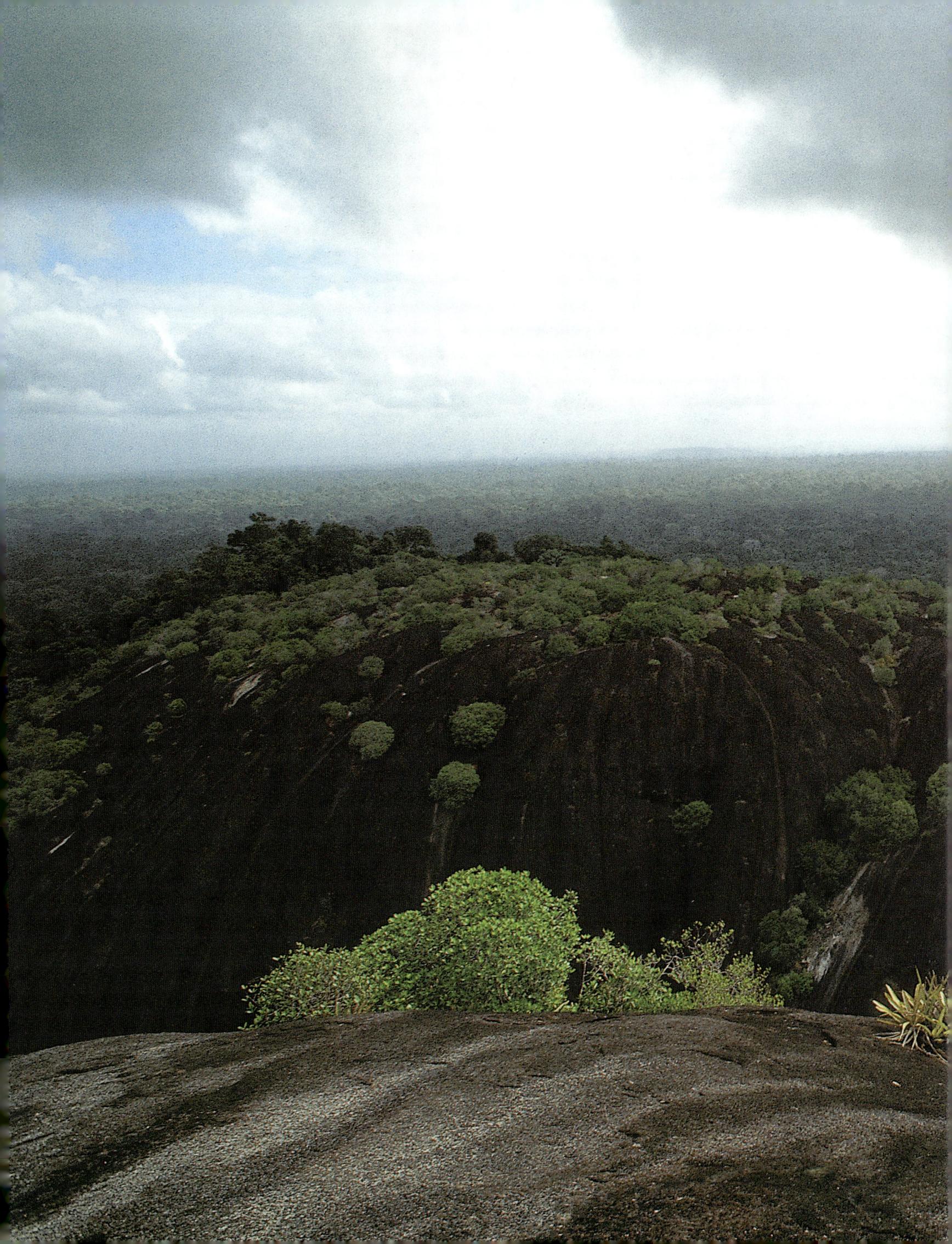

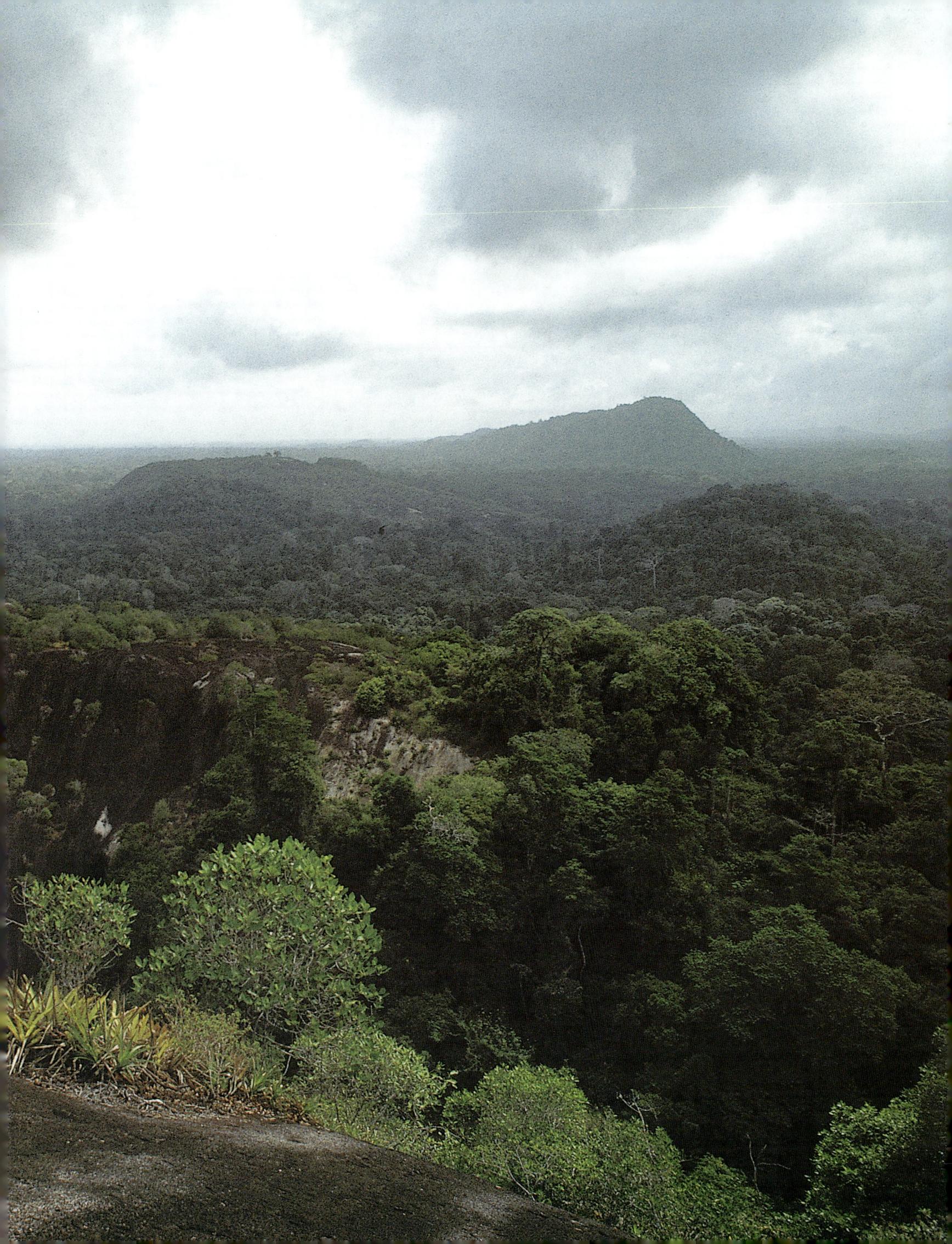

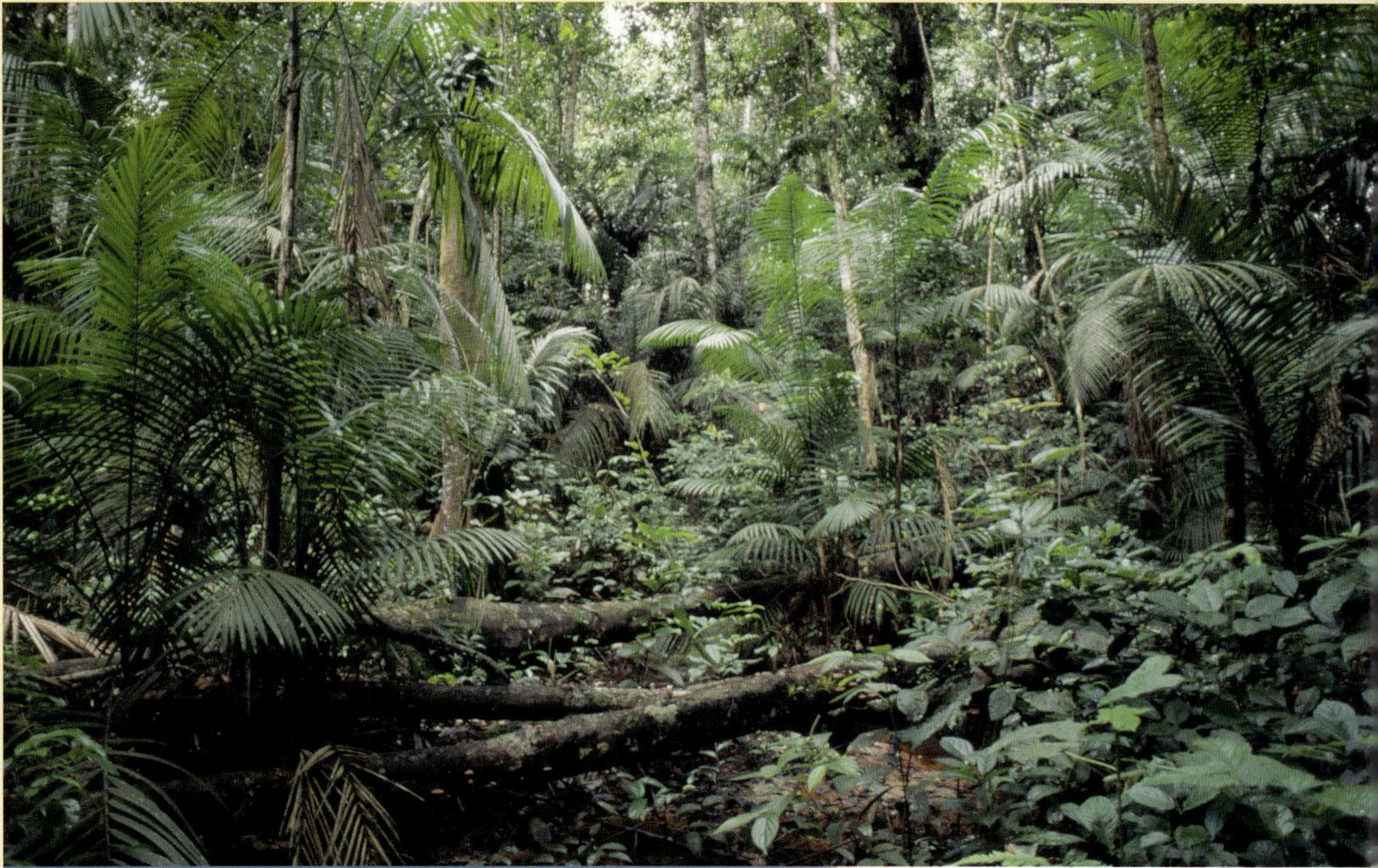

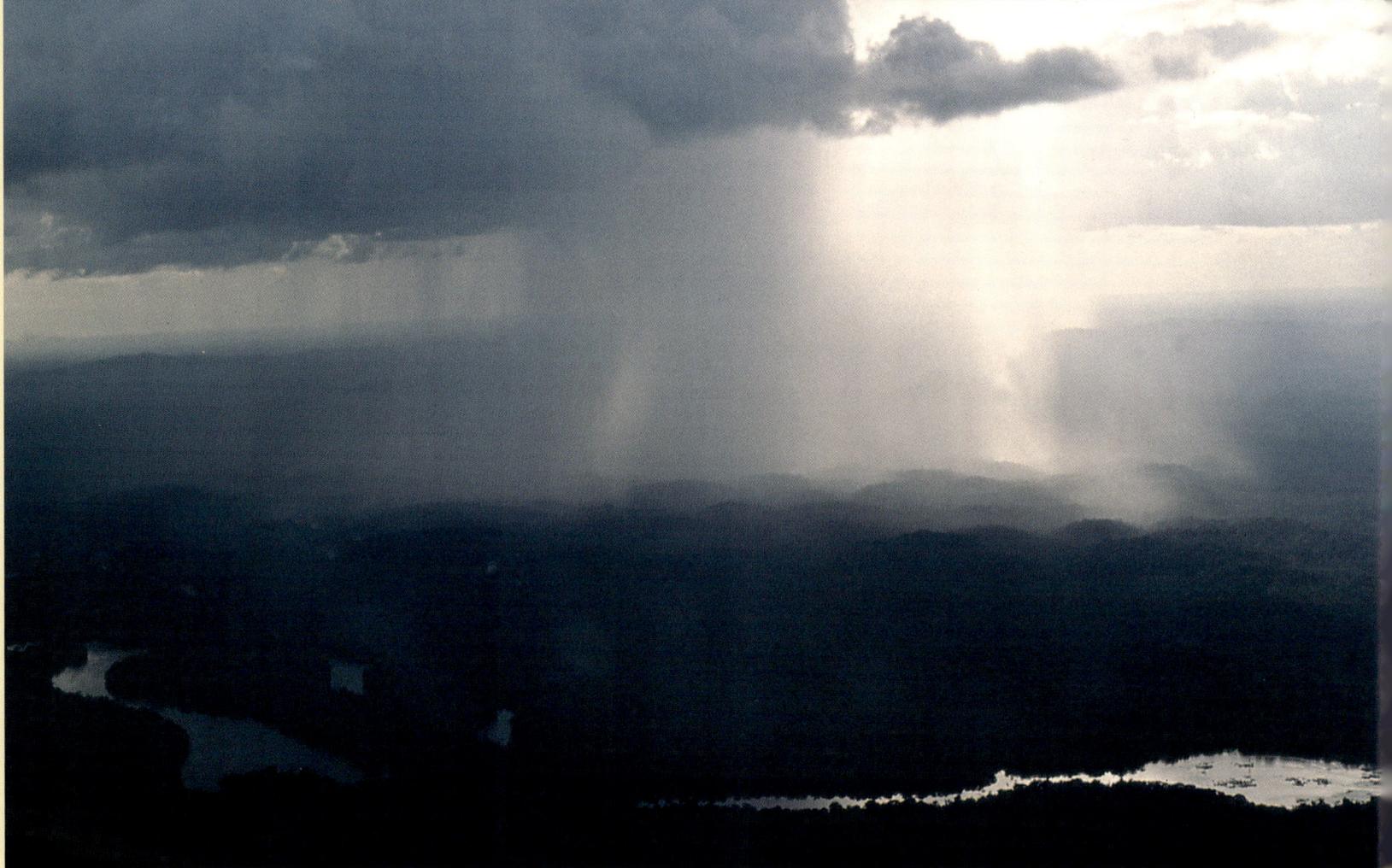

THE *land*SCAPE

Old maps of the northern coastal region of South America style the entire area stretching from the Orinoco to the Amazon 'Guyana'. This is quite understandable as the area clearly shares the same geographical identity. The coastline with its mudflats and sandbanks is difficult terrain, the rivers are hard to navigate because of the many rapids and the interior seems at first to be an impenetrable green jungle. It is obvious, even to the untrained eye, that Surinam and its neighbouring countries share the same developmental history.

PAGE 8/9
View of the Stockum Mountains from the Voltzberg.
WILLEM KOLVOORT
PAGE 10
Rainforest near Raleigh Falls.
WILLEM KOLVOORT
Rain shower over the rainforest.
HENK LUTCHMAN
PAGE 11
Flowers of the rainforest.
MARTIN HEYDE/
ERIK SOK

Flying into Surinam over the ocean, one can see three predominant types of landscape slipping by beneath the aircraft. First is the level coastal plain, home to most of the population and their culture. Further inland, one encounters a relatively level sandy strip of savannah, and after another 50 km (from the east) and about 150 km (from the west), the seemingly endless mountainous interior that is almost completely blanketed with tropical rainforest, although some isolated rock formations and the Sipaiwini savannah are found here This area comprises 80 percent of Surinam.

Elaborating on the history of Surinam's development would require another, considerably thicker book. Since solidifying from lava about two billion years ago, this region of South America (the Guinea Plate) has undergone countless geological changes resulting from fractures, ground elevated by tectonic activity, subsidence, erosion, weathering and other processes. Despite this dramatic and complex history, some evidence of prehistory can still be found without too much trouble: the highest mountains in the interior, such as the Wilhelmina and Bakhuis Mountains, with unnamed peaks of over 1000 metres, have remained largely unchanged.

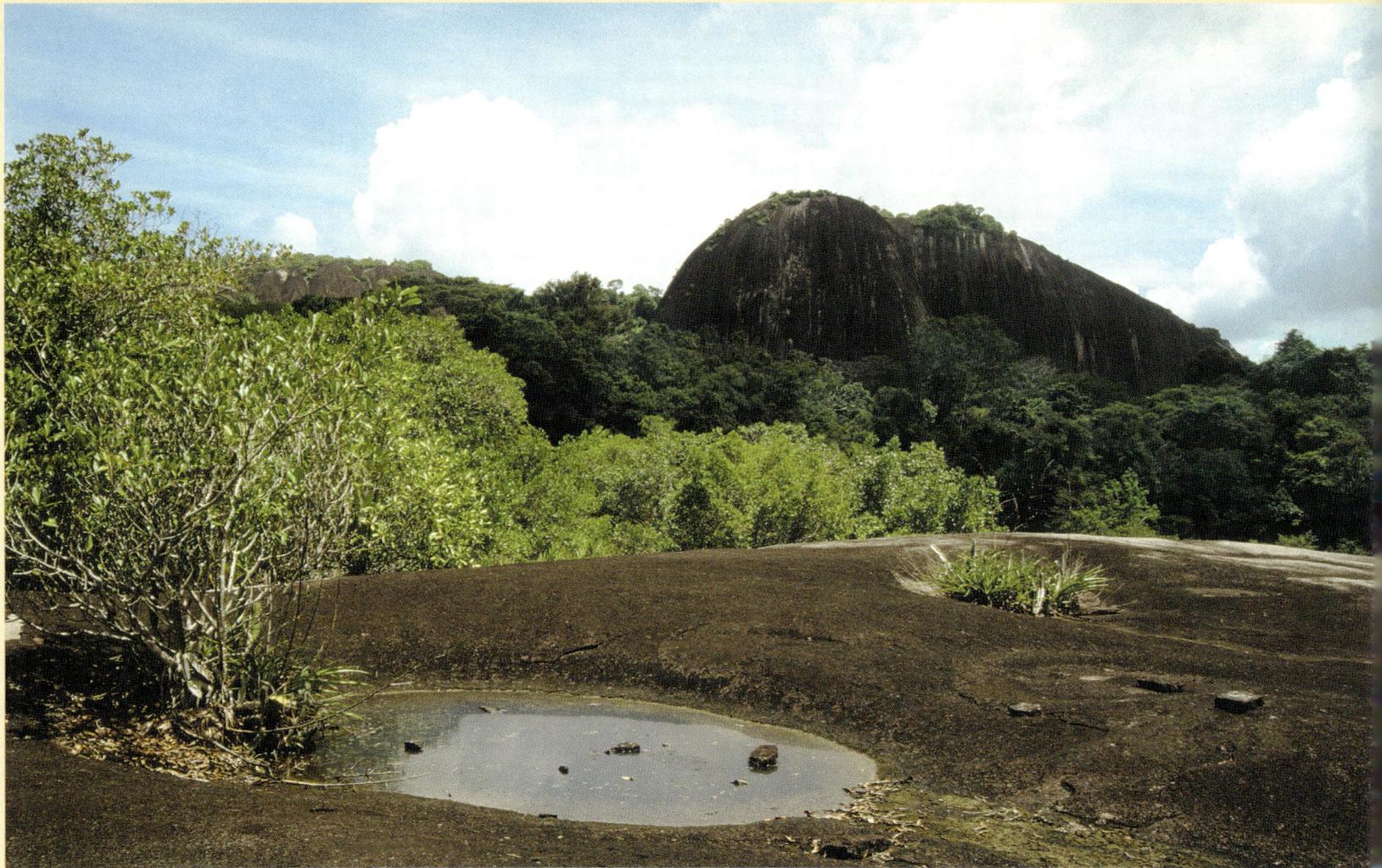

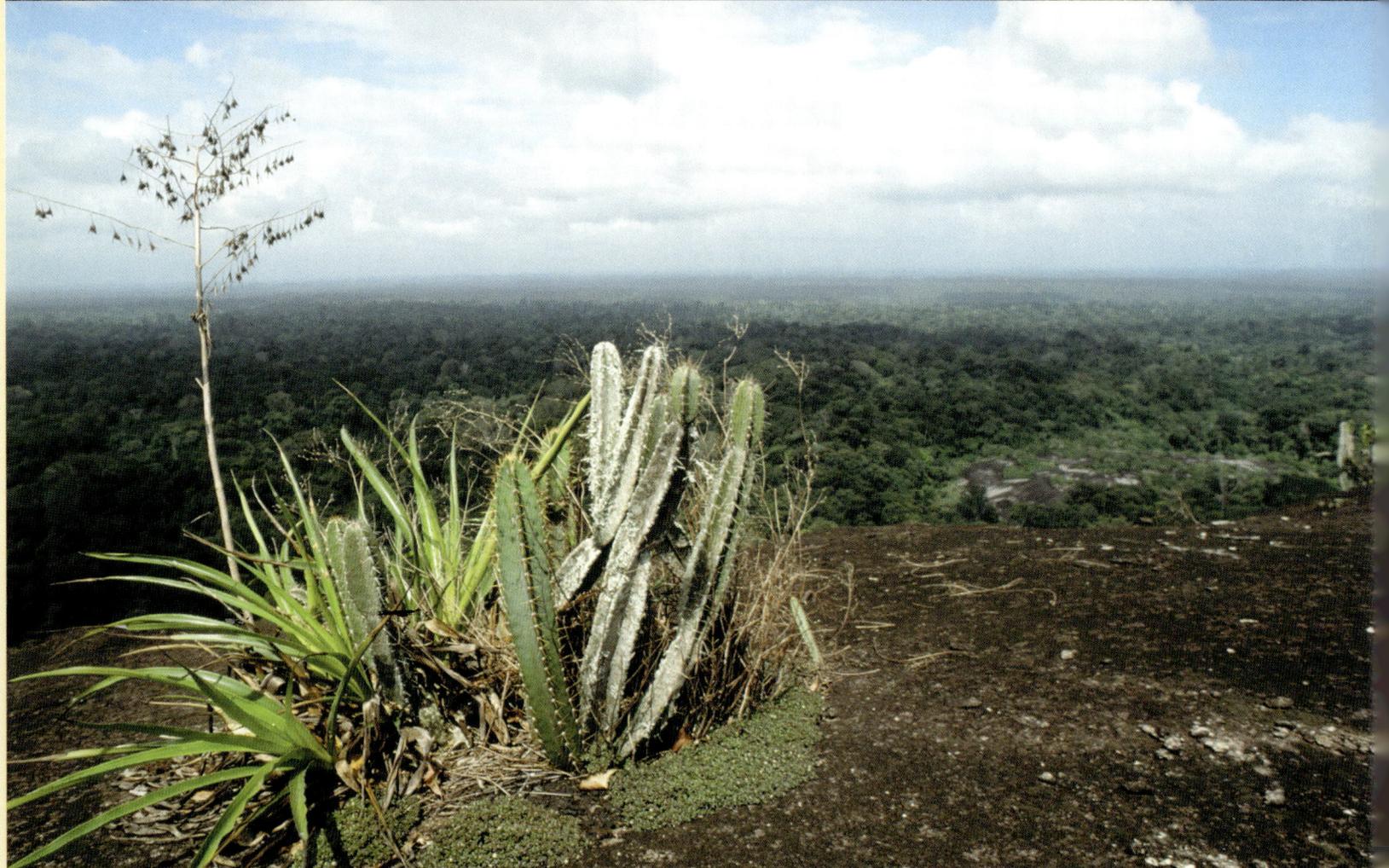

The mountains

Approximately 1,6 billion years ago and after a period of subsidence, Guyana was flooded by the sea. A layer of sand was deposited on the seabed, which was pushed up to the surface as the land rose again. These deposits slowly changed into sandstone that mostly eroded away. The most extensive remnant of this sandstone plateau, now known as Mount Roraima and located on the border between Guyana, Venezuela and Brazil, is best known for the Angel Falls, the highest waterfall in the world. Besides Guyana, the sandstone deposits are also found in Surinam in the shape of Tafel Mountain with the Augustus, Geyskes and Lisa Waterfalls.

Tectonic activity fractured the landscape and these rifts were filled with igneous rock. These so-called dolomite passageways characterise the interior, as they are highly resistant to erosion. They remain as long mountainous ridges; the Van Asch van Wijck Mountain range is a familiar example.

Erosion carved low plains that sloped gradually towards the sea. When the continent was raised again, these plains were elevated high above sea level and were subject to the process of erosion once more. As before, hard rock remained behind, this time as plateau mountains that did not erode because of their hard bauxite and laterite peaks. This process formed the Lely Mountains (700 m), the Nassau Mountains (500 m), Browns Mountain (500 m) and the Wintiwai Mountain (450 m) . Their flat peaks (plateaus) are all that remains of a former plain.

Granite occurs in the subsoil in vast regions of Surinam. The granite is visible in those places where erosion has taken place more rapidly than weathering. Further weathering and erosion has stripped away the surface to reveal a landscape of bare granite mountains, often steeply sided, towering above the land like islands. The Voltzberg and the Kasikasima Mountains are the best known. Rapids and waterfalls are found where rivers and streams gouged out the resistant granite, dolomite or other hard rock.

13

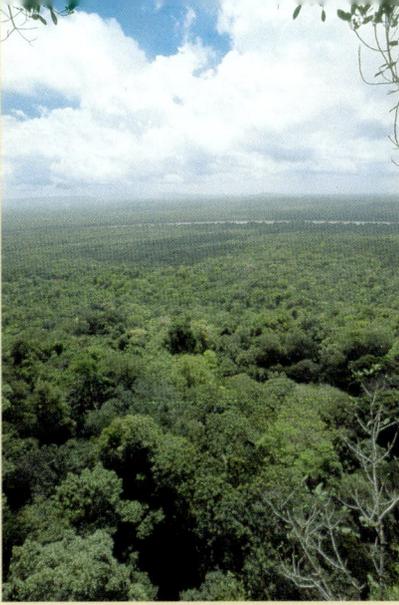

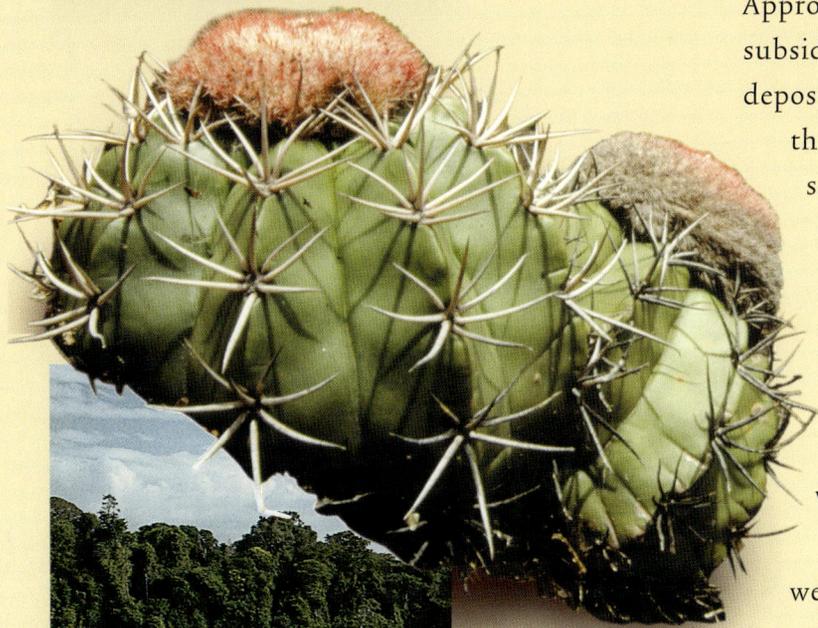

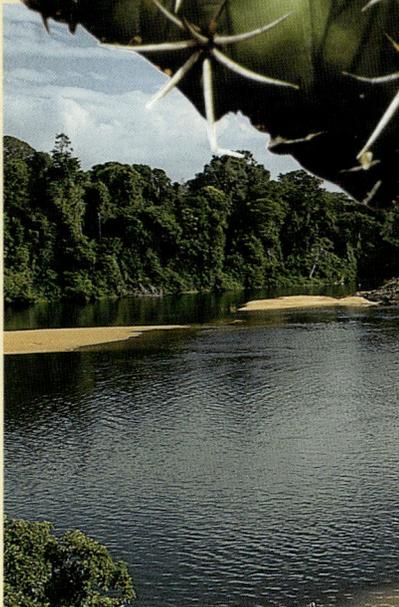

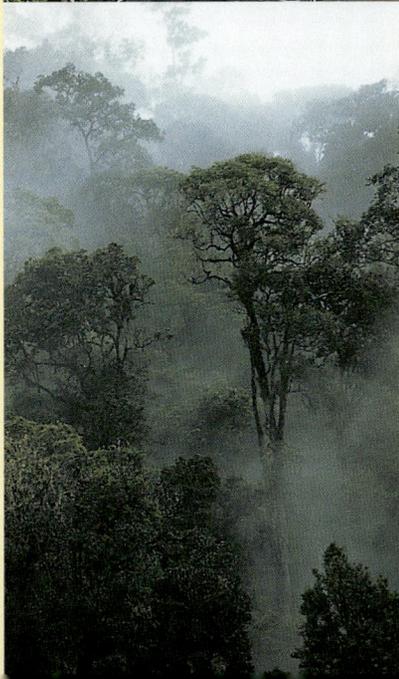

PAGE 12
View of the Voltzberg from the nearby granite plateau.
WILLEM KOLVOORT
Growth with cacti on the granite plateau.
WILLEM KOLVOORT
PAGE 13
View over the rainforest.
WILLEM KOLVOORT
Melon cactus.
WILLEM KOLVOORT
***Sula* in the Suriname River.**
TOON FEY
Low clouds over the rainforest.
TOON FEY

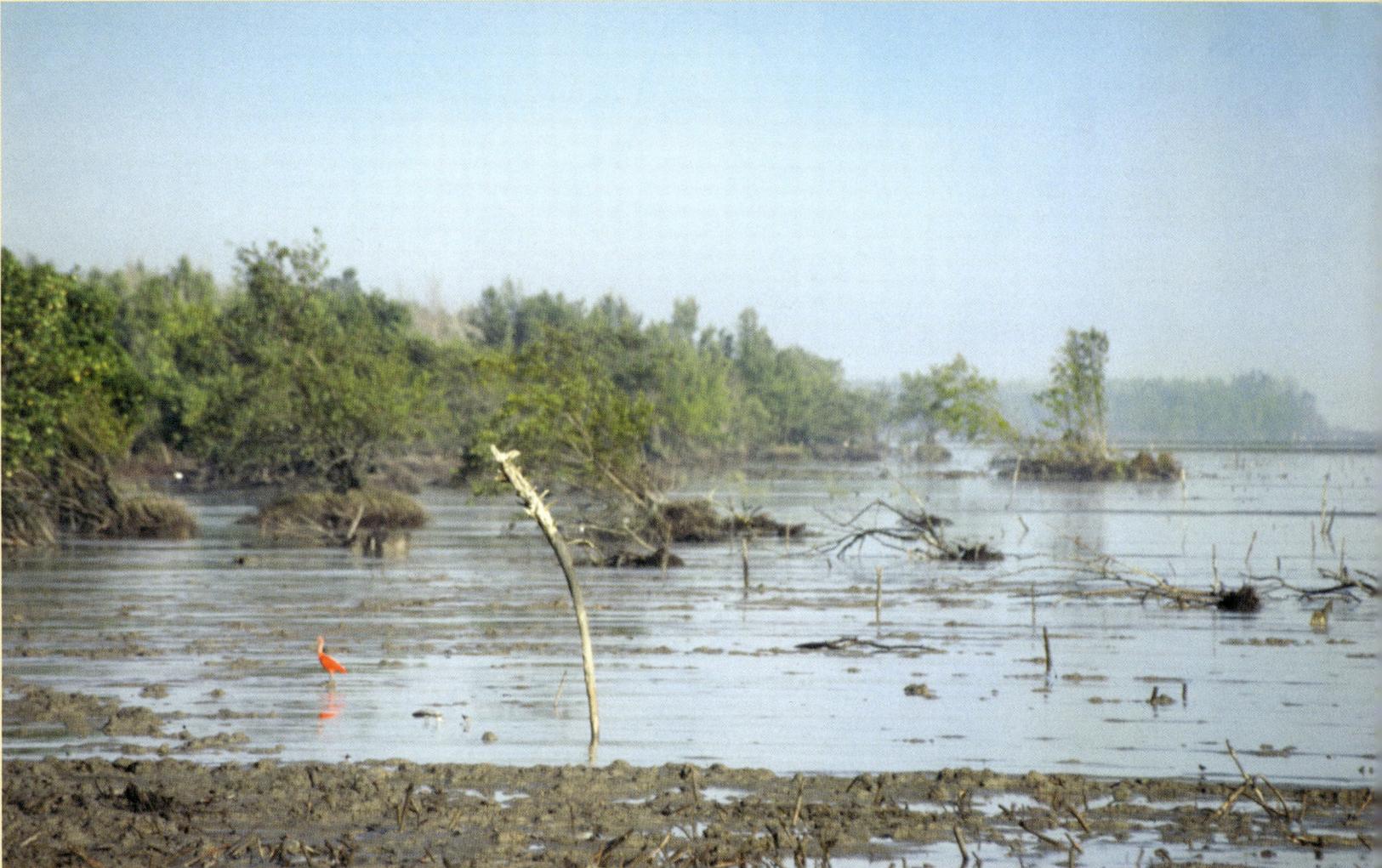

14

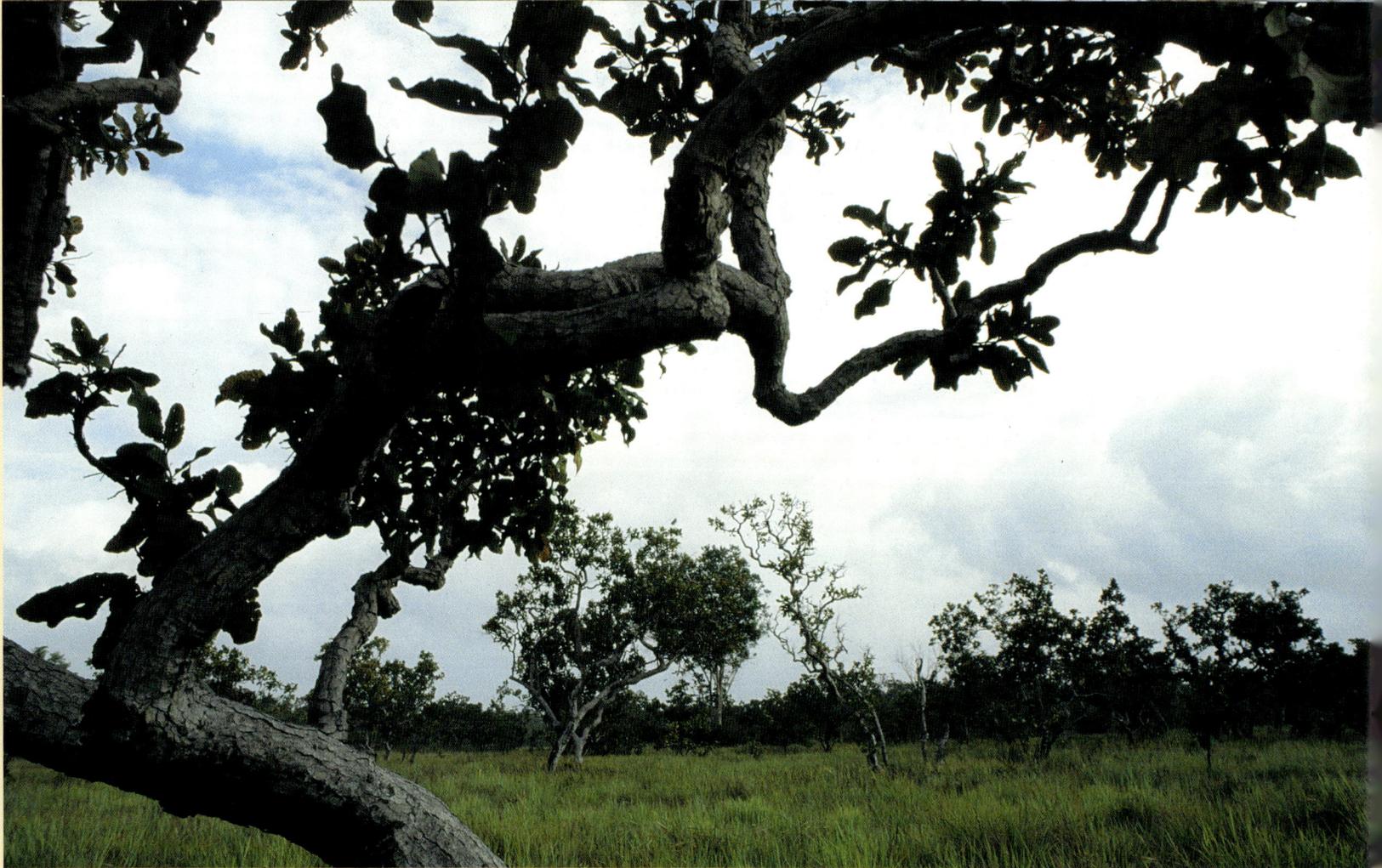

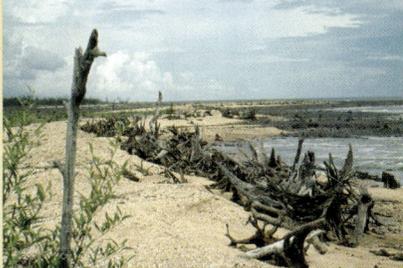

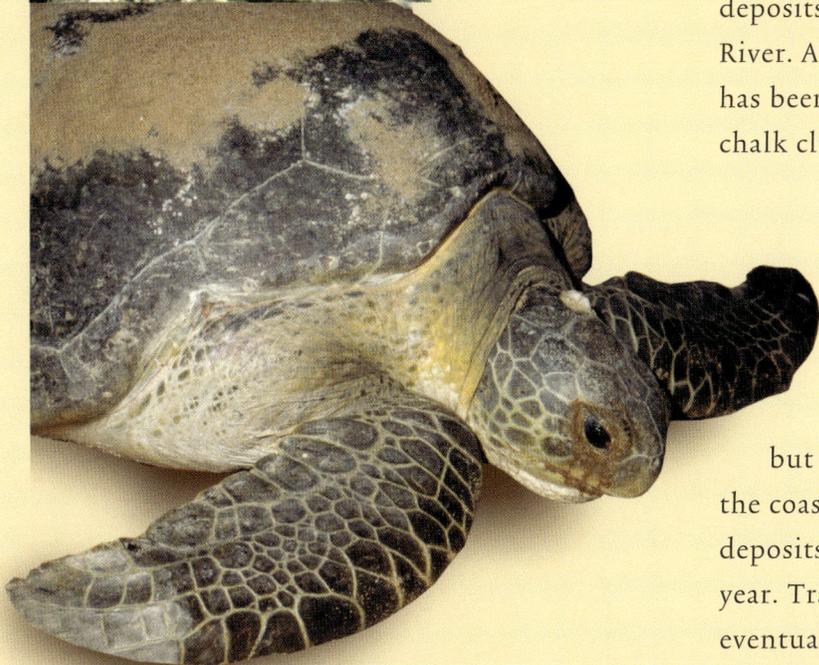

The lowlands

A strip of low-lying land stretching to the coast starts at the foot of the mountainous interior and encircles the island. There are no geological formations higher than 100 metres and the strip gradually slopes to the sea. It also narrows from east to west from 180 to 20 kilometres. In total, it covers a fifth of the country. The lowlands can be divided into three zones: the sandy plains, the old coastal plains and the young coastal plains.

The sandy plain is better known as the 'savannah belt', which is actually a rather unfortunate designation, not only because only 7 percent of this area can actually be called 'savannah', but also because a number of savannahs occur outside this 'belt'.

The savannah belt was created several million years ago and consists of eroded material (predominately sand) deposited as wide alluvial fans by the powerful ancestors of the present rivers. When this sand became exposed because of the geological activity which raised the level of the land, it dried and was bleached white. Located in such a region is Zanderij, the name of a sand quarry that served as the foundations for a railway line to the gold mines built at the beginning of the last century. Sandstone deposits are most prevalent in the area around the Corantijn River. Along the Guyanan bank of the Corantijn, this thick layer has been carved into high, white banks reminiscent of English chalk cliffs.

The coastal plain

The sandy deposits slope down towards the north and disappear beneath younger clay and sand deposits of the old and young coastal plains. These coastal plains were not formed by eroded material from the interior, but mainly by sediments deposited by the sea. Clay found on the coastal plain is predominately from the Amazon River, which deposits millions of tons of debris in the Atlantic Ocean each year. Transported by the Guinea Current, this sediment is eventually deposited along the coast of Guyana.

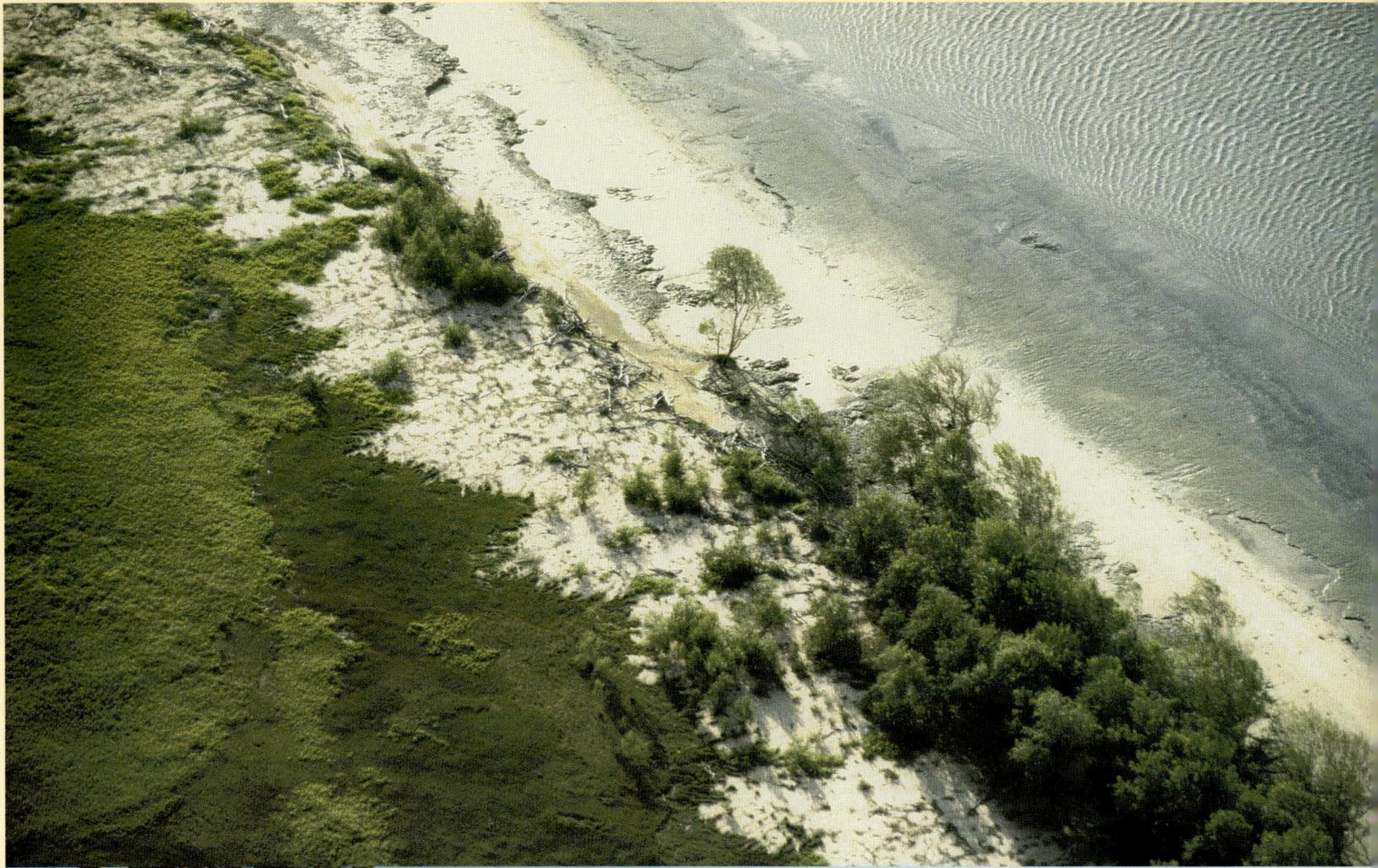
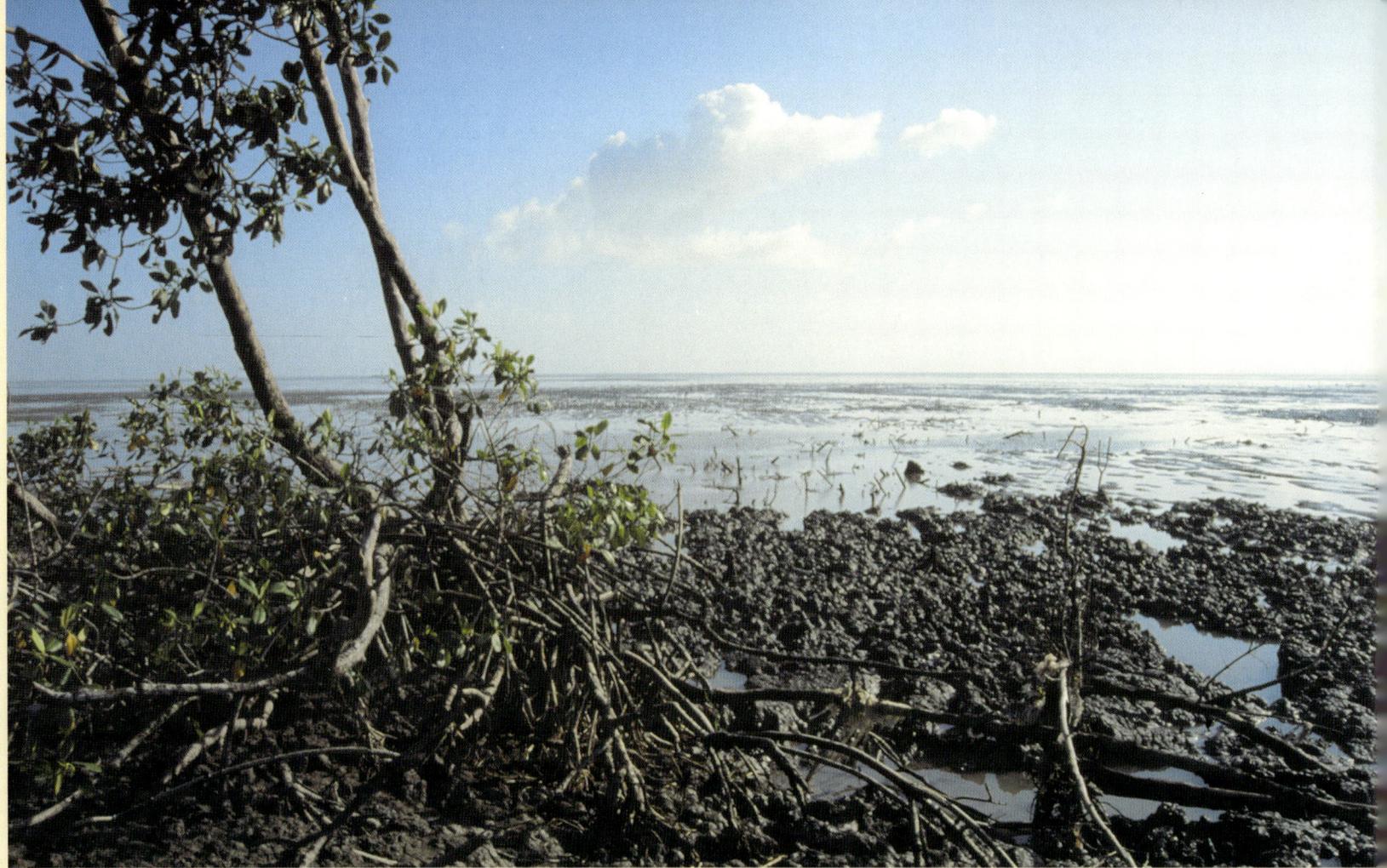

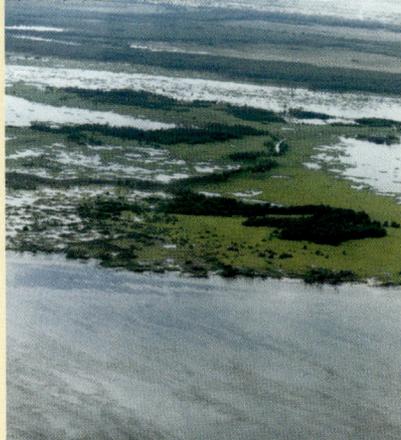

The old coastal plain borders on the sandy plain. It was created in a period marked by massive changes in the global climate when ice ages alternated with 'intervals'. During one of these ice ages, the global sea level dropped, affecting Surinam as well. The entire continental shelf stretching about 100 kilometres offshore dried out and the tropical climate was replaced by a dry savannah climate. The sea level rose again, almost reaching the height of Zanderij; to be precise, it got to the road, Weg naar Republiek. In the periods when the sea level rose, a stretch of the old coastal plain was restructured. The tropical rainforest climate also returned during one of these intervals.

Due to the high sea levels, the sea-clay regions of the Paralandscape formed flatlands. The sandbanks deposited by the sea formed grooves in the landscape now seen around Lelydorp. During periods with a low sea level, rivers eroded deep gullies. When the sea level rose after the last ice age, the land stayed at the elevation it is now, and the higher areas of the old coastal plain were drained of water. The seawater that penetrated the old coastal plain filled these gullys with young sea clay. The Coropina Creek runs through such a gully.

The young coastal plain formed after the old coastal plain and the sea level stabilised about 6000 years ago and a fair-sized stretch of coastline had been formed (the beach was then at the same elevation as Lelydorp). This developed quite rapidly due to the creation of mudflats and huge amounts of sand deposited from the French Guyana coast and the Marowijne River. Mudflats that formed beyond the beach, unaffected by the tides, gradually changed into deep swamps.

Surinam has a very dynamic coastline: it can expand up to 100 metres a year, but this land can disappear just as quickly. Rising sea levels also affect the Surinam coastline and large areas of the tidal landscape are often submerged.

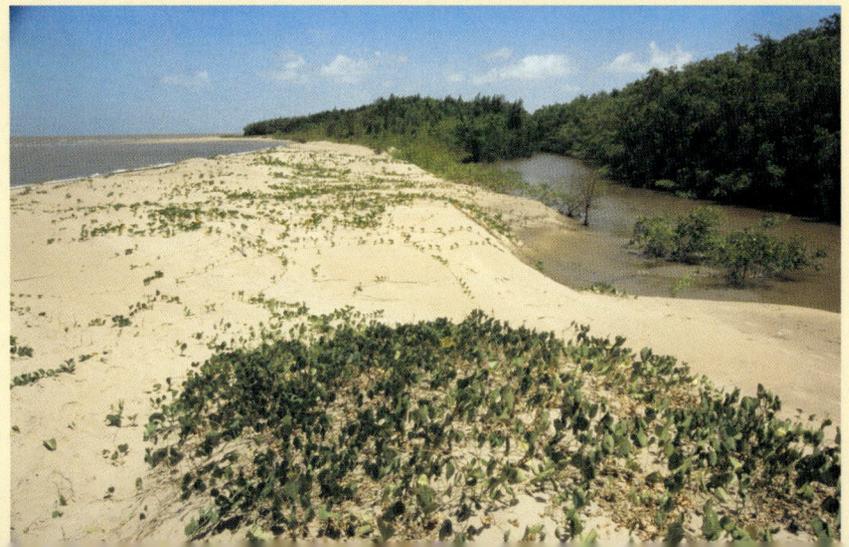

A WARM, HUMID CLIMATE

The southern border of Surinam is a mere 250 kilometres from the equator, which means that the island enjoys an almost constant temperature. The difference between the average temperatures of the warmest and coldest months (respectively September and January) is only a few degrees. Daytime temperatures in the lowlands average about 30°C; nights are about 23°C. Zanderij, for example, has an average annual temperature of 26°C.

The climate of Surinam is characterised by high annual rainfall of about 2000 mm; some regions such as the inland mountainous regions receive as much as 2500 mm. Holland, by contrast, has an average annual rainfall of 750 mm. This abundant rain is why Surinam has such profuse vegetation.

Rain is produced primarily by the meeting of trade winds from the south-east with those from the north-east. This weather system moves northwards over Surinam in the summer, carrying rain from the south. This long rainy season lasts from mid-March to mid-August. The long dry season occurs when this weather system moves further north during mid-August to mid-September. The long duration of this period is attributable the warm Caribbean Sea, which delays the return of this weather system. At the end of November, it moves rapidly back to Surinam in the south. The short rainy season lasts from mid-December to mid-January and is followed by a short dry spell lasting from mid-January to mid-March.

Despite the regularity of the four seasons, precipitation on Surinam remains to a large extent unpredictable and the different seasons can be wetter and drier than expected. Rising temperatures during the day can cause heavy rain showers during the afternoons. Surinam enjoys many hours of sun each year: Paramaribo, for example, has an annual sunshine average of 60 percent.

Unlike the rest of the Caribbean, Surinam does not endure

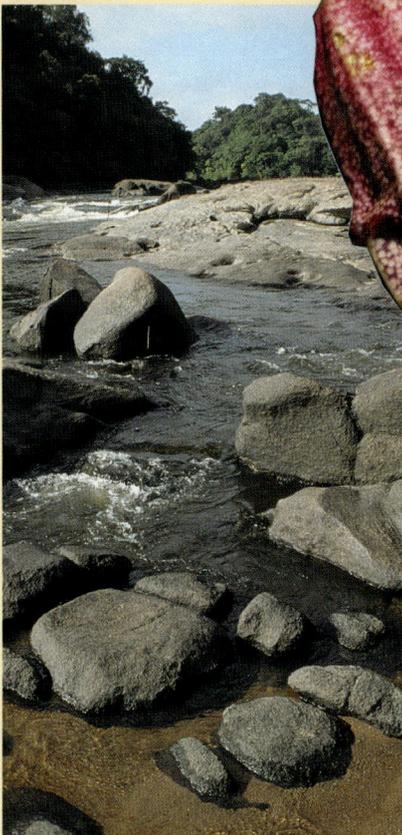

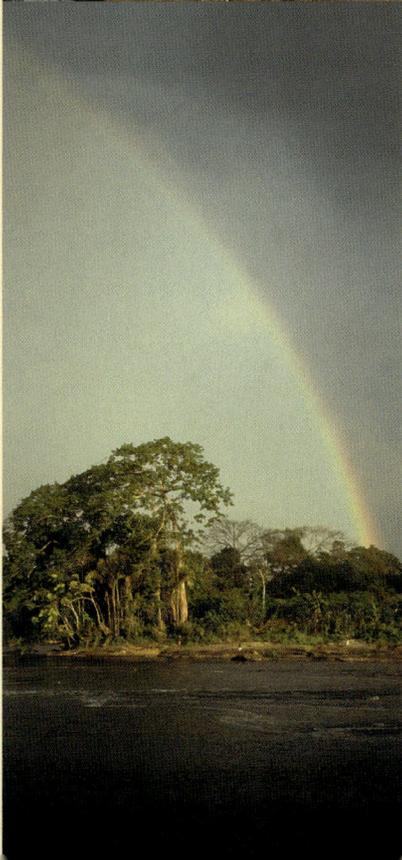

PAGE 18
Tropical storm over the Coppename River.
WILLEM KOLVOORT
PAGE 19
Sula.
WILLEM KOLVOORT
Rainbow during a downpour.
FRANS SCHELLEKENS
A cactus fruit.
WILLEM KOLVOORT

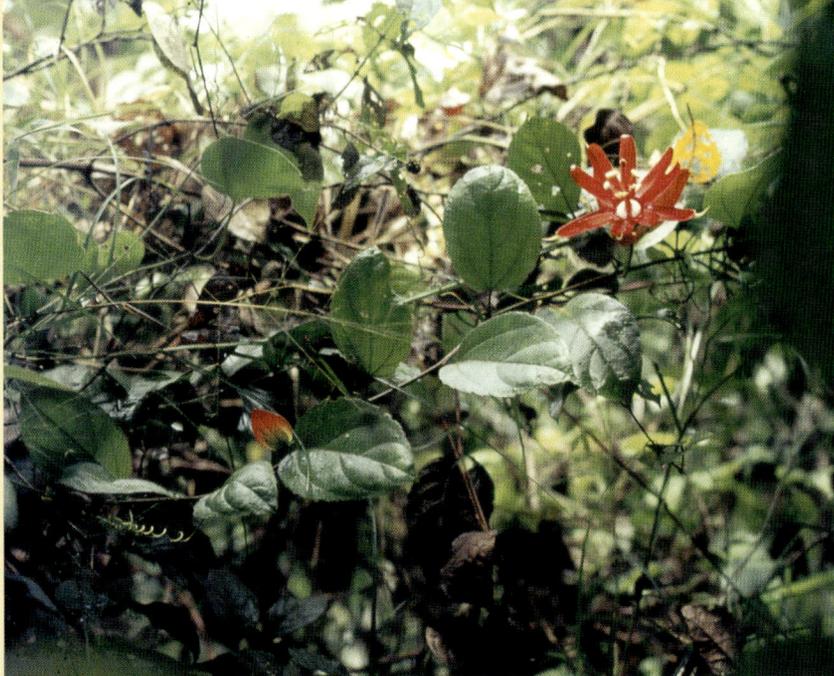

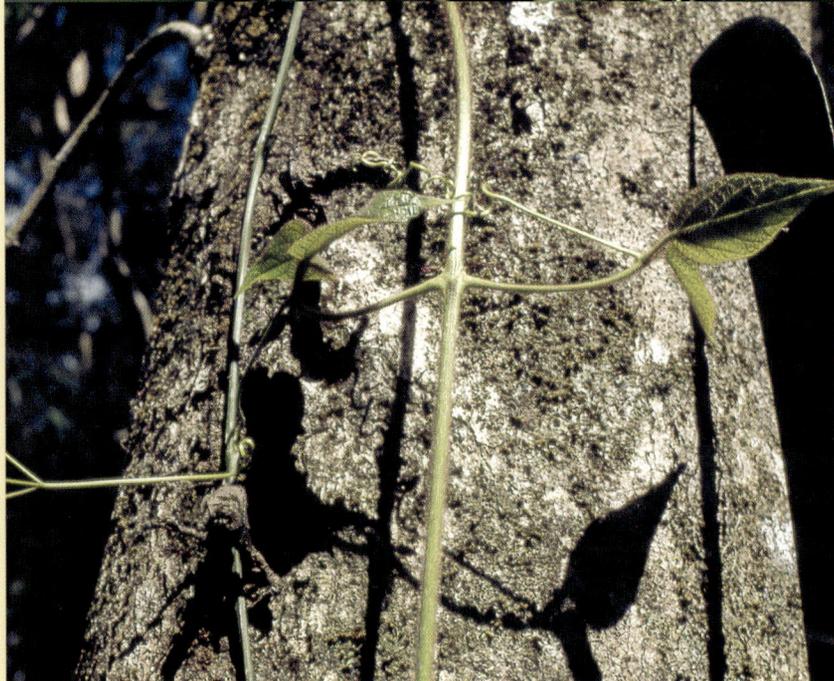

Lianas (woody vines) are frequently encountered in tropical rainforests. They are unable to keep themselves upright and survive only if there is another plant (usually trees) that can provide this support. Methods by which lianas attach themselves vary and include stem twining and clasping tendrils and spikes that attach the liana to its host. Climbers do not need thick bark to hold themselves upright. The more flexible liana stems have evolved a unique method of absorbing water and nutrients. This is important as it enables the liana to twine around its supporting tree. Many coil their stems into springs to prevent them snapping as they dangle between wind-blown trees and between the tree and the ground.

When a liana has wrapped itself around a tree trunk, which continues growing and expanding its girth, the bark becomes constricted, and the tree dies above this point. Occasionally, when the tree is stronger than the vine, the vine will snap. Lianas have heart-shaped leaves and some varieties produce splendid flowers. As lianas are rooted throughout their lives, they are not

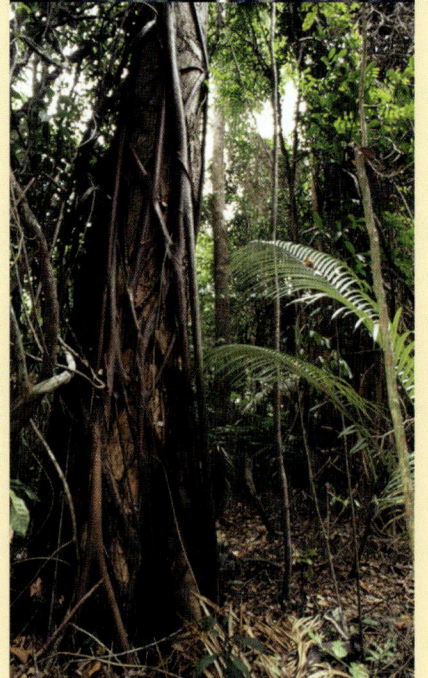

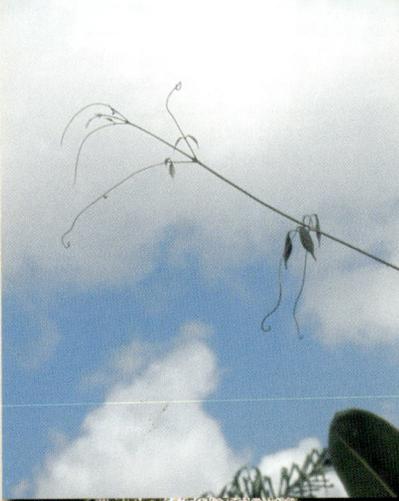

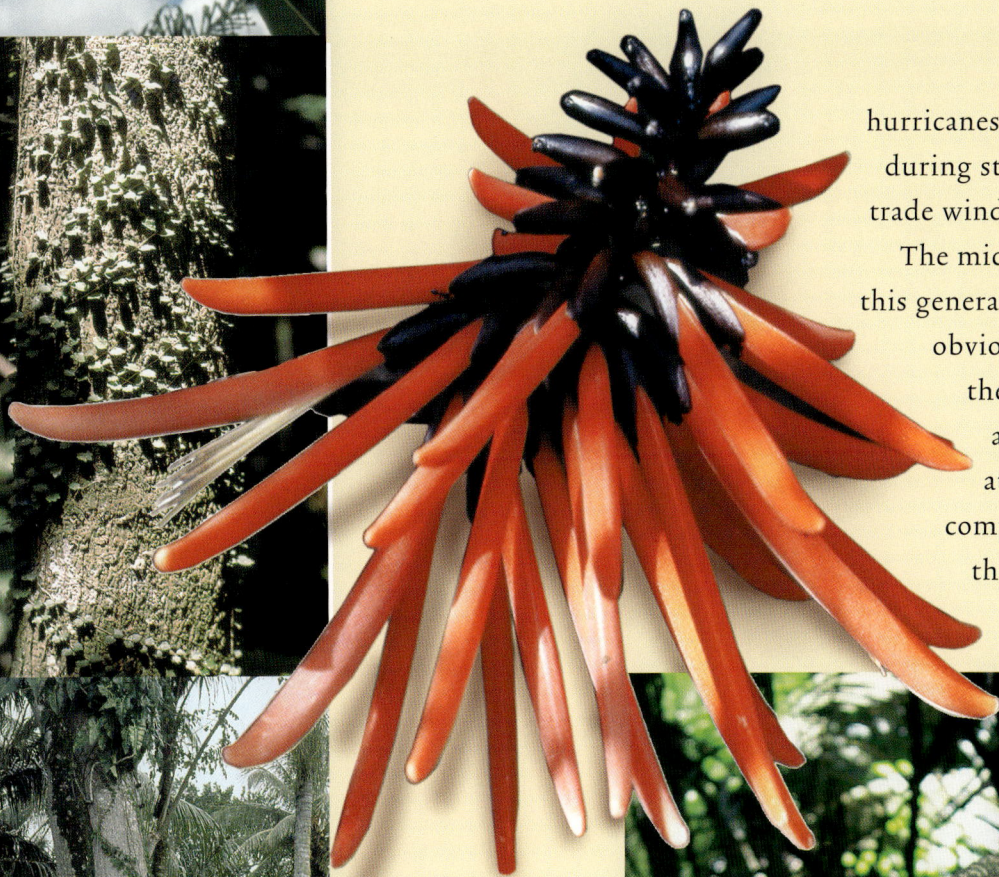

hurricanes, although powerful winds do blow during strong storms. Most of the time, the trade winds ensure a light easterly wind.

The microclimates should be included in this general overview, of which the most obvious example is the rainforest where the ground (untouched by sunlight and wind and with a high atmospheric humidity) creates a completely different climate to that of the sun-baked forest canopy.

parasites, and take nothing from the tree besides support.

Lianas should not be confused with the similar aerial roots, which grow towards the ground from the trees, are very elastic and eventually root themselves in the soil.

MARTIN HEYDE

RIGHT

Liana.

ERIK SOK

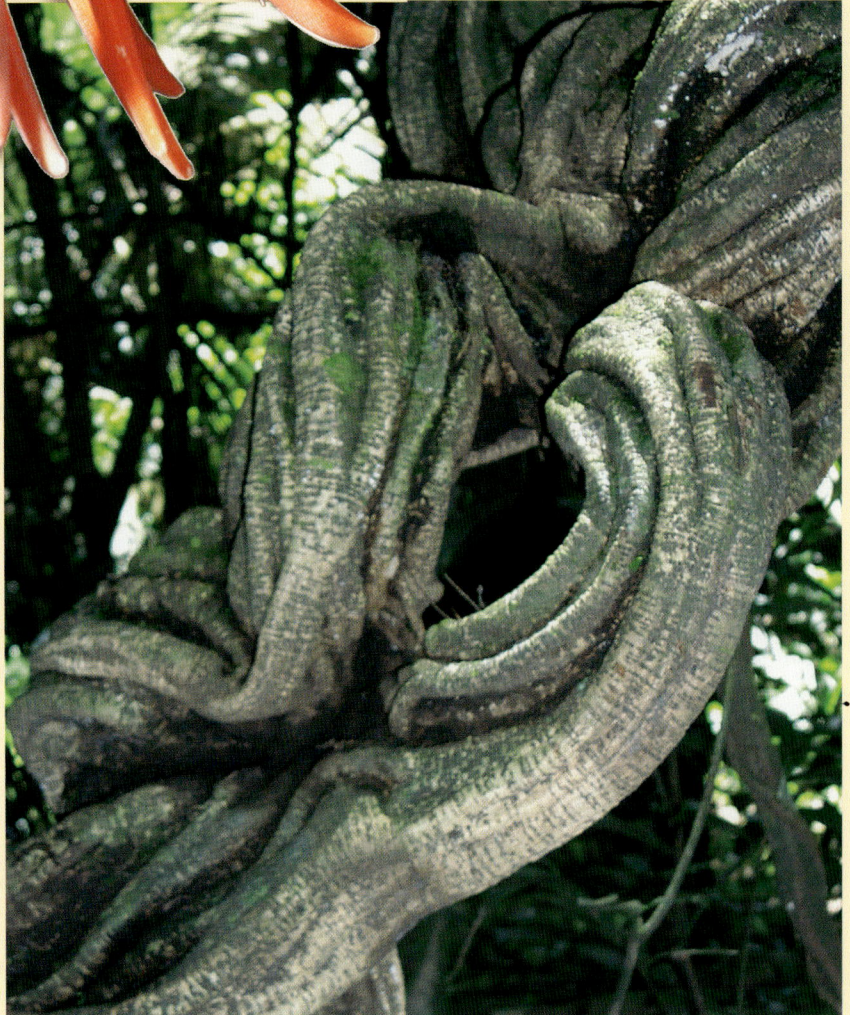

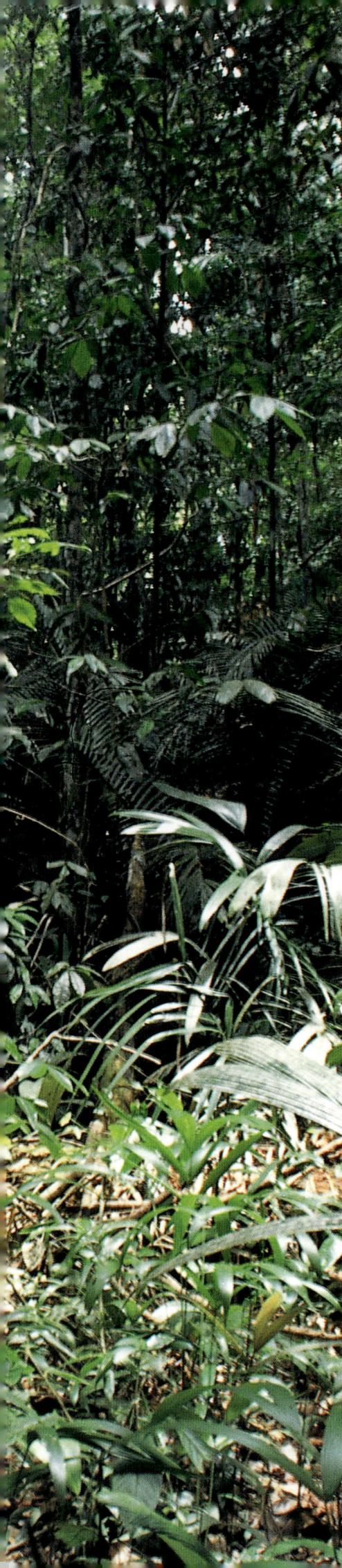

THE RAINFOREST

That the tropical rainforests are the most impressive and important natural phenomenon on the planet is by no means an exaggeration. No other natural environment contains such a diversity and wealth of natural riches. Situated in the stable equatorial climate zone, the rainforests have evolved over millions of years, resulting in a highly varied and complex ecosystem about which little is known. The wealth of genetic material, the pharmaceutical possibilities and the symbiosis between plants and animals are all areas that remain largely uncharted by science.

Rainforests are essential to global climate and their massive oxygen production has earned them the name 'the lungs of the world'. Tropical rainforests can be considered as green machines that always run at full throttle. No other ecosystem on the planet has such an impressive biomass. More than 80 percent of Surinam is covered with tropical rainforest; the country has unique wealth that should be treasured.

Ever green

One of the most noticeable characteristics of tropical rainforests is the evergreen trees. The trunks of most varieties are long and slender, but some do grow trunks several metres thick. These varieties sometimes grow prop roots at the base of the trunk to anchor them more firmly to the ground.

At first, the rainforest produces an impression of space: there is almost no growth on the forest floor, the tree trunks are quite bare or have a light covering of bark or moss. The number of different types is overwhelming: 140 different varieties can grow on a single hectare. More than 800 tree varieties grow in Surinam and more will undoubtedly be discovered. By comparison, about 100 varieties grow in Europe.

The dense forest canopy prevents sunlight from penetrating deeper into the forest and only about 1 percent manages to reach

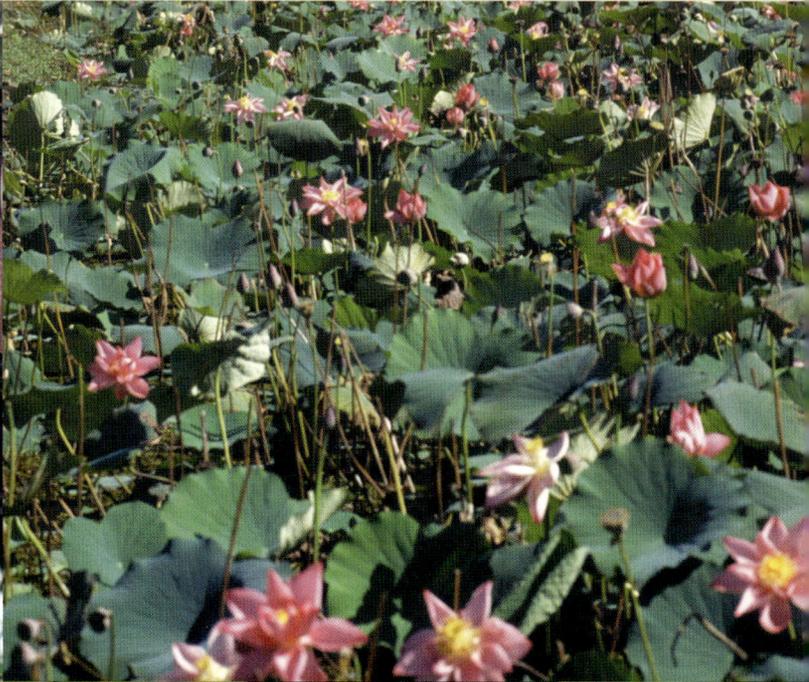

24

PAGE 24/25
Some of the vast array of flowers growing in the rainforest.
WILLEM KOLVOORT,
FRANS SCHELLEKENS,
JOKE VAN DER PEET

25

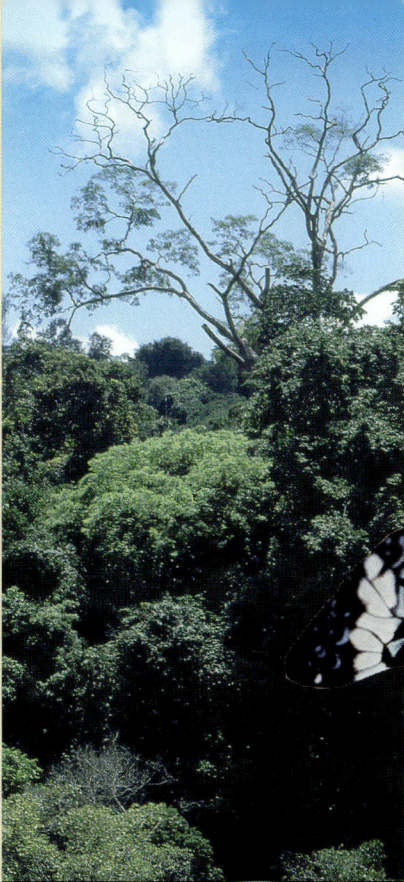

PAGE 26
Epiphytes.
MARTIN HEYDE
PAGE 27
The rainforest canopy.
JOKE VAN DER PEET
Yellow orchids.
WILLEM KOLVOORT
Epiphyte.
TOON FEY

the forest floor. At the hottest time of the day, the temperature here is about 4 percent lower than in full sunlight. Because the humidity in the forest is much higher than outside and there is almost no wind, there is hardly any evaporation. Only about 80 percent of rainfall reaches the forest floor, the rest is absorbed by the leaves and wood or evaporates. The differences between light intensity, temperature, rainfall and air humidity on the forest floor and at the treetops is remarkable. The rain forests' microclimate yields an untold wealth of life forms.

Floating gardens

The best way to see the rainforest is from the air. The forest canopy, often compared to broccoli, undulates like waves and varies in height from 18 to 35 metres above ground level. Taller trees, measuring 50 and sometimes even 80 metres high, protrude from the canopy.

Much of the wealth of the rainforest is concealed in this canopied world. There are numerous varieties of plants, insects, snakes, lizards, frogs, birds, sloths, tree hedgehogs, monkeys and anteaters. Insects, birds and bats play an important role in fertilising flowering plants, while monkeys and other mammals scatter seeds in their droppings. Our knowledge of this unique ecosystem is limited and new and valuable discoveries are being made continuously.

The crowns of shorter trees create lower levels below the canopy. The main difference to the high canopy is that the more stable microclimate supports different varieties of flora and fauna. The thick vegetation is unsuitable for larger birds, but smaller types including woodpeckers, nuthatches and hummingbirds thrive.

The forest floor

Few plants survive in the sparse light that reaches the forest floor. Besides some ferns, most are seedlings or stunted saplings. Their only hope of growing into full trees is if an old giant of the

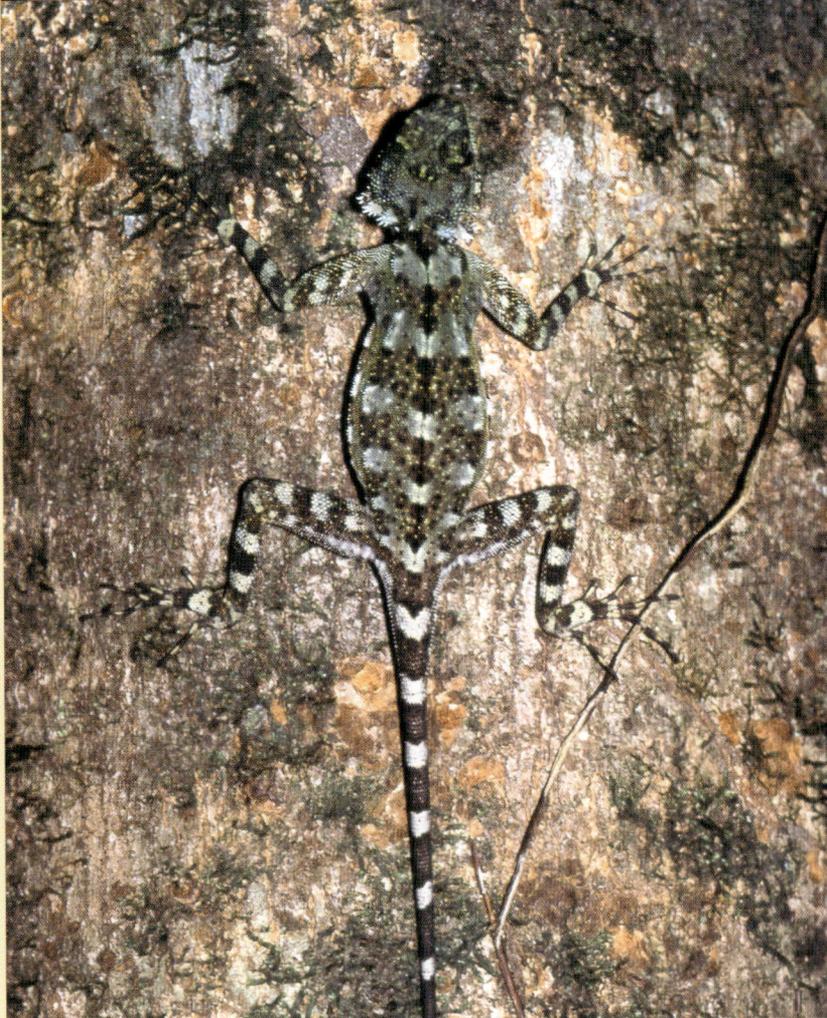

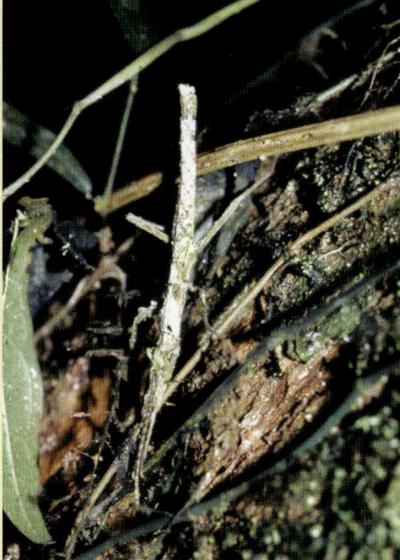

PAGE 28/29
**Coral snake.
Lizard in camouflage.
Boa constrictor.
Young Guyana
grasshoppers.
Leaf insect
camouflaged as moss.
Praying mantis.
Stinkbug.
Scale bug.**
JOKE VAN DER PEET

forest is blown over by strong wind, taking others down with it, thereby creating a gap in the canopy so that the stunted plants can benefit from full sunlight.

Considering the enormous diversity of the rainforest, a fertile forest floor would be expected, but the opposite is actually true – the forest floor is almost sterile. Relentlessly high temperatures and heavy rain have leached the minerals from the soil. Nutrients only occur in the 40–50 cm thick topsoil. The fine nutrient roots of the trees grow in this layer; deeper roots anchor the tree. Despite a constant barrage of leaves, twigs, dead insects and other organic waste, this layer of humus never gets very deep.

The rapid organic decomposition (or mineralisation) is typical of rainforests. Ants, beetles, worms and countless other insects are vital here, as they process organic waste. Bacteria and mould convert this material into the nutrients absorbed by the plants and trees. All this biological activity means that the forest floor usually looks as if it's just been swept.

Forest animals

As the forest floor cannot sustain them, large mammals are rare in the rainforest compared to insects, amphibians and birds. Additionally, most are shy and only live by night, such as tapirs, wild boars, deer, hares, giant anteaters, armadillos, pumas and jaguars.

The high humidity sustains animals we would normally expect to find close to or living in water such as frogs, leeches and crabs. Armies of ants constantly criss-cross the forest floor. Some ants build subterranean nests where they cultivate nutritious fungi; others remain on the surface. There are numerous varieties of ants and the list grows by the day. The same applies to butterflies.

Tree snakes conceal themselves in hollow tree trunks or beneath toppled trees. The topsoil also wriggles with life: worms, wood lice, grubs and beetles and the animals that eat them such as centipedes, scorpions, small snakes and lizards.

29

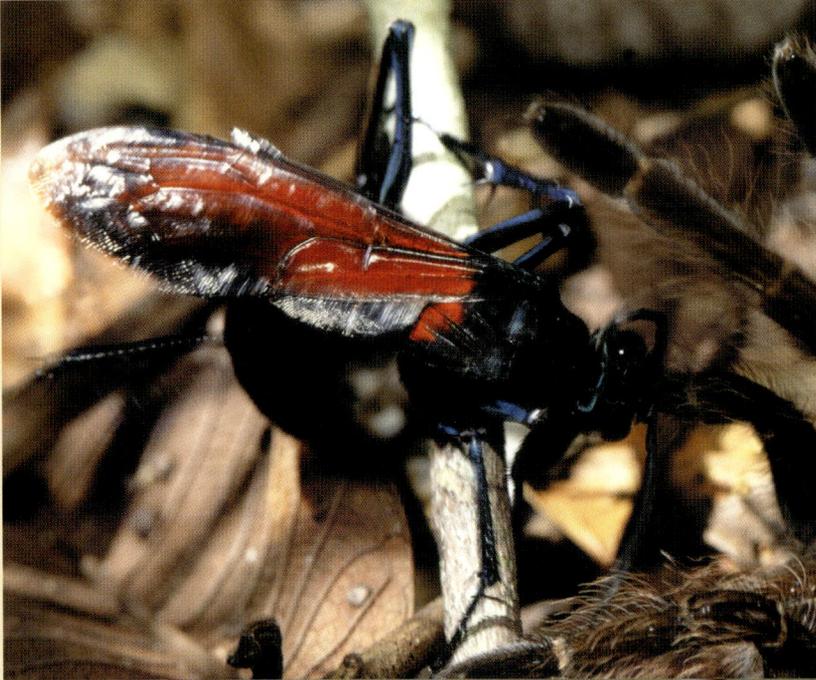

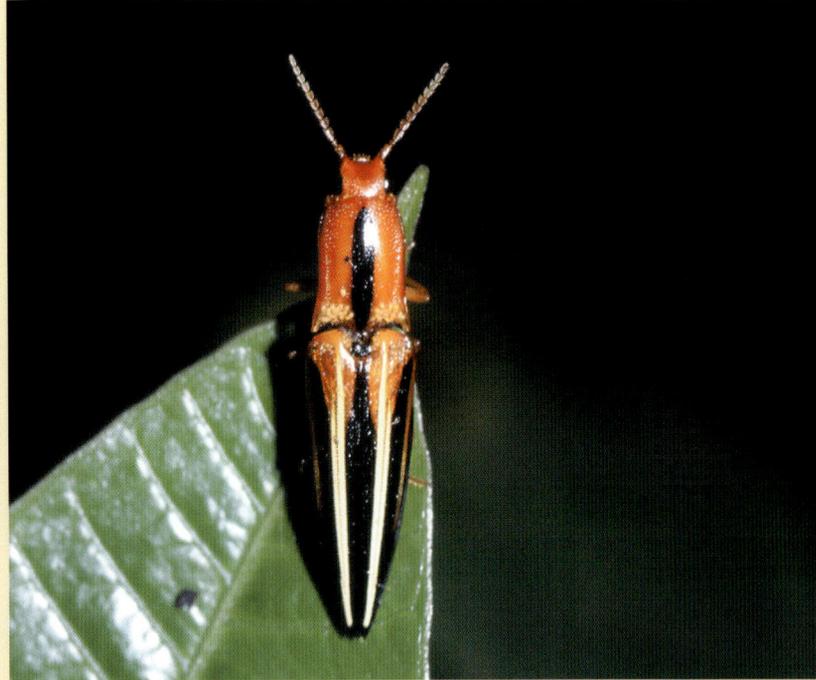
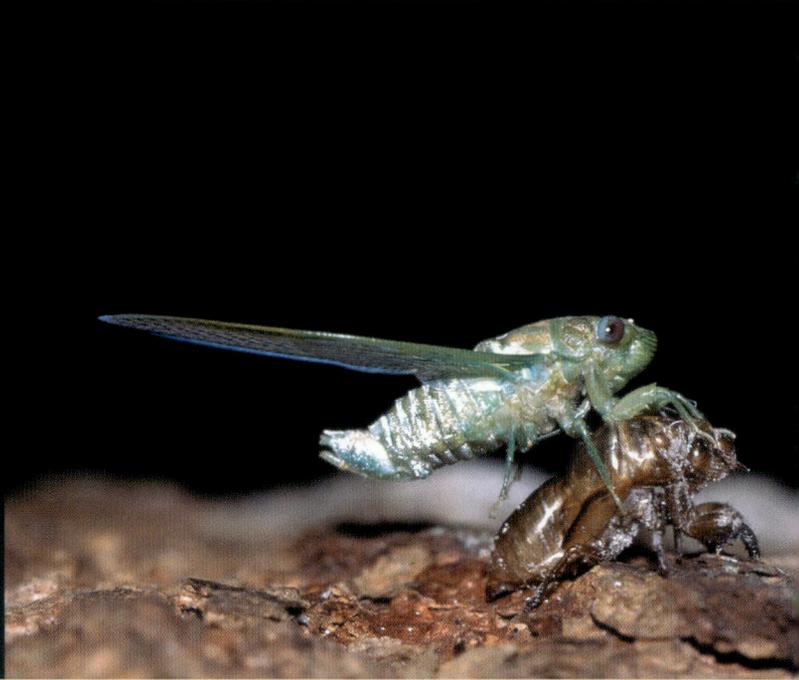

PAGE 30 TOP LEFT

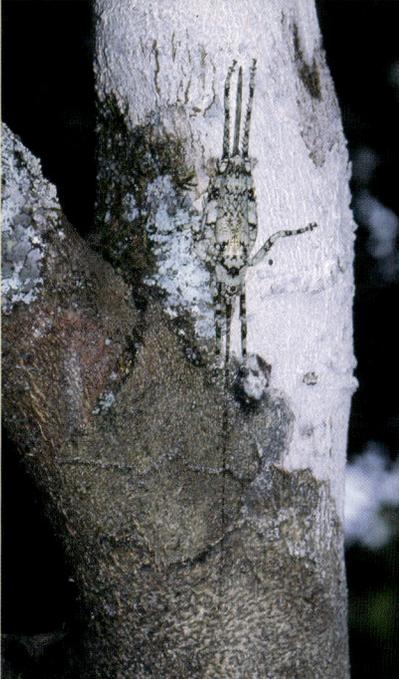

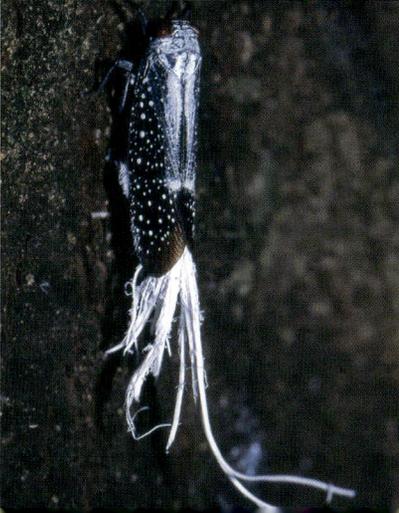

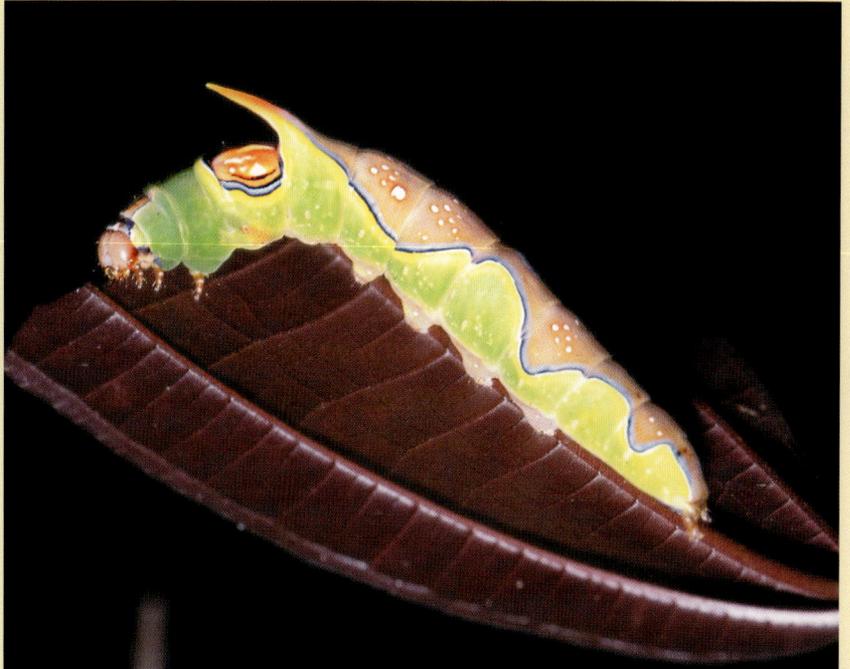

A spider wasp drags a stunned bird spider back to its nest.
WILLEM KOLVOORT
PAGE 30/31

Estimates place the number of insect varieties in the rainforest in the millions: they account for about 80 percent of all species found here. Variations in shape, colour and mode of existence are thus unlimited. Caterpillars are slow and a nutritious snack. They protect themselves by camouflage or imitating the surroundings. Some disguise themselves as twigs, while others scare off predators by imitating poisonous insects.

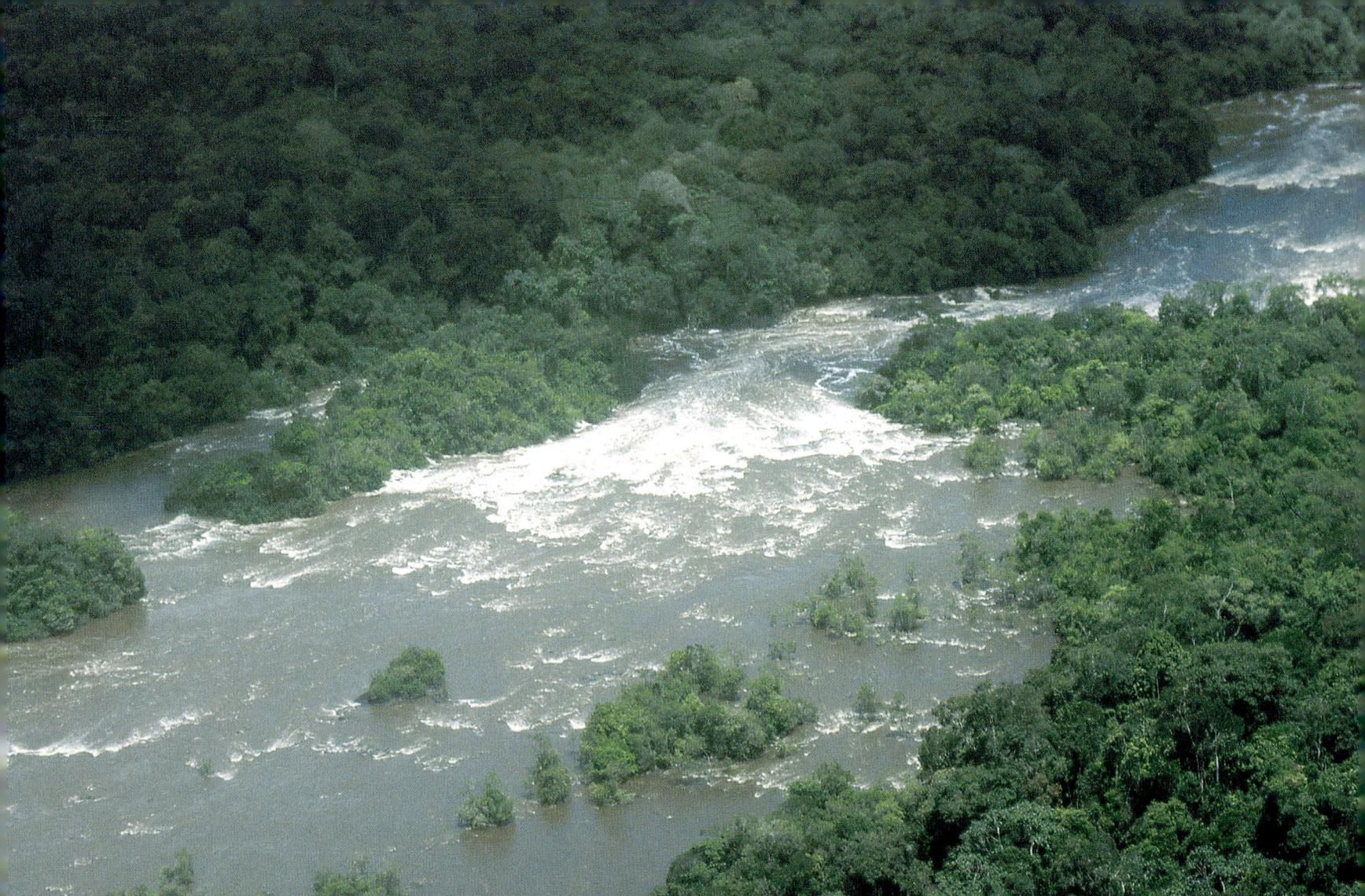
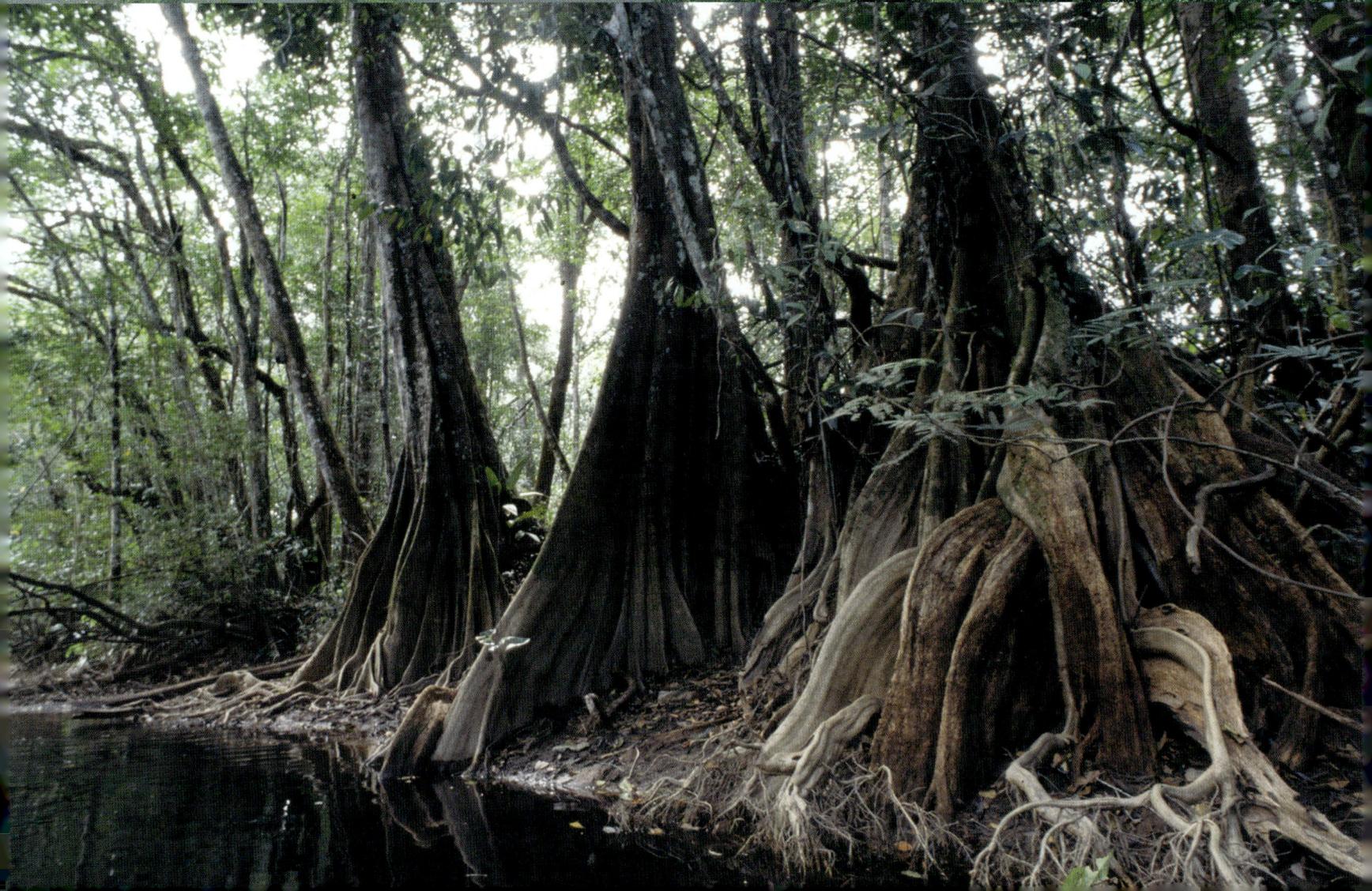

PAGE 32
Full river through the rainforest.
JOKE VAN DER PEET
Trees with aerial roots along a tributary.
WILLEM KOLVOORT
PAGE 33
The striking colours of butterflies serve to scare off predators: by suddenly opening its wings, the butterfly confuses its attacker, which tries to grab non-vital areas.

Predators confronted by the huge round 'eyes' on the wings believe they are dealing with a much larger animal. Moths (such as the one above) are usually covered with a soft down, which makes it difficult for bats to locate them by sonar.
JOKE VAN DER PEET, WILLEM KOLVOORT

Perfect but fragile

Tropical rainforests have evolved over aeons and are the most balanced and stable ecosystems on the planet. It is noteworthy that there are no plagues here: the rainforest can repair damage to itself from natural disasters. Past human practises, such as selective logging and establishing small plots, were not at all harmful.

Explosive population growth, technological advances and the ever-important economy have had a deleterious effect on the rainforests. Tropical hardwoods, minerals and the hydroelectric potential of the many rivers have resulted in the forests becoming very economically important. The large-scale exploitation of the last decades is truly alarming. When large areas are cleared of trees, heavy rains wash away the thin layer of fertile topsoil and it takes years for the forest to recover, if at all. These practises can bring about the complete destruction of the rainforests.

Maintenance of the rainforests is not something that should be done by choice: it is imperative. The amount of oxygen rainforests produce is vital to the survival of most species on the planet. Of course, there are countless other reasons why they should be protected. Rainforests contain enormous quantities of water and uncontrolled logging means that this moisture evaporates into the atmosphere with consequences for the regional climate and most likely for the entire planet.

Furthermore, little is being done to discover the potential of the genetic diversity. The probability that the rainforests are home to trees and shrubs with potential economic benefits should also be considered. Many of these varieties will disappear before they have even been discovered. Not only does deforestation pose the threat of ecological and economic disaster, it is also a direct assault on the domain and livelihoods of the people who live there.

33

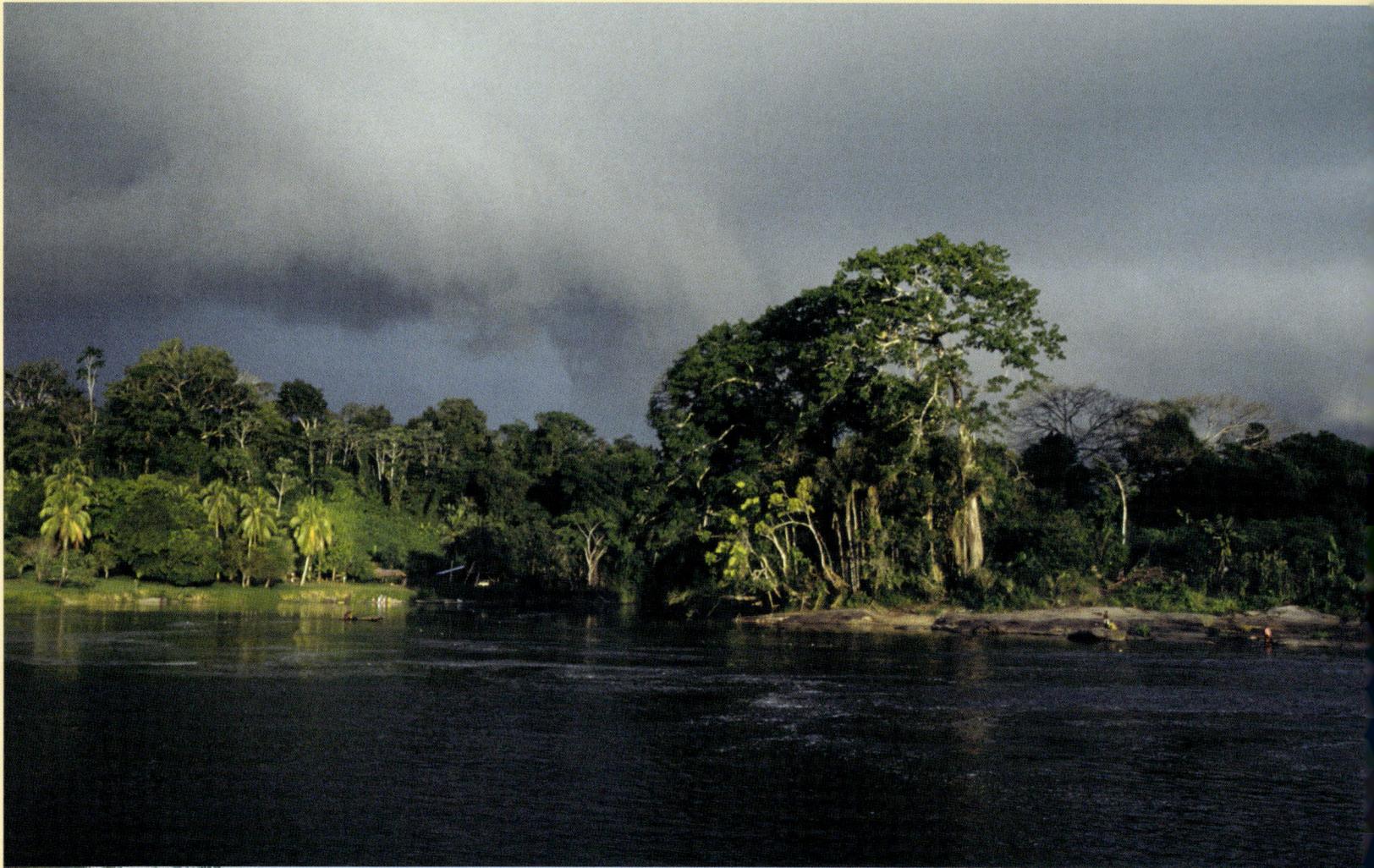

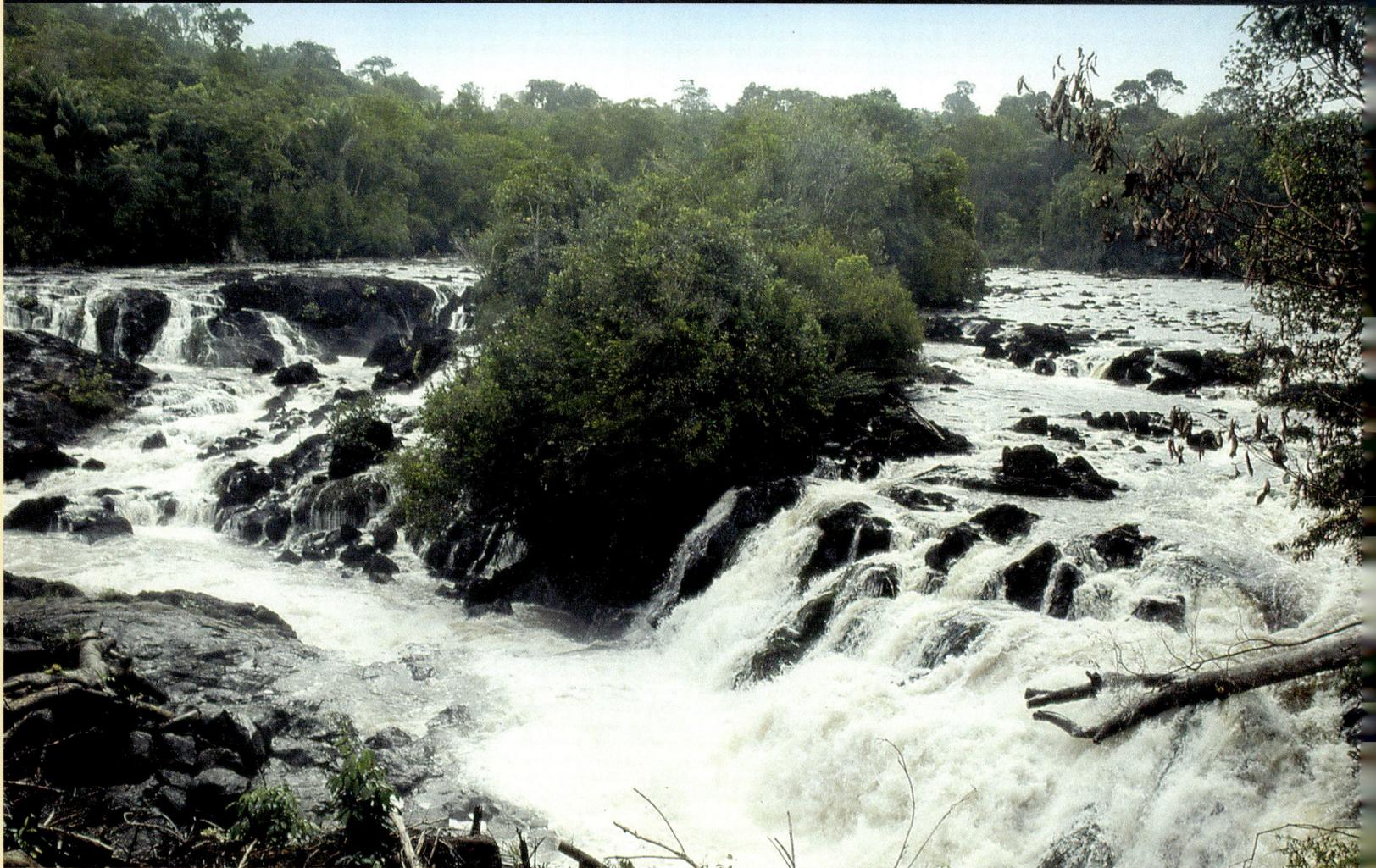

THE OTHER LANDSCAPES

Rivers

Surinam is a land of rivers. Streams gush down off the mountainous interior, heading north towards the sea. They not only drain the land, but are also used as waterways and many villages can only be reached by boat.

Flowing water does not contain many nutrients; most nourishment is derived from organic waste from the surrounding forest. When rivers flood their banks during the rainy season, much of this material ends up in the water, making it cloudy. The conditions do not sustain water plants either, and only those plants that are firmly rooted and flexible survive.

Some species of fish feed outside the water because of the limited food: insects, overhanging plants, seeds, fruit and other organic material that have fallen into the small tributaries from the trees. Piranhas are the most well known of the predatory fish. Attacks by piranhas on humans are more myth than reality.

Electric eels have a unique way of catching their prey. It unleashes 650-volt bolts of electricity, which stun fish or crabs. Another remarkable creature is the thornback, which, if threatened, swings its whip-like tail around to sting its attacker with poisonous barbs that are usually retracted under the skin.

Savannahs

Savannahs are best described as tropical grasslands with scattered clusters of trees and shrubs. These occur in those places where the soil has dried out so much during the dry season that the rainforest cannot survive. The Surinam savannahs are left over from a huge continuous savannah region that came into being during the last ice age, a period when the

35

PAGE 34
View along the river.
FRANS SCHELLEKENS
Blanche Marie Falls.
KARIN ANEMA
PAGE 35
Anjumara Fall.
WILLEM KOLVOORT
Raleigh Falls.
JOKE VAN DER PEET
Moeder Falls.
WILLEM KOLVOORT
Catfish.
WILLEM KOLVOORT

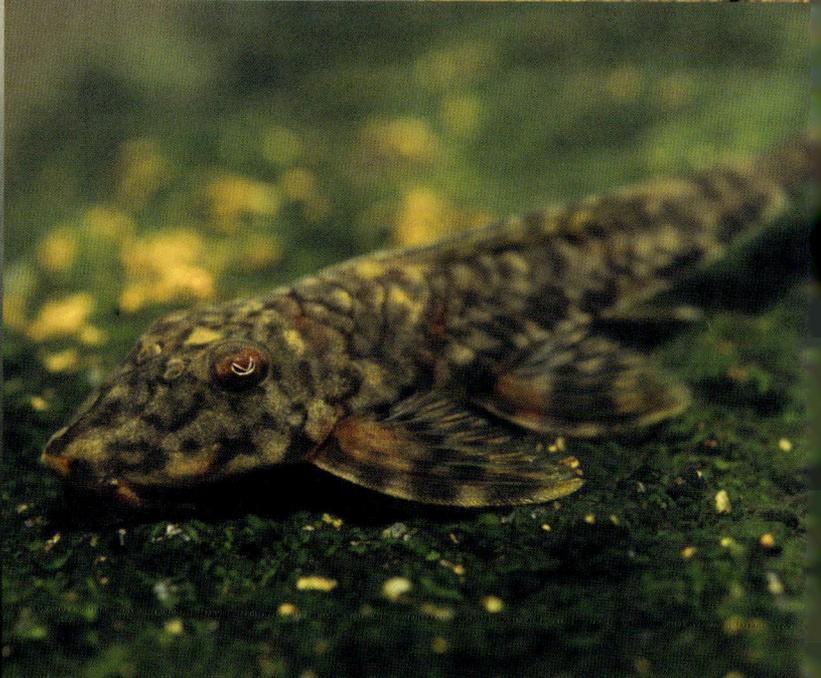

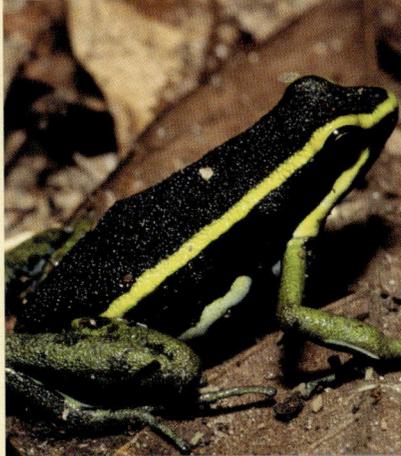

PAGE 36
An aquatic plant (*kamaru njan njan*) that grows in rapids and waterfalls, seen from beneath the surface of the running water.
WILLEM KOLVOORT
Four-eyed fish along the Suriname River.
WILLEM KOLVOORT
Electric eel.
WILLEM KOLVOORT
Black piranhas.
WILLEM KOLVOORT
Armoured catfish.
WILLEM KOLVOORT
Thornback.
WILLEM KOLVOORT
Young cayman.
WILLEM KOLVOORT
PAGE 37 RIGHT
Forest frog.
JOKE VAN DER PEET
Toad.
JOKE VAN DER PEET
Three-banded frog.
WILLEM KOLVOORT
Tree frog.
FRANS SCHELLEKENS
PAGE 37 LEFT
Forest tortoise.
WILLEM KOLVOORT
Whistling frog (only found on granite mountains).
JOKE VAN DER PEET
Frog.
JOKE VAN DER PEET
Frog.
JOKE VAN DER PEET

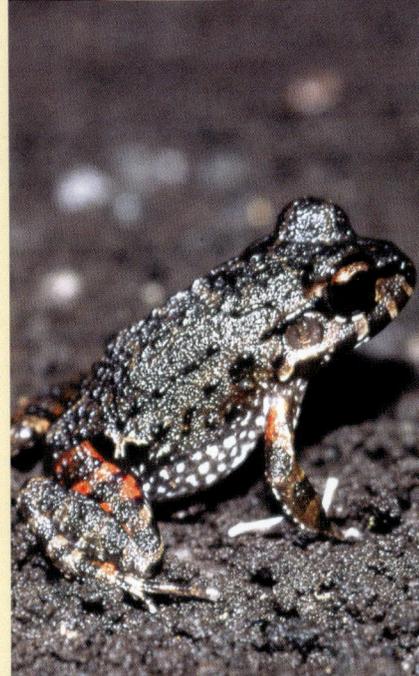

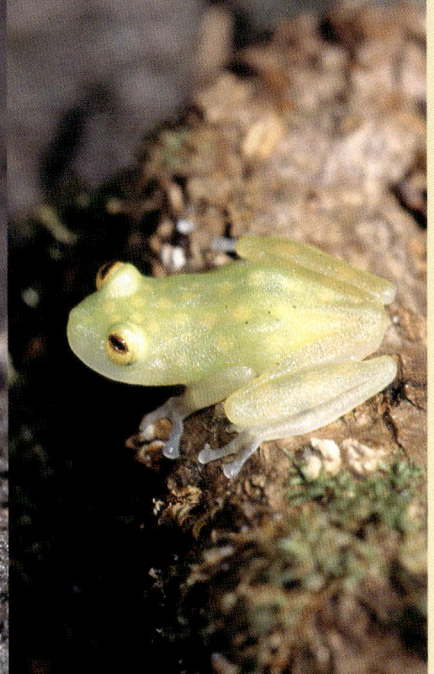

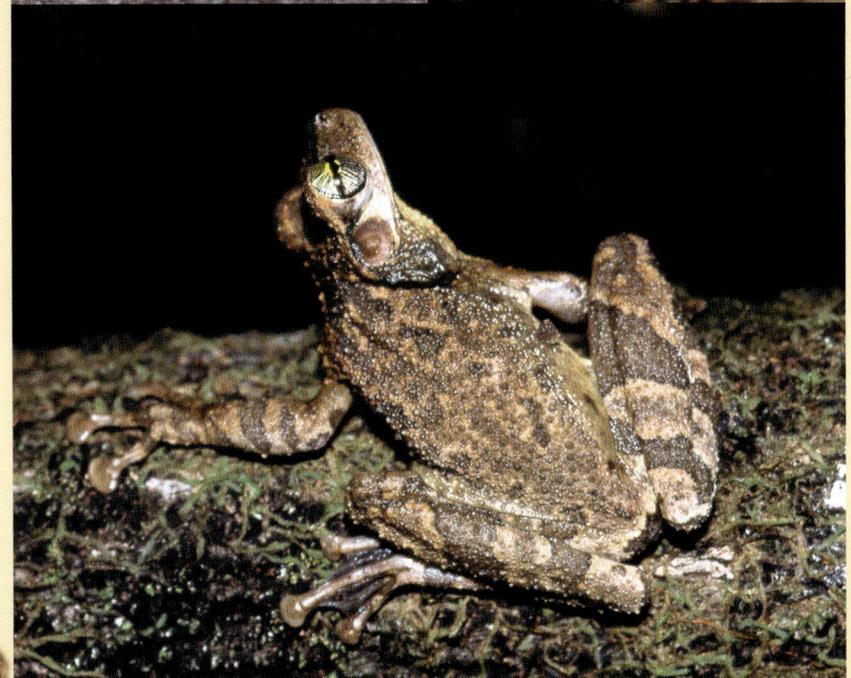

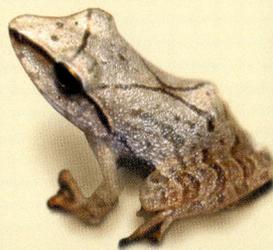

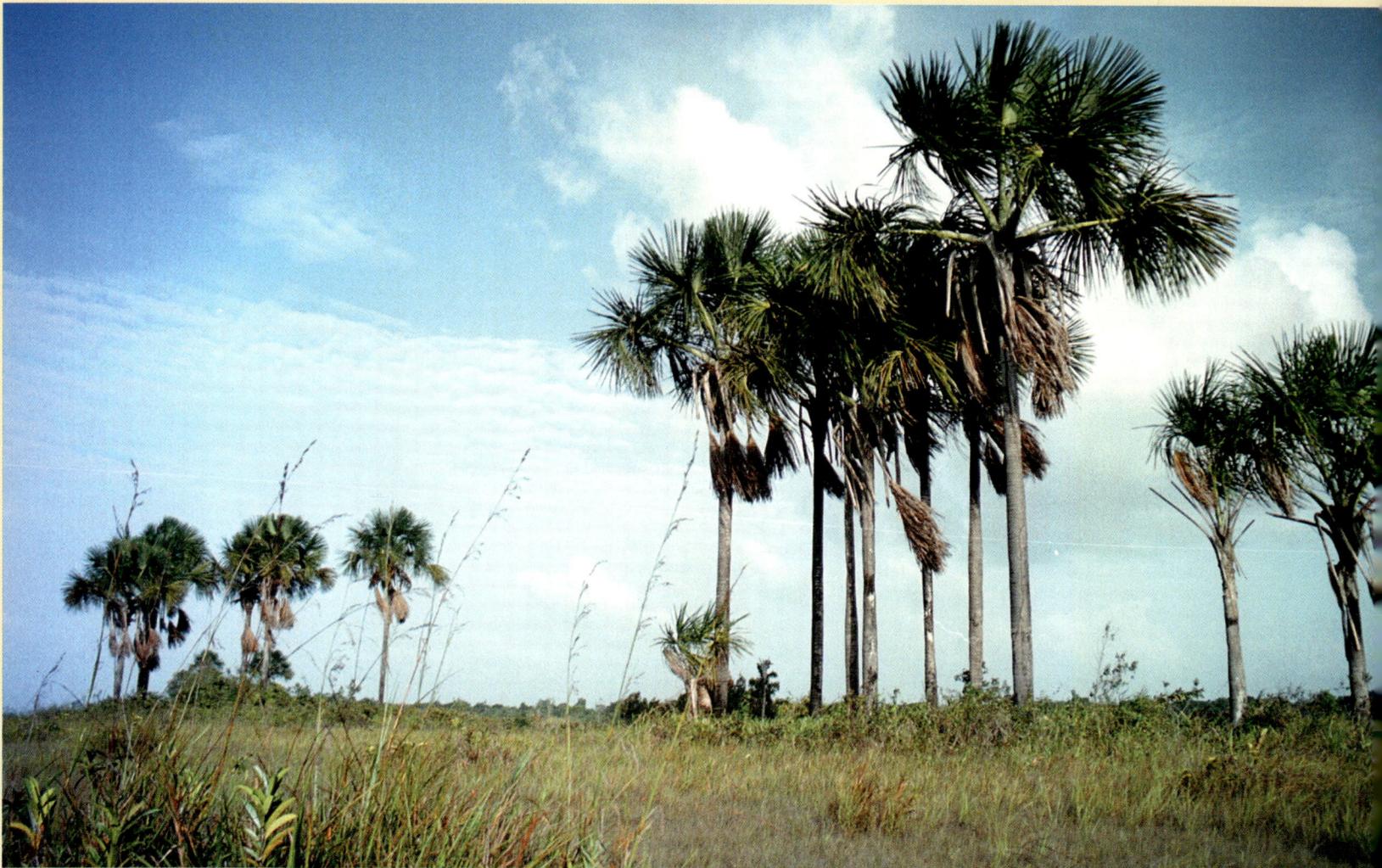

38

climate was unusually dry. The rainforest only managed to survive as isolated islets on high ground due to the regular convectional rainfall on the mountains. When the climate became moist again and the savannah climate gave way to the tropical rainforest climate, the situation changed: now the savannahs were the islands in the middle of the rainforests.

This history explains why plants and animals of the different savannah areas still display so many similarities. In the current situation it is impossible for typical savannah plants and animals to move between the savannahs as the closed ecosystems of the rainforests form such a formidable natural barrier.

The survival of the Surinam savannahs depends on human intervention in the form of controlled fires. If there is no burn off, the savannahs slowly expand into large forests. The first inhabitants of the Sipaliwini savannah practised this form of control over 10,000 years ago. Controlled fires made the savannah more accessible and moreover, the new growth attracted game. Most trees and plants die from the surface up during a fire; only some species such as the Sabanakasyu manage to survive due to their thick, insulating bark. The savannah regenerates at a surprisingly fast rate after the first rains. There is a profusion of light and the ash is rich in nutrients.

Although the savannahs only cover a small part of Surinam, there are good reasons to preserve them. They are a characteristic element of the Surinamese landscape and add considerably to the diversity of flora and fauna. That they have been the source of food for local inhabitants for thousands of years has resulted in the savannahs being declared a national treasure. Their accessibility has great appeal to nature lovers.

Swamps

The coastal terrain consists mostly of sweet-water swamps, or marshes. Swamps are caused by poor drainage, and this area is not safe from floods. Most swamps are quite shallow, usually less than a metre deep. The bottom of the swamp is mostly

PAGE 38
Mauritius palms on the savannah.
FRANS SCHELLEKENS
Savannah plant (sabanamangro), flower and fruit.
WILLEM KOLVOORT
PAGE 39
Savannah Bluebell.
WILLEM KOLVOORT
Pin-head.
WILLEM KOLVOORT
Lizard.
JOKE VAN DER PEET

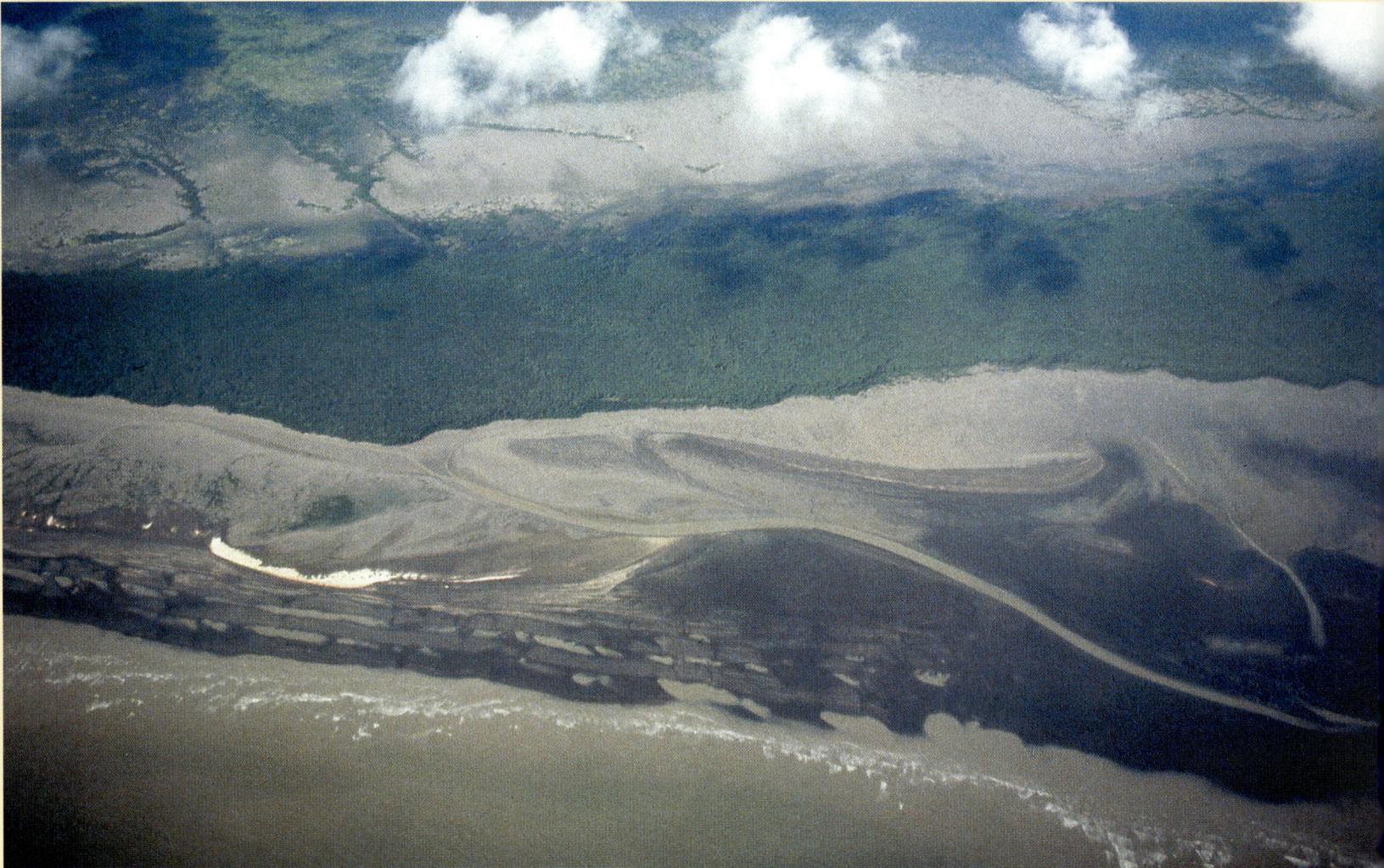

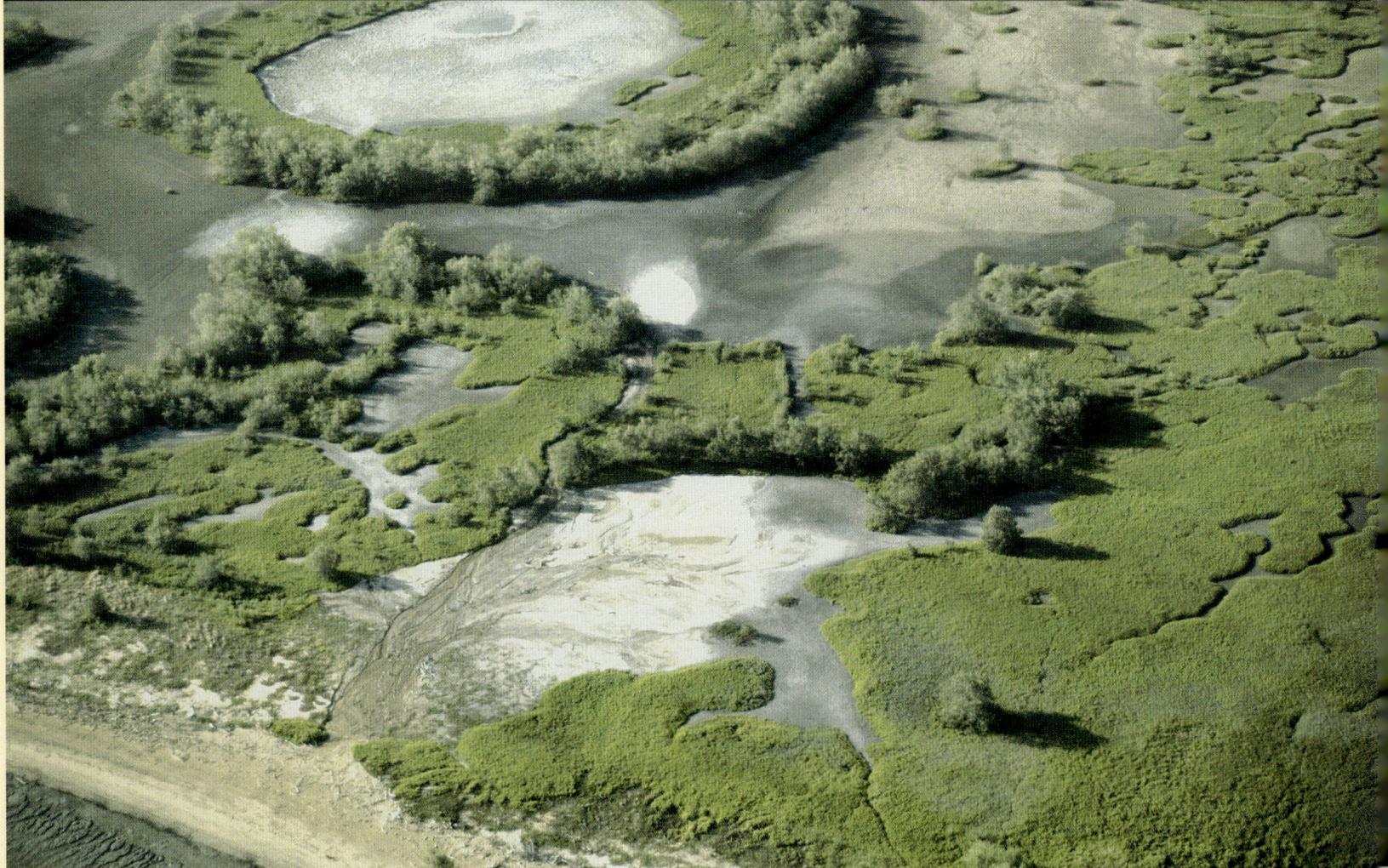

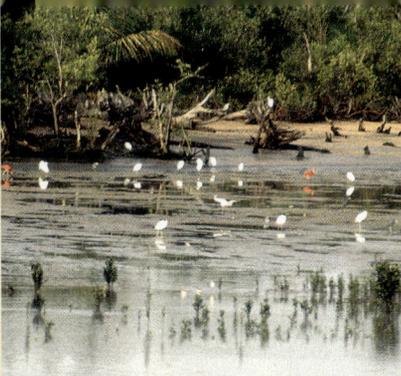

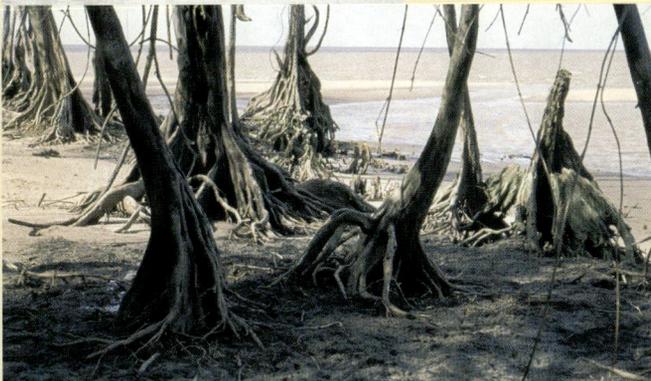

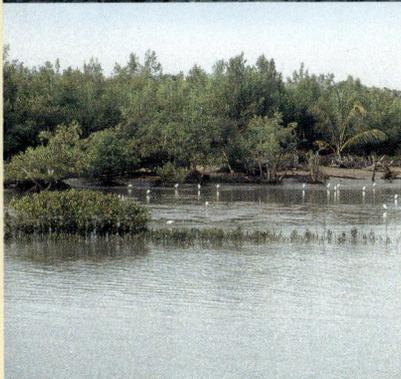

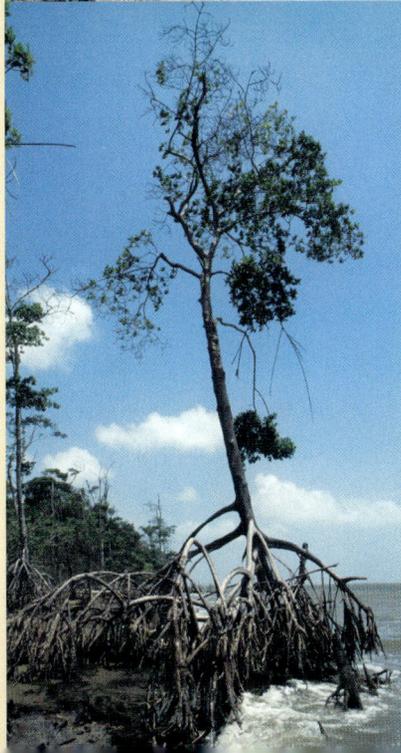

covered with a layer of peat. The vegetation in swamps varies: some are wooded while others support shrubs and grasses.

Fires break out frequently in swamps. Purposefully burning off some areas, usually in the dry season, prevents trees or shrubs from taking over. Peat fires also occur quite frequently, mostly as a result of controlled fires, but some propose that the intense decay causes spontaneous combustion. When the peat dries out during a hard dry period – which is rare – and catches fire, it can be fatal for some forests, which cannot regenerate and become marshy grasslands.

Humans have hunted, fished and gathered wood in swamps since time immemorial and the shallow water made them ideal for land reclamation. Water used in rice cultivation is taken from the swamps. The construction of roads, drainage and land reclamation projects have changed the natural water balance in many places. Nonetheless, swamps play a vital role in the natural diversity of Surinam.

'Twixt salt and sweet

There are several features along the coastline that are influenced by brackish water. The salt water travels inland up the mouths and estuaries of rivers. The salt content diminishes as the water moves further inland. During the rainy season, the large quantities of water draining off the land can carry the salt as far as Paramaribo; the salt water travels about 15 kilometres or more inland if there is less rainfall.

As with people, a high salt content in the land causes dehydration. The brackish estuaries are home to plants and trees that have evolved in this kind of salt environment. Mangrove trees are naturally equipped to reduce their salt intake, while parwa solves the problem by transpiring salt. Crabs and shrimp are permanent residents in the food-rich estuaries. Dolphins and sharks travel upstream when the salt water penetrates deeper inland during the dry season.

The mudflats along the coast consist of sediment from the Amazon River transported by the Guinea Current. The sandy beaches and sandbanks contain fragmented shells lifted off the seabed and deposited by waves. Mangrove forests are the frontline of vegetation and grow along the shore and on the banks of tidal streams. They foster new growth and protect the coast and provide ample protection for waterfowl. Herons, ducks and ibises are among the varieties that nest here.

Like the mangroves, there are other features along the coast created by occasional contact with seawater, such as lagoons, brackish saltwater-pans and brackish swamps.

41

PAGE 40
Mudflats with shell deposits at the coast.
HENK LUTCHMAN
Sweet and salt water in the tidal zone, the sea bottom left.
KIT
PAGE 41
Foraging birds on the mudflats.
HENK LUTCHMAN
Mangrove.
HENK LUTCHMAN
Foraging birds on the mudflats.
HENK LUTCHMAN
Eroded coastline.
FRANS LUTCHMAN
Coastal erosion.
KIT

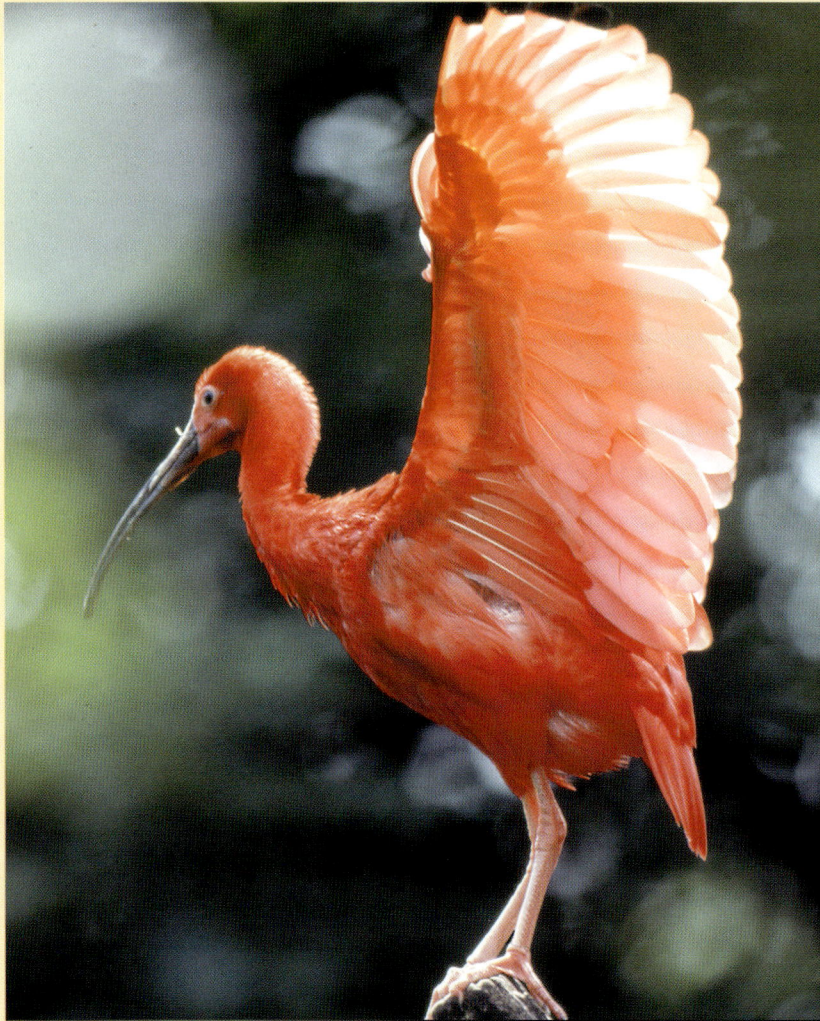

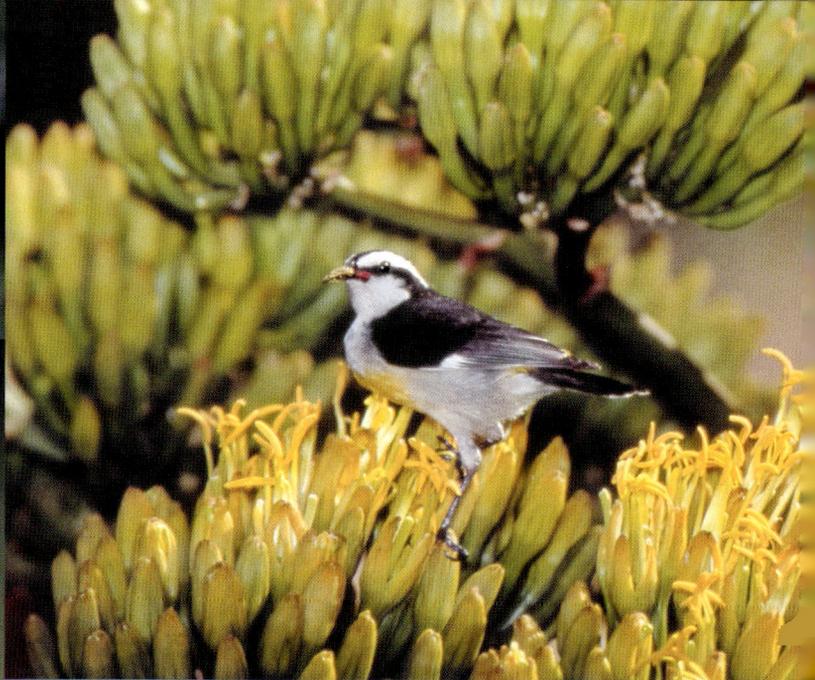
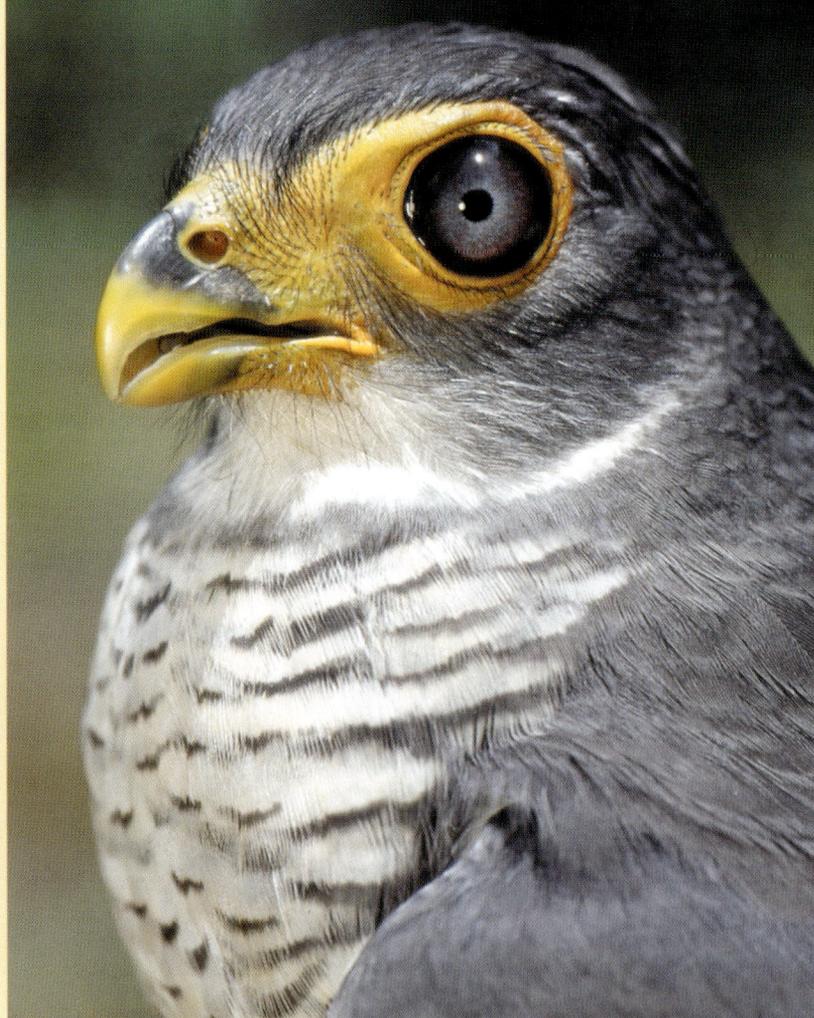
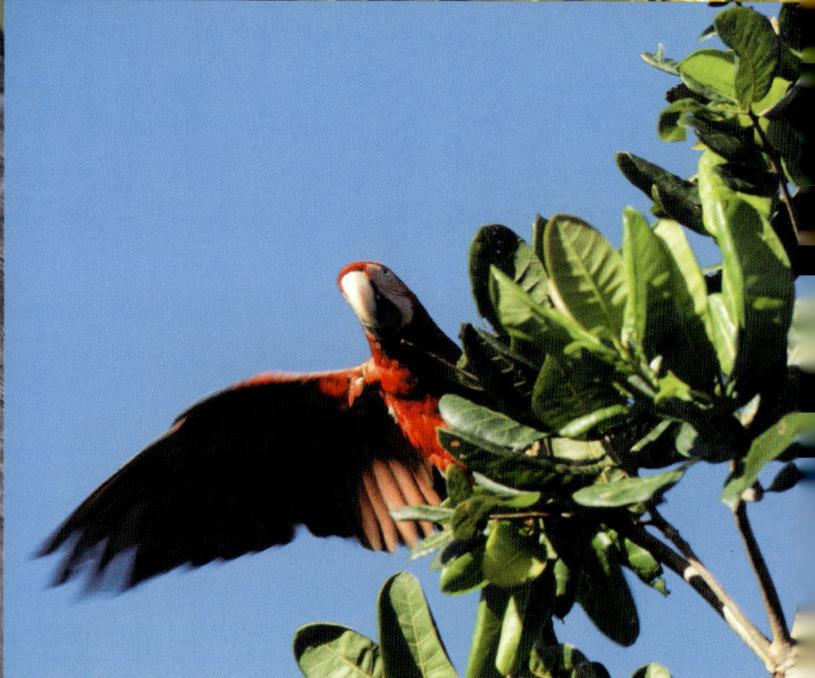

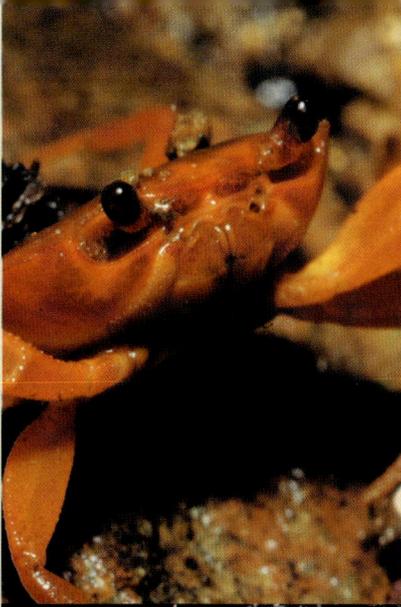

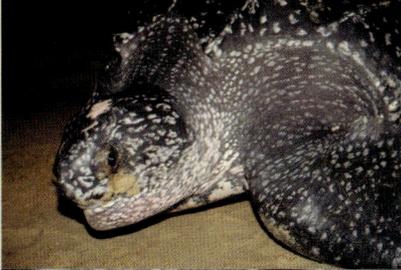

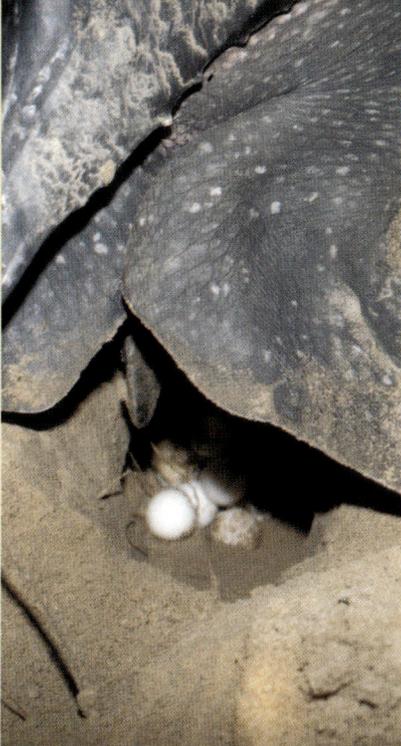

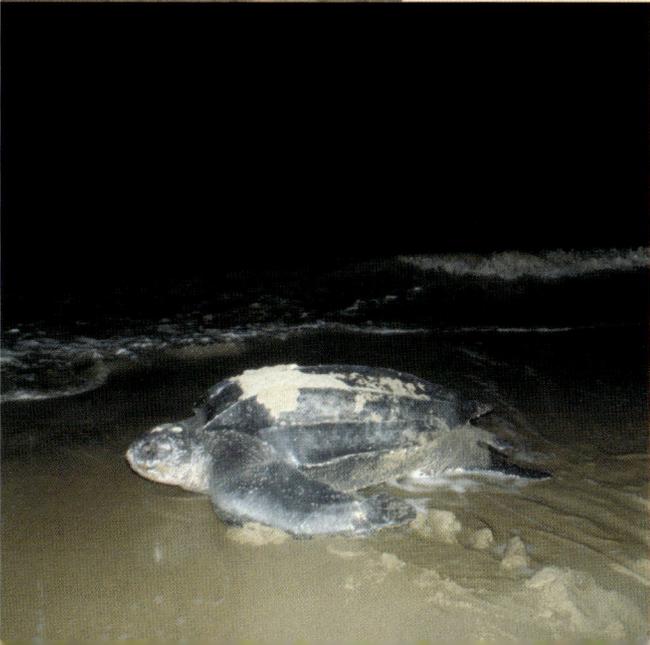

NATURE RESERVES

Surinam is famous for its diverse and abundant nature. Certain areas were declared protected nature reserves decades ago. Surinam now has eleven nature reserves and there are plans to create more.

Measuring 1.6 million hectares (almost a tenth of Surinam!), the Central Surinam Nature Reserve is one of the world's largest. It is the largest protected tropical rainforest on the planet and consists mainly of the catchment basin of one of the most important rivers in Surinam, the Coppename. It was created in 1998 by merging three existing nature reserves, the Raleigh Falls, the Tafel Mountain and the Eilerts de Haan Mountains. The reserve is virgin territory and virtually uninhabited. It is home to a treasure trove of plants and animals, many of which have yet to be discovered.

Nature Conservation

Nature conservation fall under the auspices of the Ministry of Natural Resources, which is responsible for managing protected areas and enforcing existing laws on illegal activities such as hunting and the trade in animals.

Stinasu (Foundation for Nature Conservation in Surinam) is a quasi-governmental organisation started in 1969 that oversees the exploitation of the protected areas. Stinasu co-ordinates and stimulates scientific research and educational projects focused on nature. The foundation aims to disseminate as much information as it can about nature in Surinam. It promotes (eco)tourism and organises (day)trips to nature reserves. It has also leased a part of Brownsberg nature reserve.

Conservation International (CI) is originally an American non-profit organisation primarily funded by American donors that is active in more than 30 countries. Human beings are the focus of CI; maintaining the biodiversity can be realised by a careful fusion of ecological, economic and cultural interests.

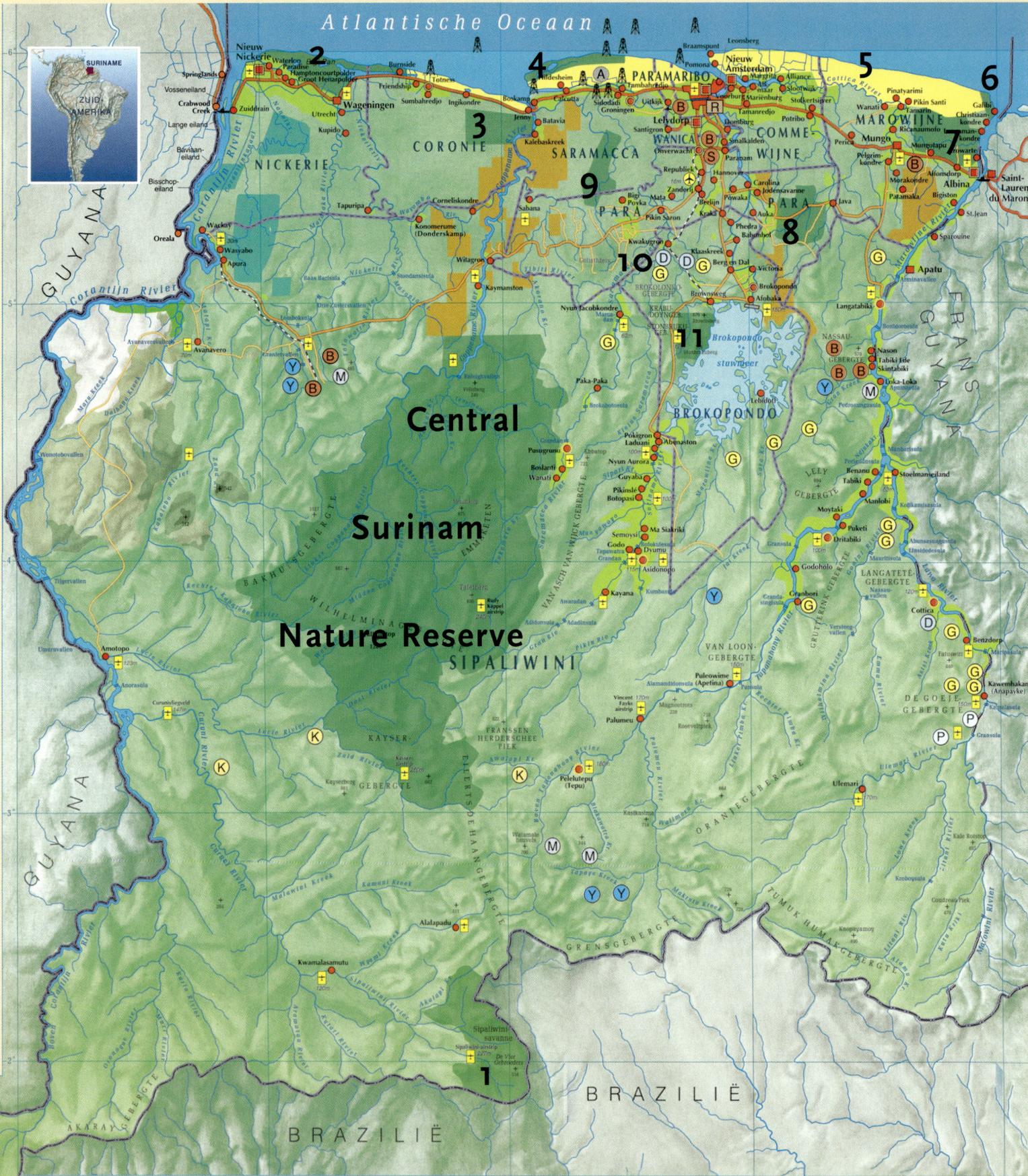

Atlantische Oceaan

GUYANA

Central
Surinam
Nature Reserve

NICKERIE
CORONIE
SARAMACCA
PARAMARIBO
COMMEWIJNE
MAROWIJNE
PARA
SIPALIWINI

BRAZILIË
BRAZILIË

FRANS GUYANA

44

Legenda

0 10 20 30 40 50km

Milieu/Economie
- beschermd gebied
- voorgesteld beschermd gebied
- voorgesteld bijzonder beheersgebied
- landbouw
- bosbouw
- visserij

Delfstoffen
- aardolievoorkomens
- R raffinaderij
- A aardoliewinning
- B bauxietwinning/voorkomens
- S bauxietverwerking
- G goudwinning/voorkomens diamantvoorkomens
- K koipervoorkomens
- P platinavoorkomens
- M mangaanvoorkomens ijzerertsvoorkomens

Topografie
- staatsgrens
- districtsgrens
- primaire weg
- secundaire weg
- overige wegen
- spoorlijn
- zeewering
- rivier
- veerverbinding
- waterval of stroomversnelling/ stuwdam
- internationaal vliegveld
- lokaal vliegveld/landingstrip, met hoogte in meters
- 120m hoogtepunt in meters
- districtshoofdplaats
- zetel lokaal bestuur
- bebouwing
- stad/dorp

Copyrights 2003: Henk T.J.Lutchman en Aart J.Karssen, Amsterdam/Nordhorn

Drs. Henk T.J.Lutchman
Geografie en Geomorfologie

Max Sordam:
Sranantongo toponiemen

Aart J.Karssen:
Cartografie

Kyran E.J.L. Educational Systems

In practise this means that viable economic alternatives to logging and deforestation have to be explored, for example, ecotourism and arts and crafts, researching the pharmaceutical potential of the rainforests and nurturing new and enduring plans for the future.

1 Sipaliwini consists of a large savannah region along the border with Brazil, and is speckled with isolated forests and granite formations. This area is also home to unique plant and animal varieties.

2 Hertenrits is a small nature reserve of great archaeological value because of the advanced agricultural methods (elevated fields) of earlier inhabitants, the Arowaks.

3 Peruvia is an important feeding ground for various kinds of parrots that breed in the nearby palm groves.

4 The Coppename River mouth is so wide that the sea and tides exert a powerful influence on the surroundings. This dynamic area attracts many varieties of water and wading birds, including migratory birds from North America. This lends the reserve international value.

5 Wia-Wia was started to protect turtles, but as the sand beach has since been moved by the tides, its value lies in the expansive mudflats and mangrove swamps which provide shelter and food for flocks of various migratory birds.

6 Galibi is situated on the Atlantic coast and is known for the variety of giant turtles that lay their eggs here between February and July.

7 Wane Creek sustains a diversity of forests, savannah and swamplands. Traces of pre-Columbian civilisation and the first Maroons have been found here.

8 Copi is situated on the old coastal plain and is traversed by the Casewinica River. It is an ideal environment for giant otters and various types of cayman.

9 Upper-Coesewijne consists of savannah and rainforest. Swamp forests and marshes grow along the Coesewijne River. Dugongs, giant otters and cayman live in the reserve.

10 Brinckheuvel is an area punctuated by hilly rock formations. A wide variety of plant life grows here.

11 Brownsberg is not an official nature reserve but a nature park as it is open to the general public and has been fitted with various amenities, such as roads, pathways and overnight accommodation. Visitors wander past streams and waterfalls and take in the splendid views over the Brokopondo Lake while familiarising themselves with the rich natural diversity of the rainforest. Brownsberg thus plays an important role in educating the public on the value of Surinam's environment.

There are also other areas that have not been designated nature reserves yet, but which are protected from any damage caused by human activity. These are the so-called Multiple-Use Management Areas. Such areas often merge with a nature reserve, as happened with the Coppename River mouth and Wia Wia. More protected land will be incorporated into these reserves in the future.

45

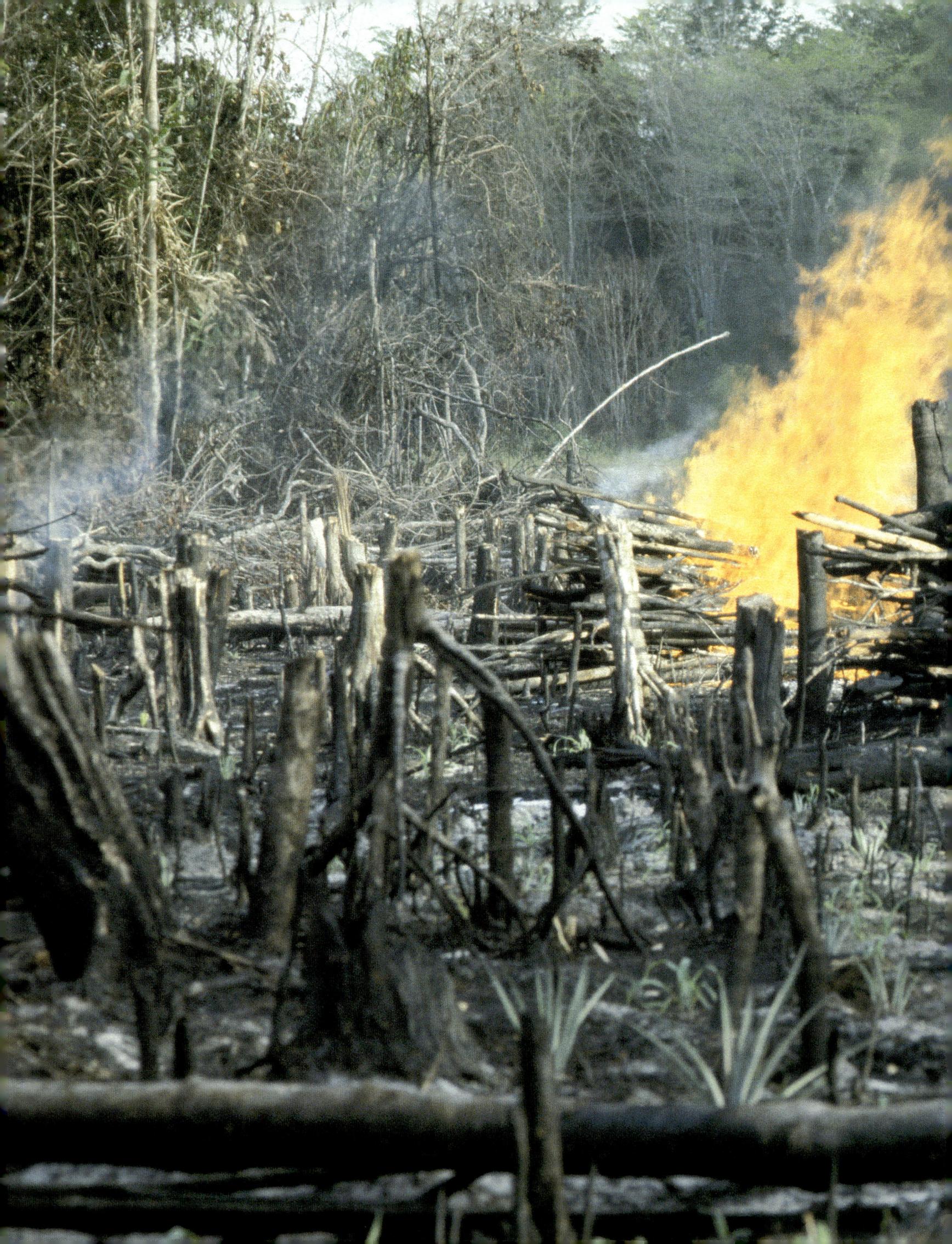

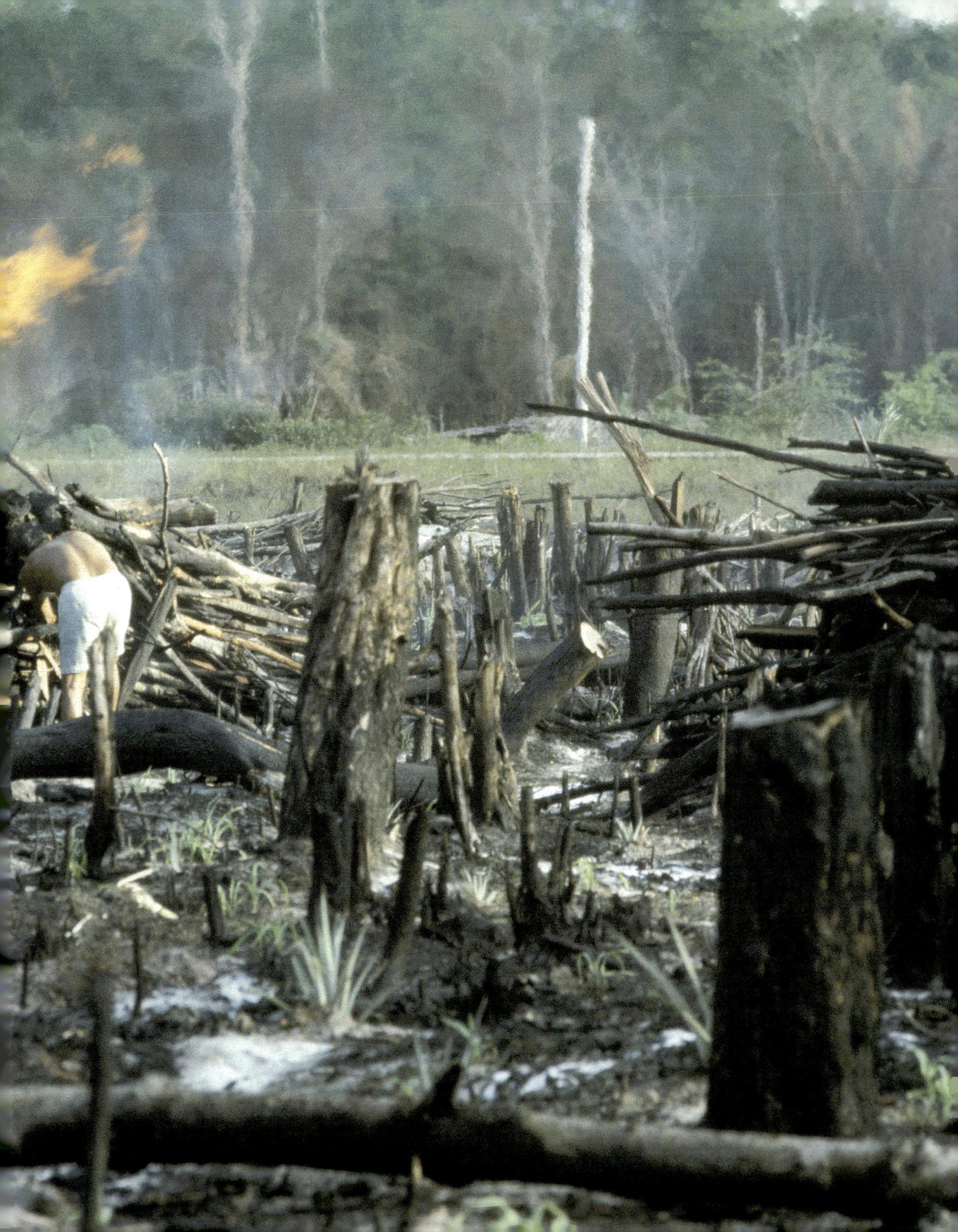

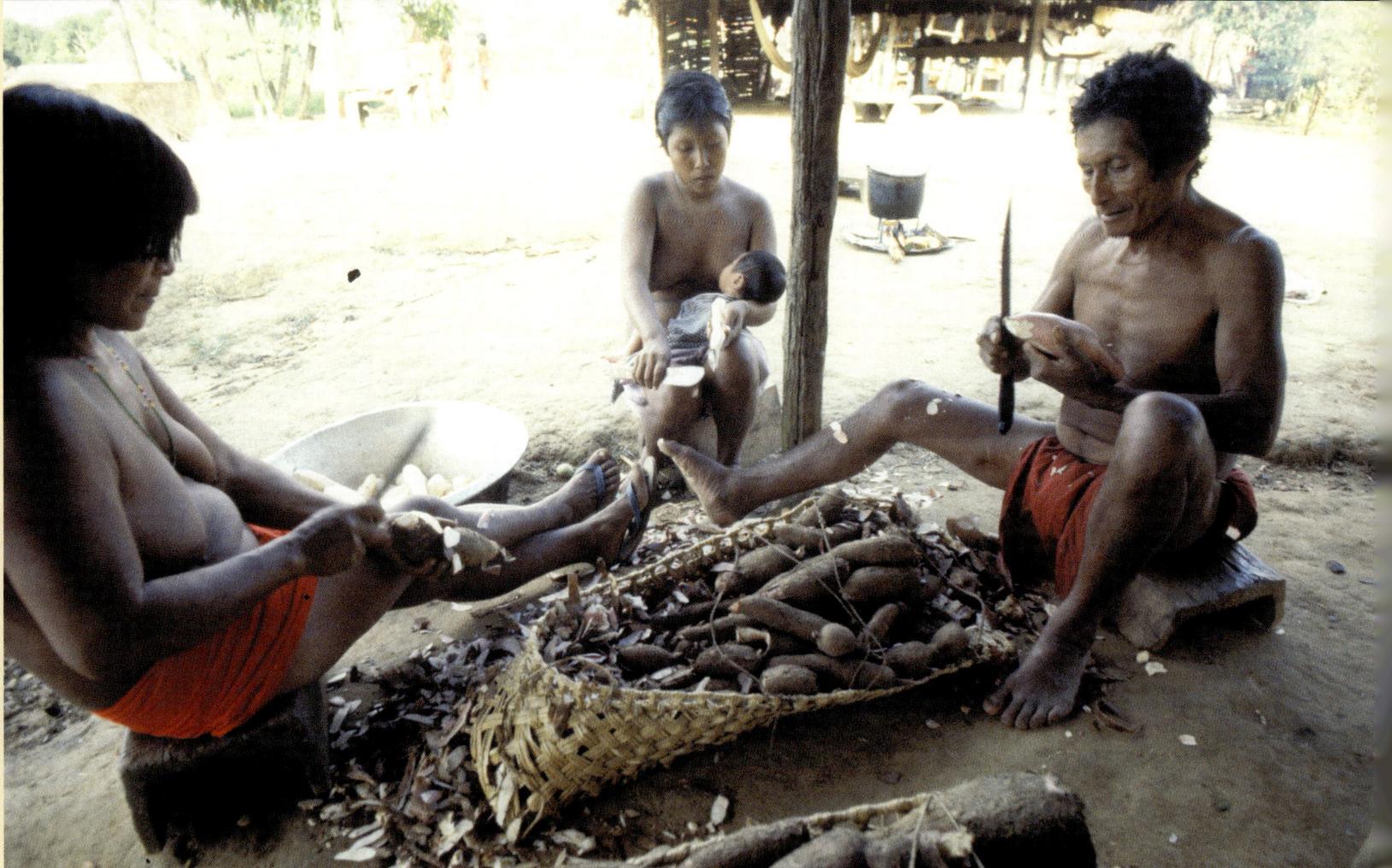

AN *empty* CONTINENT

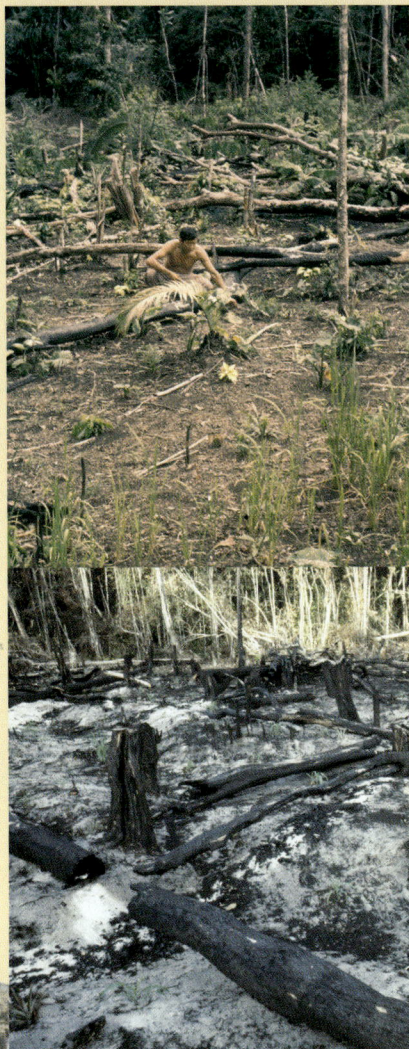

Columbus' famous expedition is known as 'the discovery of America'. Of course, this is inaccurate since the Indians preceded him by tens of thousands of years. The stir the discovery of this unknown continent caused in Europe is understandable. After all, America was almost unpopulated with a young history in comparison to the relatively densely populated Europe with its old cultures.

The first settlers moved from Asia to the American continent about 30,000 years ago by crossing the then dry Bering Straits. These tribes of hunter/gatherers needed a large territory to ensure their food supply. They later moved south because of the gradual decline in available food and competition by new groups of people. The first settlers established themselves in the South American lowlands about 12,000 years ago. The oldest traces of habitation in Surinam were found in the Sipaliwini savannah, which due to a drier climate was much larger than it is now. Evidently the dense rainforest did not appeal to these early settlers.

Artefacts from this era (stone hatchets, knives, spear and arrowheads) prove that these settlers lived mainly by hunting and gathering. The most important weapon, the bow and arrow, was used for hunting deer and small game. Sections of the savannah were regularly burned creating open territory with young growth that attracted a variety of game. These settlers probably lived in small groups in temporary camps and later disappeared from this area.

Agriculture

The settlers' way of life changed dramatically around 4000 BC. The discovery of potsherds from that era have led to the conclusion that agriculture was becoming more important as the preparation of certain vegetables required cooking utensils. Cassava, for example, which is poisonous when eaten raw, was an important staple.

49

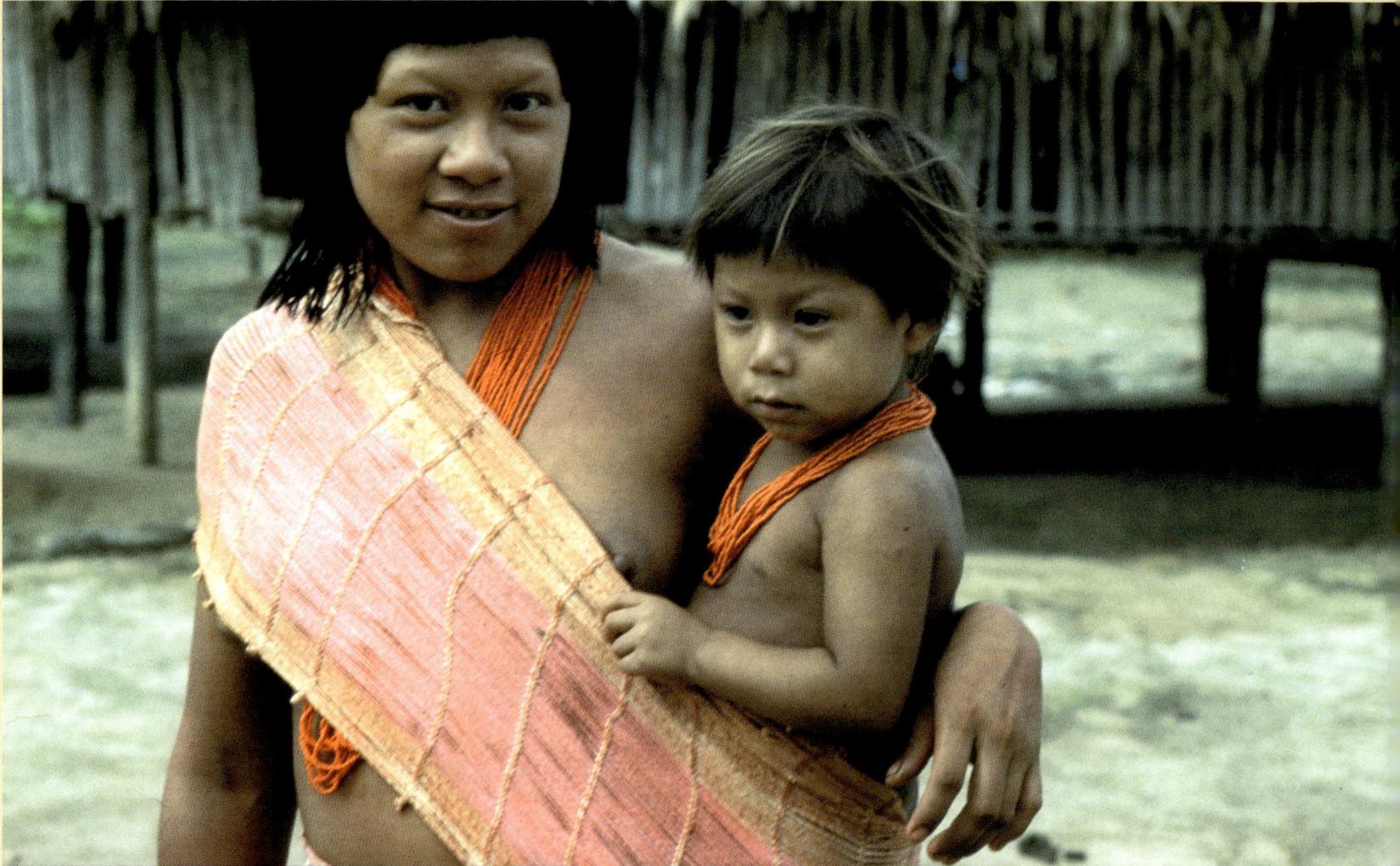

50

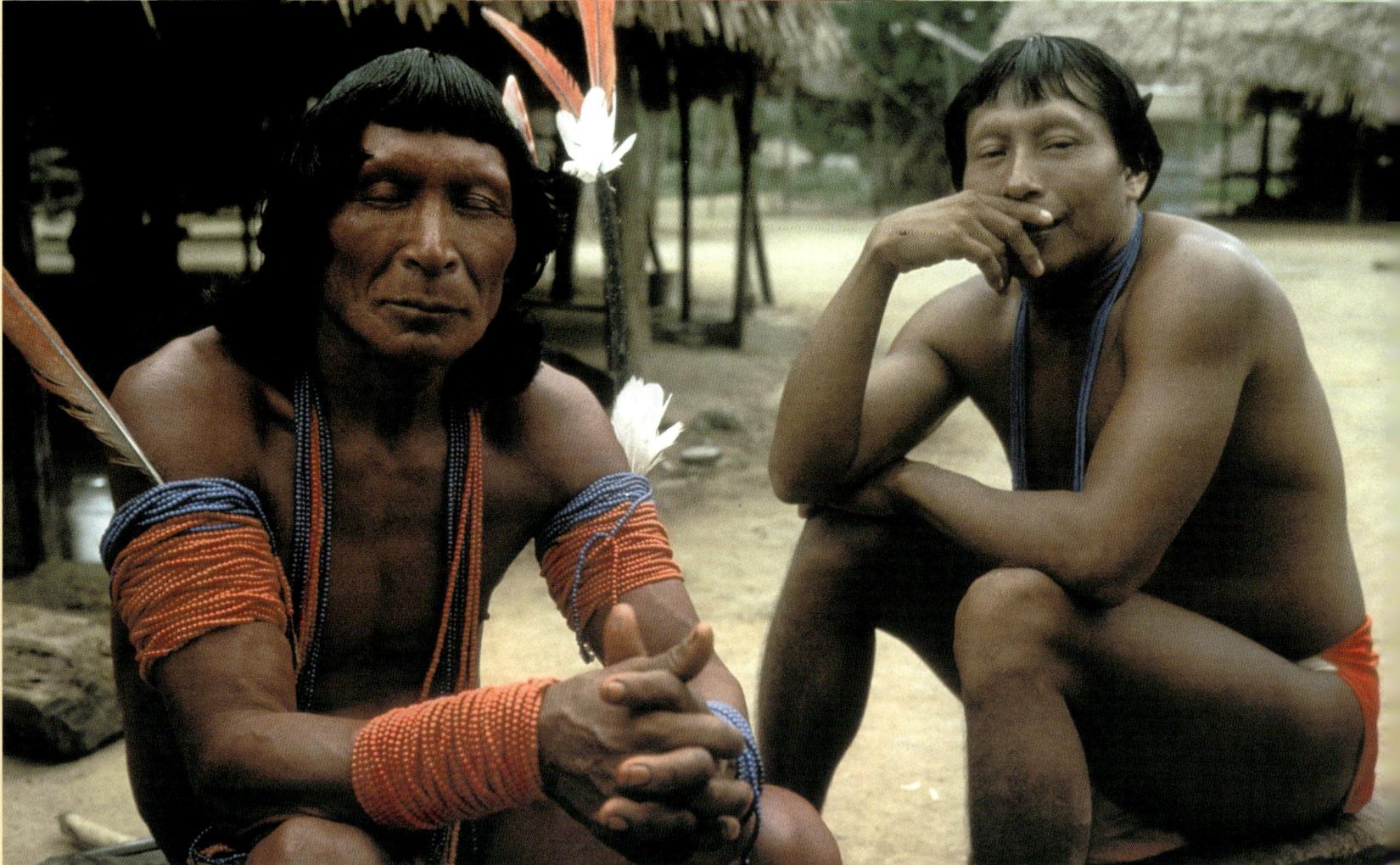

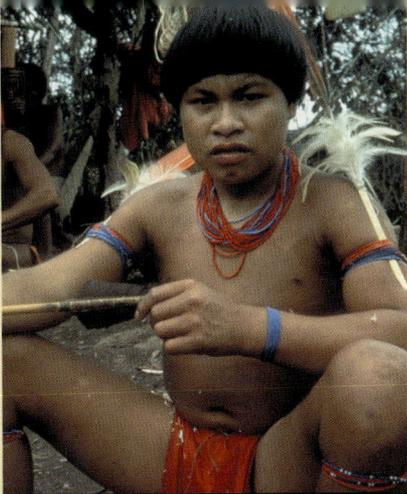

The settlements became more permanent and for the first time people lived together in larger groups. This had a major impact on social and cultural structures. Increasing population growth and the need of new arable land forced an increasing number of Indians in the Amazon to set out for new areas. Some moved north along the rivers and eventually reached the coastal plains of Guyana

Migration

Little is known about the life of the Indians, especially those living in the interior, before the arrival of the first Europeans. Expeditions undertaken just over a century ago provided a clearer picture of the distribution of the various tribes, who still lived in small groups.

51

No signs of habitation have been discovered in Surinam for the period 5000 to 2000 BC, suggesting that the area was uninhabited for a long time. However, traces of human activity have been found along the Atlantic coast in Guyana and in the eastern part of Venezuela. Piles of shells indicate that shellfish were an important part of the menu.

The high soil fertility in the coastal area attracted many settlers, thus providing a reasonably clear picture of the life of the Indians. The Arowaks moved from the Orinoco delta to the coastal plains of Surinam around 500 AD. It is difficult to establish if they were the first inhabitants of this area: they might have displaced other smaller groups of Indians. The Arowaks had a well-developed agricultural system. An important archaeological discovery near the Hertenrits in the vicinity of Wageningen shows that they were no strangers to land reclamation. They had systematically dug series of ditches, drained the swamp and brought in extra soil to create hillocks on which to build their houses.

The arrival of tribes from the Caribbean around 100 AD changed the Arowak lifestyle. They were

driven from their lands and forced to revert to 'shifting
cultivation', a method they had used earlier in which sections of
the forest were burned off and cultivated until the soil was
exhausted. The Arowaks did not leave the fertile coastal area
entirely despite the dominance of the Caribbean tribes. There
were numerous conflicts until the first European conquerors
settled in Surinam.

Europe expands

The absence of a common social structure between the various
Indian tribes and the consequent lack of any organised resistance
explains the speed with which the Spaniards (followed by the
English, French and Dutch) expanded their control over the
continent after their 'discovery' of America. Moreover, the first
Europeans had no intention of settling: their expeditions were
not funded by governments but by commercial enterprises eager
to establish profitable trading posts.

Alonso de Hojeda, an old acquaintance of Columbus, was the
first European to set eyes on the coast of Surinam (in 1499). He
avoided the impenetrable mangrove coastline with its mudflats
but did commit a description of it to his journal. It would be
more than half a century before this 'Wild Coast' received some
attention. This was the result of Indian legends about the gold
treasures of El Dorado, a local ruler who, according to legend,
bathed himself daily in liquid gold. These stories were taken
seriously because of the Indians' extensive use of gold and the
Spaniards and Portuguese soon sailed to Colombia, Venezuela
and Guyana.

English expeditions in later years to the coast of Guyana and
the Orinoco delta were also unsuccessful, but travel journals and
the first crude maps drew attention to the area. The Indians, who
were especially interested in iron tools, traded tobacco, gold,
dyes, hammocks or exotic timber with first Dutch ships visiting
the coast. A small farm and trading post were established on the
site of present-day Paramaribo. These settlements were
eventually abandoned because of disease and armed conflicts
between the European colonists.

The English and the Zeelanders

A well-prepared English expedition established the first colony
in Surinam in 1651. Among the colonists were experienced sugar
farmers who moved to Surinam because of a lack of opportunity
in Barbados. Their undertaking would seal the future of
Surinam: plantations using slave labour had become a reality.
Surinam became a Dutch colony because of minor shifts in

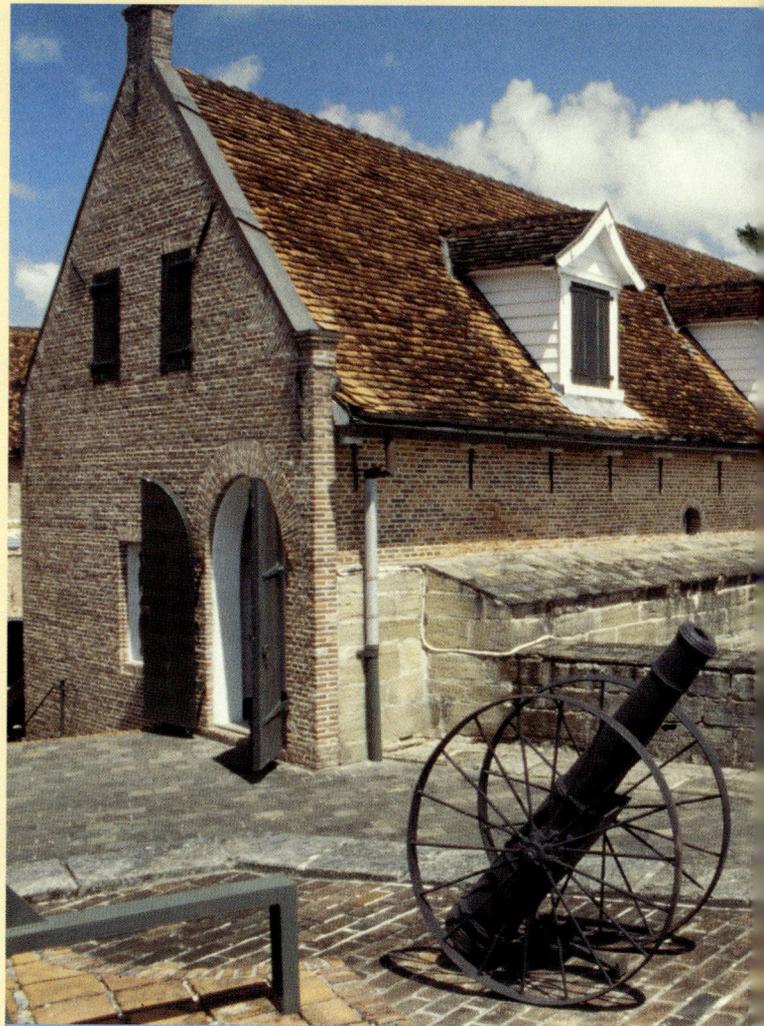

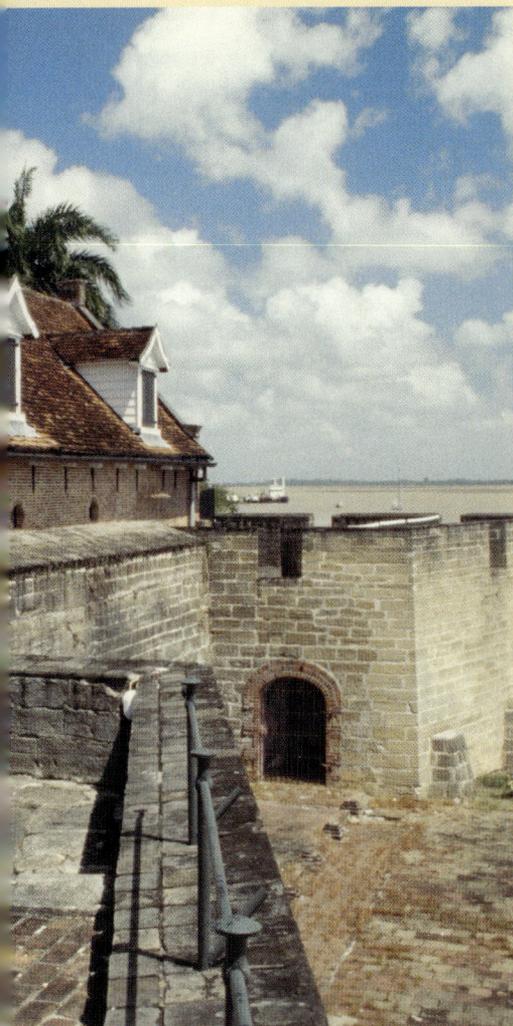

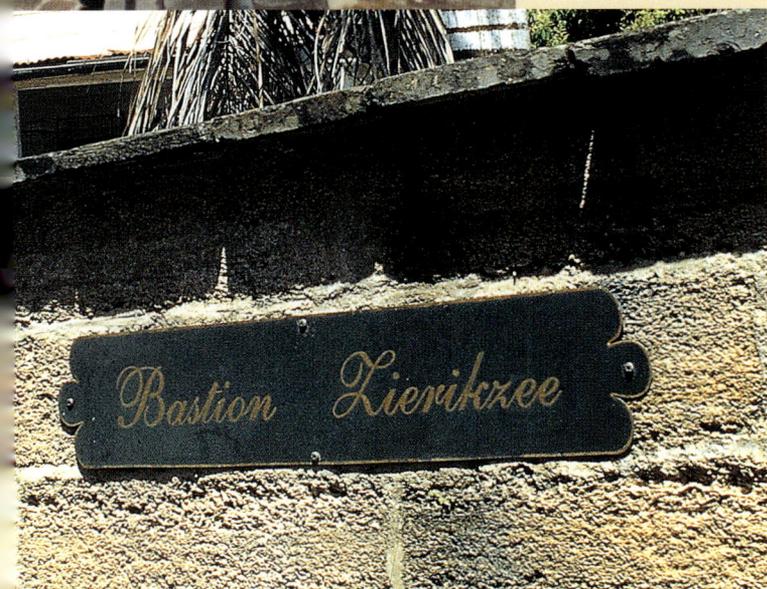

European history. The Dutch and the English went to war twice because of trade conflicts. The States of Zeeland, then the richest in The Netherlands, dispatched a fleet, led by Abraham Crijnssen, to put an end to the increasing English influence in the Caribbean.

Surinam was the first port of call and the fortress of Paramaribo with its weak defences was easily conquered. Crijnssen left a small regiment of soldiers behind before setting off to complete his – only partly successful – mission. Paramaribo was renamed 'Nieuw Middelburg', the fortress 'Fort Zeelandia'. A peace treaty was signed some months later and Surinam officially became a Dutch colony. The Dutch settlement 'Nieuw Amsterdam' (later New York) went to the English.

The Dutch soldiers left behind in Paramaribo must have been taken by complete surprise, therefore, when an English fleet overran the fortress with overwhelming force and ravaged the plantations. The commanding officer claimed to have left England before peace had been declared. The English left for Barbados taking slaves, cattle and the sugar supplies. Naturally, historians still debate the English officer's explanation. Surinam was property of the English crown and the attack might have been an attempt to regain this lost possession despite the signing of the peace treaty.

Slow start

The Zeelander colony was devastated by the English onslaught. Life was extremely hard for the few hundred inhabitants due to the exodus of about 1200 English farmers and their slaves and disputes between Holland and Zeeland over the authority of the colony and a scarcity of food.

The greatest threat at this time was the Europeans' poor relations with the Indians. The hostile attitude of the Caribbean tribes was caused by their fear of enslavement. The Zeelanders used this tension between the Indian tribes and sent armed Arowaks to oppose the Caribbeans who attacked the plantations.

53

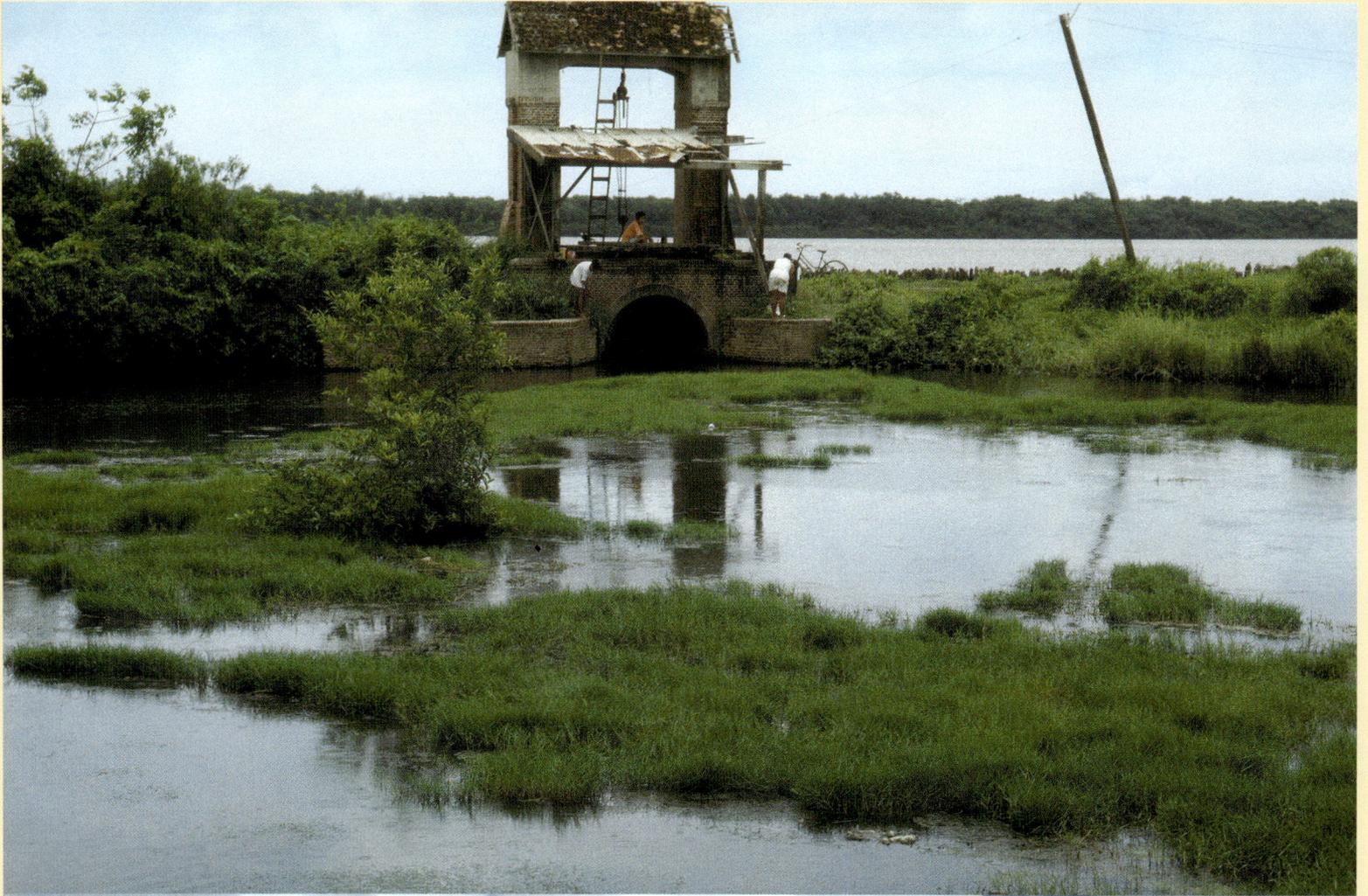

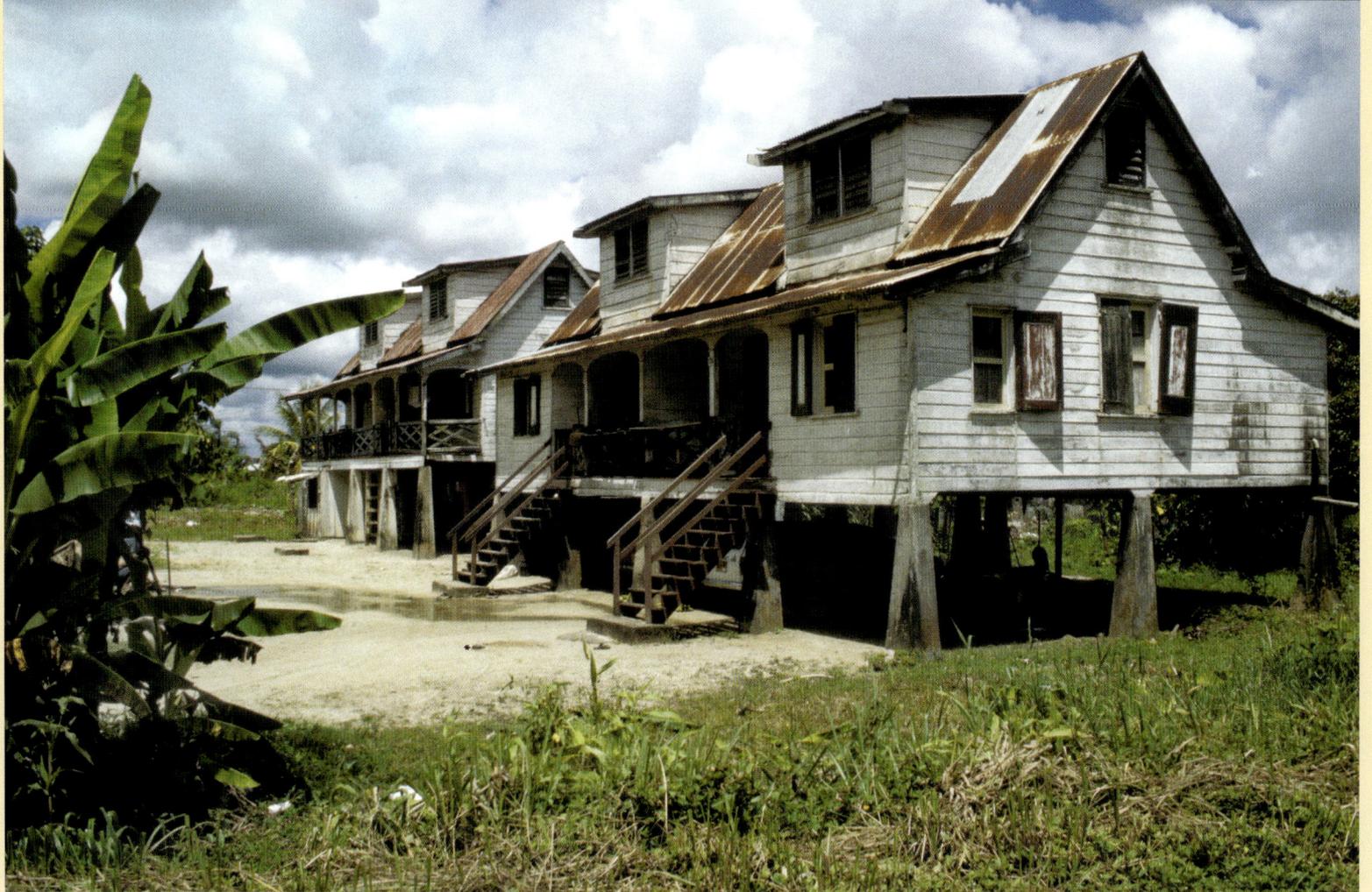

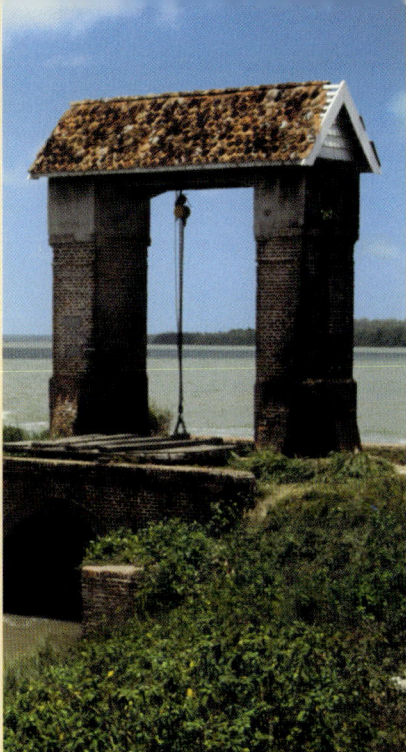

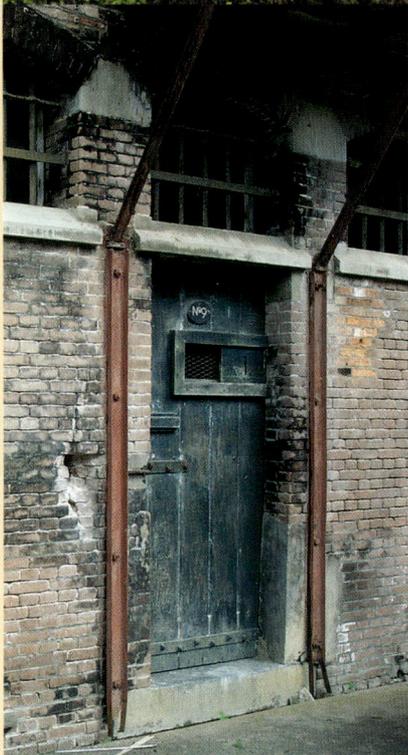

Zeelander soldiers were permanently posted at several locations outside the city to repel them. The situation deteriorated to such an extent that they decided to build a stockade around the city.

Negotiations eventually ended this tense situation and the Indians were guaranteed their freedom and rights. This arrangement specifically excluded runaway African slaves who would still have to fight for their freedom many times.

Surinam as a possession

The States of Zeeland decided to sell their property in 1682 to three buyers, the Dutch West Indies Company, the city of Amsterdam and a wealthy family called 'van Aersen van Sommelsdijck'. Surinam became a 'Licensed Society' in which the colonists had substantial involvement. The license can thus be seen as a constitution. The governor was the highest authority; there were 40 in a period of 130 years.

The 'Society' was never a great financial success, and the Sommelsdijcks family sold its share to the other two owners in 1771. The demise of the Dutch West Indies Company signalled the collapse of this venture. The founding of the Batavian Republic ended the relative autonomy of the colonists and Surinam was placed under the authority of the Dutch government.

Consequently the English conquered Surinam for the second time in 1799 when the Republic allied with France in the war against England. Little changed except for the replacement of Dutch governors by their English counterparts. The administration remained largely in place.

In 1816, after Napoleon was defeated, the 'Kingdom of the Netherlands', as it was now officially called, regained possession of the Dutch colonies that had been conquered by the English. Surinam was now an overseas territory. However, not all the former Dutch property was regained: South Africa, Ceylon and the later British Guyana remained English. With its left-hand driving, Surinam still has tangible reminders of the interim British government.

55

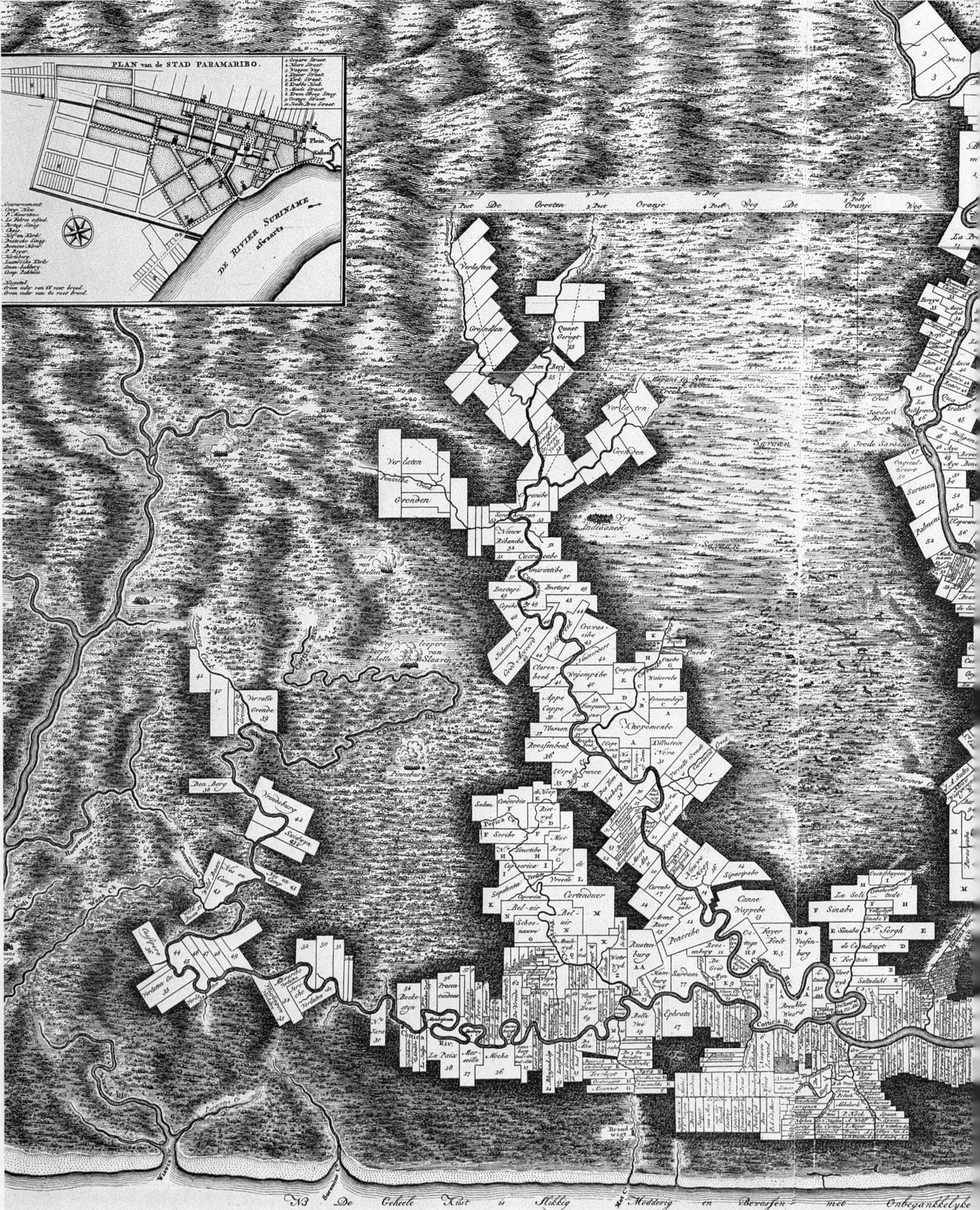

PLAN van de STAD PARAMARIBO.

DE RIVIER SURINAME afvaarts

N B De Geheele Kust is Slikkig en Modderig en Bewassen met Onbegankelyke

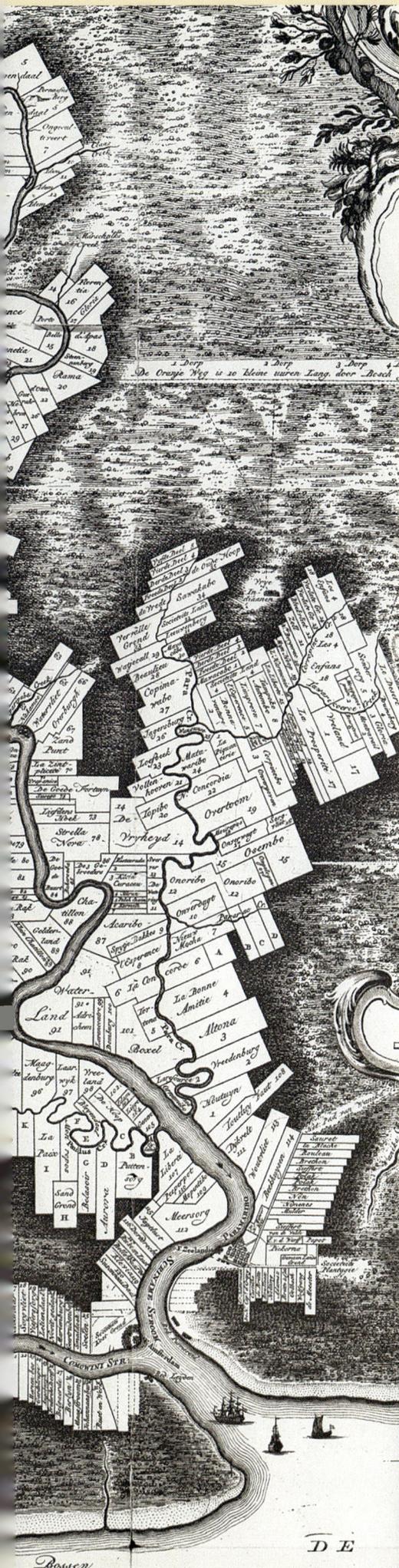

Surinam as a plantation

The first plantations laid out by the English were sugar cane. Most crops were grown close to rivers for ease of transport. Farmers could choose between establishing plantations along the inland rivers or on the soggy but fertile coastal plains. The Dutch knowledge of land reclamation played an important role in this choice.

The number of plantations grew rapidly. There were almost 600 plantations on Surinam at the peak of the plantation economy. Most were quite large, averaging several hundred hectares. Clearing the forests and cultivating the crops was done by hand. The sugar cane matured within a year and a half. The cane stems had to be pressed as quickly as possible as the sugar level in a cut stem drops rapidly. The juice was boiled down to thick treacle. Only by planting new cane throughout the year could constant production be ensured.

The first mills were powered by animals; later, power was created by using the difference in the height of tides in low-level rivers. The use of steam power increased throughout the 19th century. Improving the species could increase the yields, but this also caused more diseases and plagues.

Growing and processing coffee was less laborious, partly because the coffee trees only needed replacing after several decades. The juicy peel of the berries was removed after plucking and the berries washed and dried. As coffee is best made soon after it is ground, the beans were processed in the importing countries (mainly The Netherlands)

57

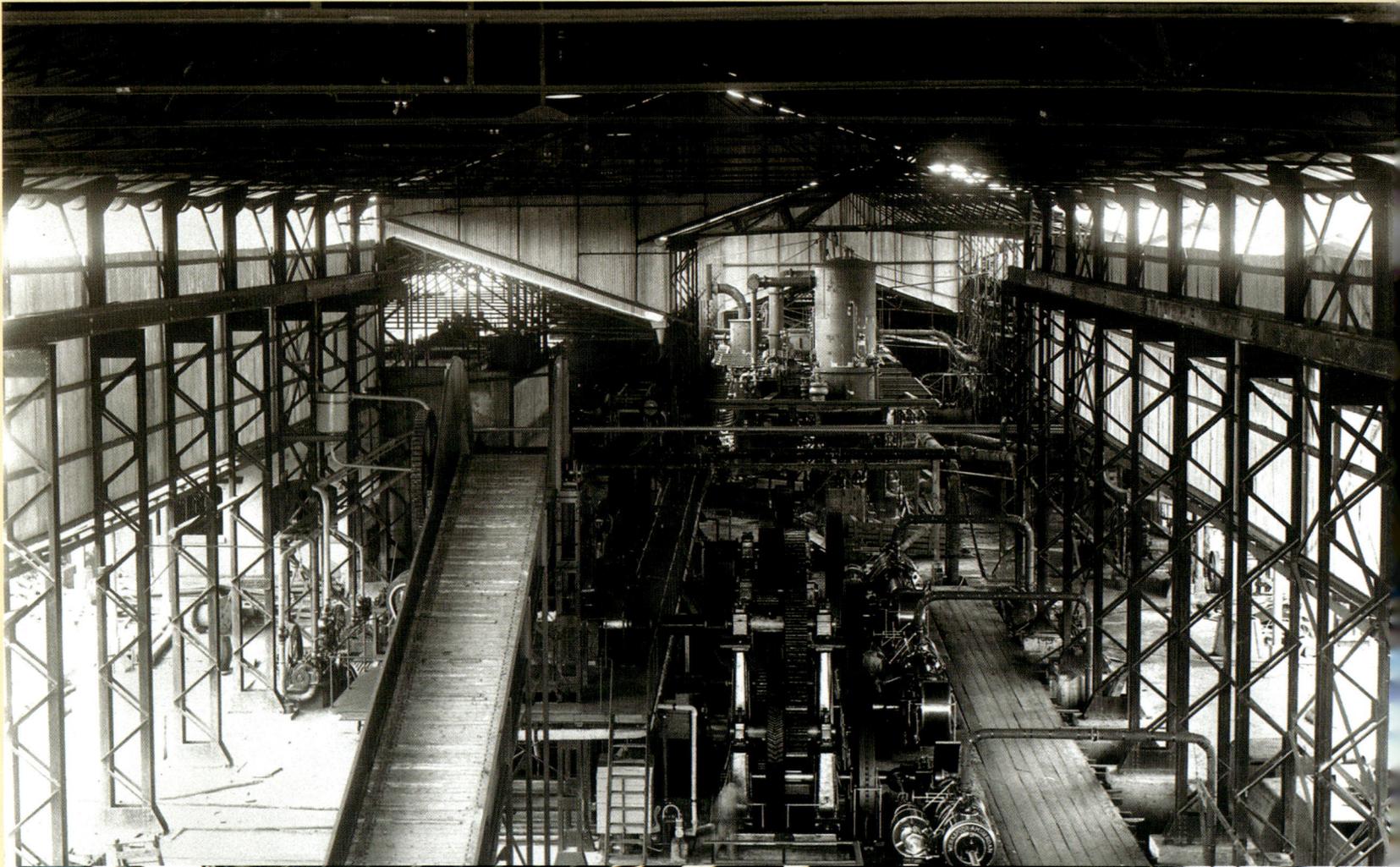

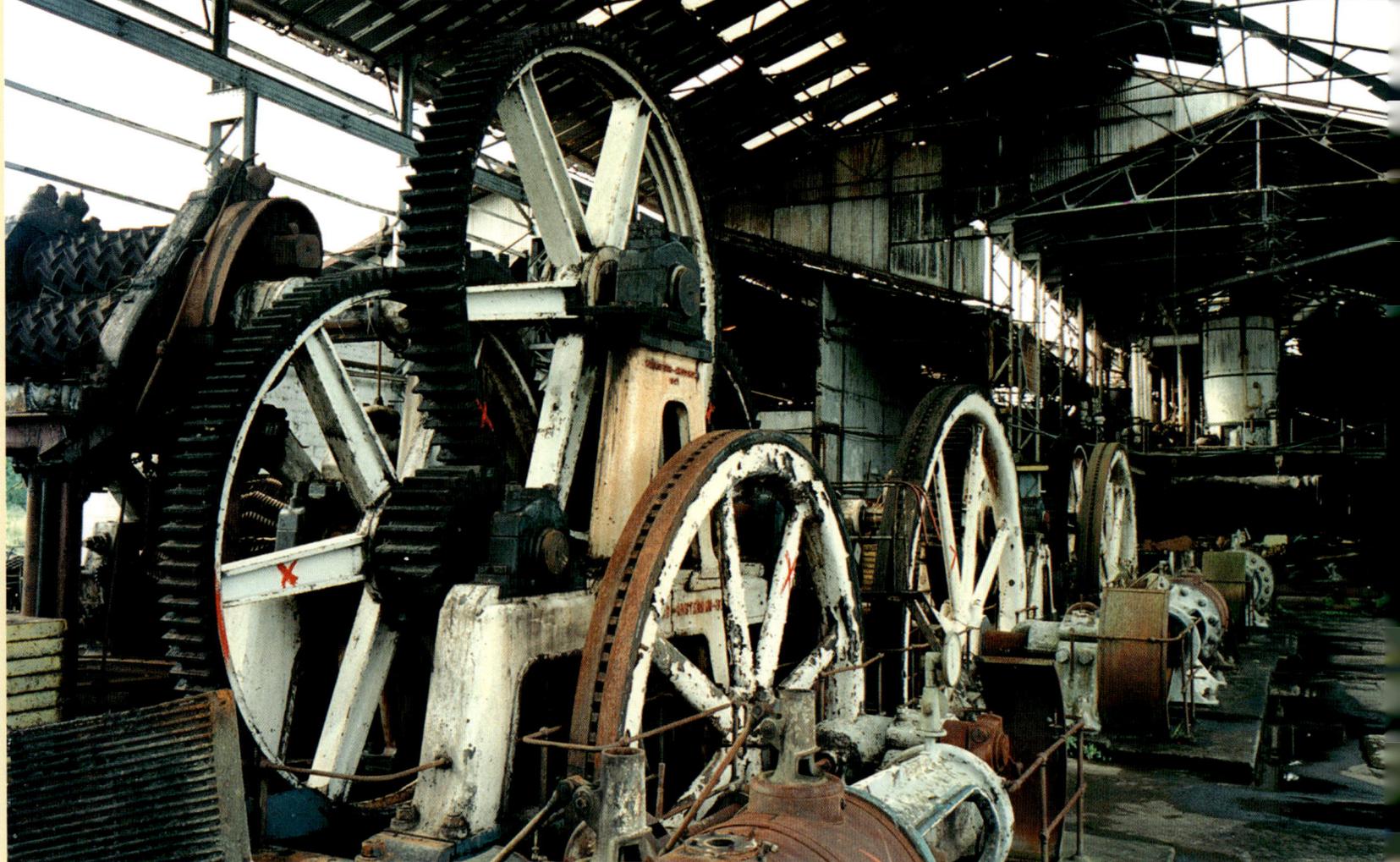

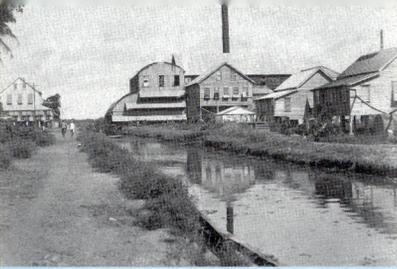

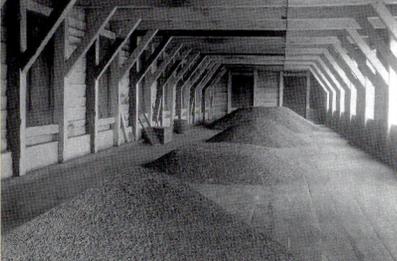

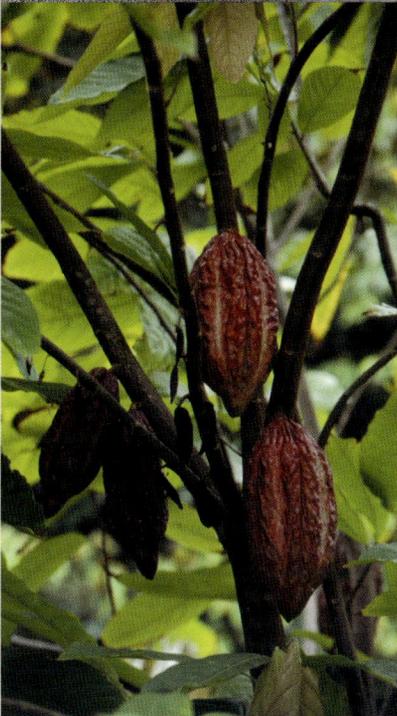

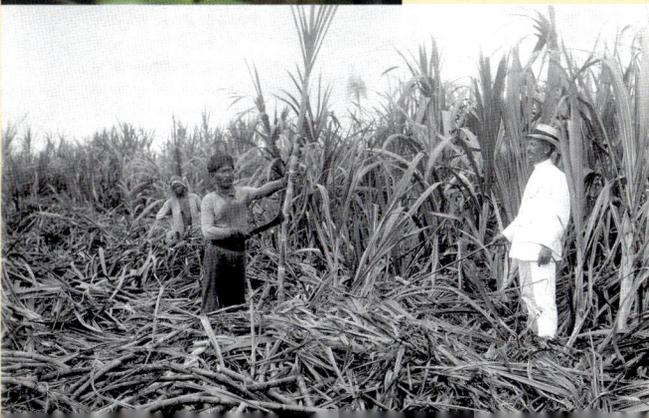

PAGE 58
The interior of the Suikerrietonderneming Mariënburg ('Mariënburg Sugar Cane Company'), *c. 1920.*
KIT
The same factory hall, 2001.
FRANS SCHELLEKENS
PAGE 59
Waterloo plantation, *c. 1920.*
KIT
The same plantation, *c. 1995.*
HENK LUTCHMAN
Drying coffee beans in the loft at the coffee plantation 'Peperpot' near Paramaribo, *c. 1920.*
KIT
The fruit of the cacao tree.
WILLEM KOLVOORT
Harvesting sugar cane, *c. 1920.*
KIT

THE ERA OF SLAVERY

Slavery was fairly common in Africa and the Middle East long before North and South America were colonised. The Europeans had no interest in slaves and thus were hardly involved in slave trade. This situation changed dramatically with the establishment of plantations in America and the Caribbean.

Attempts to enslave the indigenous inhabitants were unsuccessful. African slave practices offered a solution. The European slave traders did not even have to capture the slaves: African traders delivered them to the ports along the West African Coast. Most slaves were prisoners taken during the many tribal wars. Warfare was a lucrative business because of the demand for slaves, regardless of whether it was encouraged by European slave traders or not. Moreover, the automatic enslavement of the offspring of slaves kept their numbers constant. Unpleasant though it may sound, slavery was a good source of income, not only for European traders, but also for the African rulers.

Most of the ports used by Dutch traders to embark the slaves destined for Surinam have been recorded, but little is known about which countries the slaves came from, as traders supplied them from several areas. Most came from West and East African countries. Purchasing slaves was a costly affair and careful selection could take months

The voyage to the Caribbean took at least six weeks, but could last as long as three months if the winds were unfavourable. About 15 percent of the slaves died *en route*. Despite the immensely humiliating circumstances, this was not because of deliberate maltreatment. The slaves were valuable merchandise and the ships' captains had every reason to deliver them in good shape. The high mortality rate was caused by outbreaks of disease, which also affected the sailors. Nevertheless, the conditions the slaves had to endure on board were inhumane. Men and women were separated and slept below deck in rows. The men were chained and the slaves were only allowed on deck for a brief period each day.

Recent estimates are that 200,000 slaves, mostly male, were shipped to Surinam for the duration of the slave trade. If the prices the captains were offered on their arrival were too low, they would try to sell their 'cargo' elsewhere for a better price. The Dutch share of the European slave trade to North and South America amounted to 15 percent, which indicates that trade with the East Indies was significantly larger than with the West Indies.

The transportation of slaves was also part of a lucrative trade route. Ships left The Netherlands with merchandise for the African traders and loaded slaves. These were sold in the Caribbean and sugar, cacao, tobacco, coffee and other products were taken back to The Netherlands.

Although importing slaves to Surinam was officially banned in 1808, the illegal trade continued until 1826. Obligatory registration ended these practises. The abolition of slavery followed later.

Slave labour

After examination and sale almost all slaves were taken to plantations. Most had to do hard physical work at first: clearing the forests, working the soil, hauling and digging ditches, often from dawn till dusk. Guards who were slaves themselves and who received their orders from 'white officers' watched over these field slaves. Poor performance or laziness was punished with a whipping, or worse. Working on sugar plantations was the most demanding because the production process required extremely long shifts.

A separate category was formed by 'artisan slaves' who worked in various trades such as carpentry, gardening, farming, basket weaving, street sweeping, tailoring or as handymen. Some sold their master's merchandise on the streets or markets. Artisan slaves were almost always born in Surinam.

The life of a domestic slave was the easiest and consisted mostly of household chores. For the women this was the only chance to escape the gruelling labour on the fields. The number of house slaves was often unnecessarily high because their presence lent the masters status.

Runaway slaves

Slaves started attempting escape from the moment the first ships docked. An attempt to flee became known as 'marronage' and interestingly, most runaways were born in Africa, the so-called Saltwater Negros. The plantation workers suffered high

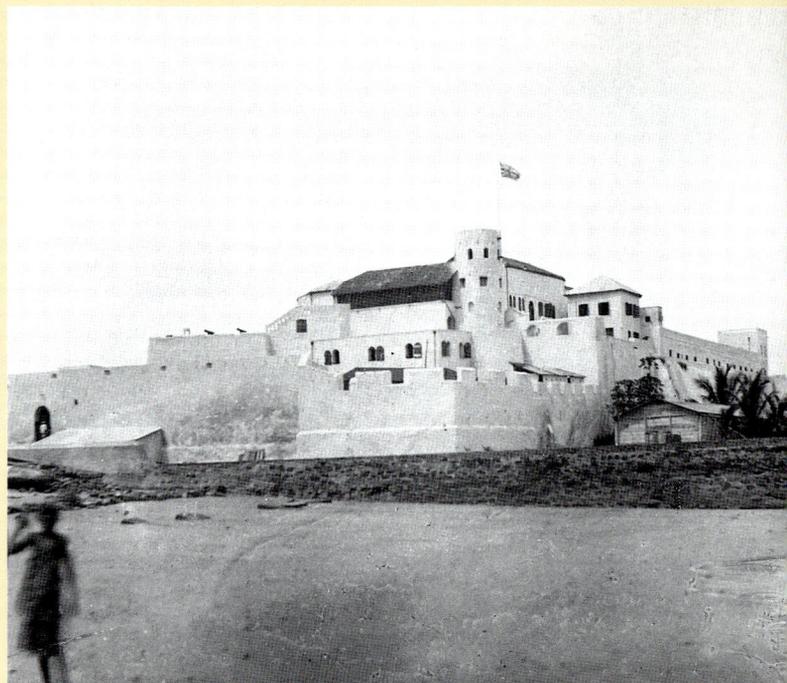

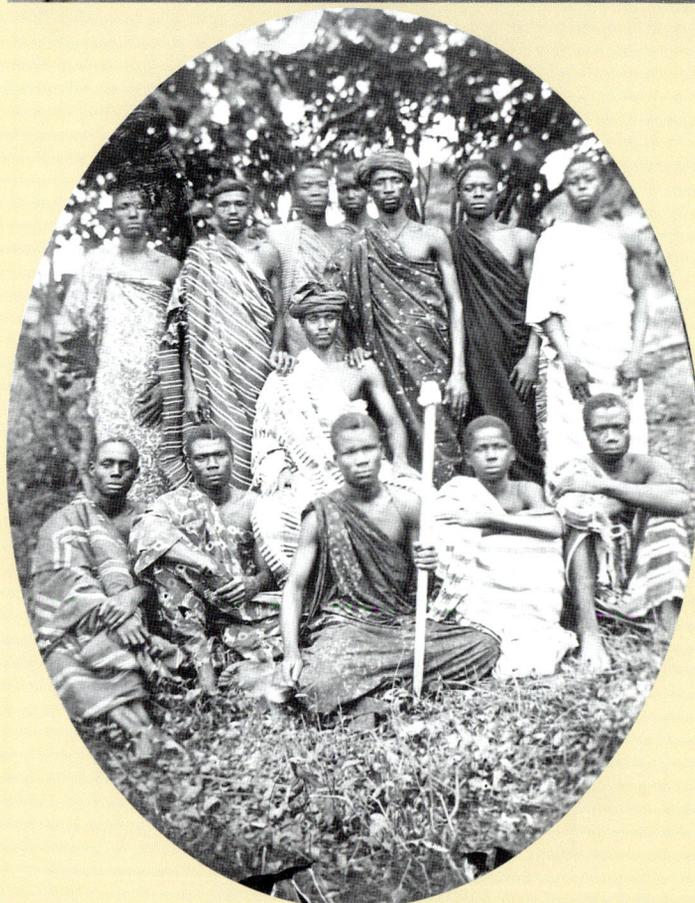

PAGE 60
Fort Elmina in Ghana, *c.* 1880, a Dutch possession until 1872 and one of the embarkation points of the slave trade.
MULLER/KIT
Achanti tribespeople, the African 'trading partners' of the Dutch West Indies Company during the slave trade,

c. 1880.
MULLER/KIT
PAGE 61
Maroon children playing in the forest near Stoluku.
KARIN ANEMA
A *pakè, dresiman* (herbalist) preparing herbs on the Meurs Road. The drawing on the board shows the part of the body that

has to be treated. The tropical rainforest harbours an unknown potential of genetic diversity and little is known of the medicinal value of many of the plants. Traditional healers are currently the guardians of much of this knowledge, and their methods of preparation can be

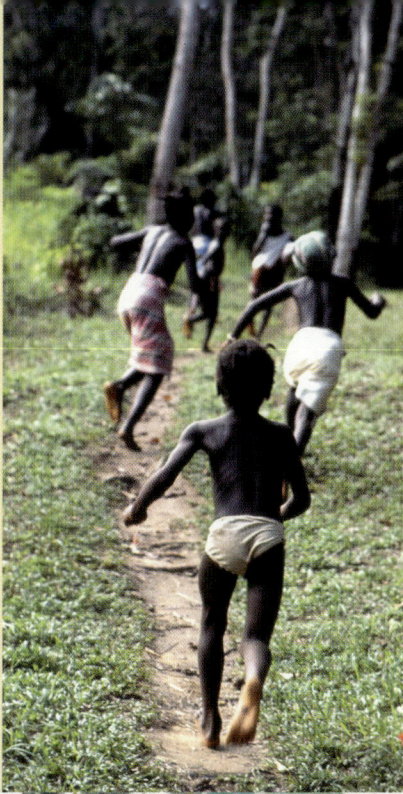

mortality and low birth rates: women were in the minority and the hard labour reduced their fertility. Slaves born in Surinam were less inclined to flee. They grew up developing an affinity with their surroundings, to them enslavement was a fact of life.

Not much prevented those wishing to escape. Security was minimal and the environment offered many hiding places. The most obvious escape route was along rivers and once the first *sulas* were passed, safety was almost certain. Small communities developed where groups of Maroons gathered and grew crops. This often led to conflicts with local Indians who regarded the Maroons as invaders. In some cases relations were peaceful and trade was possible. Such communities developed in the wetlands, although they were hard to reach and were surrounded by wooden stockades.

Contact with the plantations was seldom completely severed. Maroons often paid nightly 'visits' to the plantations in search of food, tools or women. At first, plantation owners reacted by sending out search parties to track down runaways. Soldiers were also deployed later, but neither these punitive expeditions nor the construction of the Cordon Path – a long and constantly manned line of defence against attacks on the plantations – were very effective. Better arms and organisation enabled the Maroons to offer fierce resistance. This, coupled with their knowledge of the surrounding areas, enabled them to wage highly effective guerrilla warfare. Eventually plantation owners gave up and signed peace treaties with the Maroon leaders. They would be left alone if they agreed to stop attacking and looting plantations.

Freedom

Although slaves in bondage had no rights, in time a code regulating the treatment of slaves developed. Violations were appropriately punished and Sunday was declared a day of rest. Owners could set slaves free, which often happened because owners had affairs with their female slaves. Many plantations

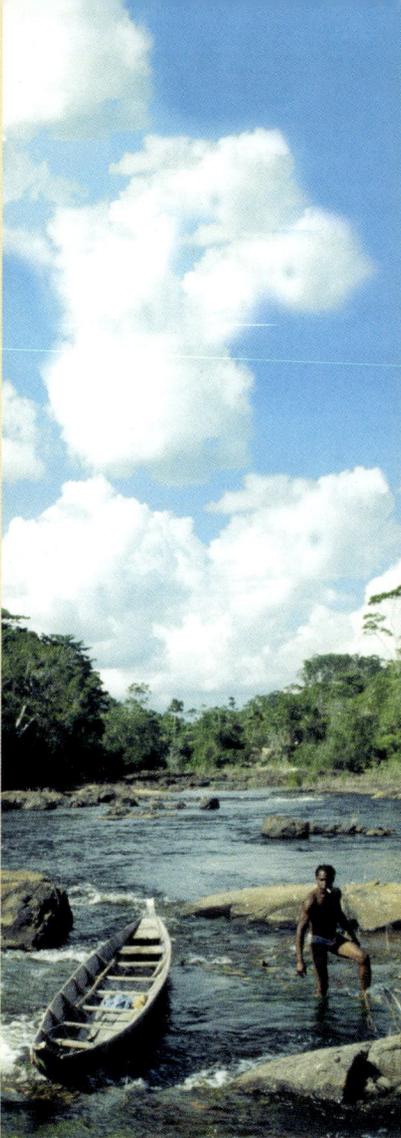

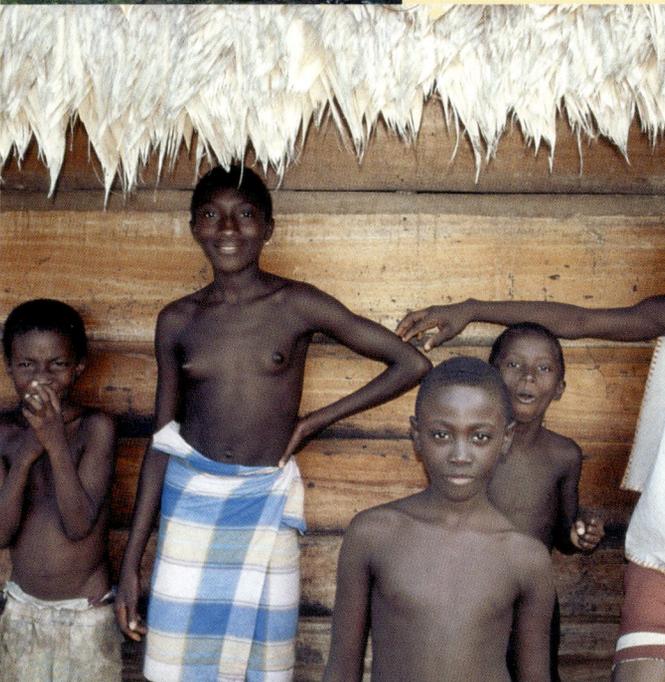

were under the direction of a manager instead of the owner, and in case of such an affair, the manager or white officer would have to pay to free the slave. The offspring they produced were free men.

Meritorious behaviour and old age were also reasons for manumission. By the early 19th century, the number of free slaves, mostly of mixed background, outnumbered the Europeans. A culture developed with its own language (Sranan) in which West African and European influences were evident.

In Europe, the debate on the morality of slavery grew louder during the 19th century. Influenced by the Revolution, France abolished slavery in 1848. Slave owners in Surinam improved the standard of living of slaves, fearing an exodus of slaves to neighbouring French Guyana. There were two camps pushing for freedom in The Netherlands: a group of conservative Christians who believed that slavery stood in the way of proper Christianisation, and liberals who believed in individual freedom as a universal right and, moreover, were convinced that free labour resulted in more effective production.

Public awareness of slavery was low. Debates on the future of the colony and financial compensation of plantation owners led to a period of political instability. Consequently, The Netherlands abolished slavery on 1 July 1863, being one of the last countries to do so. Festivities marked the days that followed. Fear of acts of violence or total anarchy proved groundless.

Ex-slaves were obliged to take on paid jobs to limit the possible economic disaster that awaited the plantations. Some of them found work in Paramaribo; most returned to the plantations to start working again, but now on a payroll. A number of plantations had to be closed, however. Ten years later, when the rule on 'mandatory paid service' was abolished, most labourers chose to go to Paramaribo or to live off the revenue of their small plots. New workers had to be found for the plantations.

63

FROM COLONY TO REPUBLIC

Migration of contract labourers.

Prohibiting the slave trade resulted in a shortage of workers even before the abolition of slavery itself and led to a demand for contract labourers. The first significant group comprising around 500 people were Chinese recruited in Canton, who arrived in Surinam in 1858. This number soon proved inadequate, more so because most Chinese opened their own businesses once their contracts had expired.

The first large-scale (and private) recruitment of contract labourers took place in the English colony of Hong Kong and yielded about 2000 workers. Migration became a governmental issue when the English prohibited recruitment several years later. The shift of focus to British India was an obvious step: immigrants from British Guyana had taken the place of former slaves in previous years. The first labourers from India arrived in 1873.

Their contracts included the right of return after five years of work, to be paid for by their employers. The majority chose to extend their contract or establish their own businesses. A minority (30 percent) went back home. The right to return could be exchanged for money and a plot of land. The authorities still saw a downside to the emigration from the British Indies as the new arrivals retained their British nationality.

The obvious solution was to encourage immigration from other Dutch colonies. The first Javanese arrived in Surinam in 1890. Many died on the long voyage because of conditions aboard ship. Despite continual attempts to enforce the rules and regulations, recruitment and transportation were not done by the book. Javanese recruiters were largely to blame, as they misled the mostly illiterate candidates and tried all sorts of ways to increase their premiums. Young men, who were most likely to have a sense of adventure, were the targets of recruitment. They were in the majority, which would be the cause of considerable friction in Surinam. Migration from Java reached its peak at the beginning of the last century and came to a stop before the Second World War. Of the 33,000 Javanese contract labourers, 25 percent eventually returned home.

Lebanese Christians migrated from French Guyana in the wake of the contract labourers and settled in Paramaribo where they specialised in textiles. They are also among the first group of immigrants.

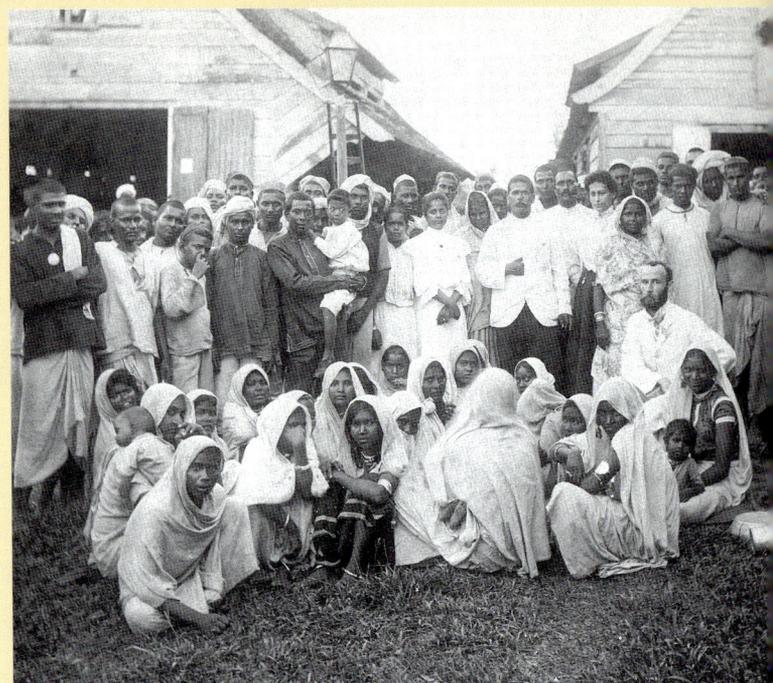

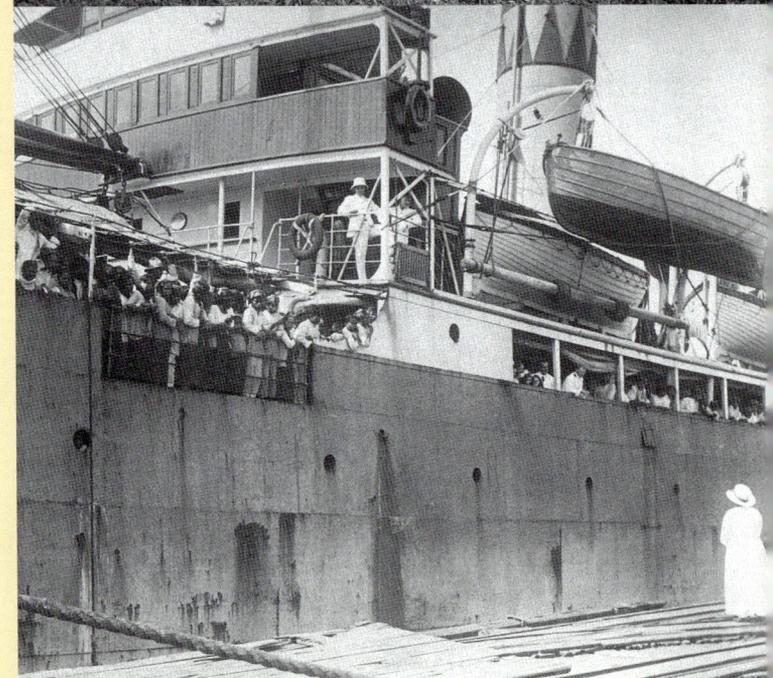

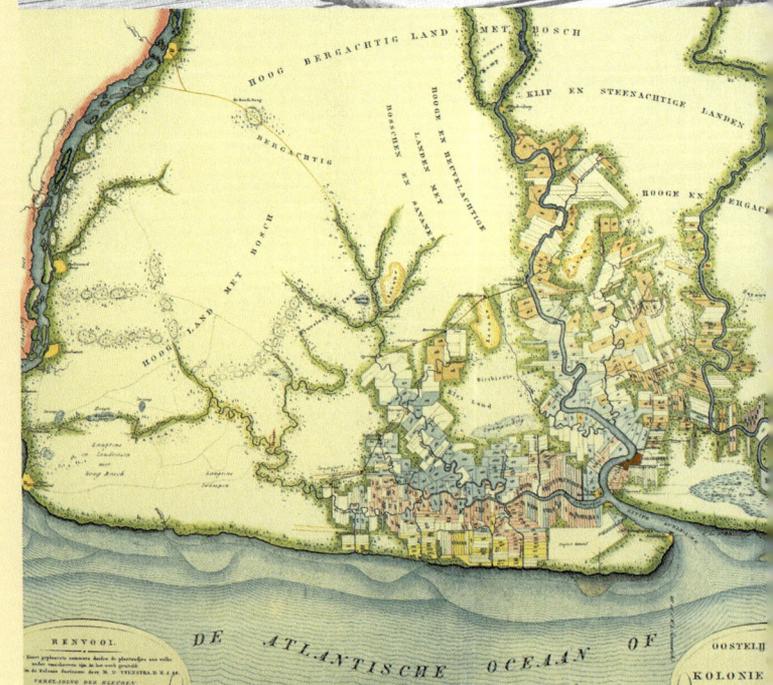

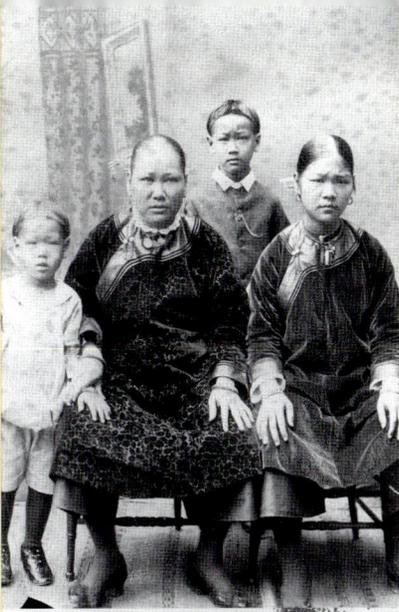

PAGE 64
British-Indian contract
workers arriving at the
immigration depots in
Paramaribo, *c.* 1915.
KIT
Boat with Javanese
contract workers at a
jetty in Paramaribo,
c. 1915.
KIT
Map of the remaining
plantations showing
the various products
under cultivation in
different colours,
c. 1900.
RIJKSARCHIEF
PAGE 65
A Chinese immigrant
family who became
wealthy through trade,
c. 1894.
KIT
Immigrant dwellings,
c. 1925.
KIT
A balata-tapper by a
rubber tree.
KIT
Growing coconut
palms in Coronie.
HENK LUTCHMAN

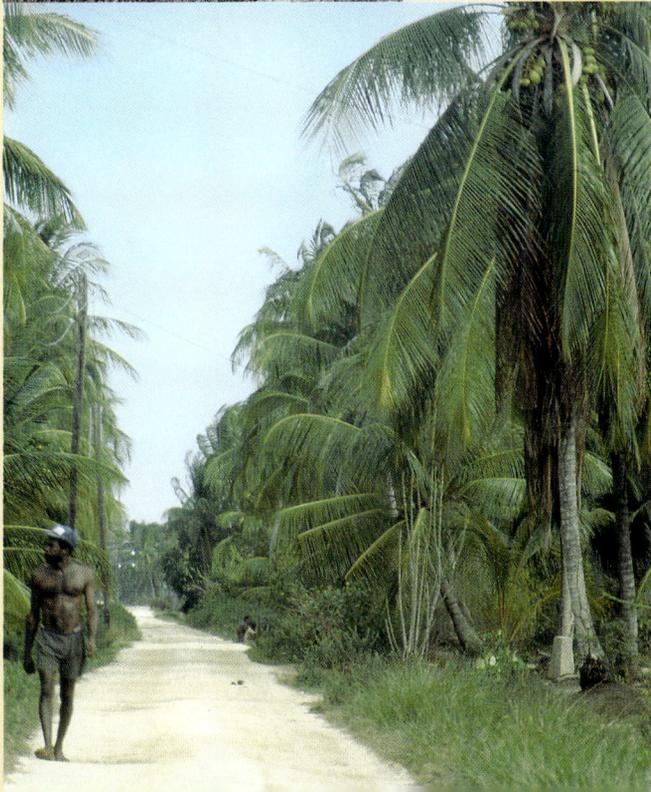

The end of the plantation economy

Surinam's prosperity depended on plantations for a long time. There were about 600 plantations in the colony at the peak of the plantation economy. This number gradually decreased during the 18th century, partly attributable to developments in the global economy and the competitive position of The Netherlands. About 240 plantations were still operational when slavery was abolished and no more than 20 or 30 remained at the beginning of the last century. Bad management, outdated technology and an unstable society were also to blame. Many plantation owners preferred living in Paramaribo or The Netherlands and left the plantations in the hands of the managers, which did not enhance the quality of the supervision.

The post-slavery era is marked by the rise of small-scale agriculture, mostly little plots of leased farmland that yielded just enough to live on, but hardly anything to sell in the cities. A group of Dutch farmers called the 'Boeroes' settled outside Paramaribo to cater to the city's needs.

Cacao was mostly grown by Creoles on the banks of the larger rivers and Coronie became renowned for its cacao plantations. Employment was created by new enterprises such as the cultivation of balata (raw material for rubber) and gold mining but these did not guarantee income because of the global market situation. Many decided to settle in Paramaribo when the demand for gold and rubber dropped off in the third decade of the last century.

A neglected colony

The multi-ethnic community that Surinam is nowadays took shape in the first half of the last century. The political influence of these groups was limited because a right to vote was reserved to those with a high income, much as it was in The Netherlands itself. Only a few hundred coloureds were entitled to vote at the beginning of last century. In 1937,

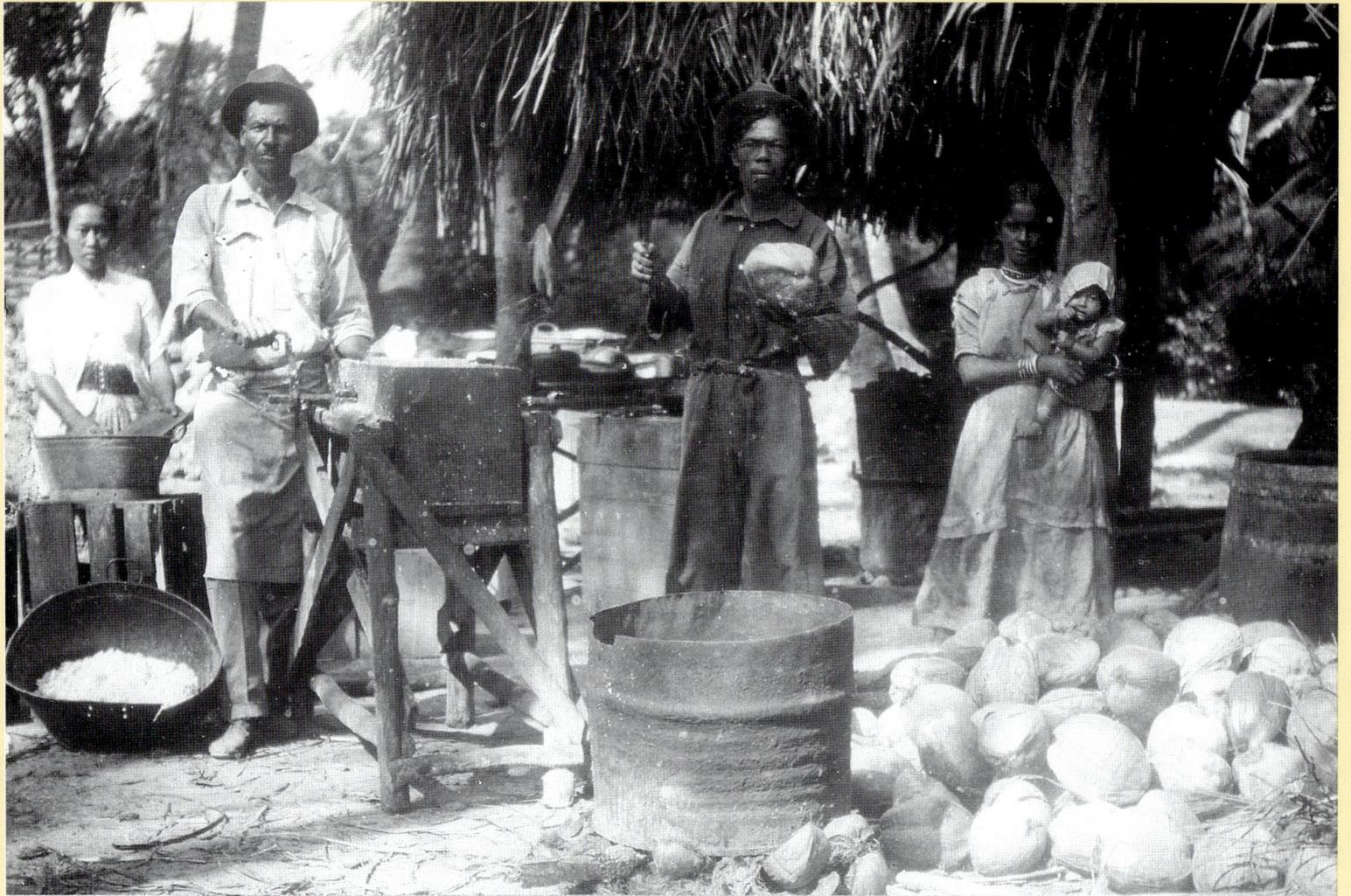

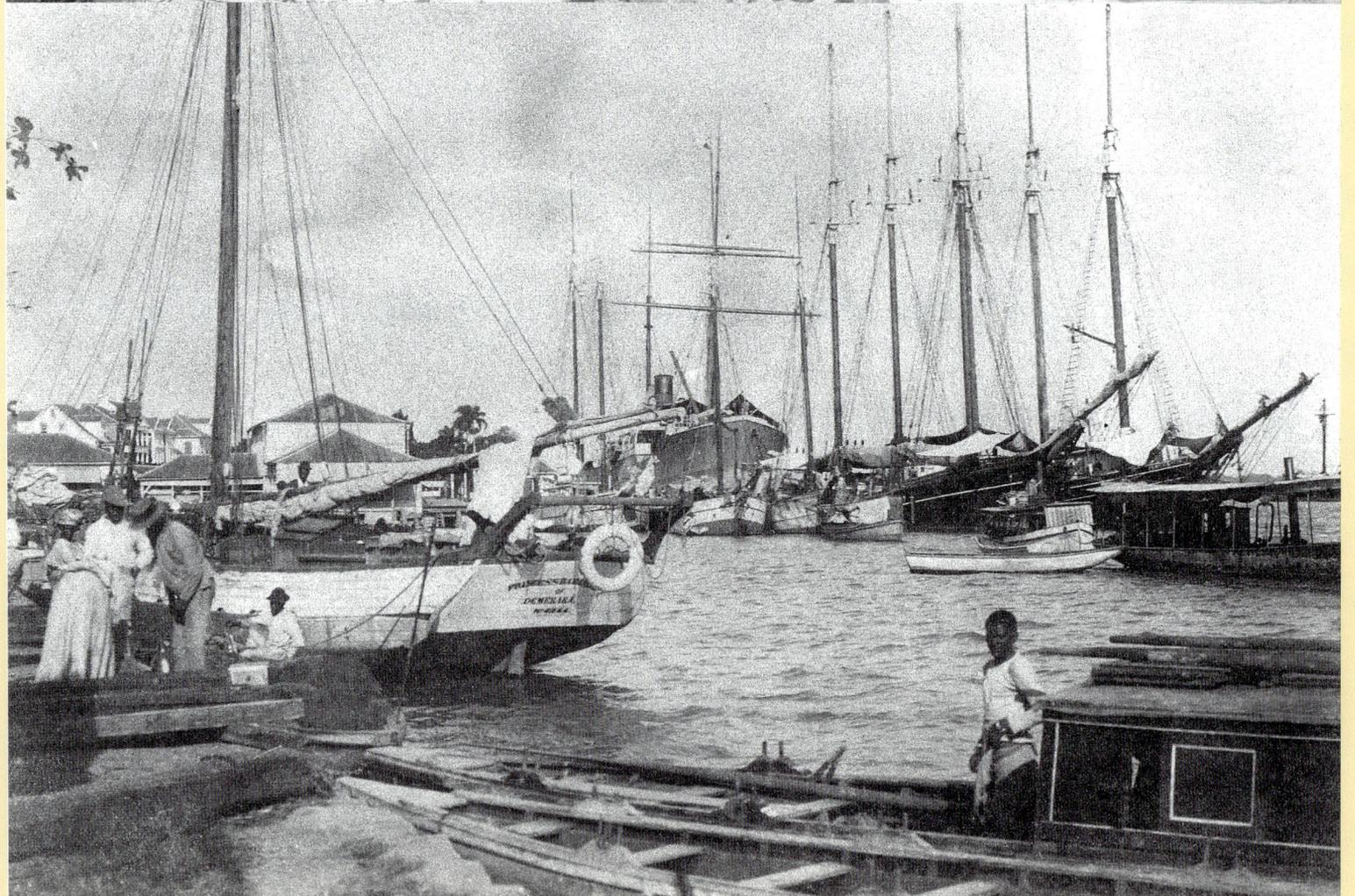

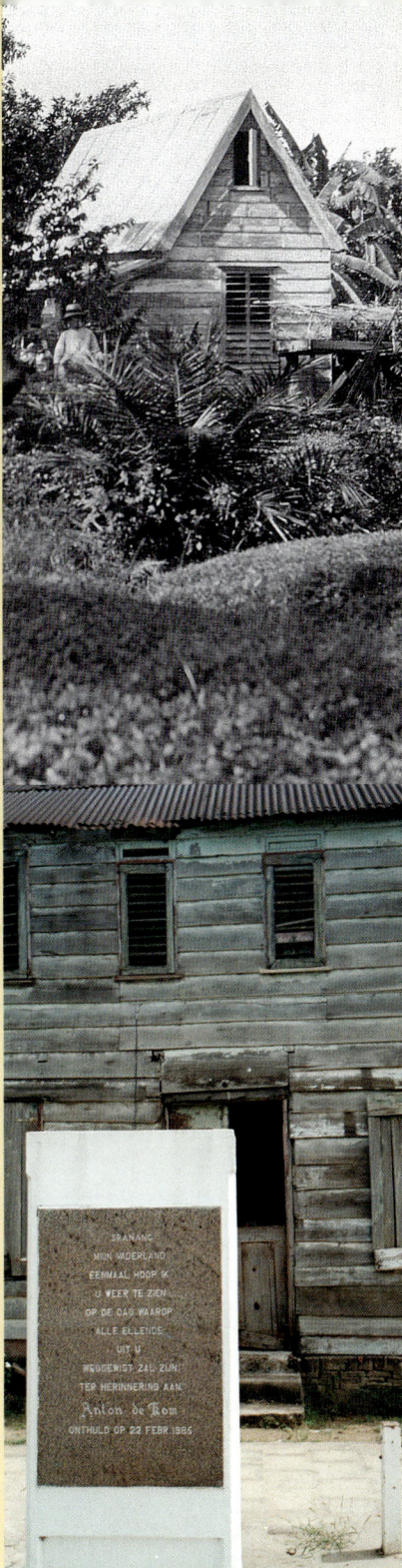

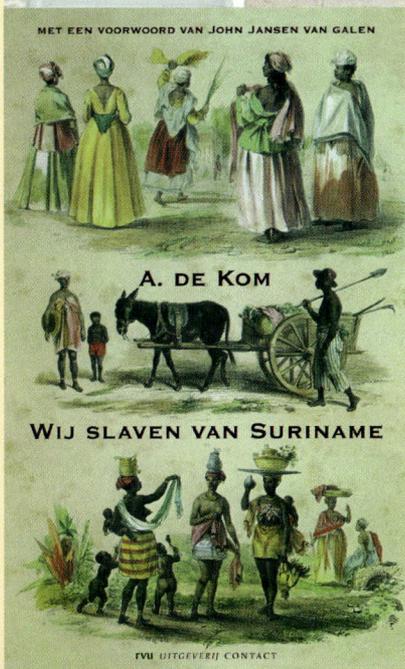

suffrage was also granted to those with a certain level of education.

The administration, the Colonial States, did not contribute much to public political awareness; non-white interests were not on the political agenda. The Dutch government was still responsible for major decisions, which frustrated many in Surinam. Furthermore, the Dutch government hardly ever agreed on the budget for Surinam and many in Surinam felt neglected by the mother country. In comparison to Indonesia, the Dutch paid hardly any attention to Surinam.

Naturally, forming political parties under these circumstances took a long time. Electors' associations did exist, however. Most were short-lived, but the association 'Eendracht Maakt Macht' ('Unity is Power') survived. Their influence in the Colonial States led to a historic breakthrough: the white elite lost its power to the Creole middle class. Massive unemployment led to demonstrations and intense debates in the 1930s, which were marked by acts of aggression and violence.

Anton de Kom

The life of Anton de Kom, born in Paramaribo in 1898, reflects the history of Surinam in the first half of the last century. His father was a prospector who later turned to farming. The young De Kom managed to get a degree, rare for a Creole at the time. While working as a clerk at the Balata Company, he became increasingly more concerned with the treatment of contract labourers, considering it a prolongation of slavery. Still quite young, he became a spokesman for the often-illiterate labourers and negotiated better pay and improved working conditions.

He left for the Netherlands in 1920 and became the first coloured cavalryman in the Dutch army. He started working for a bank in The Hague and identified with the revolutionary political views of Marcus Garvey of Jamaica on the position of coloured people in North- and South American societies. He joined a number of anti-colonial movements and wrote for

progressive left-wing magazines. His famous novel *Wij slaven van Suriname* ('We, the slaves of Surinam') was published in 1934. Never before had the exploitation and discrimination of (ex-) slaves been described in such beautiful prose by a coloured author. The book was very influential, despite the most controversial parts being censored by the publisher.

On returning to Surinam, De Kom was treated as an enemy of the state and kept under constant surveillance. When riots broke out due to rampant unemployment, he was accused of incitement and jailed without trial at Fort Zeelandia for three months. Eventually he was given a choice between confinement in a psychiatric hospital and exile in The Netherlands. His stay in The Netherlands is marked by opposition – he was accused of spreading communist propaganda and was regularly questioned by the police. His writing barely supported his Dutch wife and children. He sympathised with the resistance during the war and *Wij slaven van Suriname* was banned by the Germans. In 1944, the Germans incarcerated him on charges of contributing to a resistance journal and he was deported to the concentration camp Neuengamma from which he never returned. The University of Paramaribo was been named after him.

The Second World War as a catalyst

Although no battles were fought in Surinam during the Second World War, it was a significant period in Surinam history. Patriotism blossomed while the country was cut of from its mother country and the voices of Creole representatives grew louder in the Colonial States. Other ethnic groups also developed an awareness of their position in this multicultural society.

The war put an end to plantation farming; small farms and local industry became more important. American soldiers entered the country to secure the production of bauxite, aluminium being vital to the war effort. Paramaribo became a

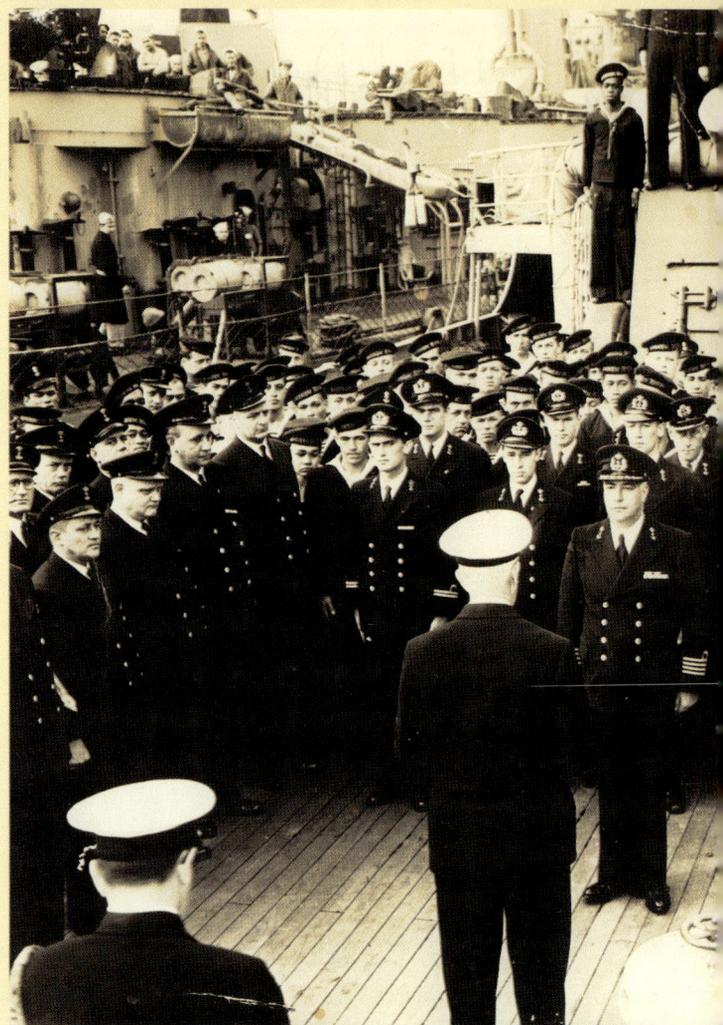

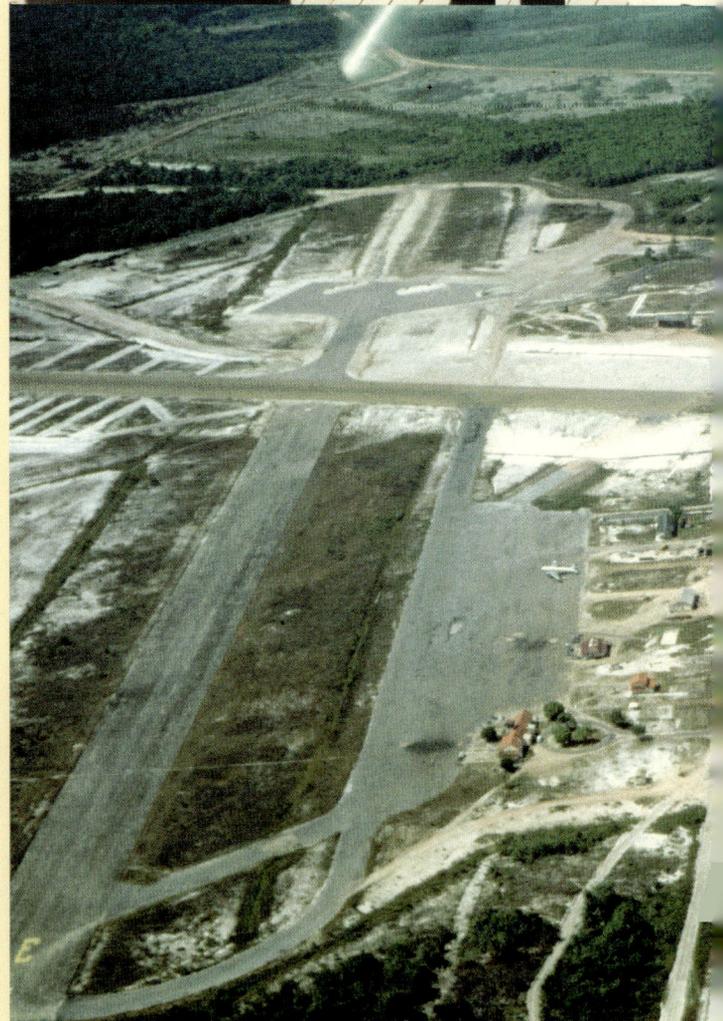

PAGE 68/69

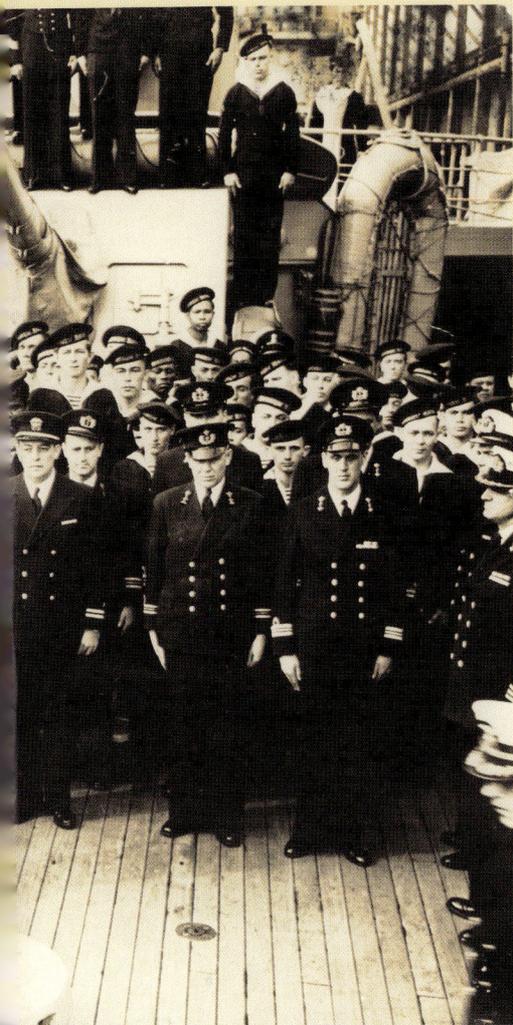

Mike Drenthe joined
the Royal Dutch
Marines during the
Second World War. He
is seen here next to a
gun at a military
ceremony in New
York. Another
Surinamese sailor can
also be seen in the
photograph.
ARCHIEF DRENTHE
Zanderij Airport after
the Second World War.
KIT
Mike Drenthe stayed
in the Marines after
the war and was
promoted to a rank
reserved for marines
who have shown great
proficiency despite not
undergoing marine-
corps training.
ARCHIEF DRENTHE
Isidoor Drenthe, who
served in the Dutch
merchant navy during
the Second World War,
was decorated for his
part in 'Operation
Murmansk' when his
ship was torpedoed
twice.
ARCHIEF DRENTHE

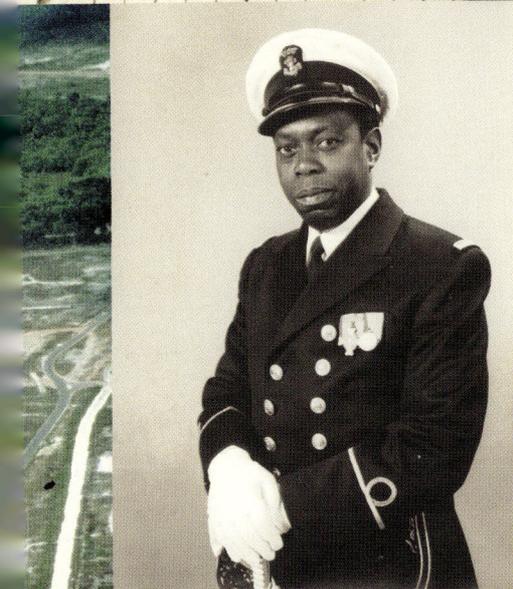

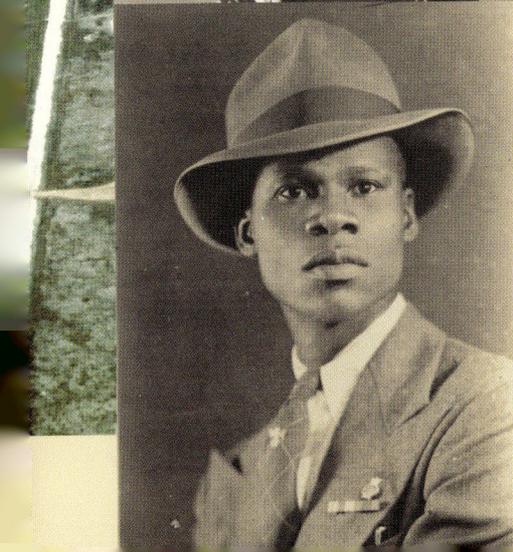

port for the American navy and the airfield at Zanderij was extensively rebuilt. The American presence had a psychological side effect: many people in Surinam became aware that their country was part of the American continent and especially the Caribbean. It was probably no coincidence that Queen Wilhelmina hinted at a larger autonomy for the colonies after the war in a radio speech in 1942. This speech was obviously heard in Surinam with great interest.

Surinam did not escape the war completely, however. Several thousand men were enlisted together with volunteers. Hundreds of riflemen reported to the Dutch ships and by the end of the war about 500 men had volunteered for duty in the Australian army. A black chapter in history was written when about 150 alleged members of the human rights group Solidaritas Nusa Bangsa (NSB) were picked up and shipped to Surinam just before the Japanese invaded Indonesia. Two of them were killed by marines for dubious reasons. The prisoners were often treated badly during their captivity in the remote barracks on Jodensavanne. A group of Dutch conscientious objectors from South Africa were imprisoned with them.

Towards independence

After the war the political and social landscape stabilised and the franchise became universal. Soon, all ethnic groups formed political parties and as a result their political agendas were hard to distinguish from their desire to advance their culture. This initiated the sectarianism that now characterises Surinam politics.

In 1954 the official autonomy of Surinam (and of the Dutch Antilles) was established. The political stage in the 1950s was dominated by two co-operating politicians, 'Jopie' Pengel, the leader of the (Creole) 'National Party of Surinam' (NPS), and Jagernath Lachmon, a representative of the 'United Hindu Party' (VHP). Surinam was by now a self-governing country, with the exception of the department of defence and foreign affairs.

69

Demands for complete sovereignty grew within the NPS. According to Lachmon, the country was not ready for this and, like the Javanese, he was concerned about Creole dominance in Surinam politics. This situation led to emotional debates in the administration where the supporters of sovereignty and their adversaries were evenly matched.

The uncertain future led to an exodus to The Netherlands. The NPS, led by Henck Arron-Pengel (died in 1969), made a strong case for independence that was backed by the Dutch government led by Prime Minister Den Uyl. The national debt would be cancelled and billions of guilders of foreign aid were promised. Finally the VHP voted in favour of independence. Official independence was declared on 25 November 1975.

An independent republic

Turbulent and weak politics marked the first years of the new republic. Prosperity and employment barely increased

Coat of arms of Surinam
Surinam adopted an official coat of arms with the motto 'Justitia Pietas Fides' ('Justice, Piety, Loyalty') on gaining independence in 1975. It consists of two Indians holding a heraldic shield. The shield shows a number of images. On the left hand side a sailing ship represents the history of Surinam, ships being the transport used to bring the slaves and contract workers to the country. The King's Palm to the right symbolises the present as well as justice. In the middle of the heraldic shield there is a diamond representing the human heart. A star in the centre of the diamond symbolises the five continents as well as the five most important population groups comprising Surinam society.

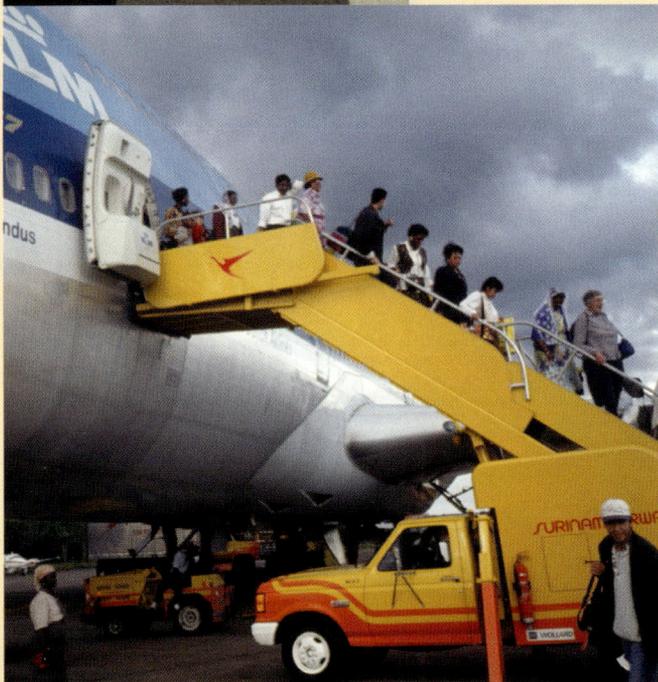

despite considerable bauxite earnings and abundant development funds. This was widely attributed to large-scale corruption and fraud. The exodus of the Surinam people, who until 1980 were allowed to settle in The Netherlands, only made things worse.

Hardly anyone reacted when a small group of non-commissioned officers took over the government after a conflict about the formation of a trade union. There was a brief moment of hope, even in The Netherlands. Unfortunately, the incompetent 'civil government' led by strongman Desi Bouterse did nothing to improve the lot of the people: civil rights remained restricted and elections were constantly postponed. The men who staged the coup reacted ruthlessly when concerned union leaders, journalists and a number of intellectuals voiced their criticism; fifteen opponents of the coup were killed in Fort Zeelandia in December 1982.

The outrage in the country and abroad was unprecedented. Foreign aid was suspended and the country slipped into international isolation. Several years later, the Bouterse administration came under threat from jungle commandos led by Ronnie Brunswijk. Innocent civilians were killed in these battles. It would take until 1991 for democracy to be restored and for free elections to be held. Bouterse participated in these with his own political party.

To an outsider the number of political parties in Surinam is somewhat confusing. Each party represents an ethnic group and because opinions within these groups can differ widely, the number of parties grows incrementally. Contemporary politics focuses mainly on the economy, which remains stagnant despite a wealth of natural resources. Education and health care are in need of improvement. However, the youth have better opportunities than a few years ago. Relationships with The Netherlands and the rest of the world have improved and Surinam is receiving more attention on a cultural and tourist level.

71

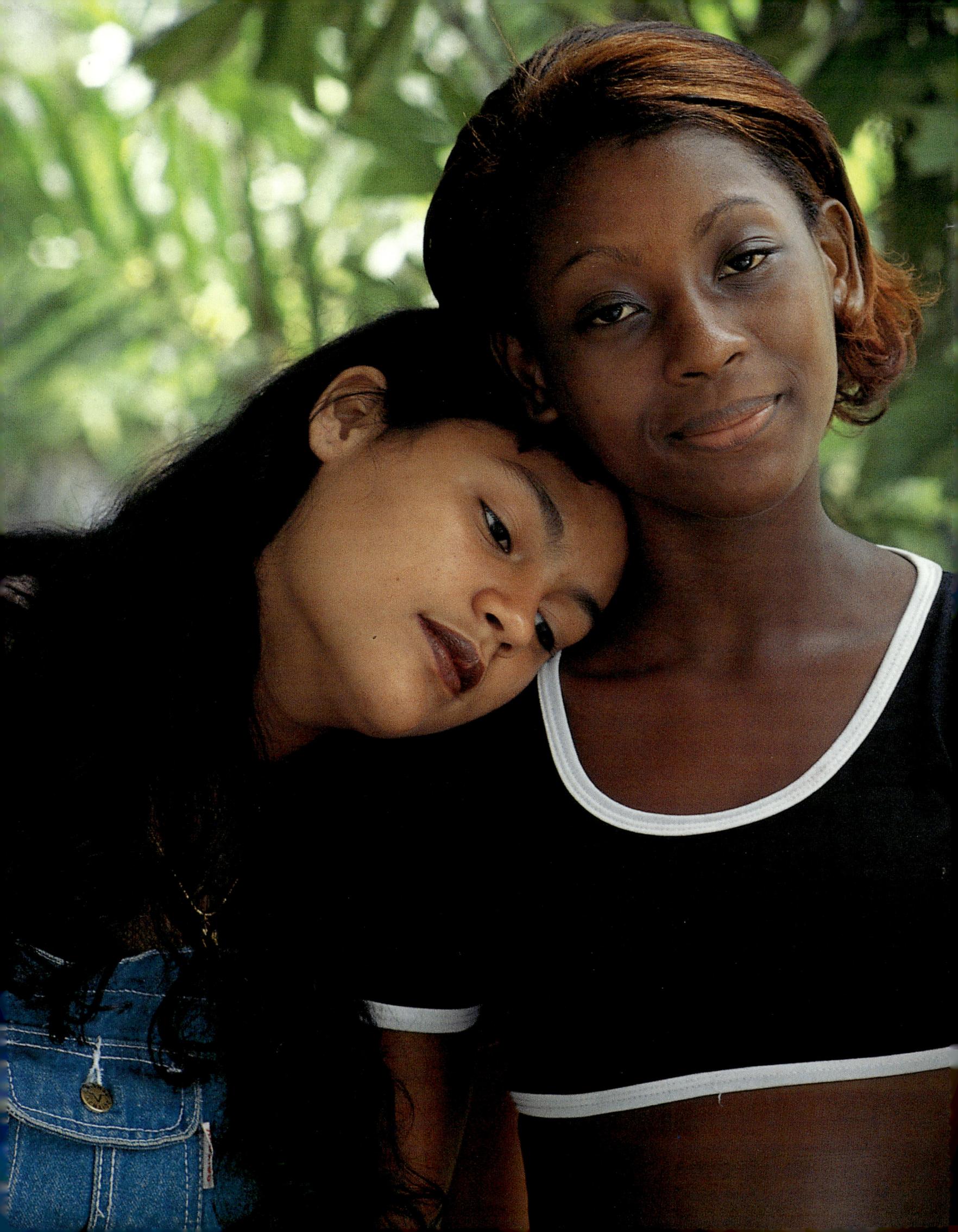

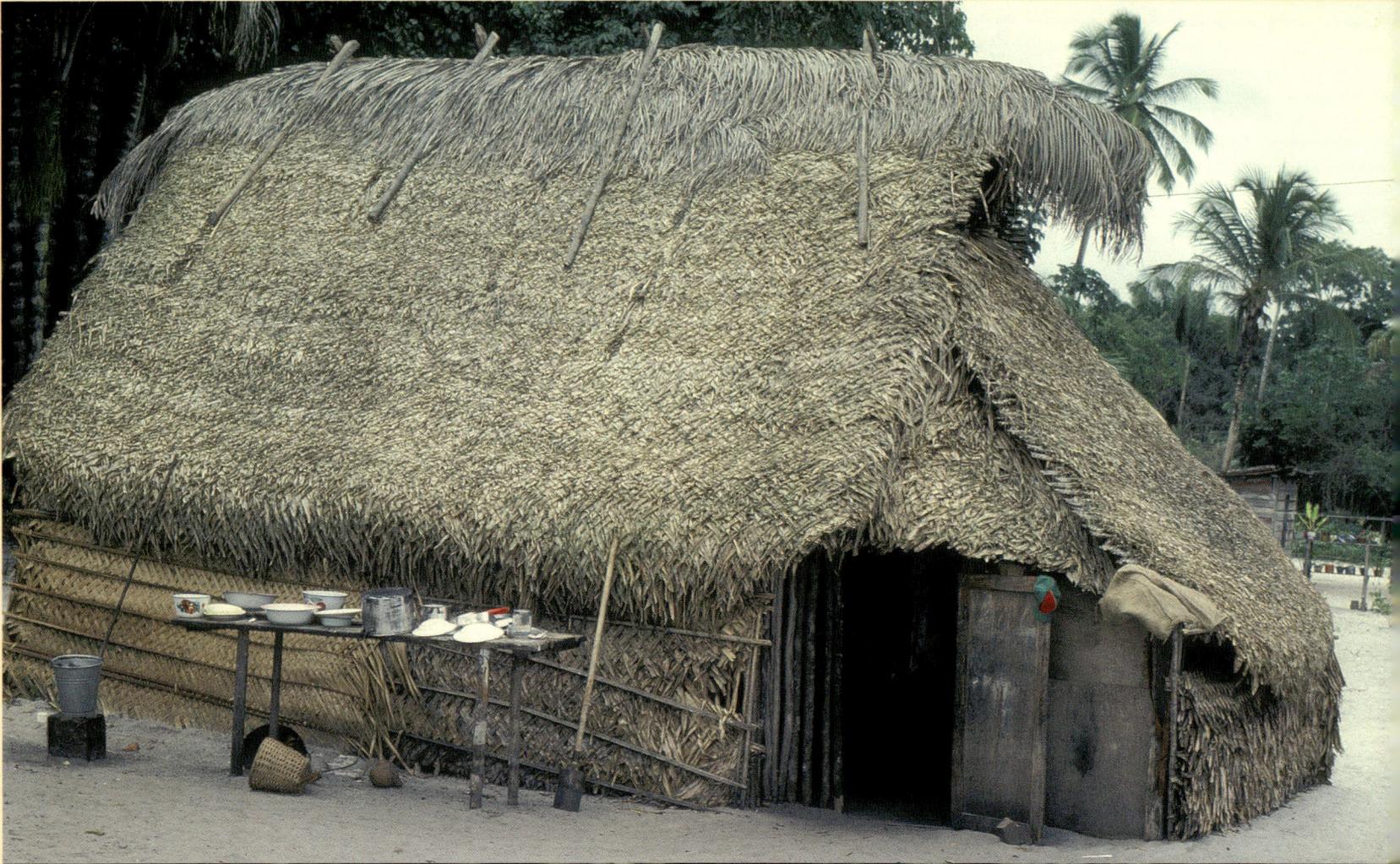

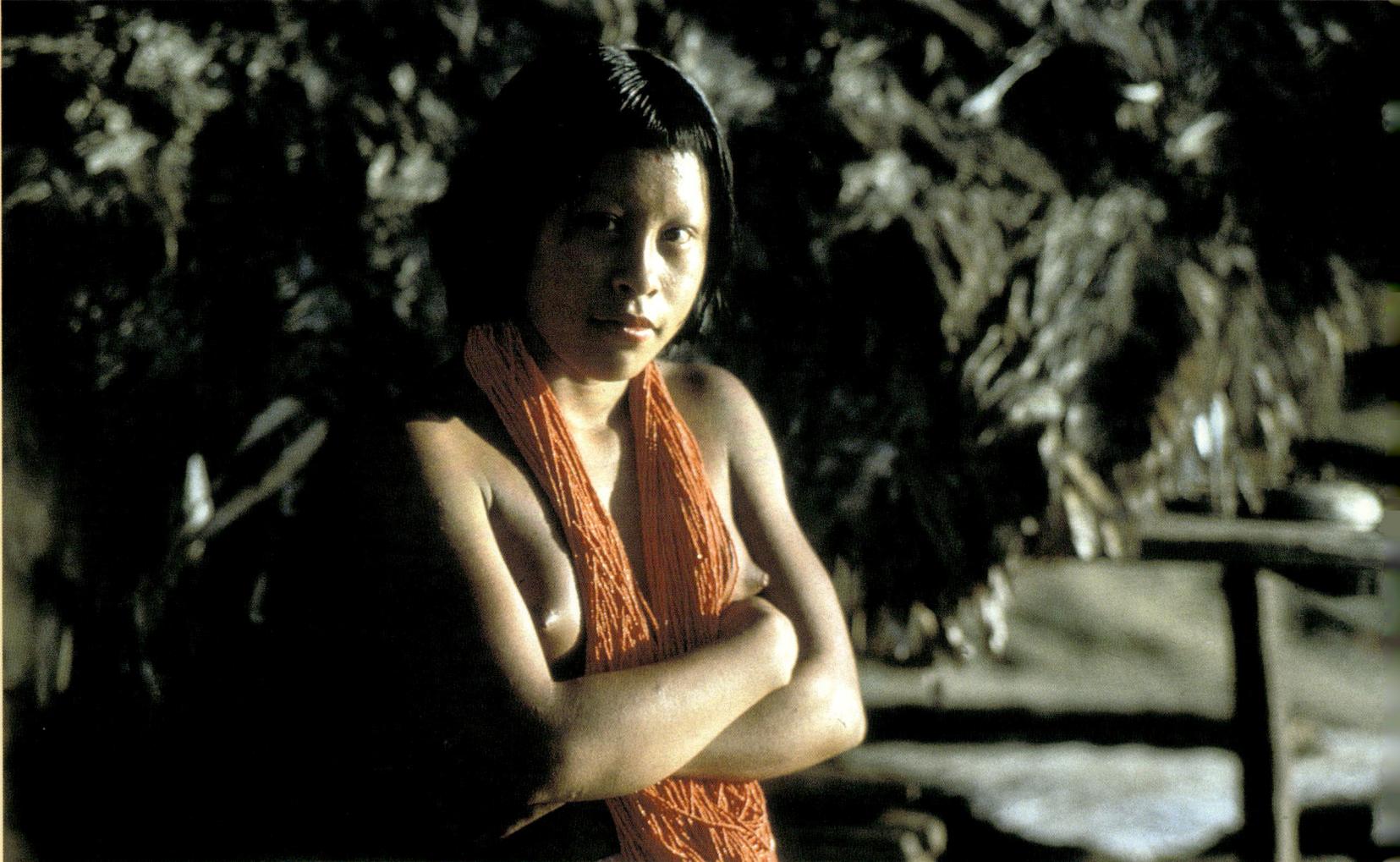

ONE *country*, MANY WORLDS

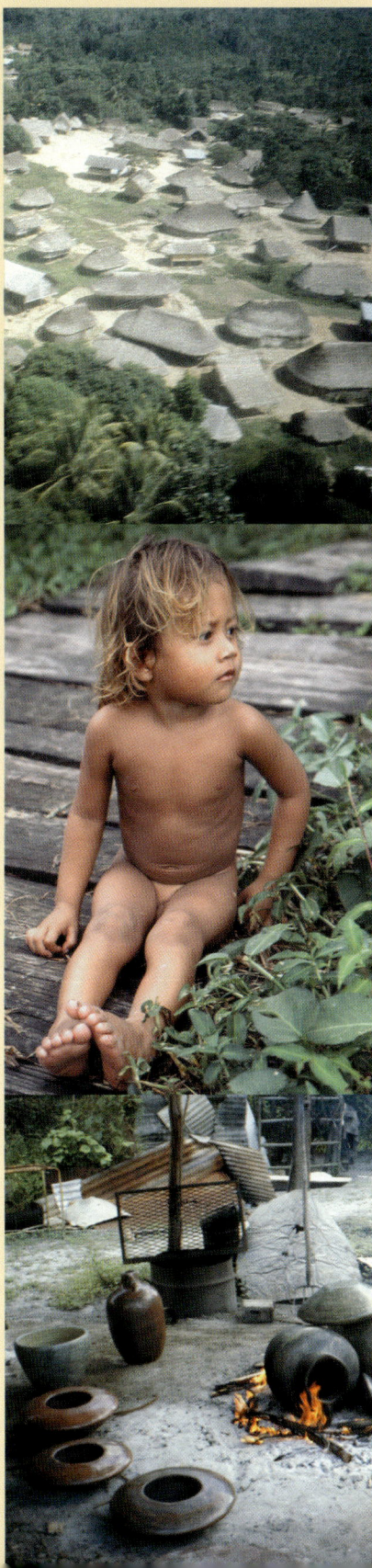

Surinam has a unique diversity of ethnic groups considering that it is a small country with less than half a million inhabitants. Their peaceful co-existence is the envy of many. Some groups maintain their traditional lifestyles and eschew interracial marriages. There are also mixed relationships and marriages with a consequent blending of these colourful cultures. While the various population groups live mostly according to their own cultural mores, Surinam is by no means a fragmented society. It is a vibrant mosaic of cultures and lifestyles.

The Indians

Despite numbering only about 17,000, the indigenous Indians form an essential part of the Surinamese multicultural society. There is a saying, 'Surinam is an Indian land', and there are good arguments to support this. They are the original inhabitants of Surinam, and the colonial settlers not only adopted many of the indigenous place names but also many elements of their culture. Many of the products cultivated by the Indians were unknown in Europe before the discovery of America, such as potatoes, cassava, tobacco, cacao, tomatoes, corn and peanuts.

This group is roughly divided into the lowland Indians, who live on the coastal plain and in the savannah, and highland Indians, who reside in the interior. The lowland Indians are predominately Catholic and comprise the majority of the indigenous Surinamese population. The highland Indians are largely Protestant due to the efforts of American missionaries. Christianity has by no means replaced the Indians' own belief system and ritual is still vital to their society. The *pyjai* or shaman, the spiritual leader and healer, still fulfils an important function in the spiritual lives of most Indians. The rite-of-passage from childhood to adulthood is heavily ritualised.

That some of these tribes do not understand each other's language clearly shows that they evolved in separate habitats. The Arowaks and the Caribbeans comprise 80 percent of the

PAGE 72/73
Three girls of different ethnic backgrounds. The girl at the right is descended from Dutch farmers.
TOON FEY
PAGE 74
Indian dwellings in Powaka.
KIT
Trio Indian woman.
KIT
PAGE 75
The Indian village Kwamalasamutu.
KIT
Toddler in Apura, one of the group 'with light eyes'.
KARIN ANEMA
Indigenous pottery made in an open fire.
KIT

75

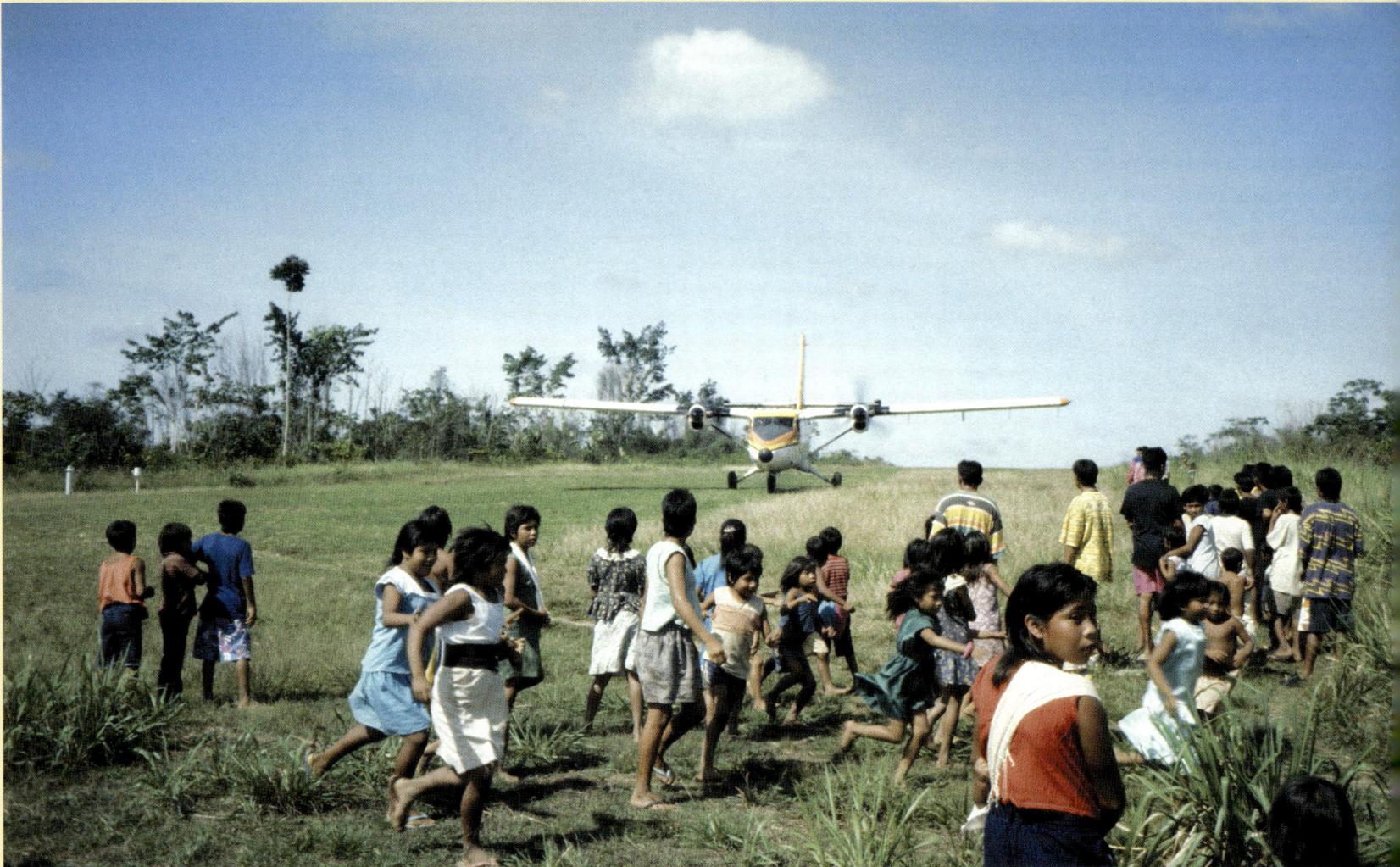

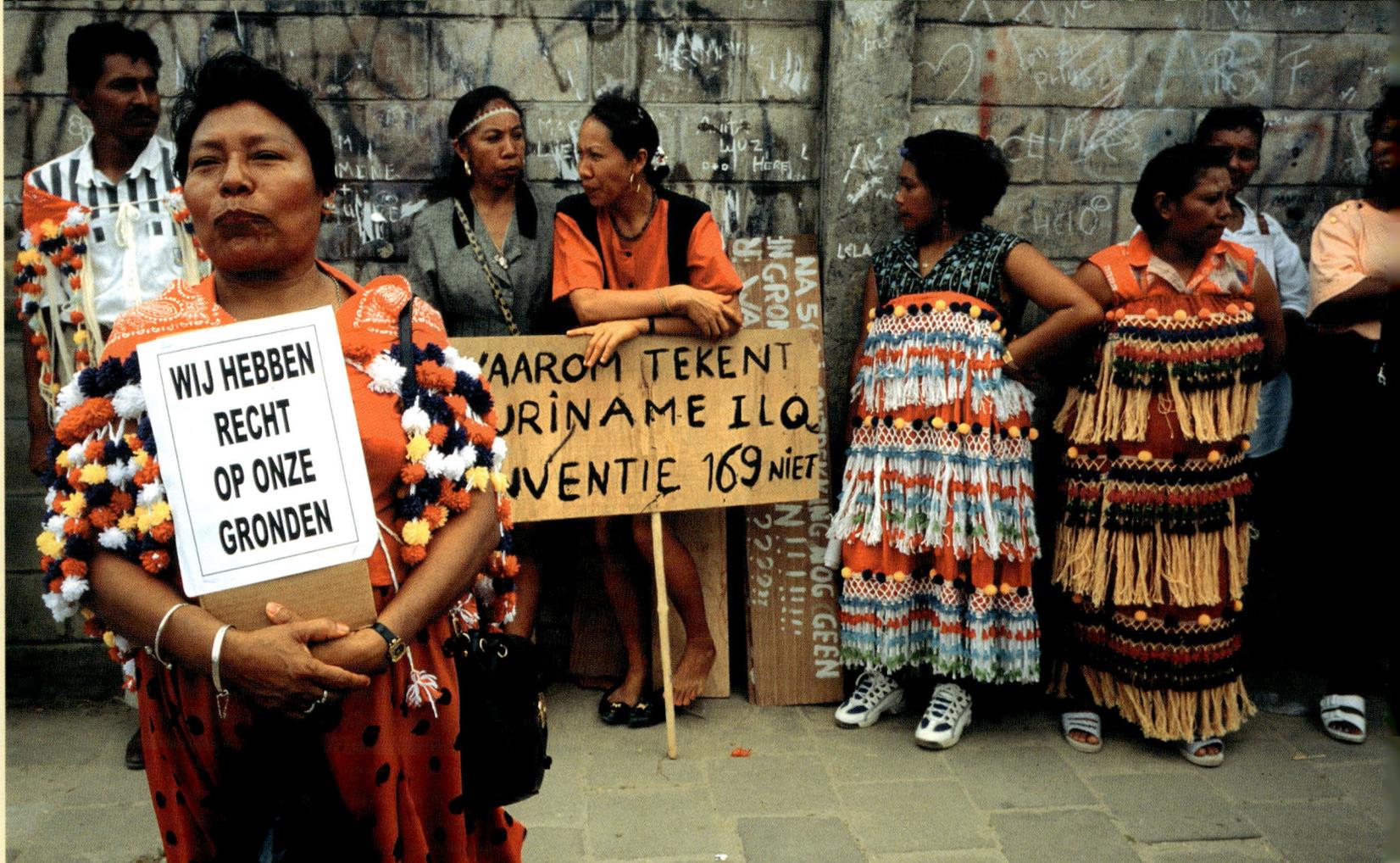

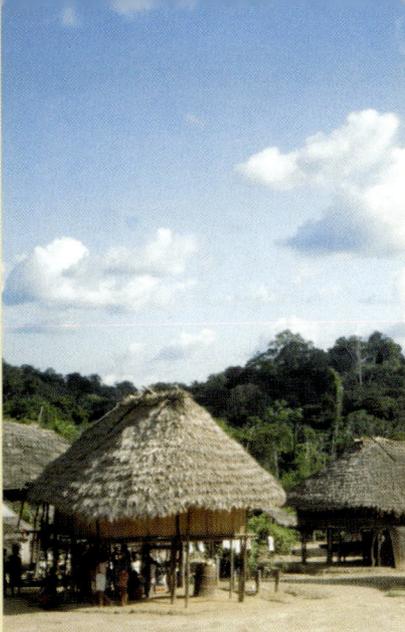

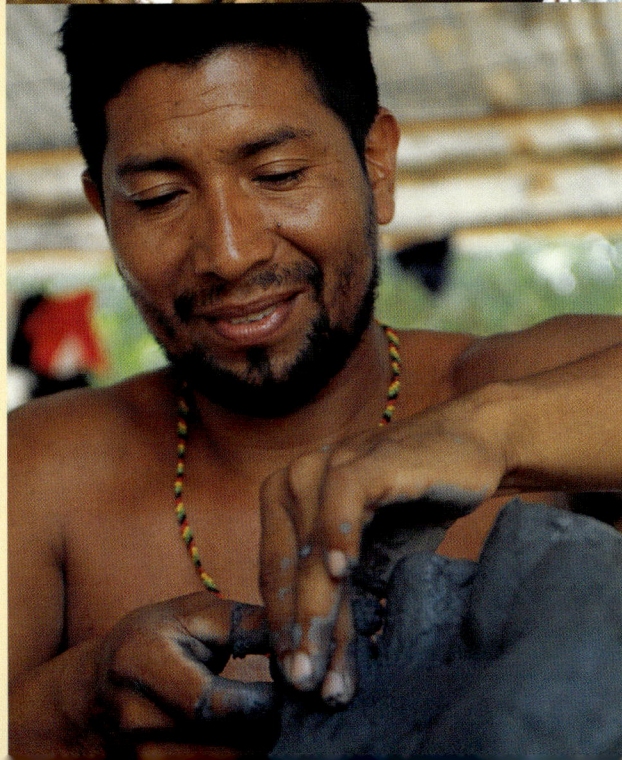

indigenous population. The Arowaks (or Lokono, as they call themselves) have lived on the fertile coastal plains for about 1500 years in villages such as Apura, Wasjabo, Mata, Powakka and Ansjumarakondre. They live mainly from slash-and-burn farming. Their language differs considerably from other indigenous languages.

In time, the Caribbean tribes split into three groups: those living along the Coppename and Wajambo rivers who make a living from logging, a group in the neighbourhood of Paramaribo who are best adjusted to modern society and are salaried workers, and the Caribbeans in the east, who survive by fishing.

In comparison to the Arowaks and the Caribbeans, the highland tribes are a minority of the total indigenous population. Until encountering American missionaries for the first time in the 1960s, the Akurio lived as nomads. They are only a small group. The Trio live along the banks of the Tapanahony and the Sipaliwini; their way of life is strongly influenced by missionary doctors. The Wajana showed scant interest for the missionaries' efforts and still live by their old traditions.

The Indians barely play a role in Surinamese society and have no political influence to speak of. Younger members of indigenous tribes have a growing interest in their past and identity. They would like to have more say over their living space and hunting grounds; this remains a point of contention.

The Maroons

A few names are used to designate the descendants of runaway slaves, including 'Maroons' and 'Forest Creoles'. 'Maroon' is the preferred term. Virtually all the ancestors of the Maroons were slaves born in and shipped from Africa. Consequently, many elements of West African culture have survived. Moreover, that the runaway slaves travelled far upriver and lived deep in the forest to escape their pursuers helped preserve this culture in relative isolation.

Following a period of armed conflict with the colonial authorities and almost a century after slavery was abolished, the Maroons were declared a free people. The authorities subsequently paid little attention to the inland population. Left to themselves the settlements developed into villages with unique cultures and administrations. Most of the villages were situated along the river and being separated by the dense forests meant that each tribe evolved a unique language.

These tribes still had many things in common, however. The highest authority in a Maroon tribe is the *granman,* who decides

77

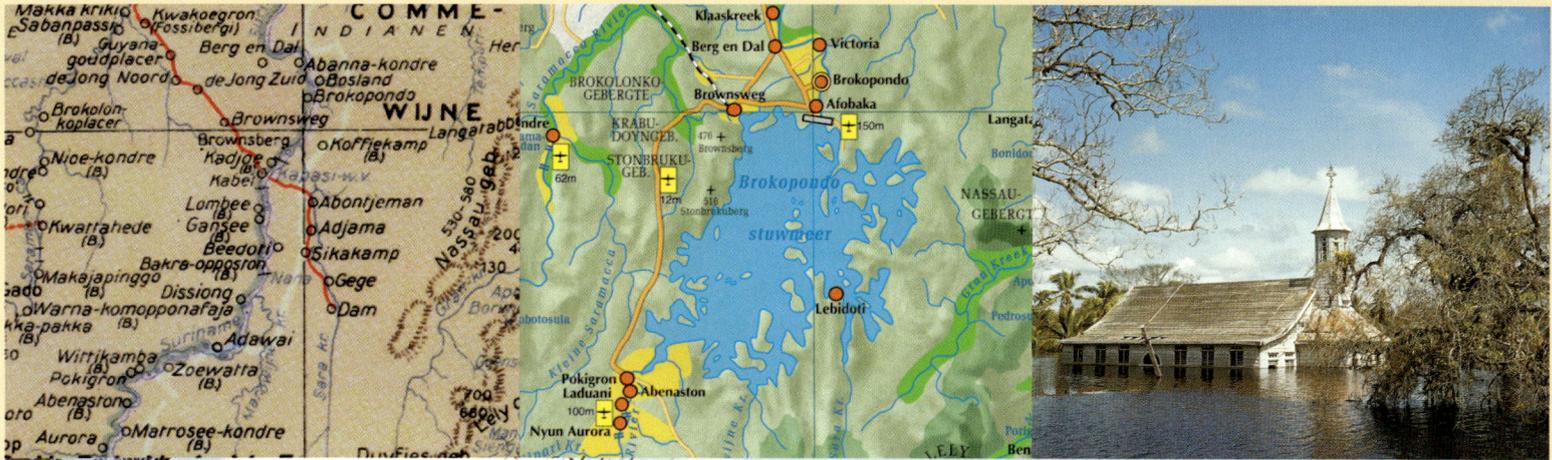

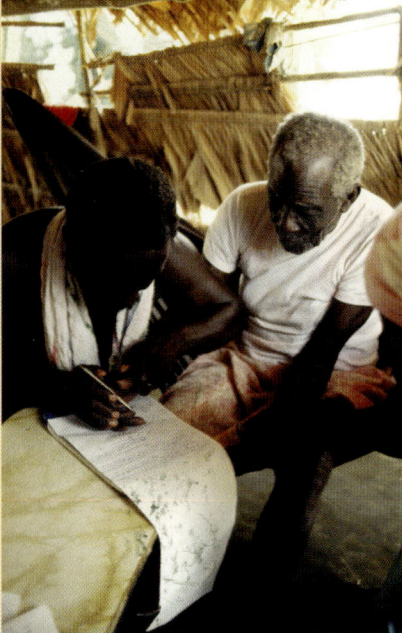

PAGE 78
Map from the Elsevier atlas of 1948. The Brokopondo reservoir had not been built yet and the railway line to Dam is still intact. The current district of Brokopondo did not then exist and formed part of the district Commewijne.
ELSEVIER PUBLISHERS
New map of the Brokopondo area.
H.T.J. LUTCHMAN
The church in the village Gansee ended up at the bottom of the reservoir.
KIT
The village of Dessiong was also submerged after the Brokopondo dam was built.
KIT
PAGE 79
The Brokopondo reservoir.
ERIK SOK
Granman Forster, a few days before his death, is assisted in signing a letter to Beatrix, Queen of The Netherlands.
FRANS SCHELLEKENS
Captain Alfaisi of the village Godoholo.
FRANS SCHELLEKENS
The captain of Stoluku with one of his wives.
KARIN ANEMA

practical issues and functions as the high priest. The *granman's* succession is matrilineal. *Granman* have considerable authority. Requesting a meeting with a *granman* requires great tact, and communication usually occurs through a third person. The *granman* is recognised as the leader of the tribe by the official authorities who pay him a salary. In the separate villages, 'Captains' represent the *granman*.

Religion is an important part of Maroon life. Their conversion to Christianity did not mean the end of their ancient practise of ancestor worship or their belief in spirits, *winti*. The Supreme Being, Gaan Gudu, communicates with people through the spirits, and the *winti* play an important role in daily life.

The Saramaccans are the largest and one of the oldest Maroon tribes. Their ancestors escaped on a relatively large scale from the plantations managed by Portuguese-speaking Jews. The influence of this language on Saramaccans is evident. Many Samaraccan villages were lost beneath the surface of the Brokopondo reservoir, which formed after the completion of the Afobaka Dam. This was a dramatic and emotional event for the affected villagers as they were forced to abandon their ancestral lands. Thousands were relocated to 'transmigration villages', such as Brownsberg and Klaaskreek. There is lingering resentment. Most of the Saramaccans live along the Suriname River in the central region of Surinam.

The Aukaners (also called Ndjuka) are the second largest Maroon tribe and mostly reside in villages along the Tapanahony and Cottica rivers. The Matawai, Paramaccans, Kwinti and Boni are smaller Maroon communities.

The traditional way of life of the Maroons has changed considerably during the last decades. During the civil war, many Maroons fled to Paramaribo and French Guyana, never to return to their old villages. The lure of the city (especially among the youth) and attending school means that there is often not enough manpower to maintain the crops. There is a shortage of educational aids and teachers, as a post in the interior is filled

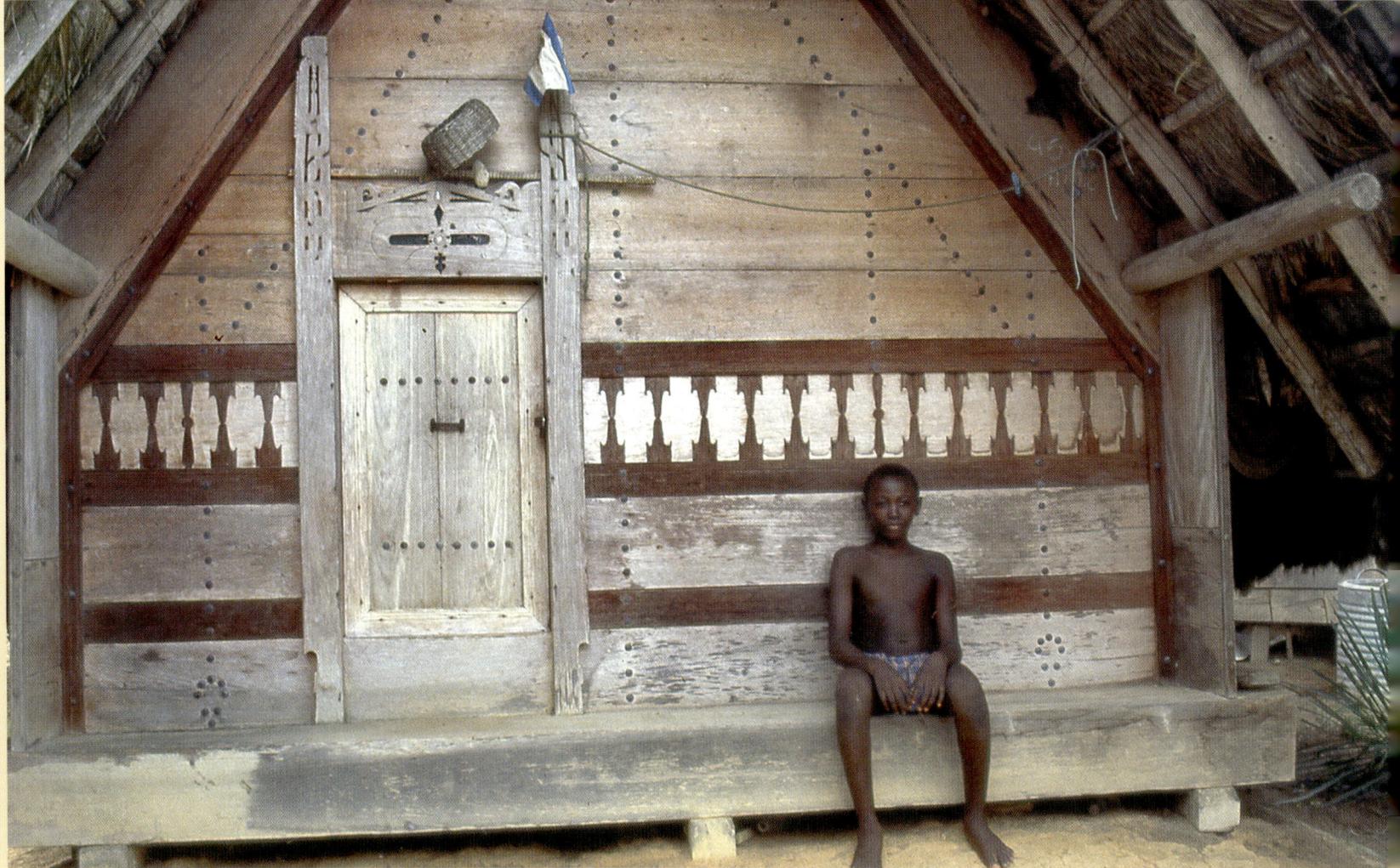

with disadvantages. The Maroons frequently complain that their problems are only reviewed during elections.

The Creoles

That such a clear distinction is made between the Maroons and the Creoles is not always clear to outsiders as both groups are descended from African slaves. There are convincing historical reasons for this: most of the original Maroons were born in Africa and those who could, escaped inland from slavery from the moment they arrived. Isolated deep in the forests upstream, they did not participate in Surinamese society.

The Creoles on the other hand participated in Surinamese society from an early stage. After slavery was abolished, many freemen took to small-scale farming. This did not provide much security, however, as they received no government support. Lacking pesticides, the Creoles abandoned their smallholdings in the 19th century and moved to the cities. That Paramaribo became predominately a Creole city is largely due to the collapse of their small farms. Moreover, they could work at timber yards or tap balata, a form of latex produced by the bulletwood tree.

Creole society developed in diverse ways soon their arrival. There were already a considerable number of freed slaves before slavery was abolished. This social head-start over the slaves had enormous influence on their status and by adapting their lifestyles and dress to that of the colonists they became the elite among the coloured people. Mixed marriages produced offspring with skin tones ranging from very dark to extremely pale, the latter being the most desirable.

Living in Paramaribo meant that this group could avail themselves of the education system. There was already compulsory education for children in 1876. At the end of the 19th century, a number of Creole families were able to send their children to study in The Netherlands. Naturally, educated

81

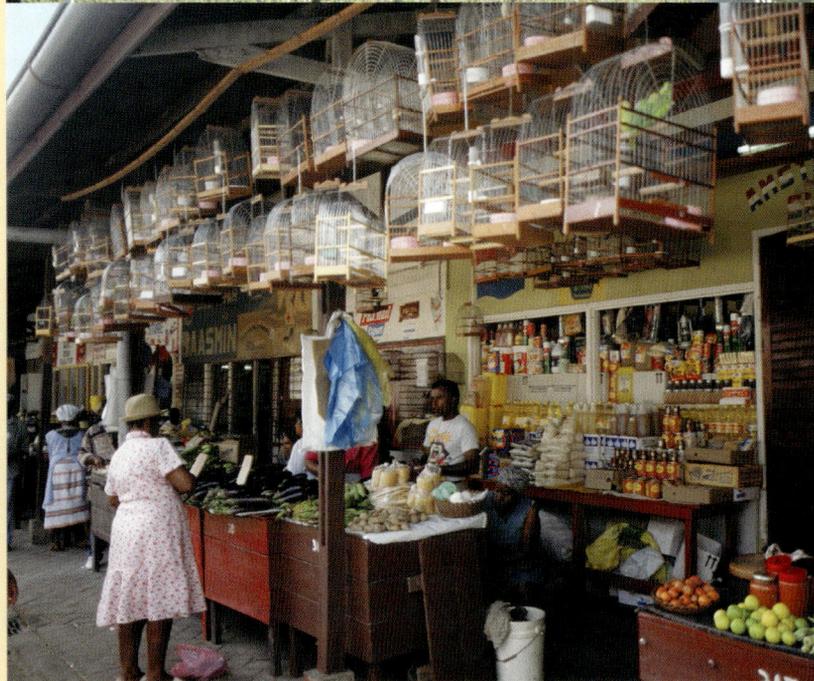

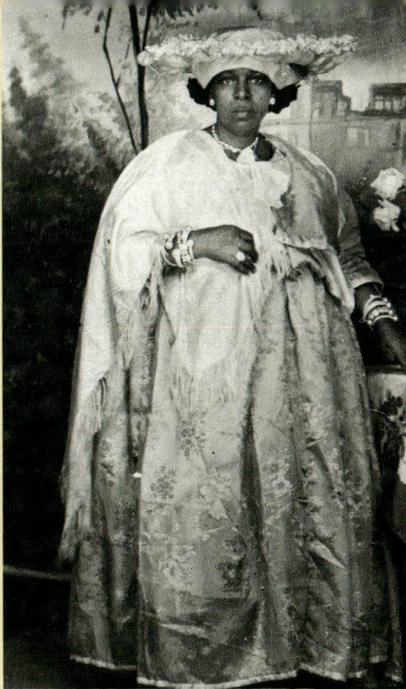

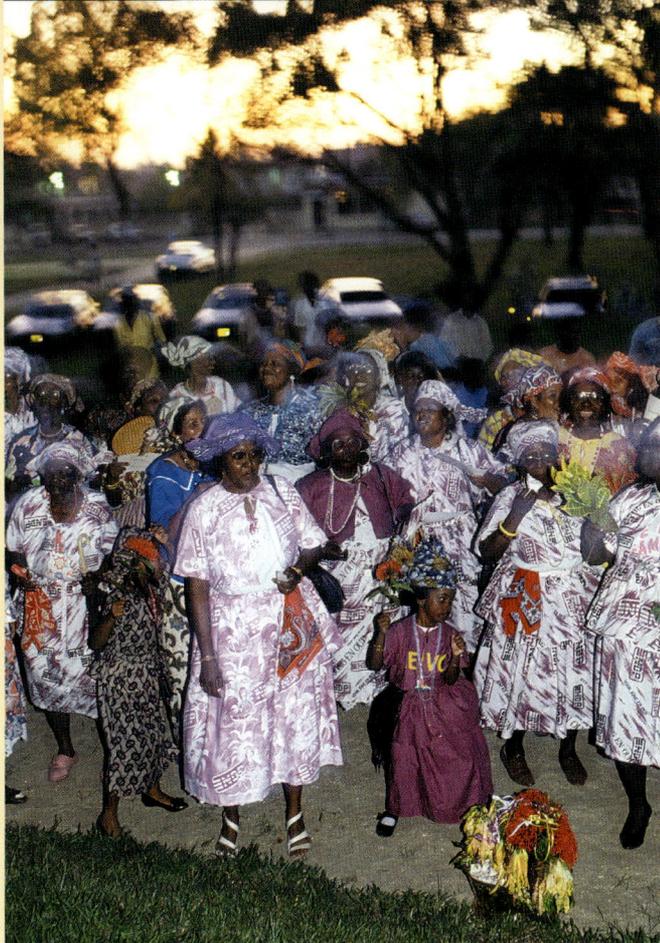

Creoles were appointed to positions of authority and control.

Freed artisan slaves could establish themselves as carpenters, tailors, policemen or clerks. Along with a large group of coloured people they formed a middle-class. Women in this group did not have the same job opportunities and they supported themselves as domestic servants or as market vendors. The freed plantation slaves were left behind and once their smallholdings failed, they tried to gain employment in the cities as labourers.

They developed into a large group of 'city Creoles' with only tenuous ties to the Western way of life in comparison to the other groups. Official marriages are still rare; people usually just live together. A frequent phenomenon is that the women are heads of families with children from more than one father. This kind of situation was fairly common during the time of slavery when official marriages between slaves and coloured people were outlawed and common-law arrangements were the norm.

Rural Creoles found the formality of Christianity less appealing than did the Creole middle class. They freely blend African rituals, dance and *winti* with those of the church.

Although present in all levels of society, Creoles play a significant role in government and a relatively minor role in farming. The diversity, openness and exuberance of the Creole culture are the most striking of Surinam. They are trendsetters in fashion and music.

Woman with skirt

'Kotomisi' translates literally as 'woman with a skirt', and is generally used to describe the characteristic party dress of Creole women. The amount of fabric used to make the dress creates a voluminous effect. Sometimes many dresses are worn over each other. A *jaki* (jacket) is worn over the top. The carefully folded *angisa* (headscarf) is a large piece of fabric that can be tied in various ways to convey all sorts of messages. The designs on the

83

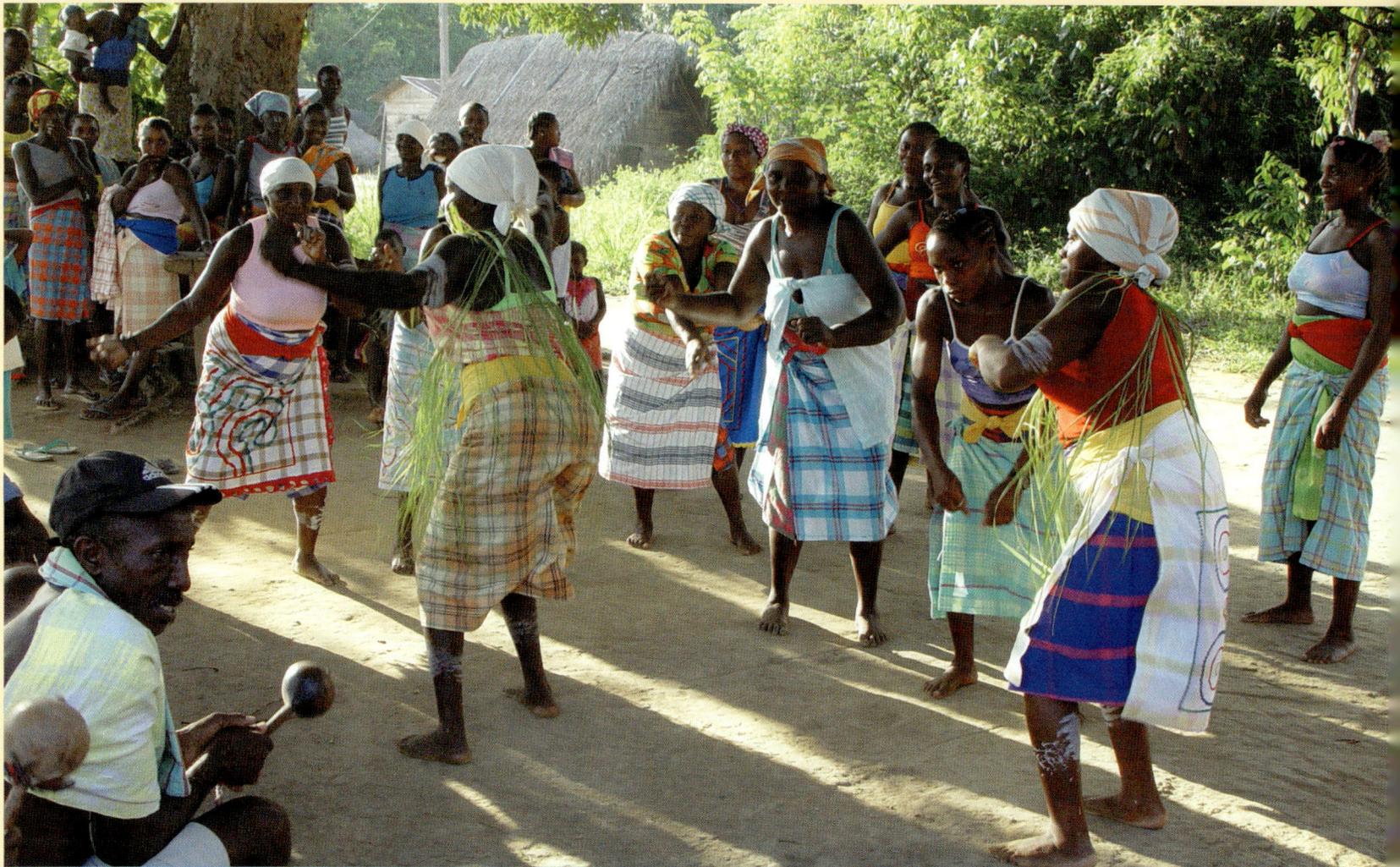

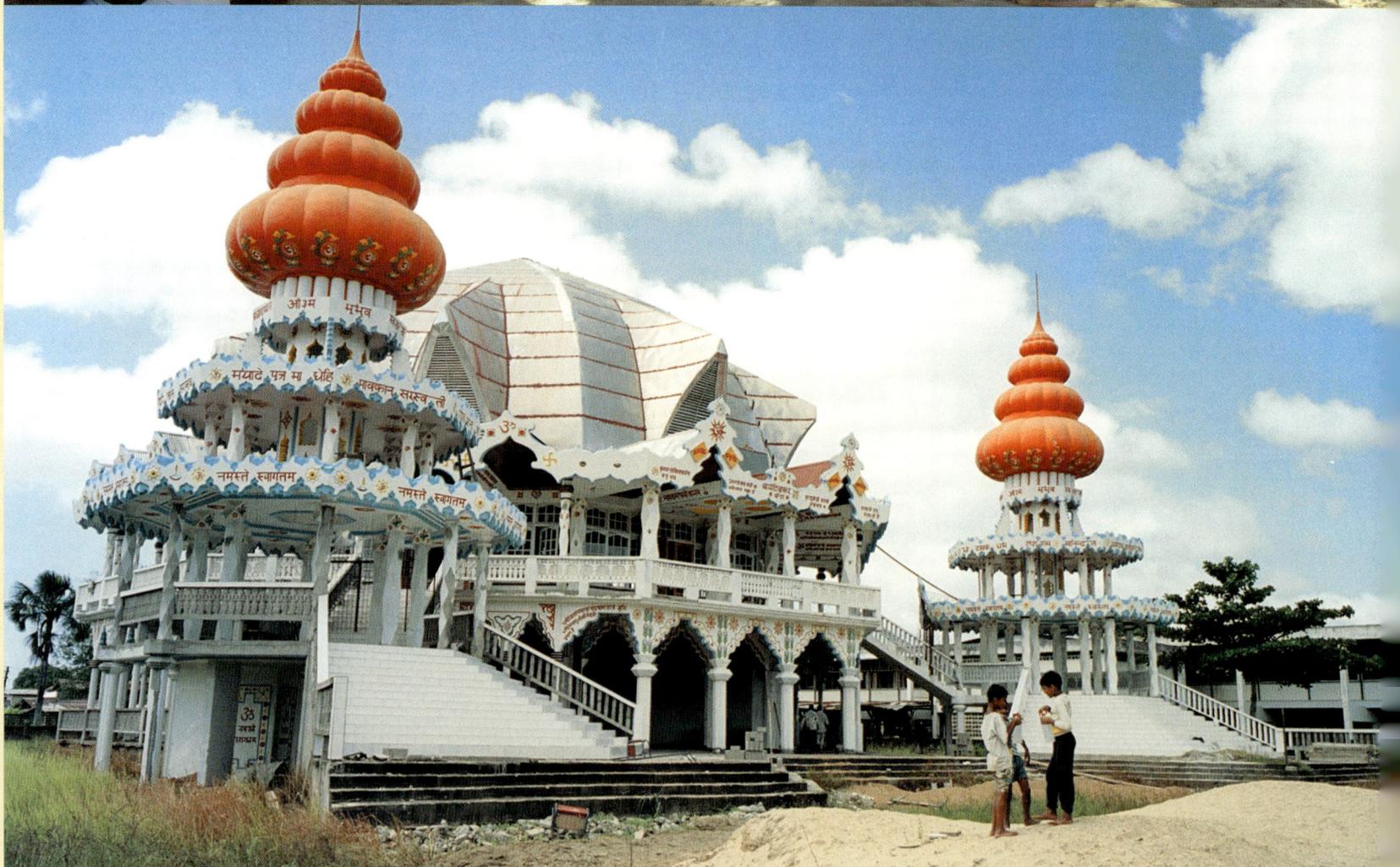

kotomisi are rarely chosen at random and almost always have a meaning.

There are theories that the *kotomisi* evolved as part of the slaves' all-over attire chosen by the white women so as not to lead the white masters astray. This is not true, however. Headscarves have always been popular in West Africa and their use was merely continued in Surinam. The oldest headscarf in Surinam was first used in about 1780. *Kotomisi* should be considered a blend of African and European styles, with additional flourishes by Creole women.

The Hindus

The Hindu population group grew rapidly during the last century and now numbers approximately 140,000 people, about 33 percent of the population. They are largest population group; the Creoles take second place. As the name indicates, the Hindus in Surinam are descended from British-Indian immigrants and practise Hinduism. Nevertheless, about a fifth are Moslem and even less are Christian.

A Dutch agent who had local representatives charged with selecting workers arranged their selection and transportation from India. These representatives received a fixed amount per immigrant. The reasons for leaving India were identical to those on Java later: escape from poverty, family strife caused by the caste system, or the desire for adventure. As there were many more men than women, the premium a recruiter received for a woman was higher than for a man. It is remarkable how many women were actually interested in emigrating. This is partly explained by the oppression they suffered in their own country, especially single mothers or young widows. Most contract workers came from the catchment basin of the Ganges River in North India. They agreed to work on plantations for five years. There was a six-day working week: the gruelling days on the fields lasted seven hours; domestic servants had ten-hour days.

The initial years of the first immigrants were characterised by cultural and social upheaval. Maintaining traditions, lifestyle

85

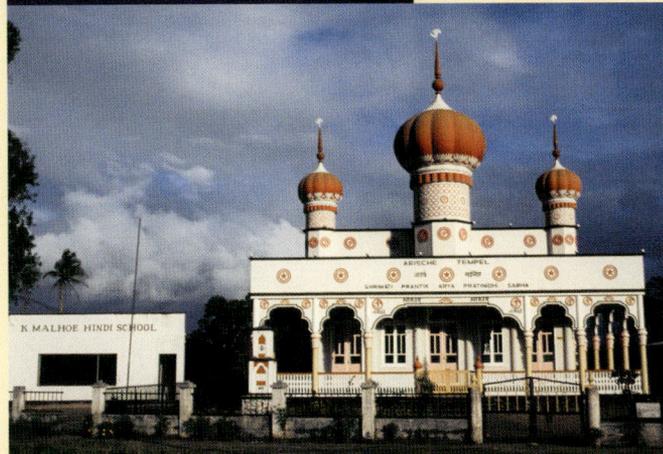

PAGE 84
Pre, a ceremonial dance, in Kayana.
ROY TJIN
Hindu temple.
FRANS SCHELLEKENS
PAGE 85
Hindu temples. A Hindu school can also be seen on the bottom photograph.
FRANS SCHELLEKENS
The 'Grote Boom Markt', a Hindu-owned supermarket.
ROY TJIN

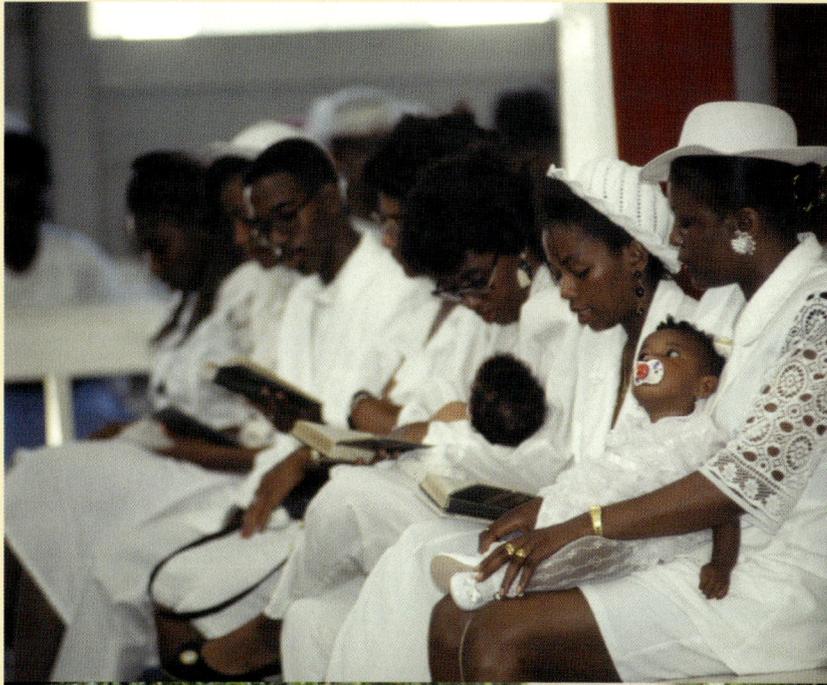

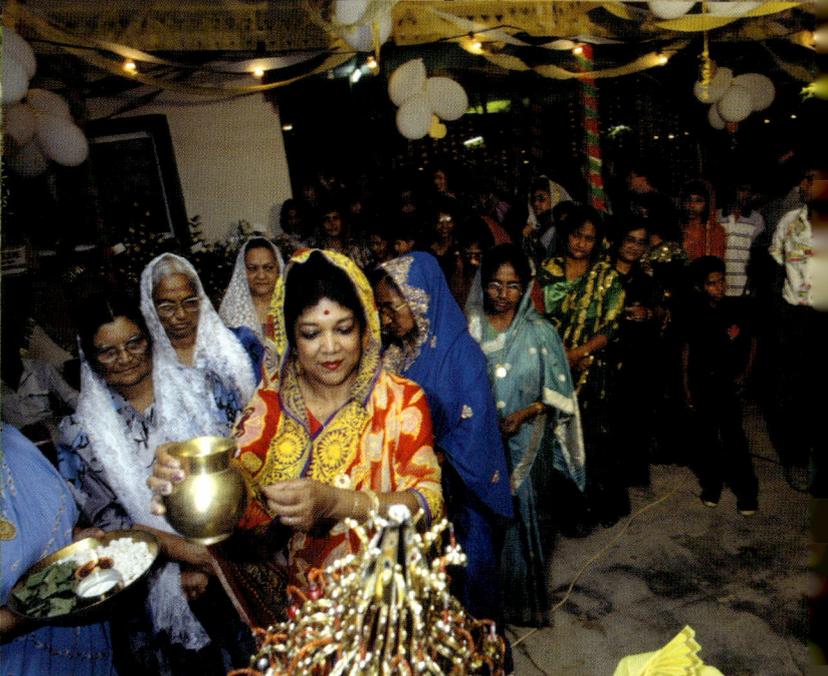
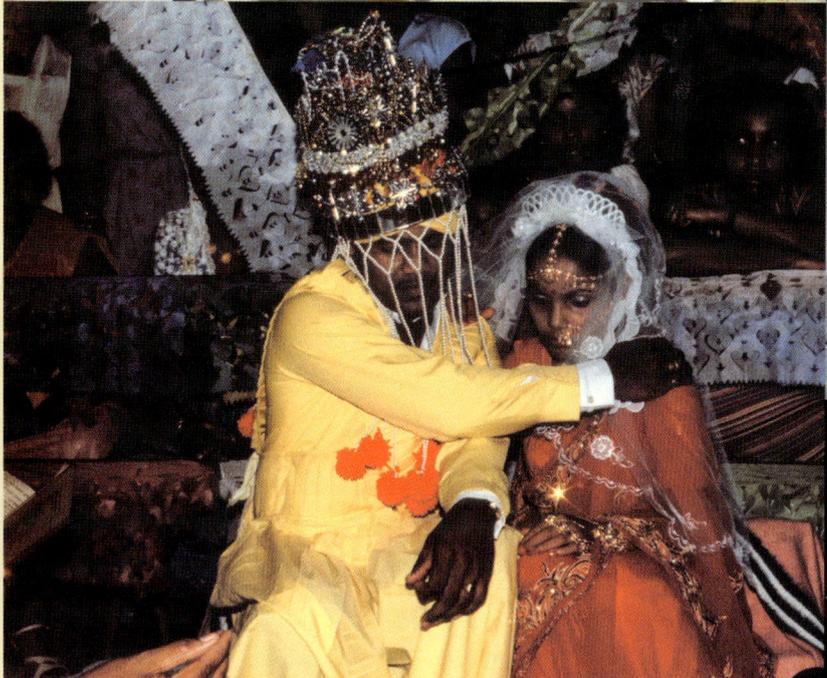

PAGE 86
Christian baptism, Paramaribo.
FRANS SCHELLEKENS
Akilingi Kampu along the Marowijne River.
FRANS SCHELLEKENS
Schoolbound children near Lelydorp.
FRANS SCHELLEKENS
Preparation ceremony at a Hindu wedding.
FRANS SCHELLEKENS
Performing a preparatory marriage ceremony according to Hindu tradition. The groom places his hand on his bride's shoulder indicating that she will be his wife.
KIT
Retirement home in Paramaribo.
FRANS SCHELLEKENS
PAGE 87
Pre-school.
FRANS SCHELLEKENS
A junior school in Klementi, Stoelmans Island.
FRANS SCHELLEKENS
Lands Hospital, Paramaribo.
FRANS SCHELLEKENS
Graveyard, Paramaribo.
FRANS SCHELLEKENS
Creole funeral. Dancing people carry the coffin to the graveyard.
FRANS SCHELLEKENS
Hindustani cremation, Weg naar Zee.
WILLEM KOLVOORT
Indian graveyard, Powaka.
HENK LUTCHMAN

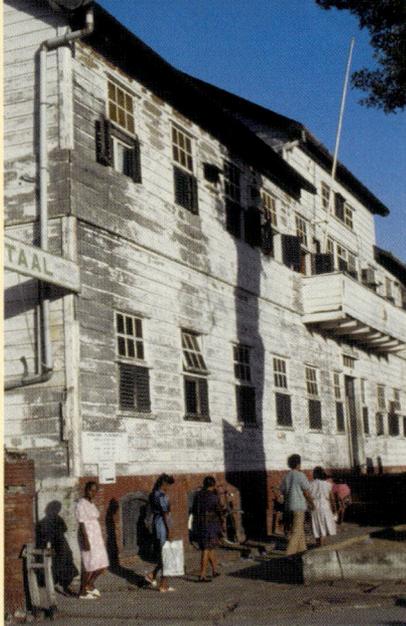

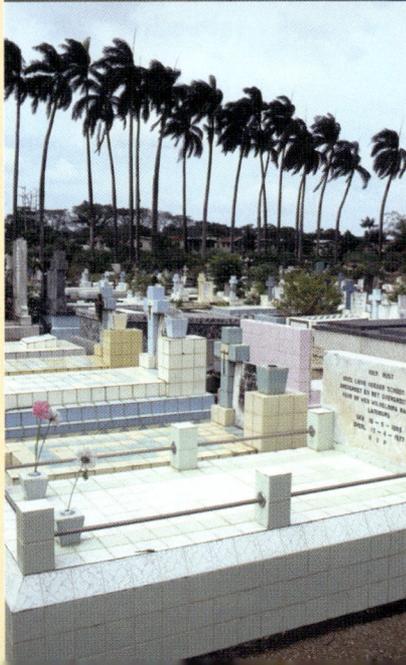

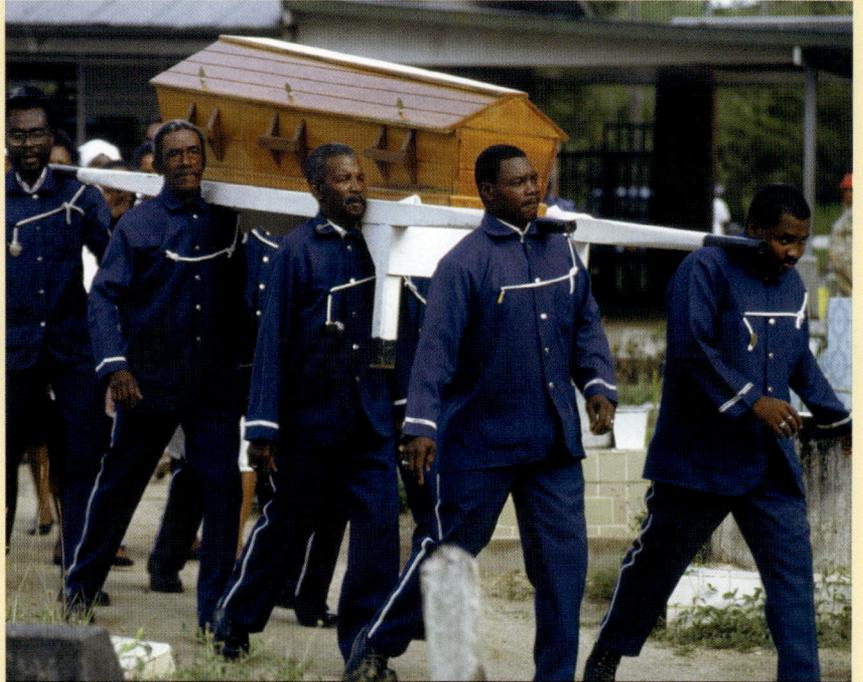

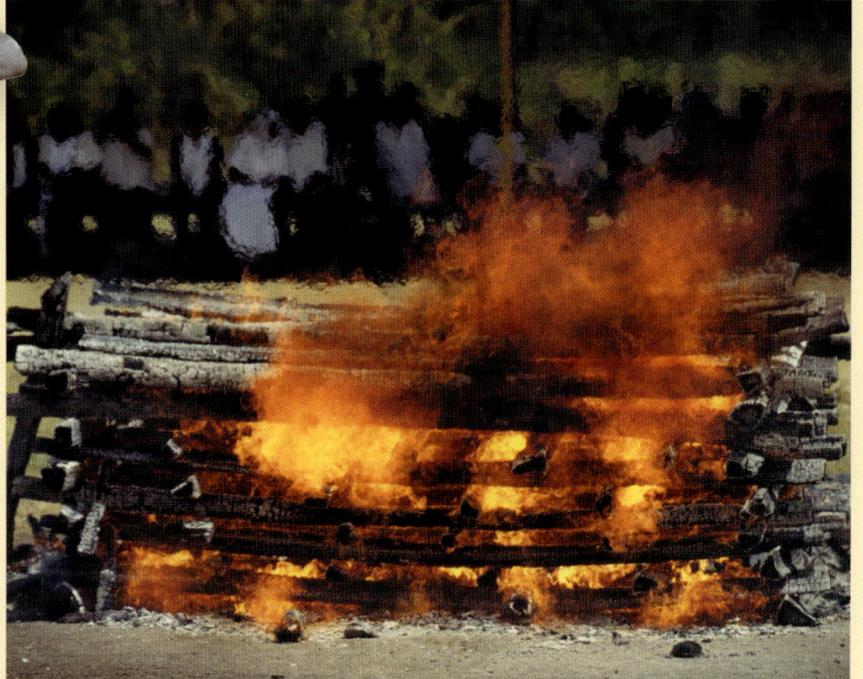

87

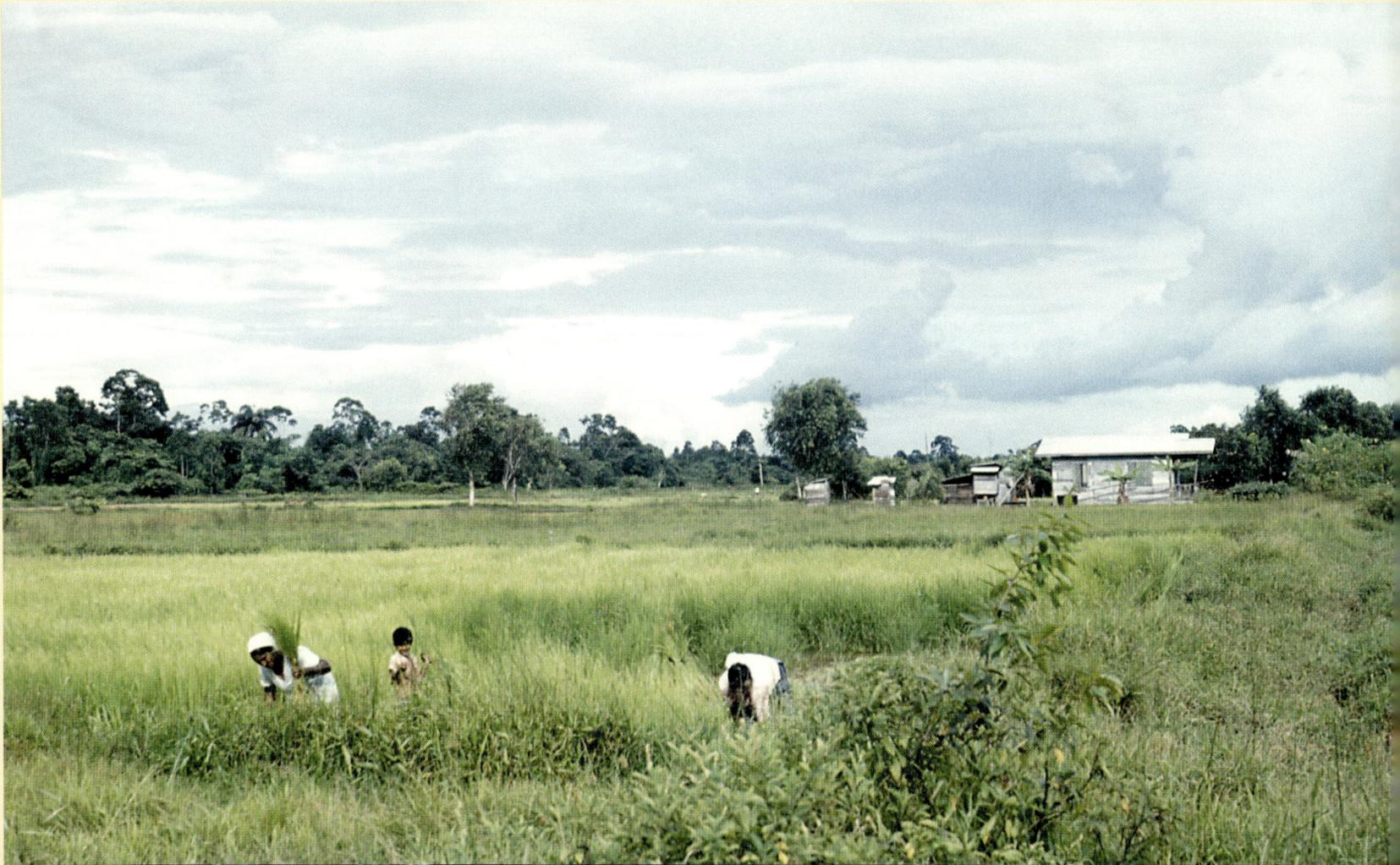

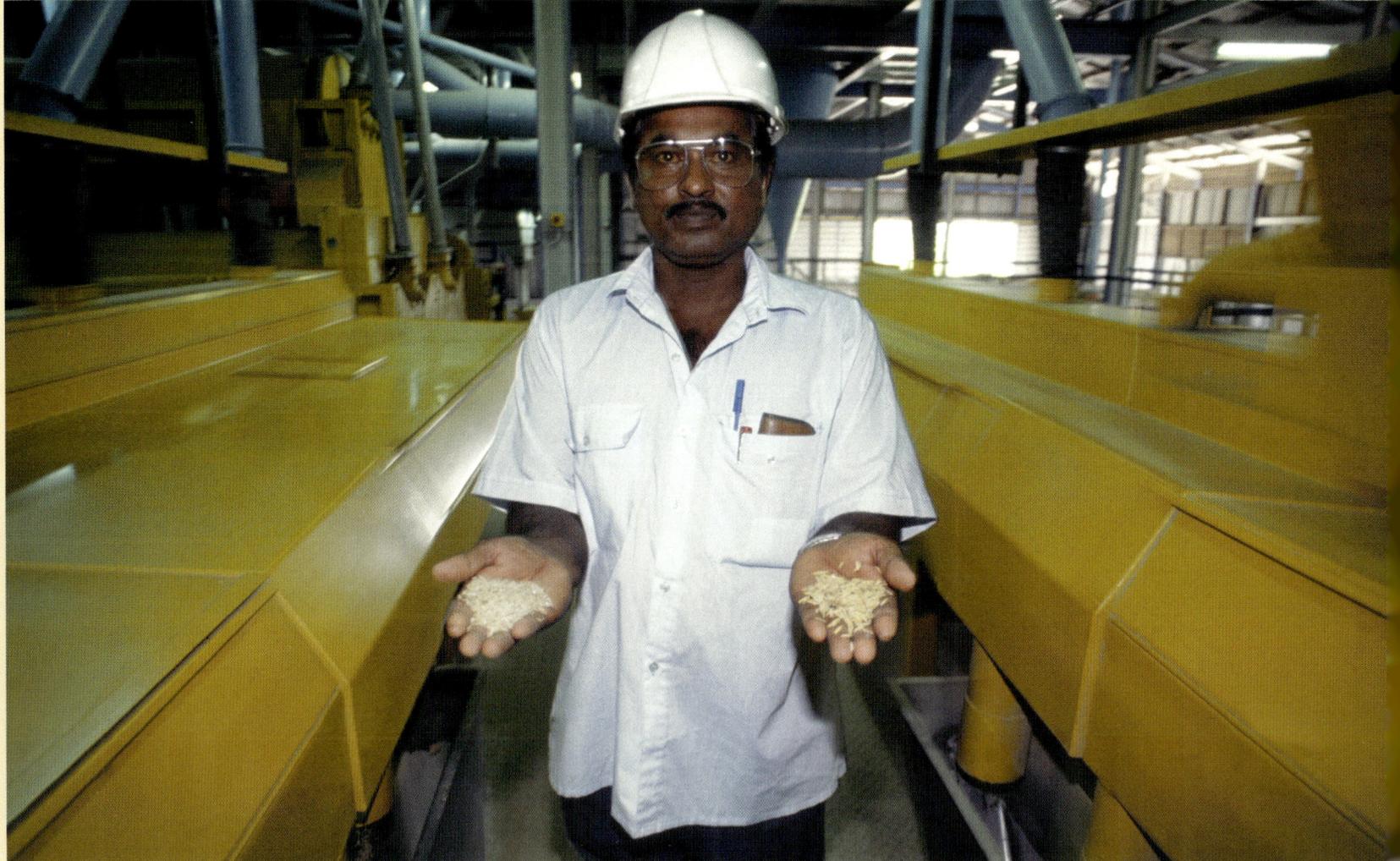

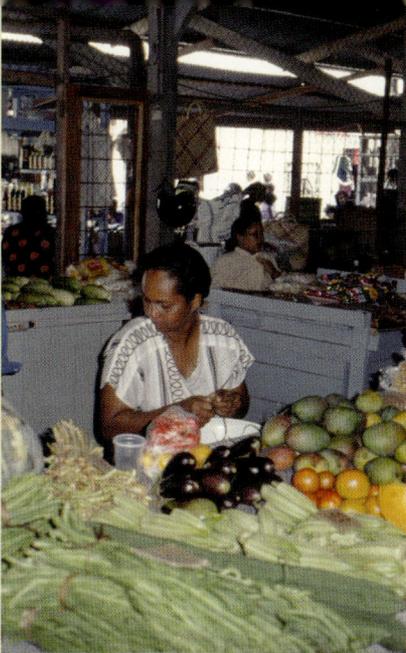

and their language proved difficult under their new circumstances. They managed to adjust and in time traditions were revived, a process helped by the Brahman priests. They could spend their free time as they pleased. Festival days were restored to their former glory and marriages were conducted according to tradition.

Once their contracts ended, they could buy or rent land at favourable prices. Many took advantage of this and only a few returned to India. There were obstacles that prevented them from integrating into the society, however: their culture and language were too different. The Europeans and Creoles displayed little interest in the Hindus, who they considered volunteer successors to the slaves.

The Hindus eagerly seized the opportunity to cultivate land of their own. The last ship with British-Indian contract workers arrived in 1916. The Hindus already living in Surinam regarded this with dismay. There were even attempts at a political level to resume immigration, but the growing nationalism in the British colony prevented more arriving.

The Hindu population started to become more 'Surinamese' during the 20th century. The authorities no longer considered them as immigrants and those born in Surinam were automatically granted Dutch nationality. Children, who earlier had largely been denied a Dutch education despite it being compulsory, now spent more time at 'normal' schools. Asian marriages were also officially recognised. During the Second World War, food prices soared and many Hindu farmers were able to save some money. These reserves were the foundation of their later economic success.

As the other population groups, the Hindus also became more self-aware and the first Hindu political party was established in 1946. After the war, they were able to expand their farms and rice fields. Increasing prosperity meant that many could also set themselves up in other businesses such as trade and transportation. The latter remains predominately a Hindu enterprise.

Their language underwent some interesting changes. In

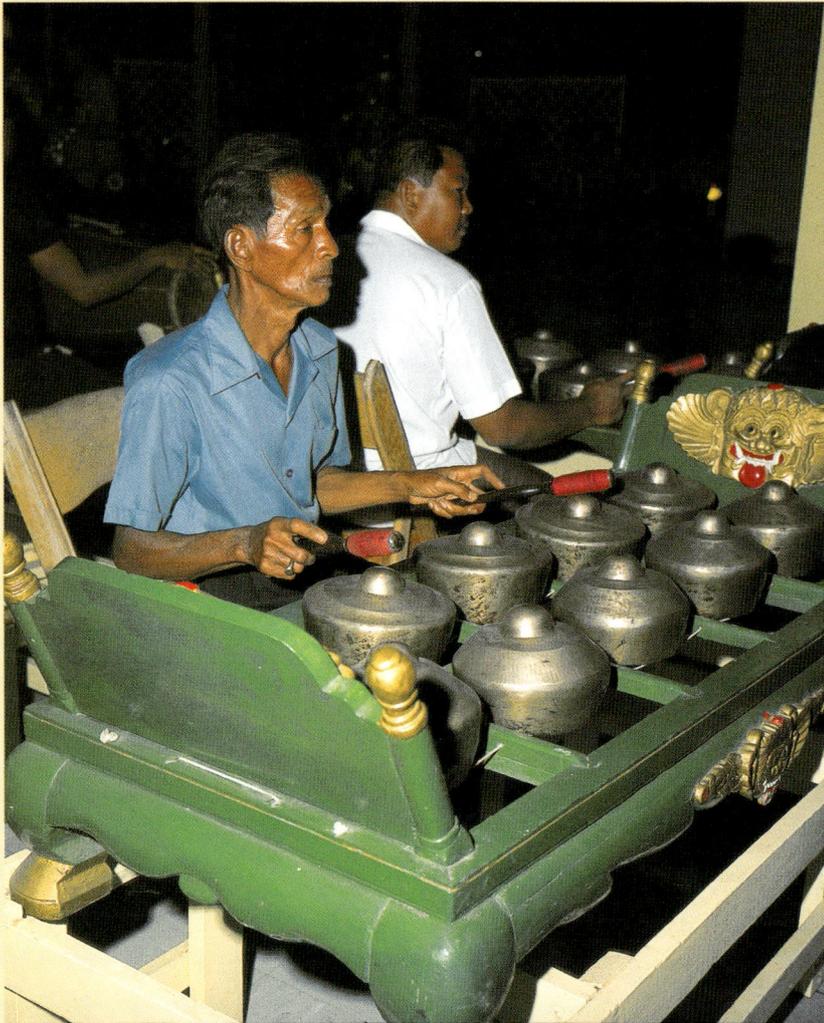

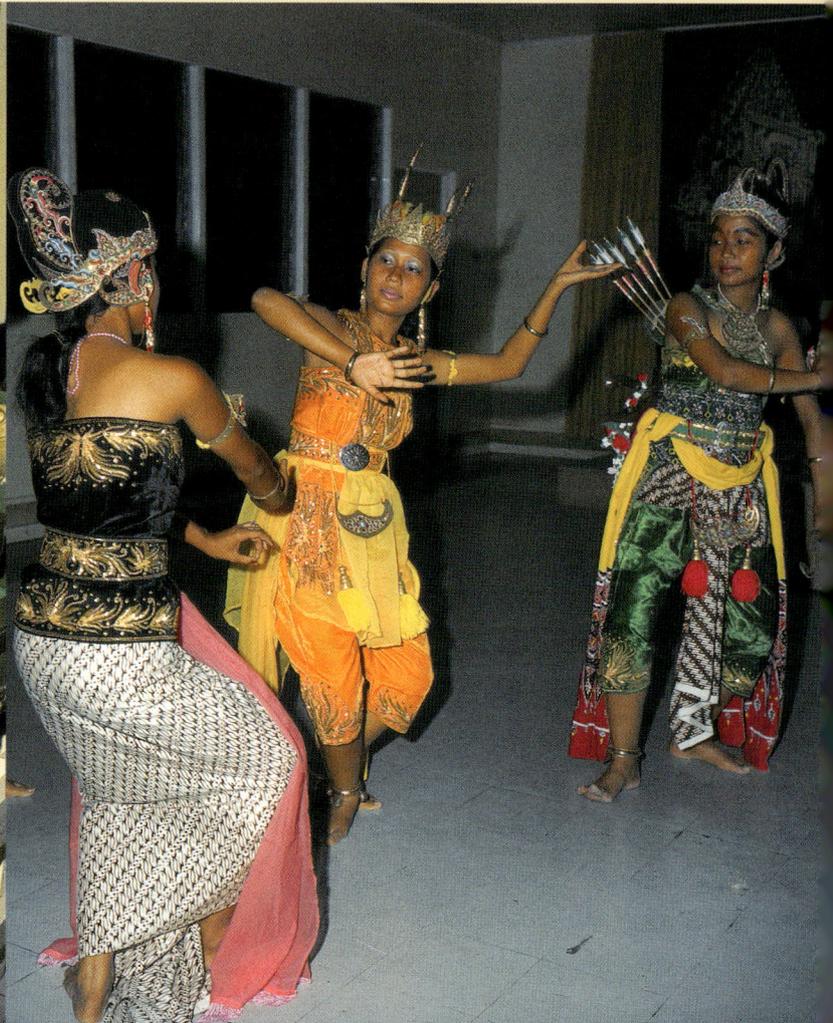

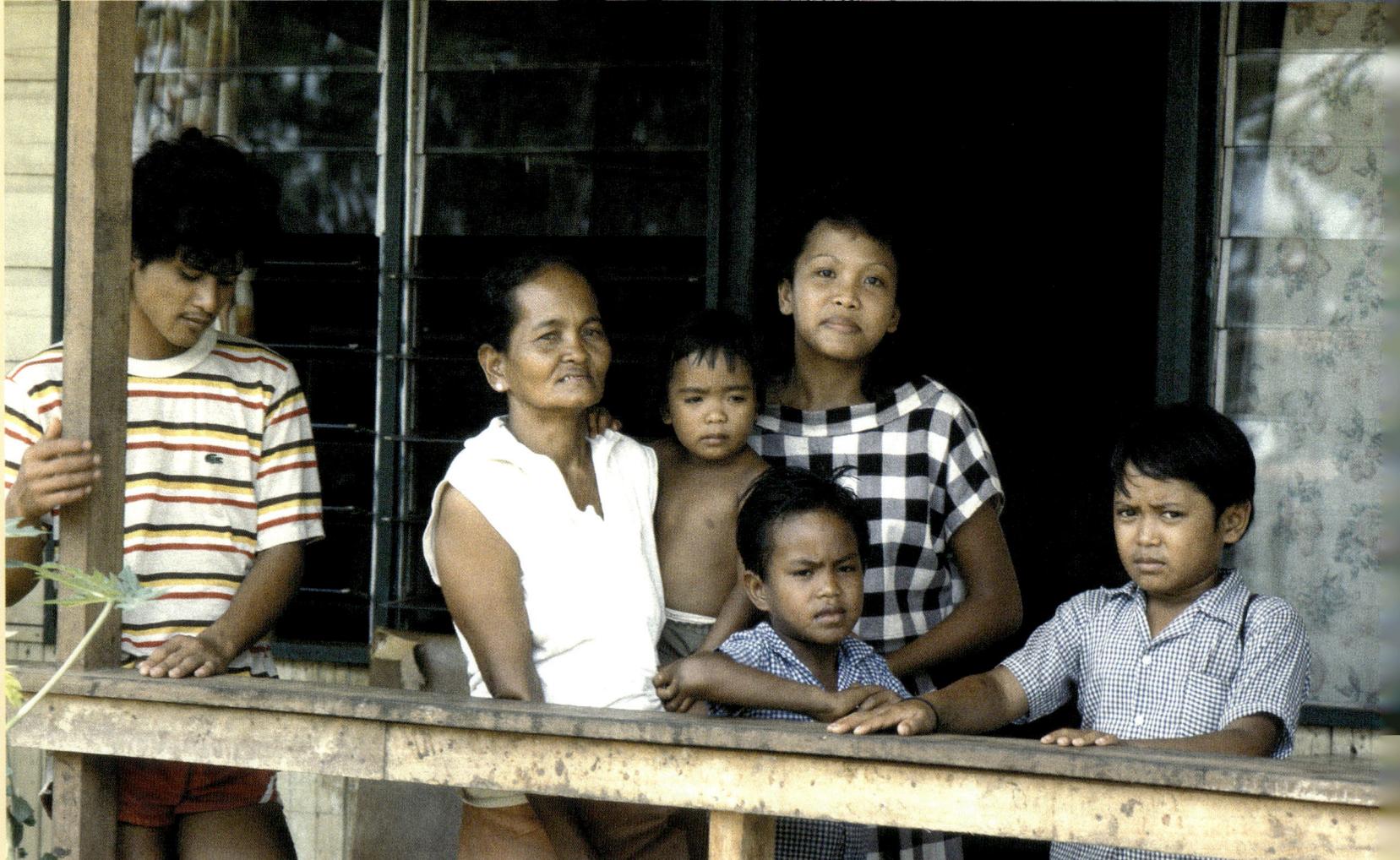

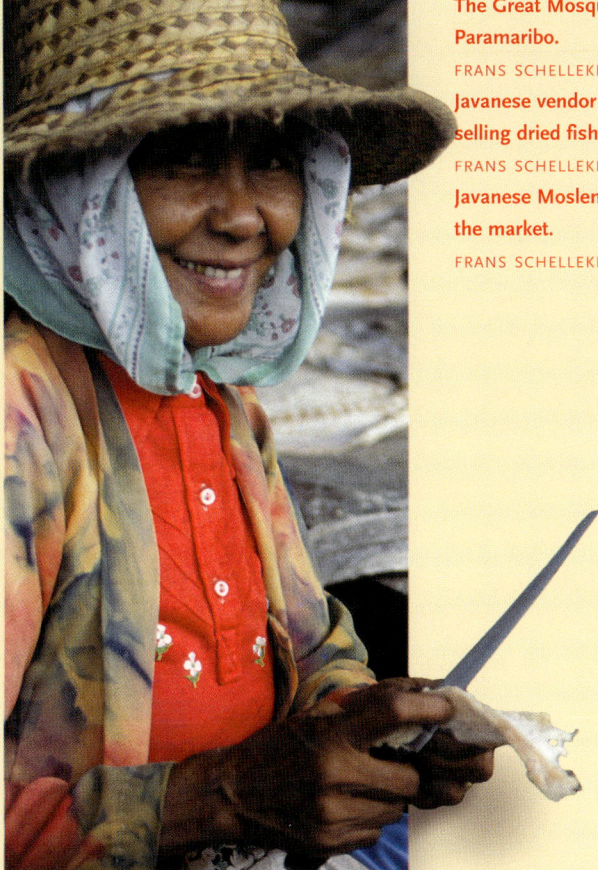

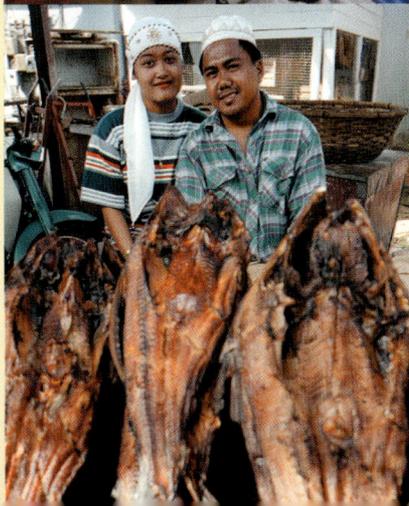

addition to their regional language, most also spoke Hindustani, the common language of India. A hybrid form of Surinamese (Sranantongo) also developed, 'Sarnami Hindustani'. Some, especially the young, also spoke Dutch, but this depended on their education. Hindustani was still used at certain ceremonies and on the radio.

There are two main belief systems: the conservative Sanatan Dharm and the Arya Samaj, which is based on 19th-century reforms. The caste system did not survive, but signs are still evident in marriages, for example. The traditional Hindu wedding ceremony was officially recognised in 1940. Although they no longer live in traditional Indian communities, their family ties remain strong.

91

The Javanese

Javanese contract workers started immigrating at the end of the 19th century and numbers increased dramatically during the last century. They proved to be less suited to plantation work than the Hindus and there are clear reasons for this. The physical examinations during the selection process on Java were not conducted properly: many workers arrived ill and unsuited to demanding physical work. Moreover, the selection concentrated on young people and there were not enough young women, a source of great frustration that often ended in violence. Naturally, this had a deleterious effect on the way they worked.

Problems were also caused by the lack of any family structure and traditional parental authority. The Javanese also gained a bad reputation from their alcohol abuse, rivalry between different groups and sexual disease. The Creoles, who had acquired better social status, looked on the Javanese with disdain, as they did the Hindus, despite their relatively disciplined way of life. The language barrier was another obstacle, and the Javanese trailed even further behind because of their lack of education.

Many Javanese were disappointed by their move to Surinam, and none of the good life they had been promised materialised.

They were poorly paid and the frequent wage reductions were a constant cause of friction. After the massive closure of plantations during the crisis years, many Javanese started cultivating their own plots, which were often part of the old plantations. Later, bauxite mining offered some hope, and employment was on the rise in the cities.

Nowadays, Javanese work in almost all sectors and have managed to retain a respectable share of smallholdings and rice cultivation. Disappointing harvests are frequently supplemented by selling fish, poultry, fruit or spices.

Most of the Javanese are followers Islam, which also developed into two schools. The *abangan*, the largest group, are considered by theologians as pre-Islamic as their religion is primarily based on old Javanese rituals, the spirit world and ancestor worship and not on praying five times a day. During prayers they face westwards (as they did in Java), which has earned them the name 'westbidders' ('bid' is 'to pray' in Dutch).

In contrast to this somewhat loose interpretation of Islam, the *santri* or 'oostbidders' do face the 'right' direction while praying. They practise Isalm by the book and are concerned about the liberal lifestyle of the *abangan*. While there has been considerable animosity between these two groups in the past, they now co-exist peacefully.

Slametan, a sacrificial feast for men, is one of the most important Javanese customs, as is the ritual dance festival called *tajub*. The youth have little interest in old Javanese traditions. Though Javanese is still spoken, it continues to be replaced by Sranan and Dutch, and the youth turn increasingly more to Creole culture for fashion and music.

The desire to live in close-knit communities is still strong among the Javanese. Javanese villages outside the city are highly redolent of the Indonesian *kampong*, or compound. A small piece of Java can be found in Paramaribo, the Blauwgrond neighbourhood. Besides numerous small mosques, there are also many tiny restaurants, which attract weekend visitors from other neighbourhoods.

The Chinese

The first Chinese contract workers arrived in Surinam before slavery was abolished. It is noteworthy that only very few stayed on the plantations or settled down as farmers once their contracts had expired. Many set up shops or became traders and it was not long before Chinese ran most of the small grocery stores. Most Chinese immigrants, however, were not contract

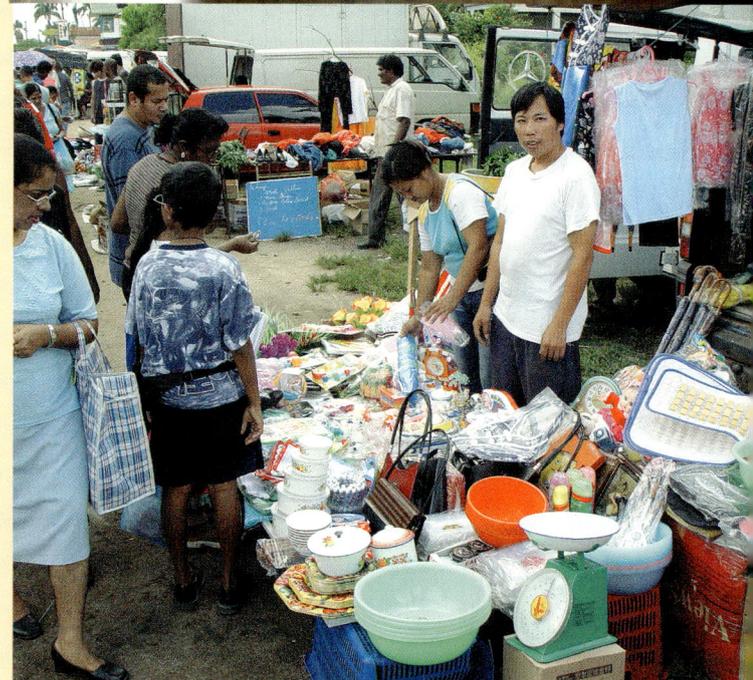

workers, but family members who came to Surinam of their own accord to create a life for themselves. They still do this today. Their natural flair for business, simple lifestyle and family networks ensured that they soon joined the most economically successful group.

At first, most Chinese lived in Paramaribo, but when the equally astute Hindus became too competitive, they started to move to the districts. Those who could, sent their children to study in China, but this stopped after the communists seized power. Not many returned to China to live out their old age. Chinese born in China are a tightly-knit group that perpetuate its own culture and rarely speaks any language but their own. They distinguish themselves in many ways from second- and third-generation Chinese and the many who have married or have relationships with Creole or Javanese women.

Chinese born in Surinam are often baptised, attend Catholic schools and barely speak their own language, all signs that maintaining their own identity is unimportant. Some Chinese associations have tried to generate interest in Chinese culture and history. Education is paramount and many Chinese are intellectuals or work in medicine.

The Jews

Jews in Spain and Portugal were forced to flee abroad with the onset of the Inquisition. They moved to more tolerant countries such as Italy, Holland and England. Some moved to Surinam and its environs and established themselves as plantation owners. Once there was no more land in Jamaica and Barnados, Jewish-English plantation owners moved to Surinam, still an English colony and with land aplenty.

Portuguese Jews formed another group who had fled to the Dutch territory of Brazil. After Portugal overran Brazil, they moved to French Guyana, which was in the hands of the tolerant Dutch. They soon followed the Dutch to the new colony Surinam where they established the settlement, Jodensavanne ('Jew's

Savannah'). The ruins of the stone synagogue they built can still be seen today. Polish and Russian Jews settled in Surinam later; these High-German Jews upheld their religious traditions. In time, they left the Jodensavanne and moved to Paramaribo.

The Jews in the second half of the 18th century were victims of anti-Semitism driven by envy of their prosperity. They later gained the same rights as the white colonists.

Jewish culture and religion is now marginalised as most Jews have integrated into Surinamese society. Their names are the only reminders of their Jewish heritage. High-German and Portuguese-oriented religious movements still exist, but now worship together.

The 'Boeroes'

Led by a preacher and supported by King Willem II, a party of Dutch farmers moved to Surinam and settled in the neighbourhood of Groningen. Minimal preparations had been made for their arrival: there was not enough drinking water, proper housing or tools. The experiment ended in 1853 because of major setbacks. About 250 of the 400 colonists had succumbed to an epidemic and other illnesses.

Only a handful of these unfortunate Dutch colonists stayed in Surinam, where they were known by the locals as 'boeroes' (farmers). Authorities in the immediate vicinity of Paramaribo came to their aid by asking them to supply food for the city, but they could not compete with the Hindu farmers. As Paramaribo expanded, the farmers sold their land in small lots for good prices. Their descendants had no inclination to farm, preferring city life instead.

The Lebanese

A small group of Lebanese from French Guyana moved to Paramaribo at the end of the 19th century. Relatives and friends from Bazhoun, a village close to Tripoli, joined them later. Some moved to other islands in the Caribbean. They were part of the Christian minority and were welcomed into the Catholic Church without any problems.

They started trading in textiles immediately and the solidarity within their community led to them creating successful enterprises. They only numbered 400, but despite being such a small group, they made their presence known by their many shops and trade. They have no 'own' culture to speak of and more than half the marriages are mixed.

PAGE 94/95
The late Mrs Brohim
(of Lebanese descent)
in her textile shop.
ROY TJIN

The interior of
Paramaribo cathedral
is made entirely of
wood.
ROY TJIN

95

MISSIONS

Protestant missionaries

Besides those immigrants who moved for economic reasons, there
were a few who went for ideological reasons: the missionaries. The
first missionaries were members of the Evangelic Brotherhood,
better known as 'Hernhutters'. This originally German Protestant
religious community established a branch in Zeist in 1745.

The German missionaries undertook their first expedition
inland in 1735. They had been denied permission to proselytise
among the slaves by the colonists, so turned their attention to the
Indians instead. The first missionary post was built on the bank of
the Saramacca River, but was destroyed by a group of Maroons
who were feuding with the local Indians. The missionaries could
only start their work once certain groups of Maroons had made
peace with the colonists. The results were disappointing.

The Hernhutters did not anticipate much co-operation from
the colonists. The plantation owners were worried that
converting the slaves to Christianity would make them too
independent. While the Hernhutters were not opposed to slavery
in principle, the colonists' fears were not unfounded. The
missionaries introduced the slaves to writing and their language,
'Nigger English', was accepted and used by the Hernhutters. The
brothers preached and wrote in Sranan.

When it became clear that slavery was coming to an end
during the 19th century, farmers started allowing their slaves to
be baptised. The Evangelic Brotherhood rapidly grew into a large
and influential religious community. It later became compulsory
for farmers to give the missionaries free rein. Almost three-
quarters of the slaves were members of the Brotherhood by the
time slavery was abolished. The slaves and other coloured people
might have given Christianity a rightful place, but they usually
combined it with their own traditional ideas of a higher power.

Though the Dutch increasingly replaced German missionaries,
the German influence is still evident in place names.

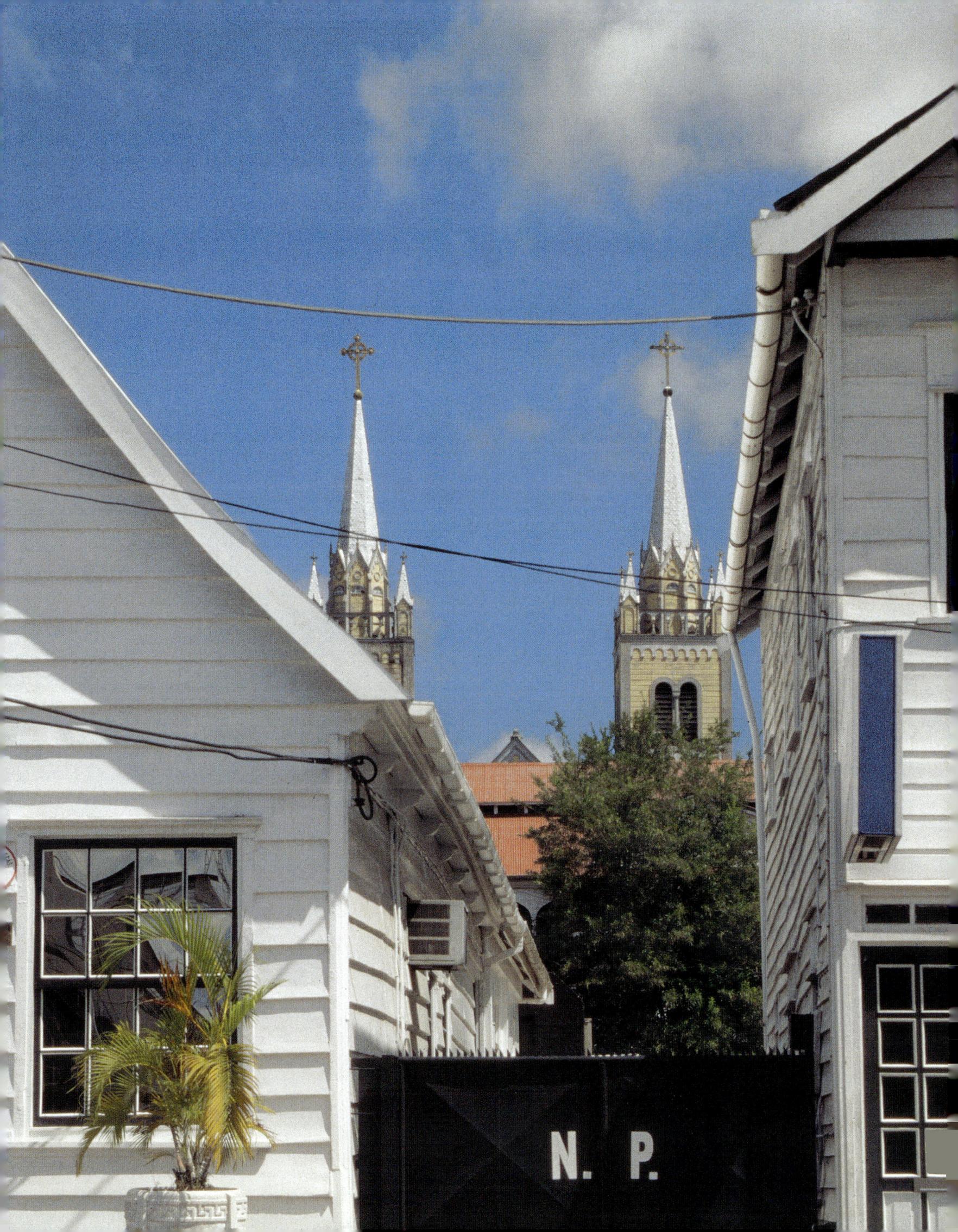

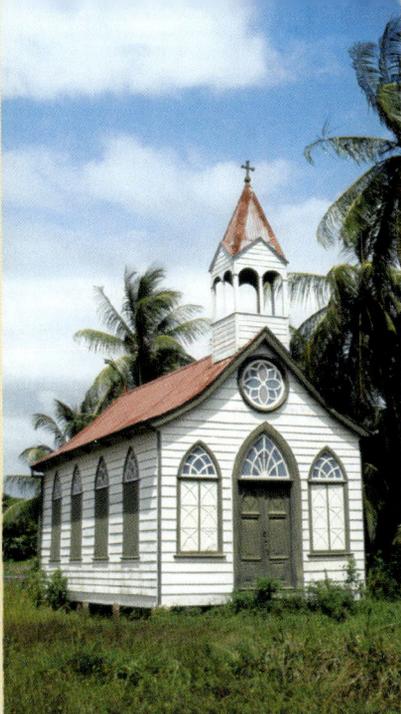

PAGE 96
View of the cathedral steeples.
TOON FEY
PAGE 97
Evangelic churches.
KARIN ANEMA
TOON FEY
FRANS SCHELLEKENS

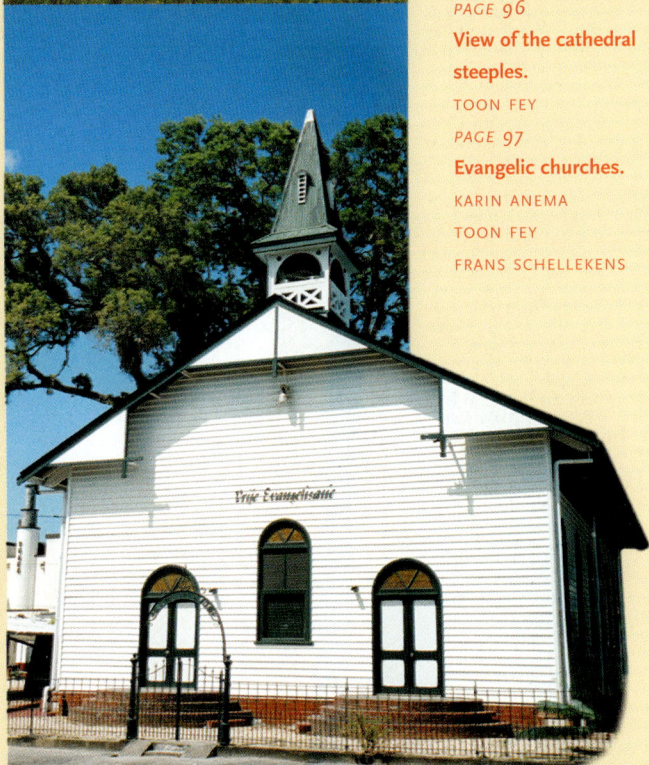

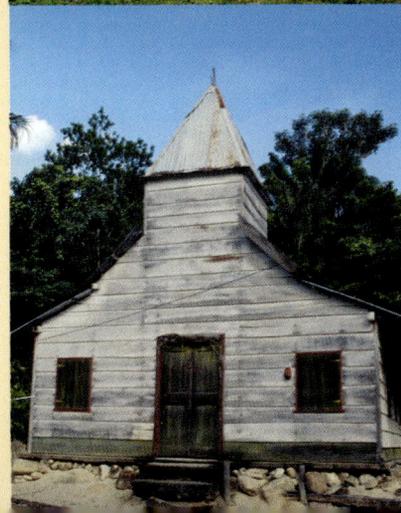

American missionaries are now active on the island, especially in the interior.

Catholic missions

The influence of the Catholic Church in Surinam only became evident later. The first priests targeted the colonists, without much success. The predominately Protestant authorities were uncooperative and tropical diseases took their toll. The turnover of priests was high and only a few were active in Surinam until the mid-19th century.

97

A number of effective measures improved this state of affairs. Nuns were sent to Surinam to educate the girls, something forbidden to priests. The church started sending friars in addition to priests to compensate for the shortage of people. The friars taught the boys and took care of practicalities such as building schools and houses.

This pragmatic approach led to the establishment of a leper colony in Batavia: lepers were banned from public life. The leper colony is inseparable from the work of the missionary 'Peerke' Donders, who worked here with impressive zeal until his death, despite there being no cure for this contagious and often deadly disease. The church beatified him in 1982.

That the Catholic Church had less influence in Surinam has nothing to do with the religion itself, because it was quite popular. It had to do its best in the face of adversity. The Protestant church had already baptised many (free) slaves and Creoles, and the contract workers brought their own religions with them.

Christian congregations mainly comprise Creoles, who have deep convictions. The Mormons, Jehovah's Witnesses, Pentecostal Church and a number of other small religions also have relatively large congregations.

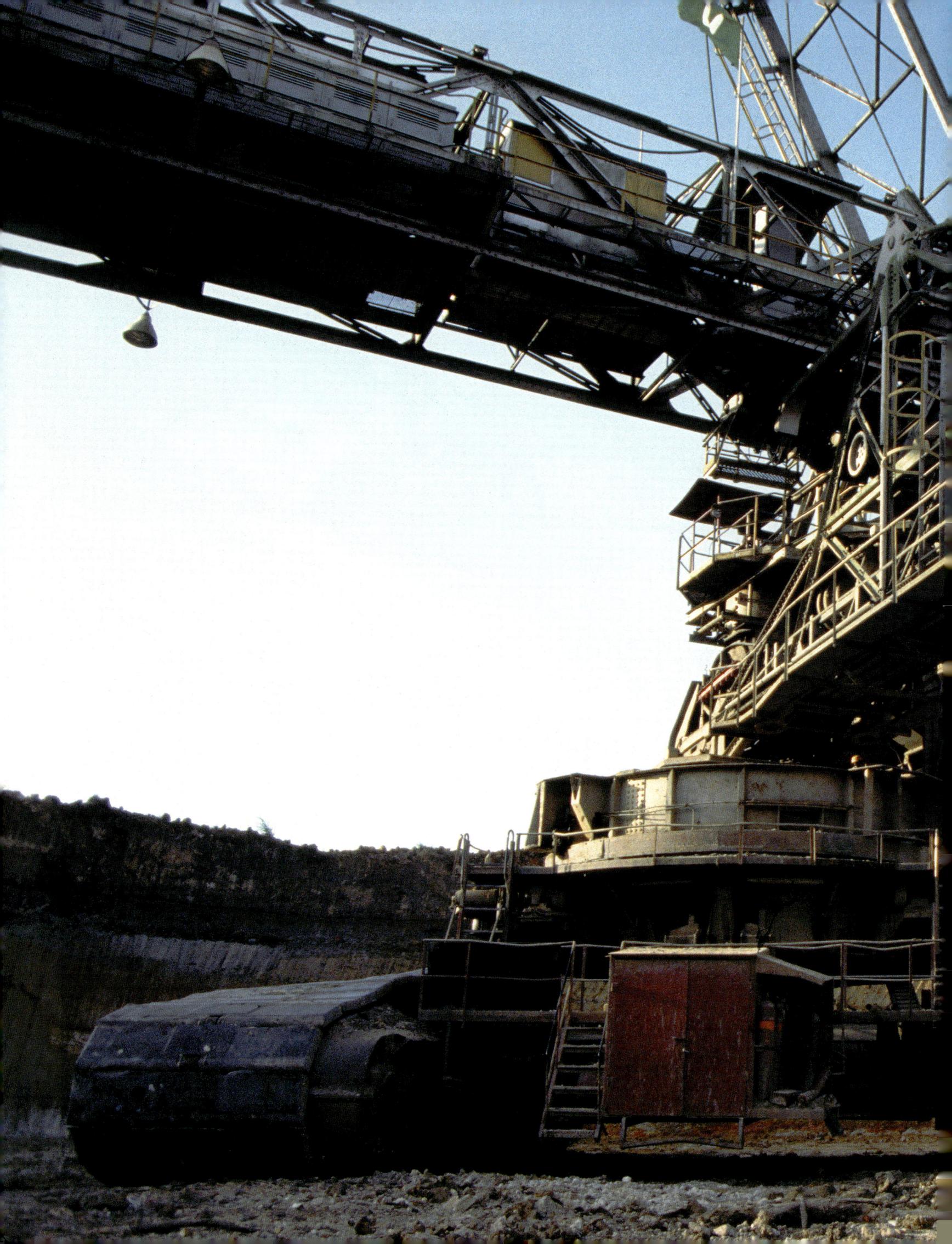

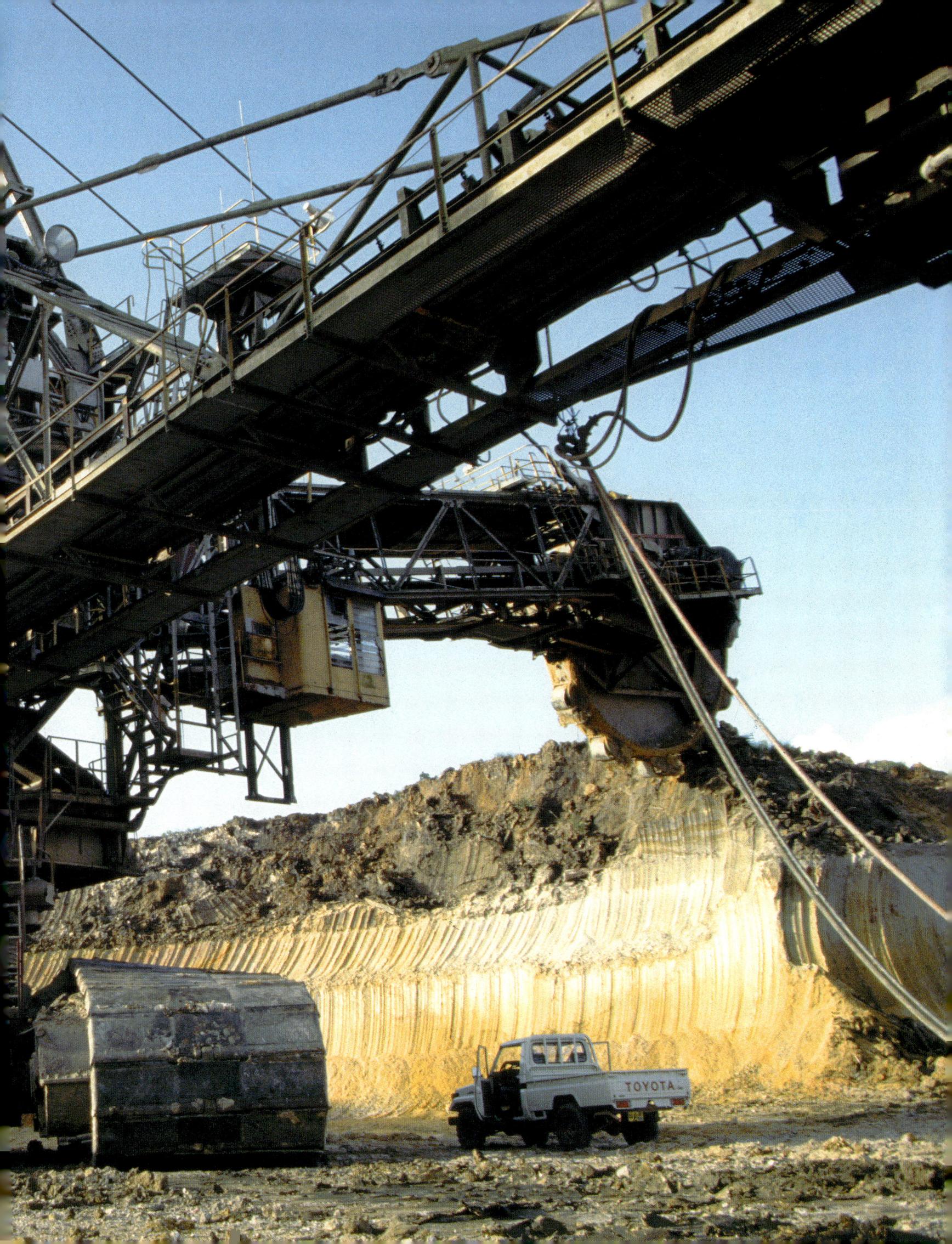

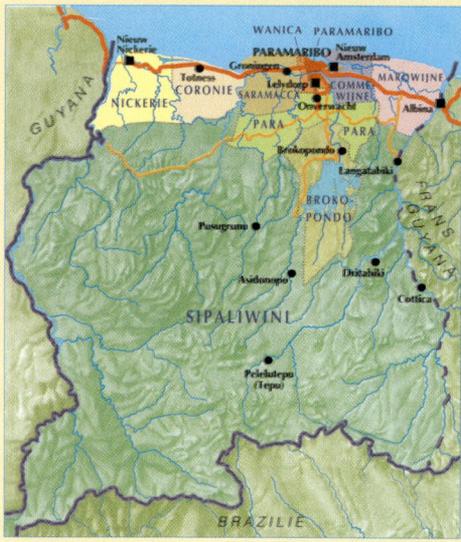

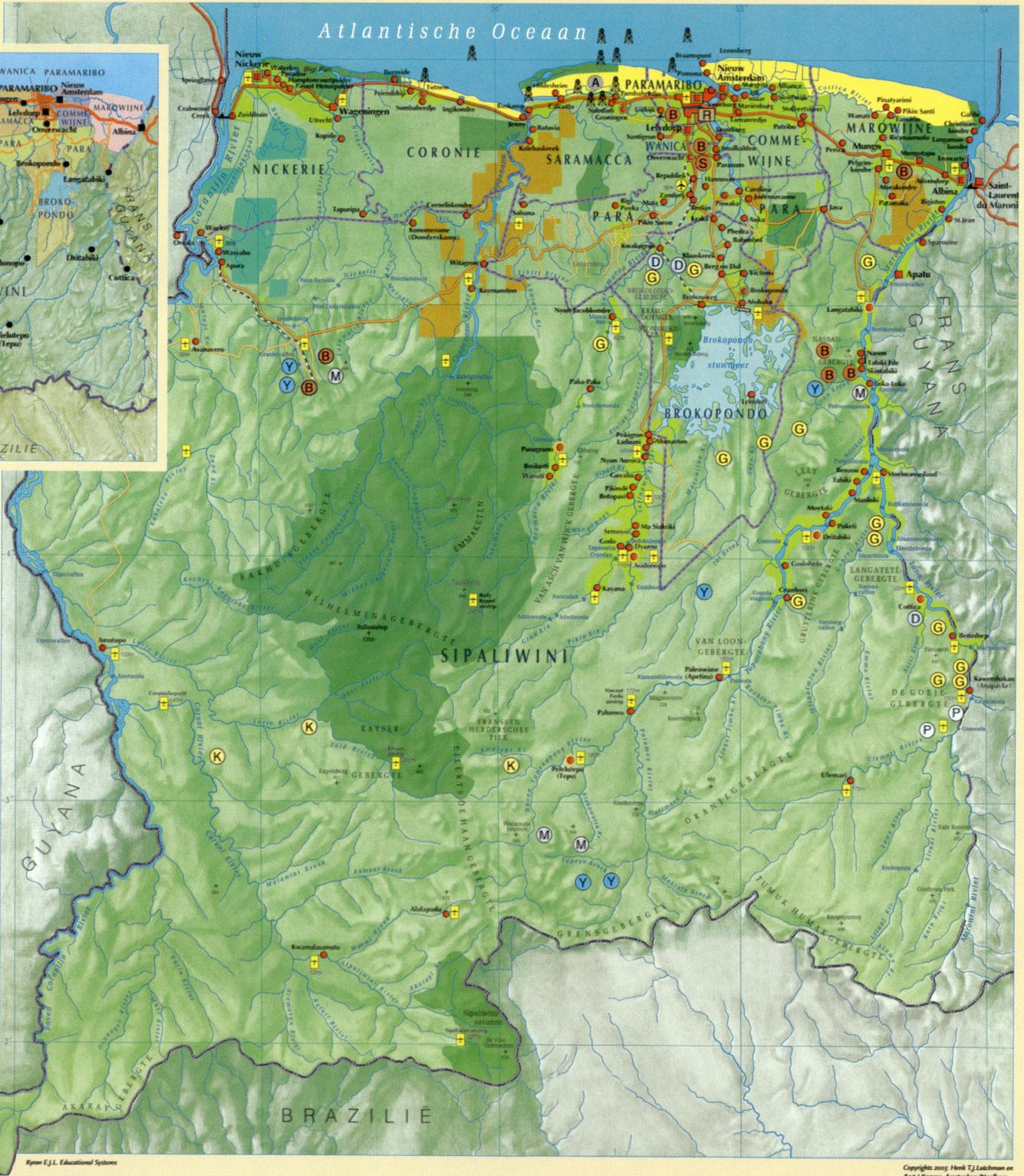

Atlantische Oceaan

Legenda

Milieu/Economie

- beschermd gebied
- voorgesteld beschermd gebied
- voorgesteld bijzonder beheersgebied
- landbouw
- bosbouw
- visserij

Delfstoffen

- aardolievoorkomens
- R raffinaderij
- A aardoliewinning
- B bauxietwinning/voorkomens
- S bauxietverwerking
- G goudwinning/voorkomens
- D diamantvoorkomens
- K kopervoorkomens
- P platinavoorkomens
- M mangaanvoorkomens
- Y ijzertsvoorkomens

Topografie

- staatsgrens
- districtsgrens
- primaire weg
- secundaire weg
- overige wegen
- spoorlijn
- zeewering
- rivier
- veerverbinding
- waterval of stroomversnelling/stuwdam
- internationaal vliegveld
- lokaal vliegveld/landingsstrip, met hoogte in meters
- hoogtepunt in meters
- districtshoofdplaats
- zetel lokaal bestuur
- bebouwing
- stad/dorp

GUYANA

FRANS GUYANA

BRAZILIË

SIPALIWINI

NICKERIE

CORONIE

SARAMACCA

PARA

BROKOPONDO

COMMEWIJNE

MAROWIJNE

WANICA

PARAMARIBO

Drs. Henk T.J. Lutchman
Geografie en Geomorfologie

Mar Sordam:
Saramtongo toponiemen

Aart J. Karssen:
Cartografie

Kpron E.J.L. Educational Systems

THE *riches* OF SURINAM

Economists share the view that Surinam is a potentially wealthy country. A sound economic base is provided by the climate, the soil fertility and by the presence of minerals such as bauxite, oil and gold. There are several reasons why the economy is in such a poor state, however.

Neither the military nor the incompetent 'civilian government' were capable of running a decent administration; moreover, the promised foreign aid was suspended after the savage military coup. The administration under the newly elected government sent foreign debts spiralling. The current government, now in its second term, cannot be accused of reckless politics, but is facing some difficult decisions.

There is a general consensus on the reforms that are needed. The loss to foreign countries of revenue from gold mining and forestry is evident. The excessive bureaucracy puts too much pressure on the budget. The membership of Caricom, a trade union of fourteen Caribbean countries, holds promise. This membership does have a downside, however, because of the lifting of trade barriers.

Contributions from relatives in The Netherlands and local creativity make life more bearable than would normally be expected under such circumstances. The future still seems quite promising: the natural wealth and visionary politics could make Surinam a wealthy nation.

Bauxite

Bauxite is often referred to as the mainstay of the Surinam economy. The income raised by exporting this raw material for aluminium production comprises the lion's share of total export revenues. This dependence on the production and export of bauxite is worrying. Fluctuations in the global bauxite trade thus have a direct influence on the Surinam economy.

The growth of bauxite mining in Surinam started during the First World War when the existing bauxite supplies to the United

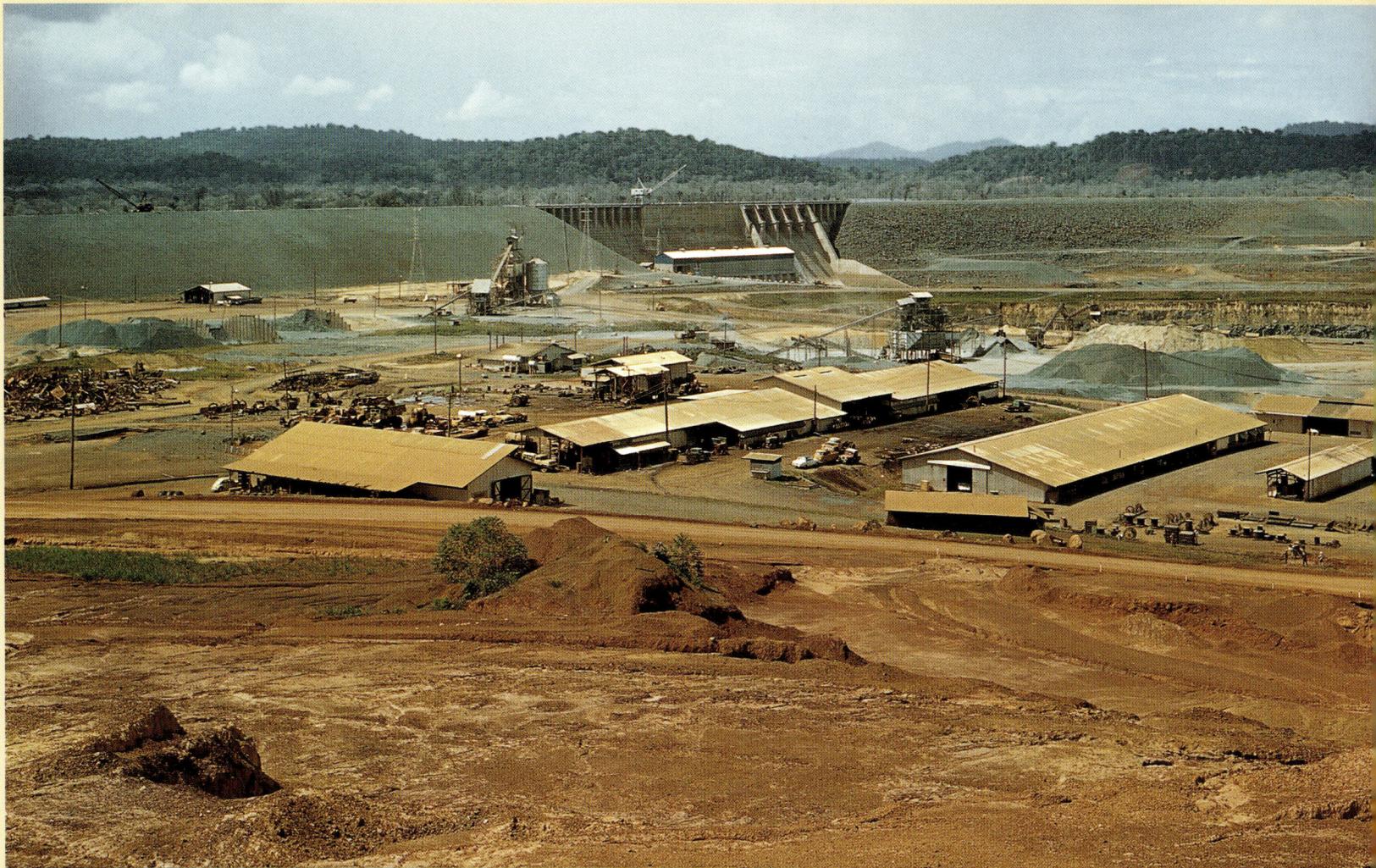

PAGE 102
Storage sheds, during the Brokopondo Dam construction.
KIT
Central control room.
KIT
PAGE 103
Bauxite mining.
KIT/ROY TJIN/
FRANS SCHELLEKENS

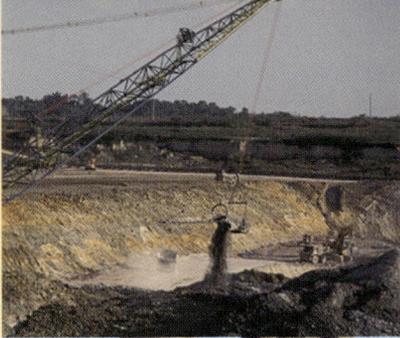

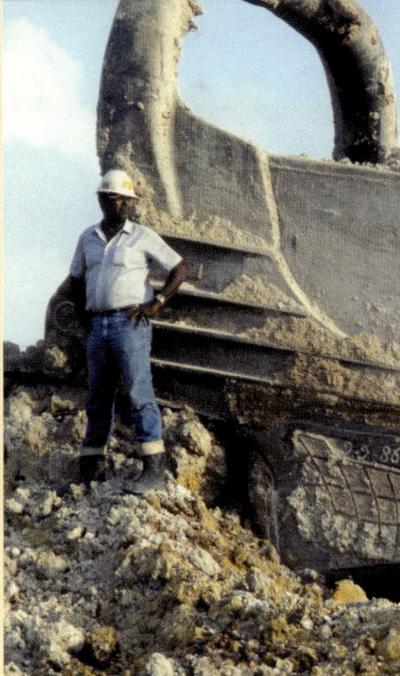

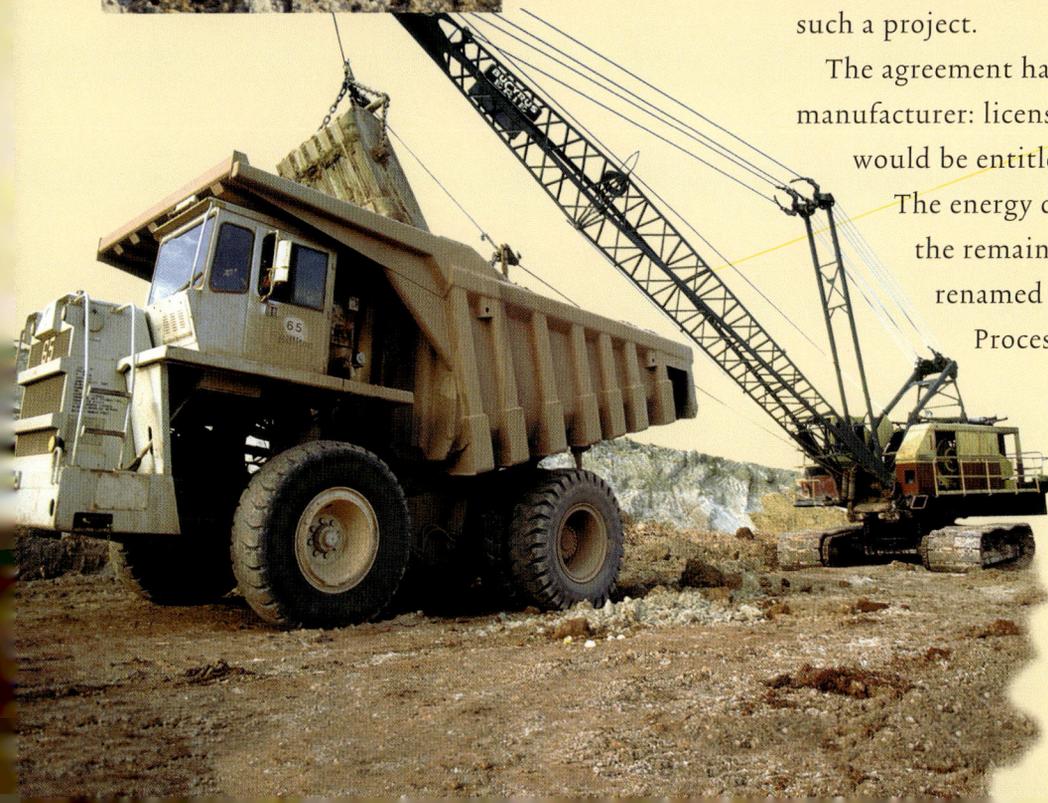

States declined and alternative sources had to be found. It was already known that the red stone was used in Surinam as roadbed, but this did not prompt further investigation. The results of research conducted by the Aluminium Company of America (Alcoa) were very positive. The bauxite reserves near the Cottica River and around Moengo were vast and, moreover, were so close to the surface that it could be obtained through surface mining. The Surinam Bauxite Company (SBM), a subdivision of Alcoa, was granted a 60-year license.

Bauxite was mined by hand in the first years and shipped before it was processed. It was crushed, washed and dried locally once the appropriate machinery had been installed. The level of export charges was a constant cause of tension between Surinam and the Dutch government, who wanted to keep them low to avoid scaring off potential investors. Surinam was by then one of the largest bauxite producing countries in the world. This position gave the country the protection of the United States during the Second World War.

The history of bauxite mining is closely linked to the construction of the giant Brokopondo reservoir. Plans to build a dam in the Suriname River and create a vast reservoir that could feed a hydroelectric power station had been drawn up after the Second World War. Apparently, only Alcoa were able to finance such a project.

The agreement had two main advantages for the aluminium manufacturer: licenses would be extended for 75 years and Alcoa would be entitled to 90 percent of the electricity produced. The energy company 'Energiebedrijf Suriname' would get the remaining 10 percent. The Surinam subsidiary was renamed 'Surinam Aluminium Company', or Suralco. Processing most of the bauxite locally instead of overseas was the deciding factor for the Surinam authorities. This process involved turning bauxite into alum and melting this into aluminium.

The project was carried out between 1960 and 1965. The power station could not produce enough electricity for the

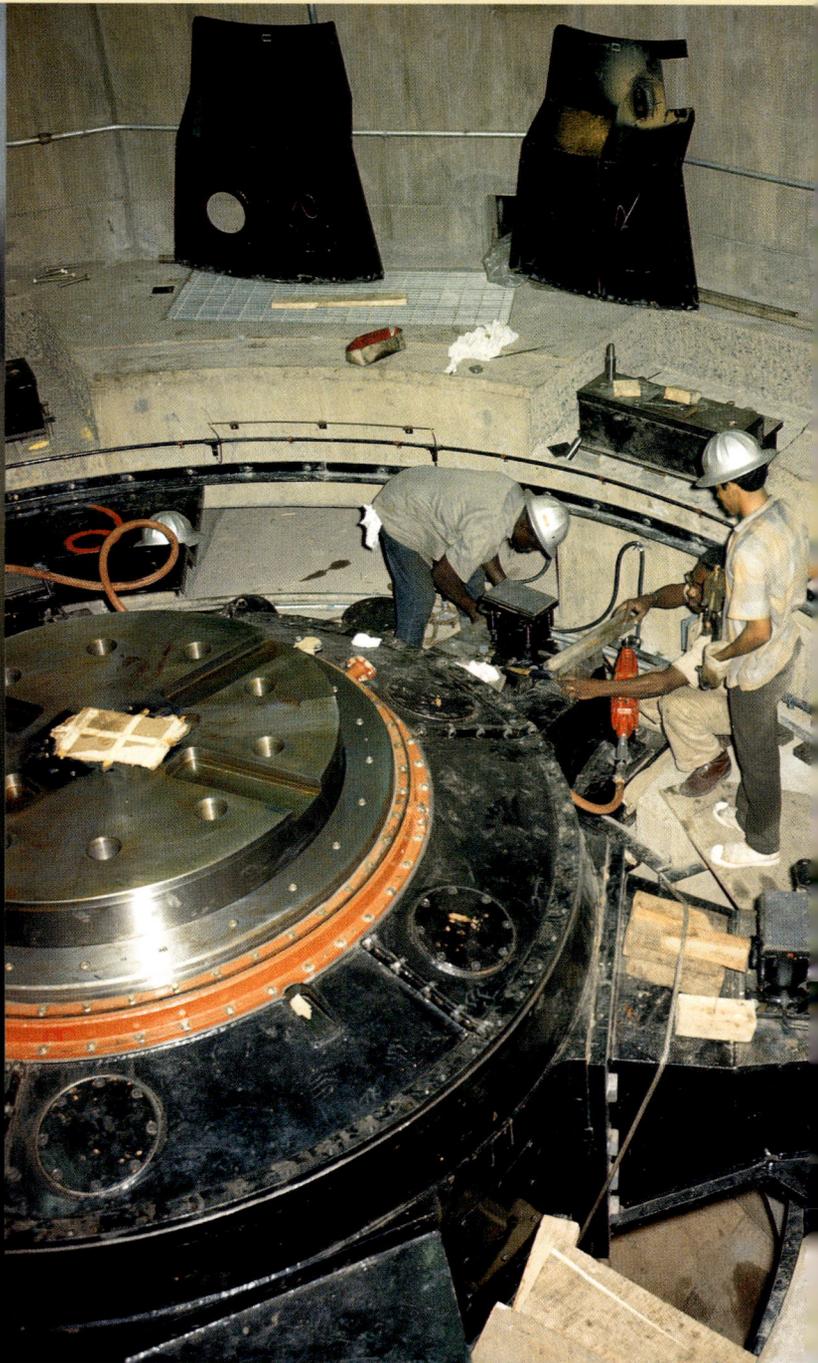

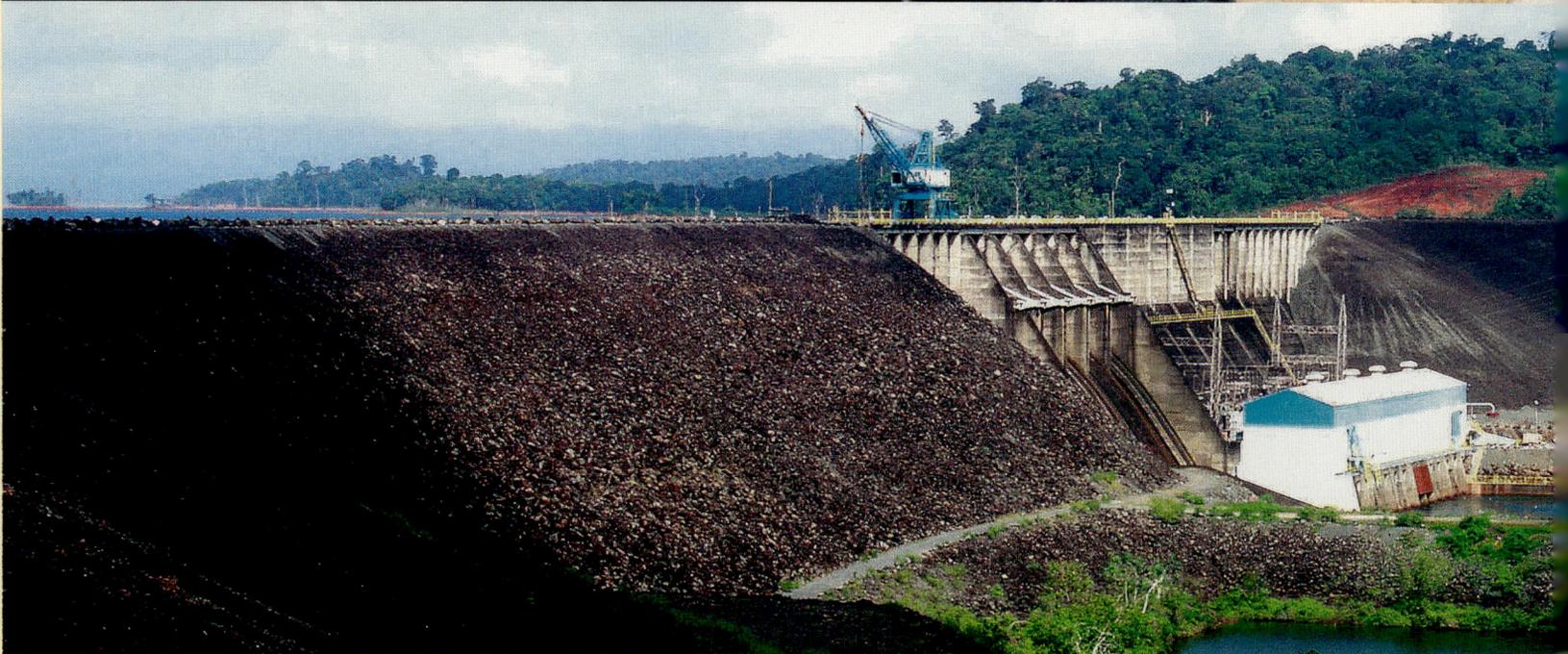

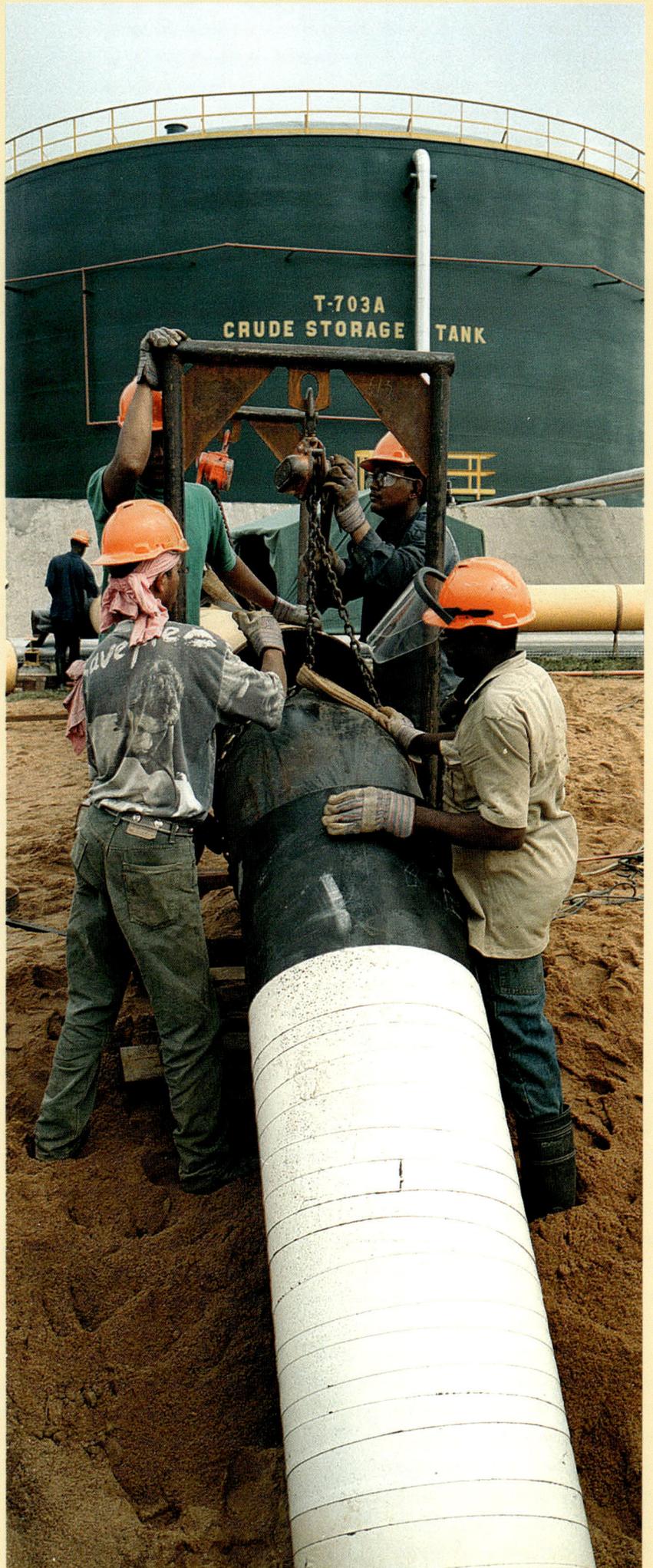

105

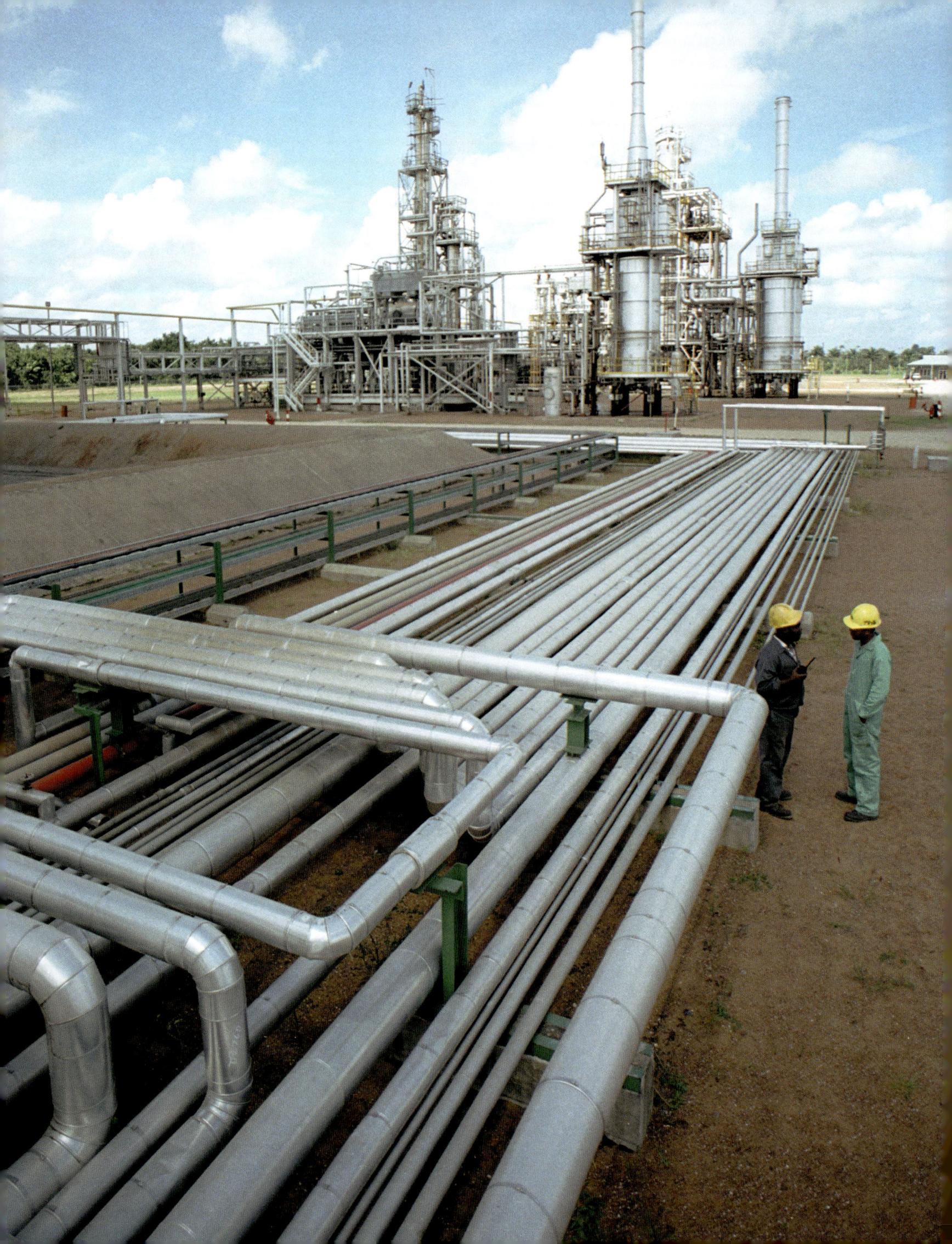

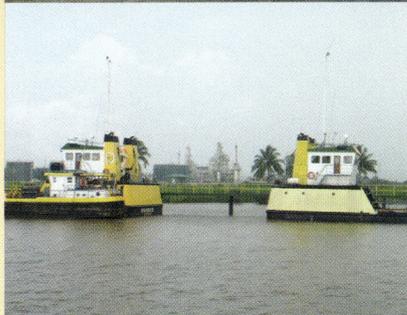

aluminium production, which was hardly surprising because of the energy-intensive nature of the process. Not all bauxite could be processed into alum and the smelting machine could only handle a limited amount. Aluminium production was therefore small. Nevertheless, the high demand, good prices and large stocks enabled Suralco to grow into a highly successful company. When the jungle commandos of Ronnie Brunswijk blew up a number of high-voltage pylons during the civil war, solidifying aluminium destroyed three of the four smelting machines.

Meanwhile, aluminium prices started fluctuating drastically. Suralco decommissioned the remaining, inefficient smelting machine and the production of ready-made aluminium came to a halt. Alum exports continue with varying degrees of success, but it remains vital to the economy of Surinam. Two multinationals, Alcoa and Billiton, formally own the bauxite production, of which the current deposits will soon be depleted. These companies are hoping to exploit the bauxite supplies in the Backhuis Mountains in the west.

Oil

In 1980 the state-owned company 'Staatsolie' struck oil for the first time. Production has gradually increased to over 10.000 barrels a day, part of which is processed into diesel. This production is small on a global scale but significant to Surinam.

Offshore oil reserves are more promising. Initially sceptical, large oil companies soon detected profit and a consortium was formed by Staatsolie and several multinationals including Shell and TotalFina. Expectations are high: oil production could increase considerably in the years ahead.

There is competition, however. The oilfields extend into the territorial waters of Guyana and the line of separation is still under dispute as a result of border conflicts between the two countries. A couple of years ago the Surinam marines commandeered an oil

107

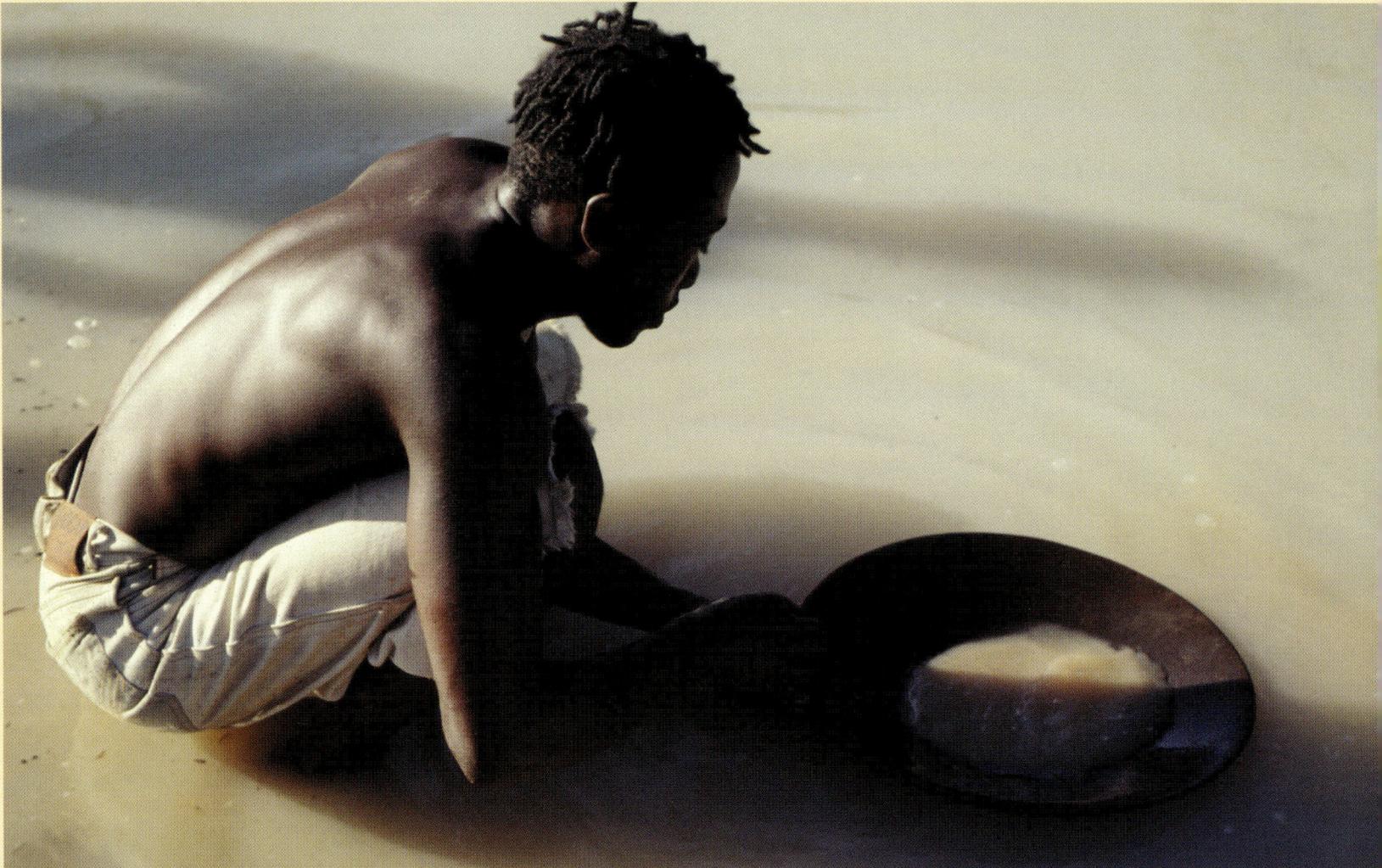

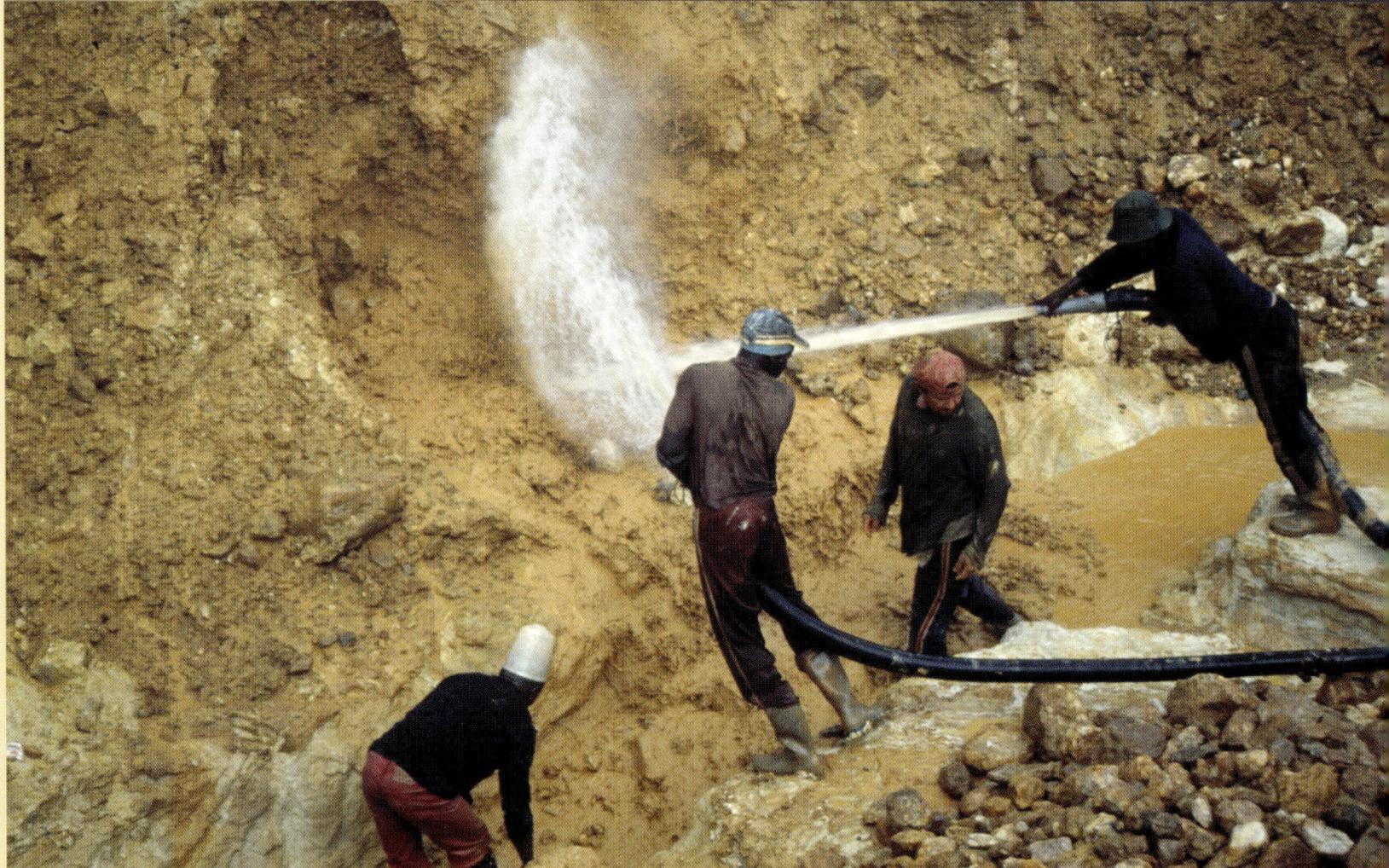

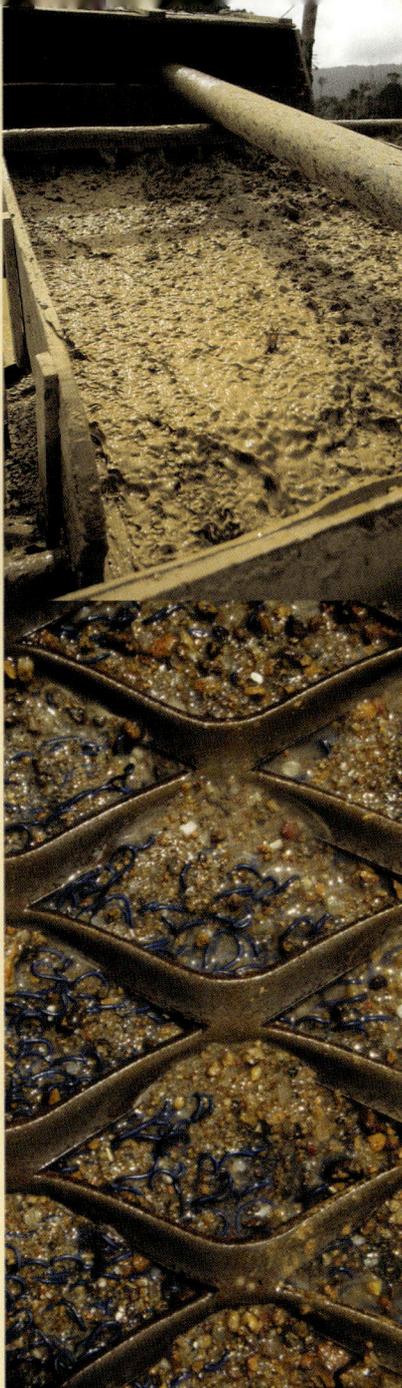

PAGE 108
Gold prospector.
TOON FEY
Drilling with water.
WILLEM KOLVOORT
PAGE 109
Separating gold with a grill and a retrieval mat, a method not requiring chemicals.
WILLEM KOLVOORT
Paying for purchases with gold, Godoholo.
FRANS SCHELLEKENS
Washing gold using a 'longtom', c. 1895.
KIT

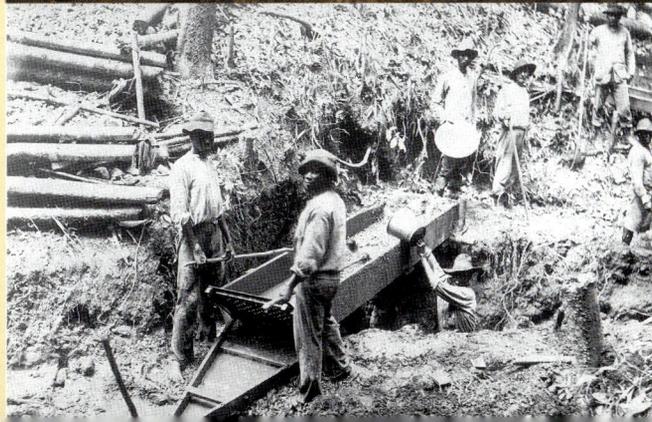

platform operating on behalf of Guyana in the Surinam-claimed Corantijn River mouth. This potential oil wealth offers Surinam a brighter future and could significantly reduce the dependence on bauxite exports.

Gold

Inspired by the gold fever that had swept America, the Dutch engineer Van Sypesteyn started the first large-scale gold prospecting in 1876. This would not just create wealth but also provide jobs for the Creoles. Routes were cleared through the forest in northeast Surinam and licenses were granted for the bordering areas. The yields were not impressive but incidental finds of 'petieten' (small gold nuggets) inspired investment.

Large-scale mining was undertaken during the first years of the last century with some result. Water cannons, drills, dredging machines, pumps and heavy equipment were transported inland with considerable effort. An American company even built a railway to transport the ore to the Marowijne River for washing. Mercury was then used to extract the gold; little was known at the time of the health risks or the damage this could do to the environment.

This period of mechanisation and investment soon ended. There were hardly any profits, the gold fields were exhausted and technical setbacks were daily events. The first companies started to leave after a couple of years, many without their heavy machinery. The American locomotive also remained in Surinam.

The 'gold train' that ran 170 kilometres from the gold fields to Paramaribo is the most lasting memory of this period. The track started at Republiek and ran through Kwakugron to the Surinam River. To save money, a funicular railway was used instead of a bridge to transport the ore-bearing wagons from Kabel to the opposite shore. Another locomotive was then used to take them to the final destination, Dam. The last section of the route and the Kabel train station are now submerged in the Brokopondo reservoir. This part of the railway was already closed down in 1936.

109

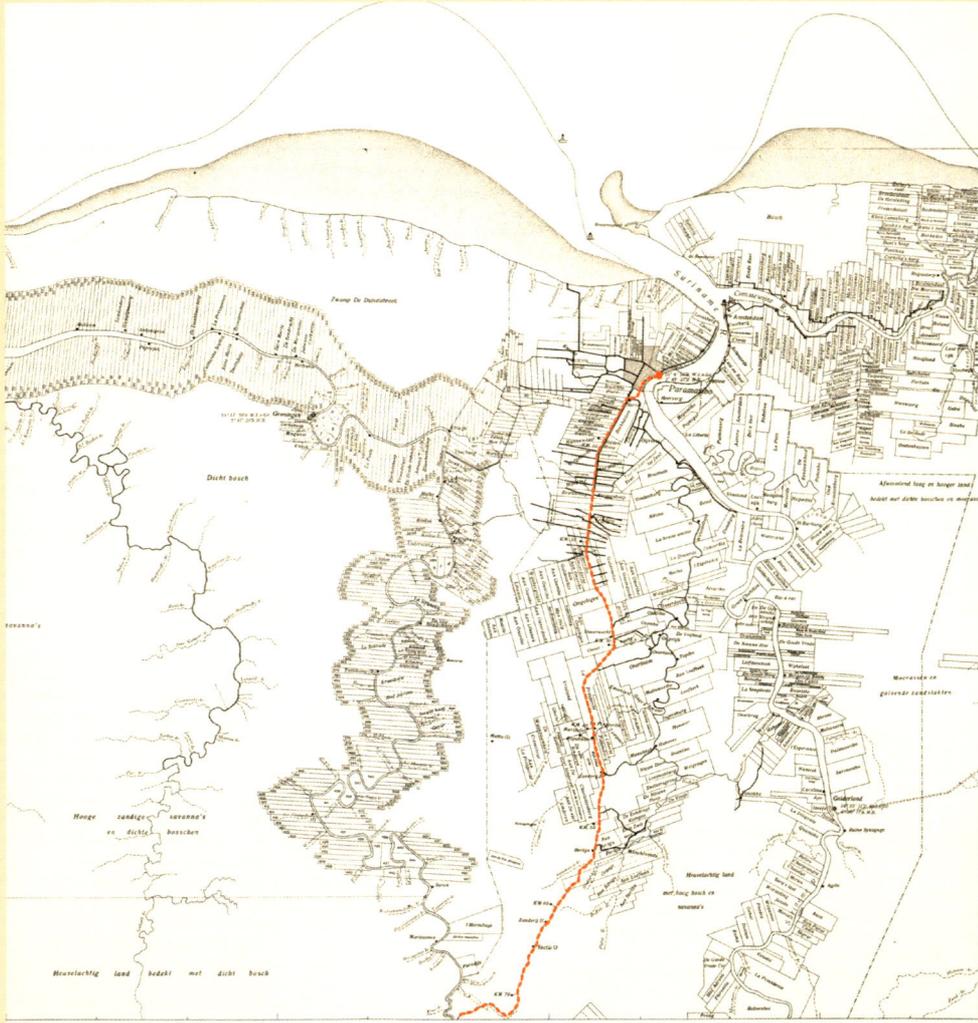

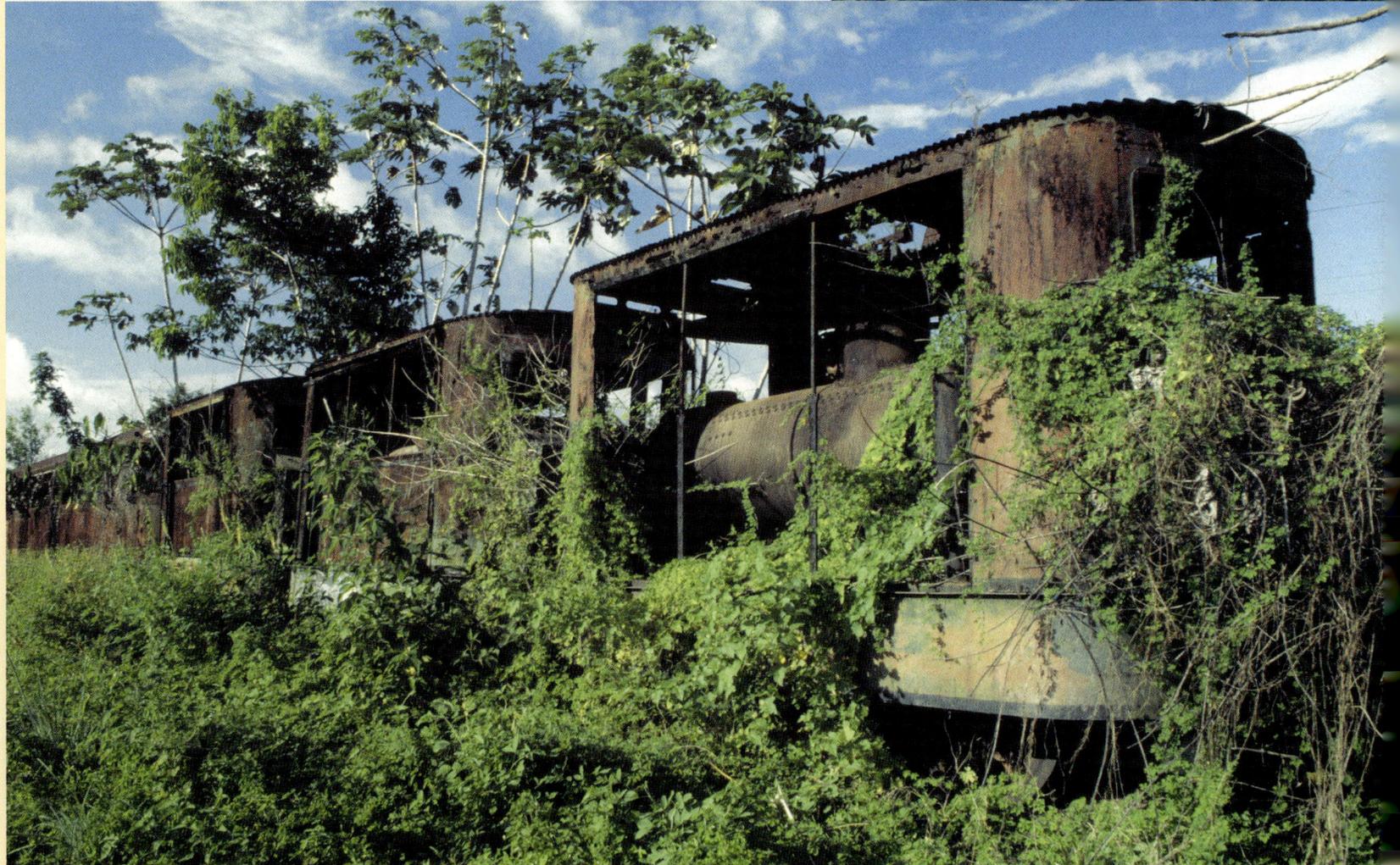

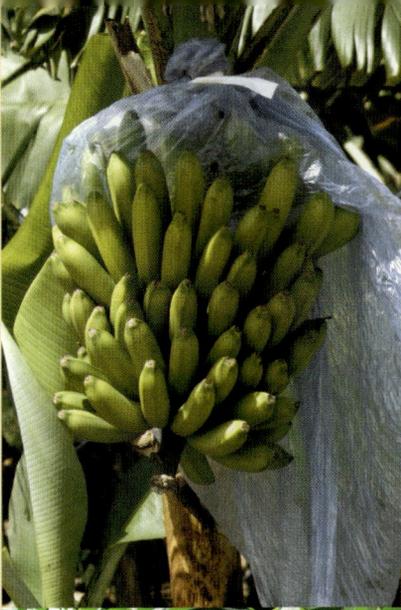

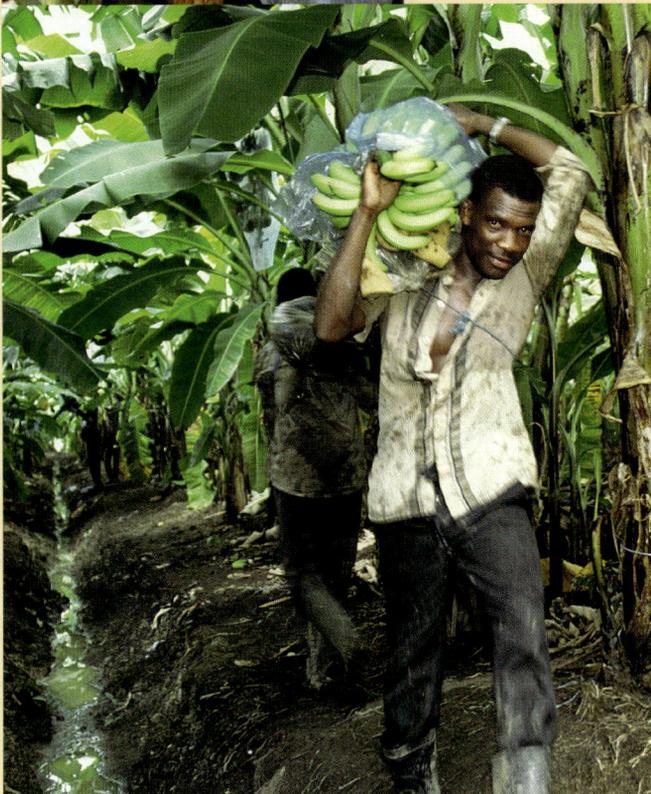

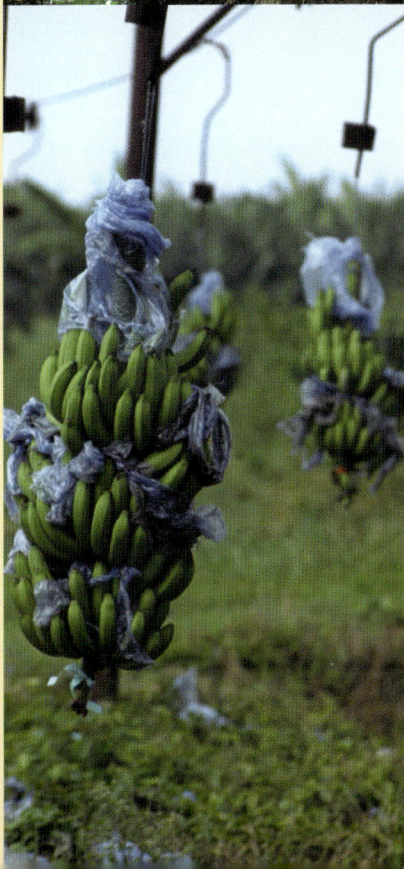

The trajectory Onverwacht to Brownsweg was operational until 1986. The inhabitants of this area would like to see the railway service reinstated.

Small-scale gold prospecting

The failure of mechanical gold mining was replaced by flourishing small-scale prospecting. License holders leased their claims to the predominately Creole labourers for a percentage of the yield. The work of these independent labourers, called 'poknokkers', was profitable largely due to their simple approach. This small-scale method of gold prospecting still exists. A pontoon purchased by the license holder is frequently used to suck up the sand, which is then deposited in a 'longtom' (washing basin). The gold is then extracted from the ore with mercury.

Small-scale gold prospecting of the last decades has been done by a sizeable group of *garimperos*, prospectors from neighbouring Brazil. Some estimate that there are tens of thousands of these *garimperos*, and while they are not troublesome, illegal exports have increased since their arrival. It is been claimed that up to 80 percent of the gold is smuggled out of the country.

A large Canadian company has been active in recent years. Benefits to the country are tighter controls on exports and mercury use. However, locals protest against the issuing of such large licenses.

Bananas

Bacove, or bananas, have long been one of the main exports of Surinam, ranking third for a considerable period. The state-owned company Surland grew the bananas on plantations near Jarikaba and Nickerie. Until recently, the trade in bananas was very profitable and Fyffes bought large quantities. The process is quite labour-intensive: bananas have to be picked, washed and

111

PAGE 110
Railway line from Paramaribo to Kabel, *c.* **1930.**
RIJKSARCHIEF
The railway line has long since been reclaimed by nature.
FRANS SCHELLEKENS
Overgrown 'gold train' last used in 1985.
TOON FEY
PAGE 111
Surland, bananas from the tree to the transport belt.
FRANS SCHELLEKENS/ KIT

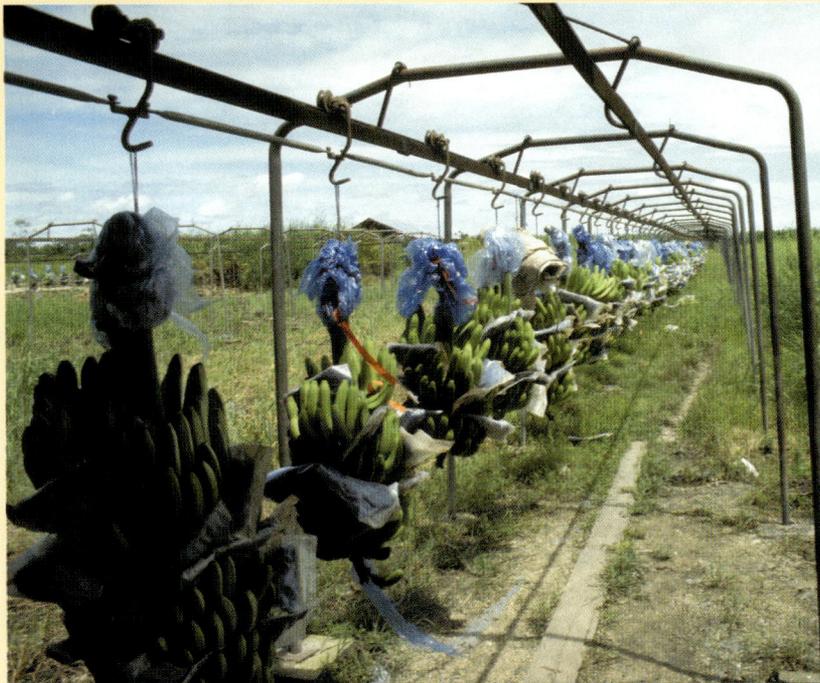
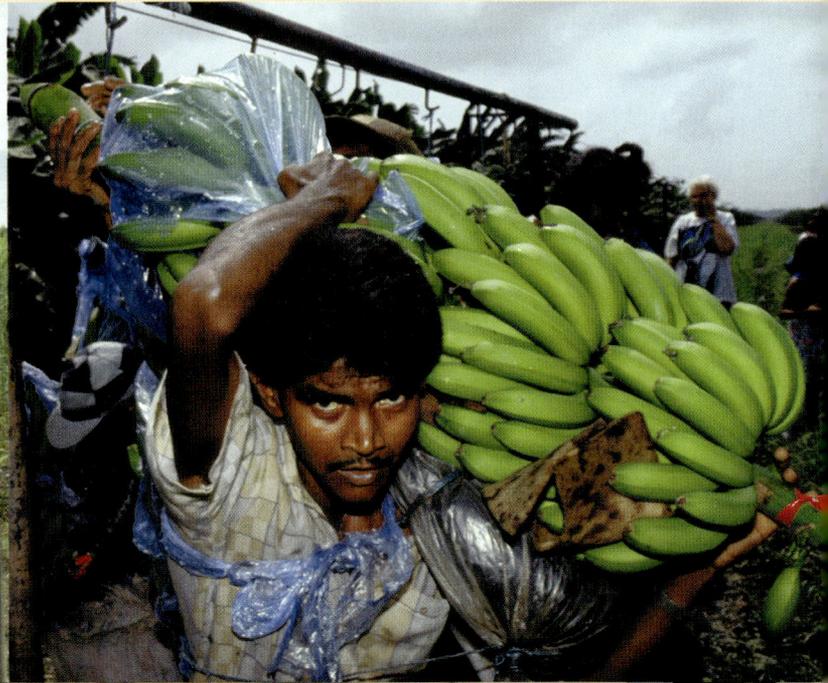
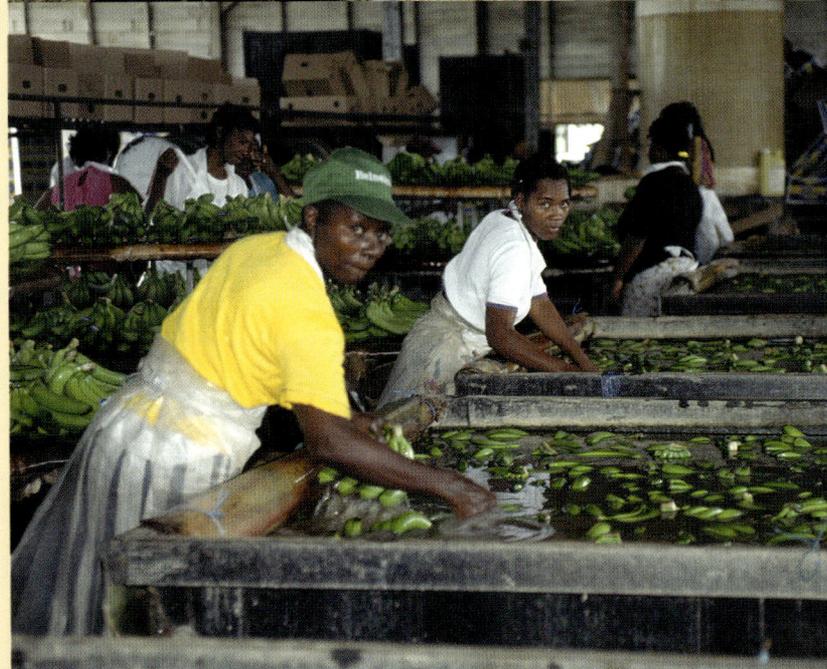
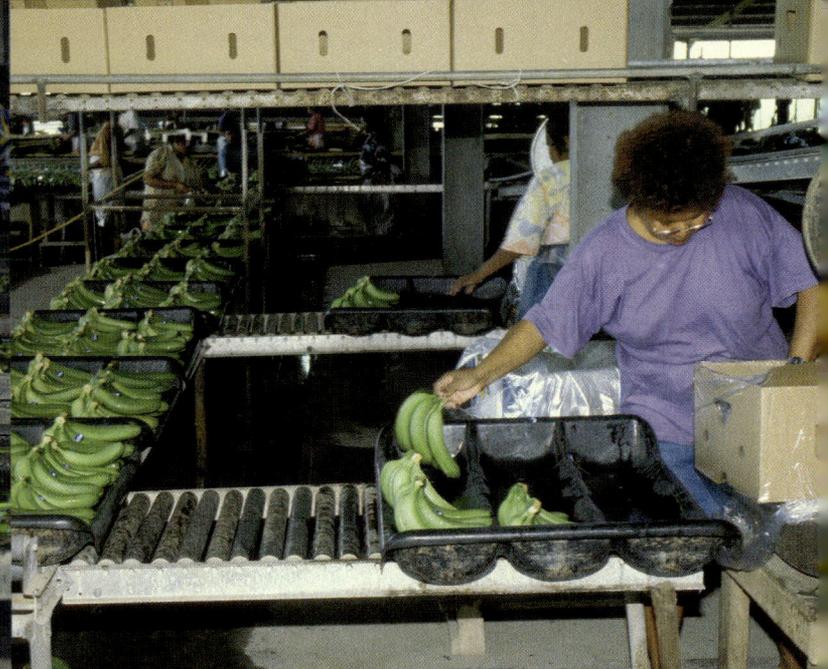
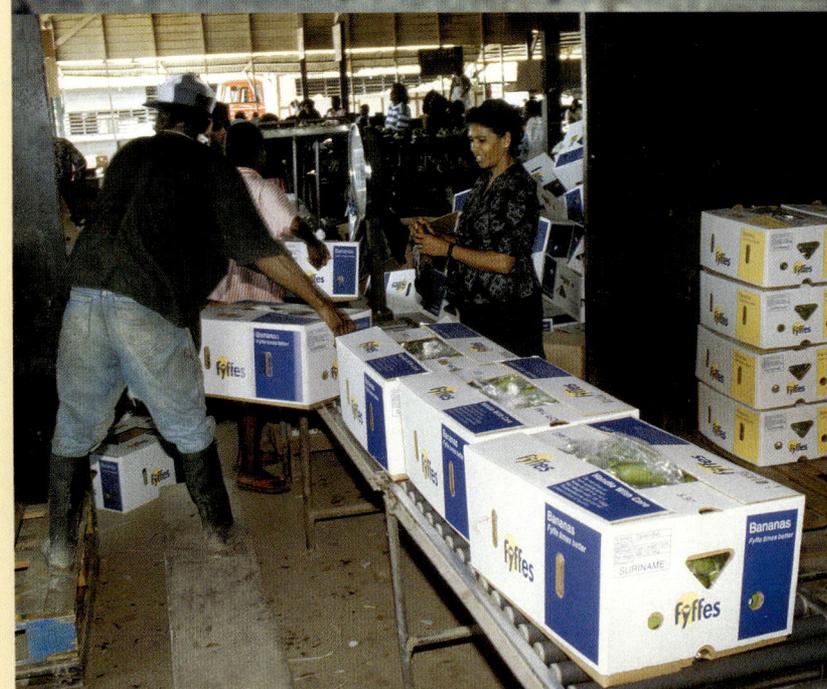
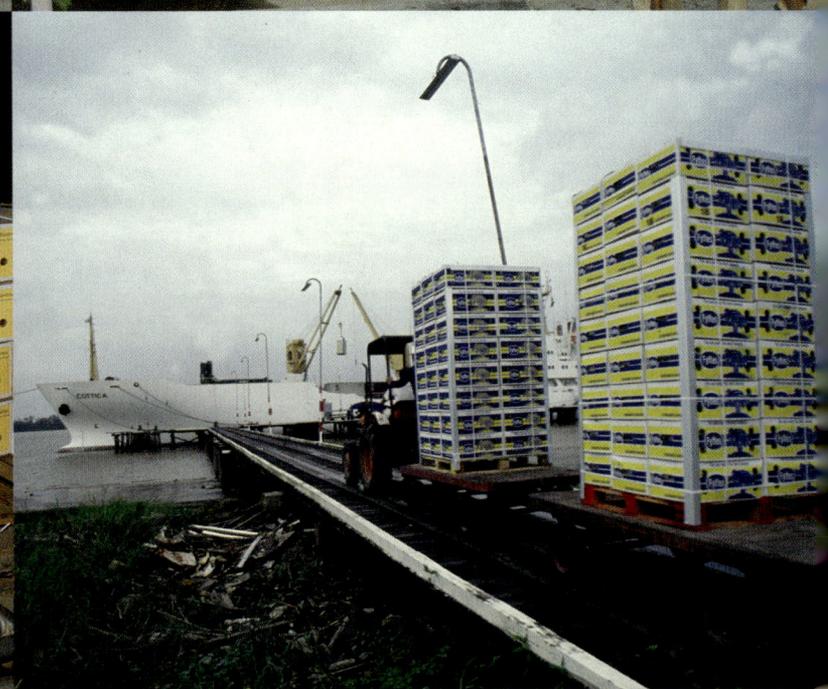

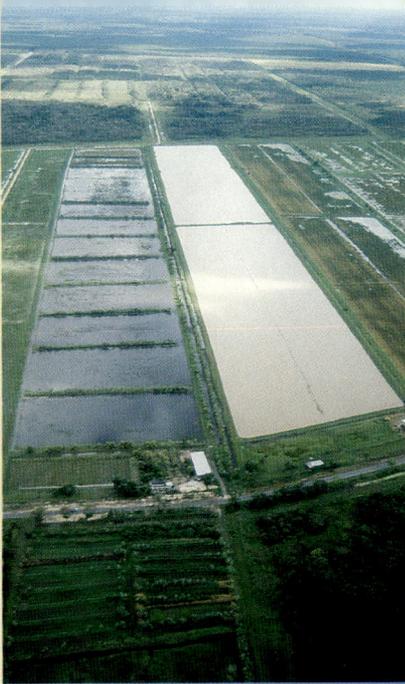

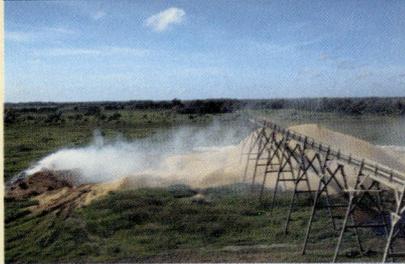

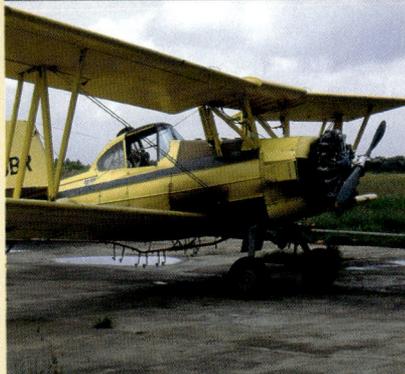

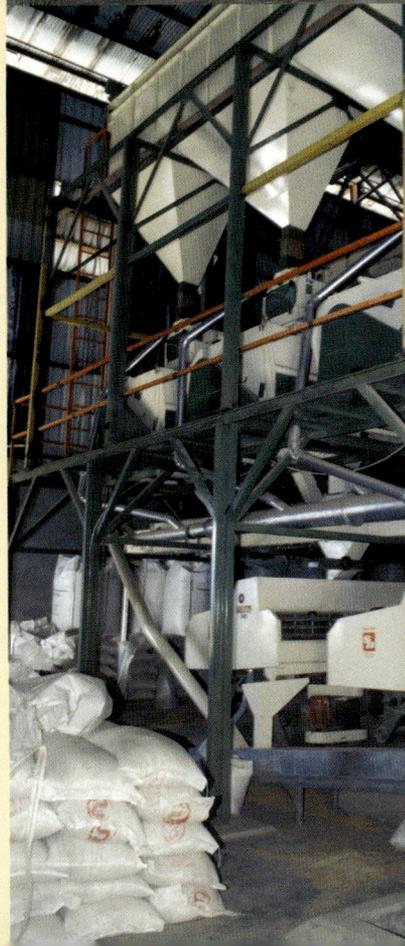

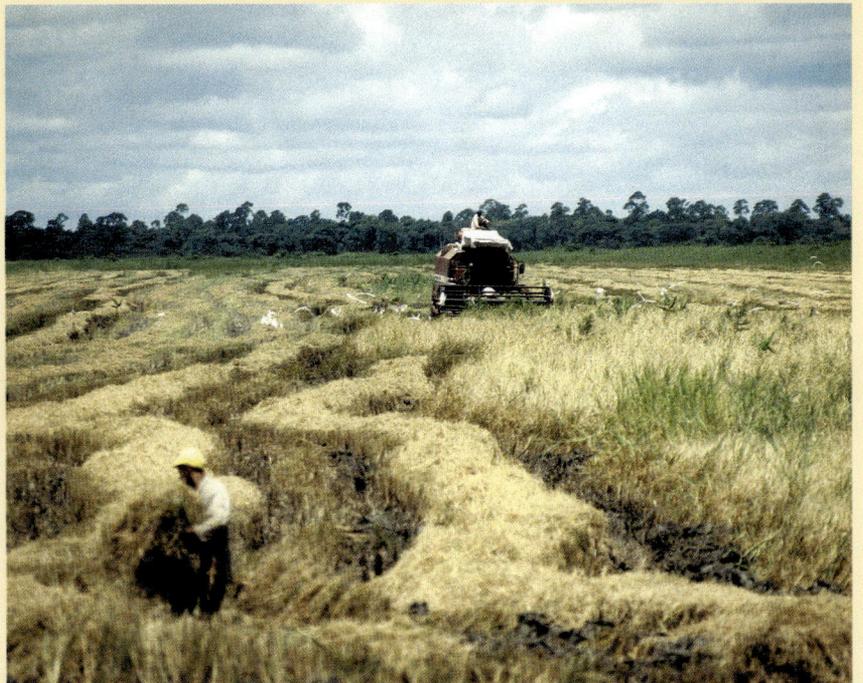

PAGE 112

From the transport belt to the washing and packing areas.
KIT/FRANS SCHELLEKENS

PAGE 113

Large-scale rice cultivation.
HENK LUTCHMAN

Rice processing plant; the chaff is blown outside and burned.
FRANS SCHELLEKENS

Light aircraft used to sow and spray crops.
HENK LUTCHMAN

Filling bags with rice.
KIT

Harvesting rice near Paramaribo.
KIT

Timber!
ROY TJIN

Sawmill, Nieuw Nickerie.
KIT

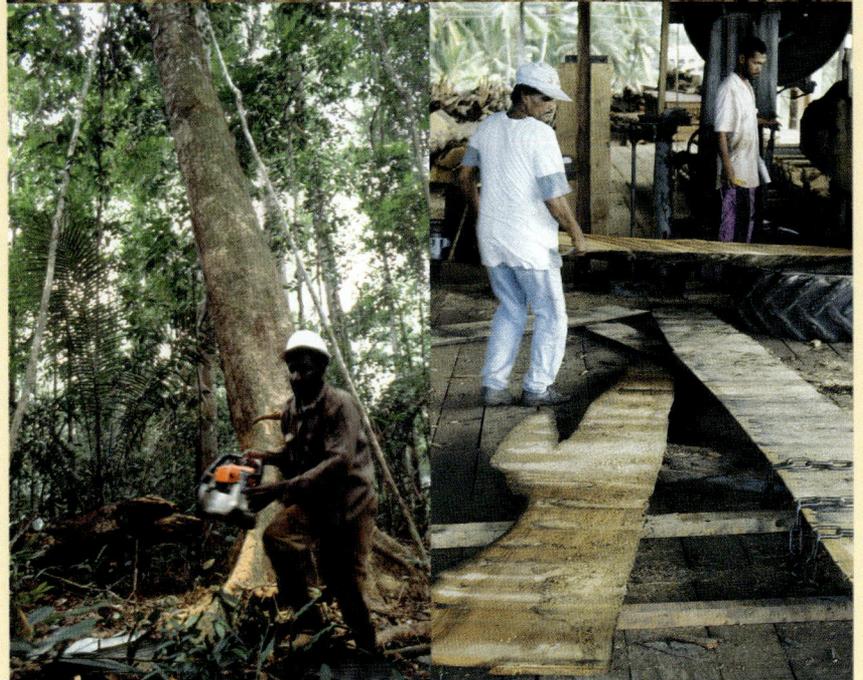

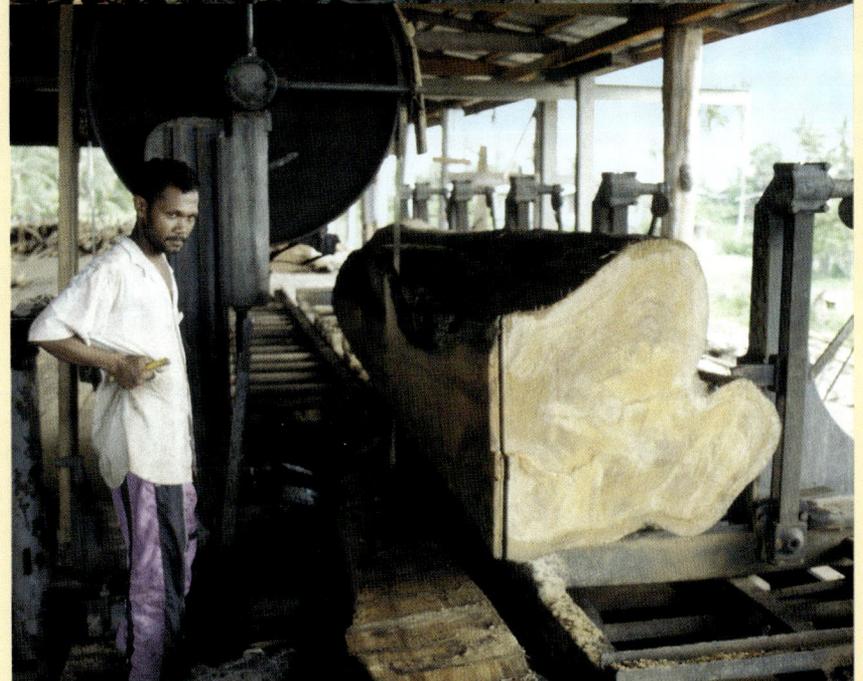

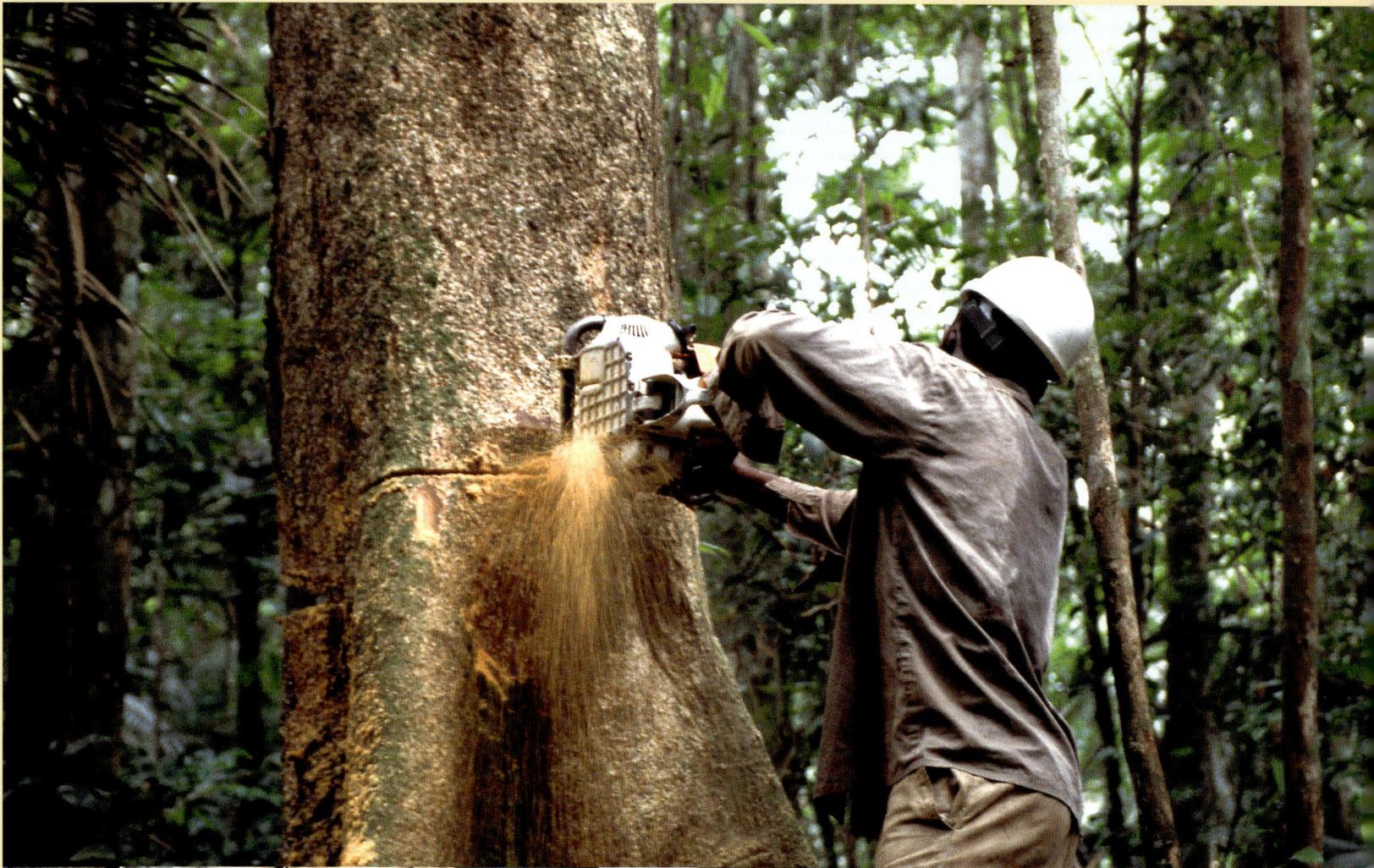

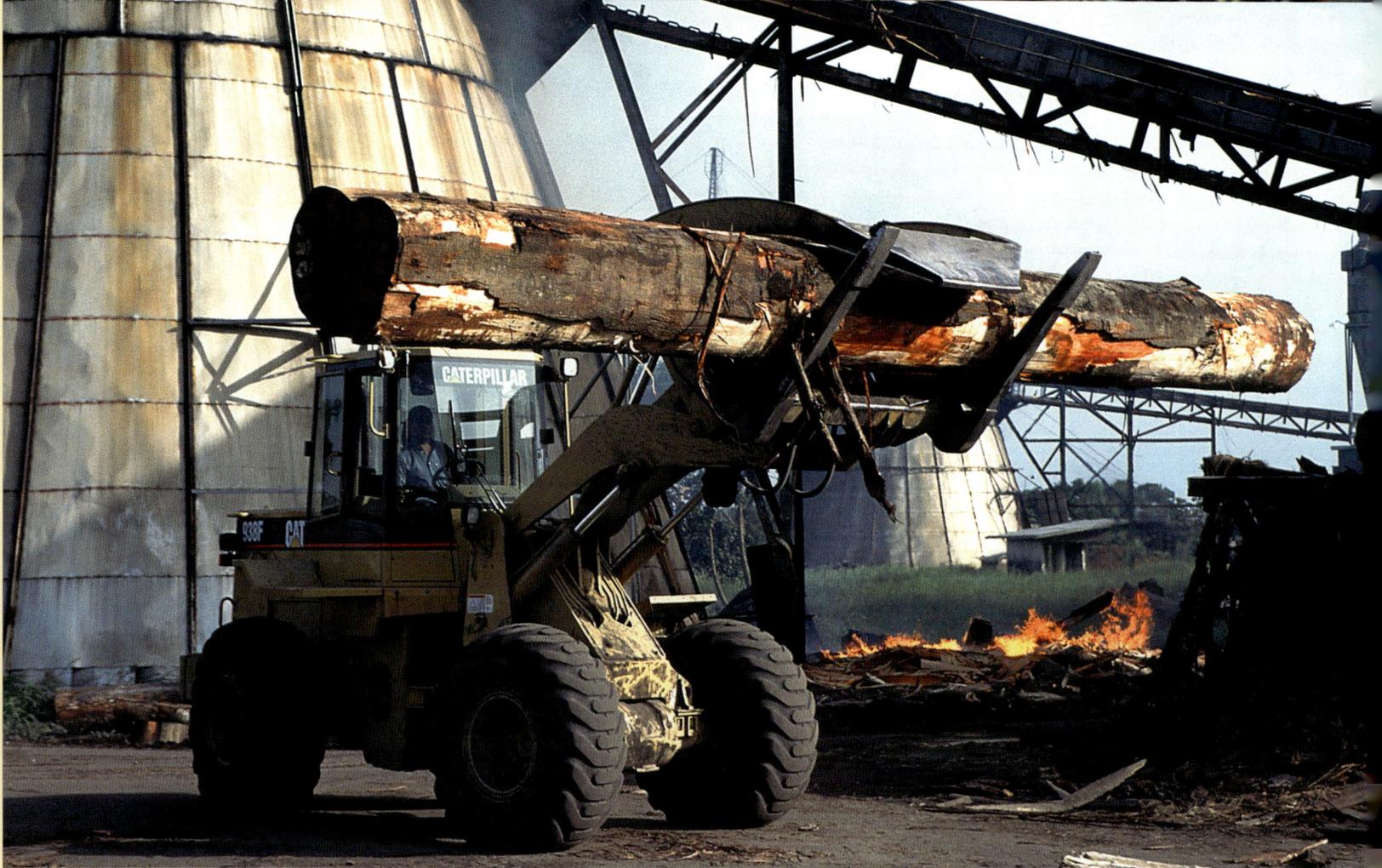

selected with care. Fluctuating markets and ongoing labour conflicts have recently caused Surland problems, threatening continuity.

Rice

Those who see the extensive rice fields in the Nickerie district realise that Surinam produces much more rice than it needs for its own consumption. Hindus and Javanese who used to grow the rice on their family plots dominate the rice culture. Manual cultivation has been replaced by mechanisation, sowing is done by plane and harvested by machines designed to operate on the wet rice paddies. The move towards large-scale production threatens many small farmers.

The total area of the rice fields measures around 52,000 hectares. However, not all of this has been used in recent years, partly because of global competition and also because the soil is becoming brackish in places.

115

Forestry

It is evident that Surinam's extensive rainforest represents a potential fortune to the timber industry. Logging has been profitable for a long time. Some large Asian companies have obtained large-scale concessions, but whether these companies will abide by the rules is doubtful, as there are no government controls. It is most likely that more trees are being felled than is permitted. The government simply does not have the resources or enough qualified personnel. Timber is only processed in some parts of Surinam. Smaller timber firms have trouble obtaining enough large tree trunks because foreign companies willingly pay higher prices to the loggers.

Despite the current setbacks, measures are being taken to improve the quality of forestry to meet strict international standards. The Foundation for Forest Management and Production (SBB) has been established to this end.

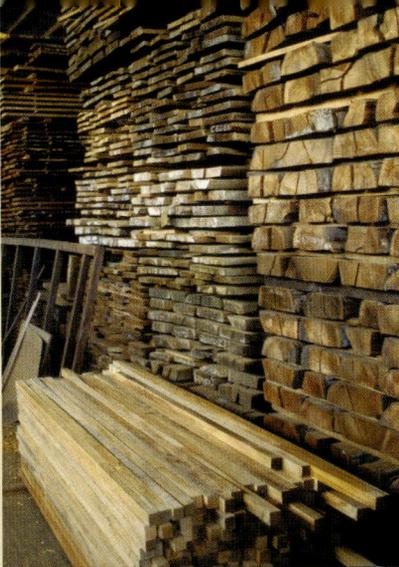
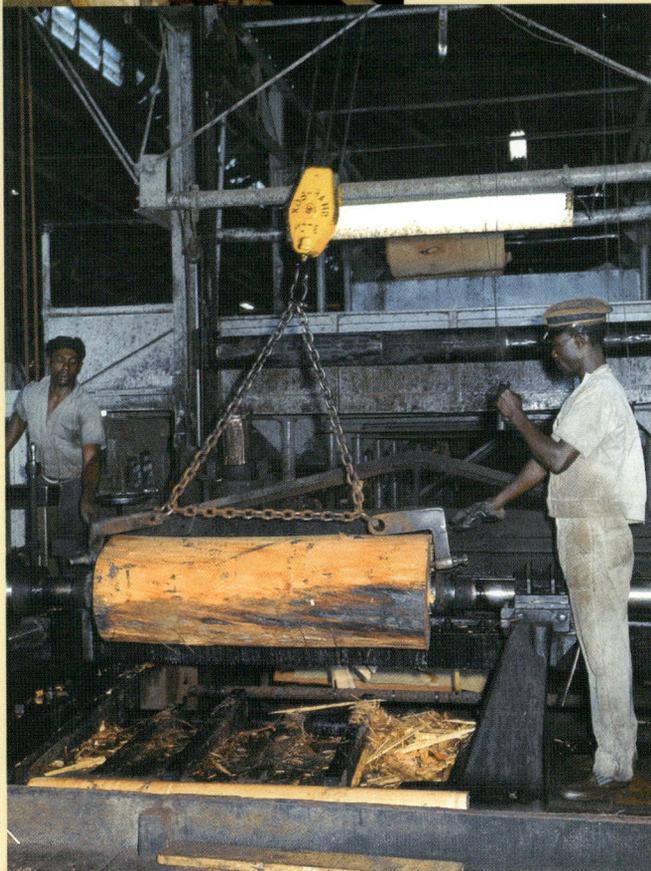

PAGE 114
Using a chainsaw to fell a tree.
ROY TJIN
Delivering roundwood.
ROY TJIN
PAGE 115
Storing wood in a furniture factory.
KIT
Bark removal machine in the Bruynzeel factory.
KIT
Stripped bark.
KIT
Stripped bark being made into multiplex.
KIT

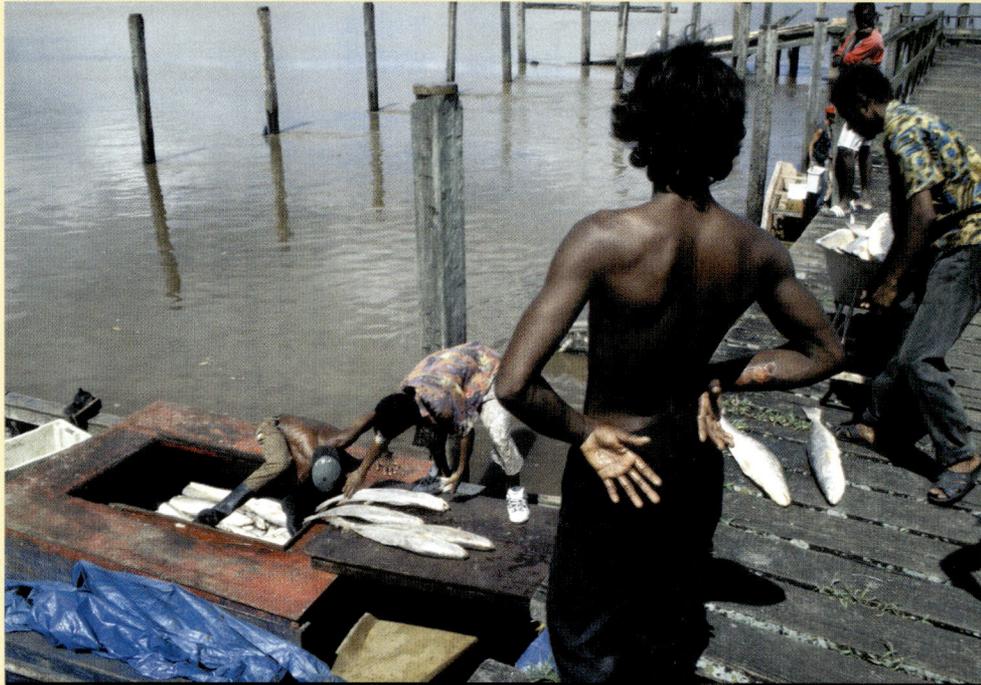
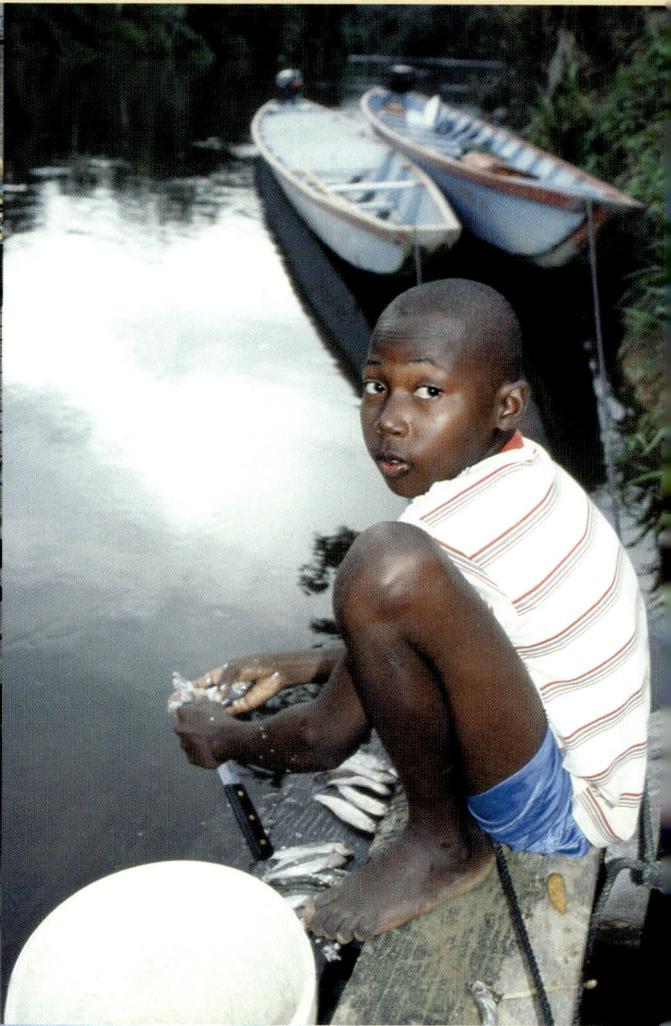
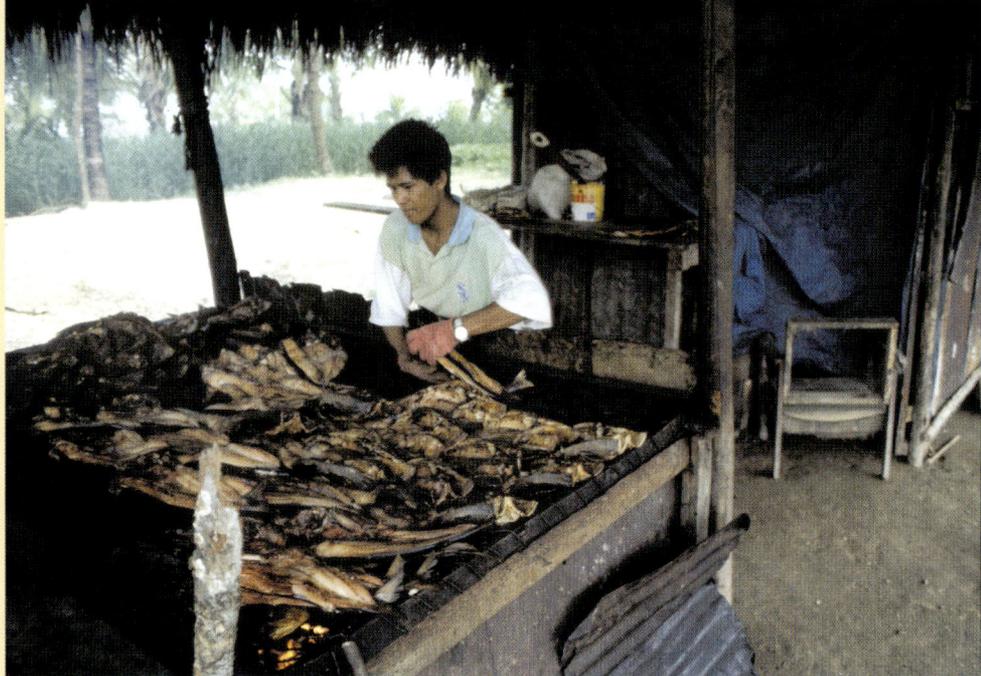

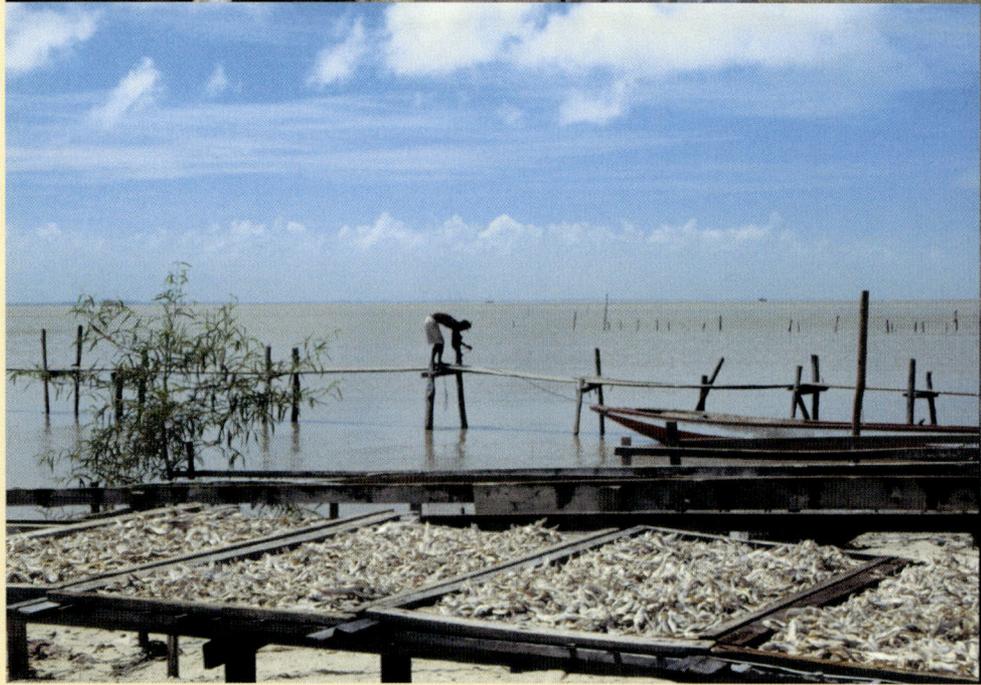
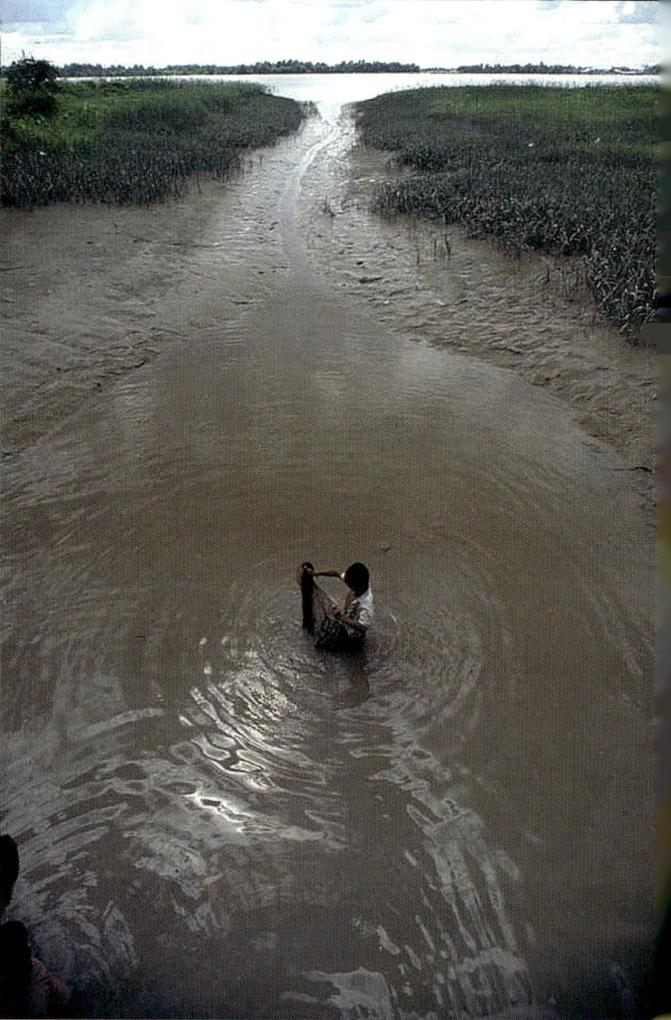

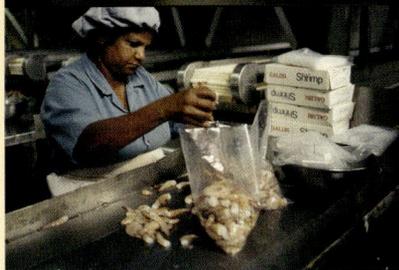

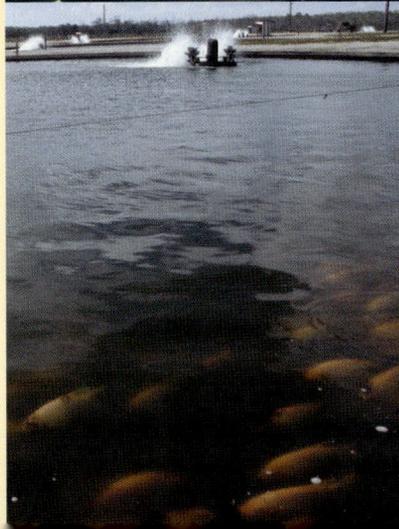

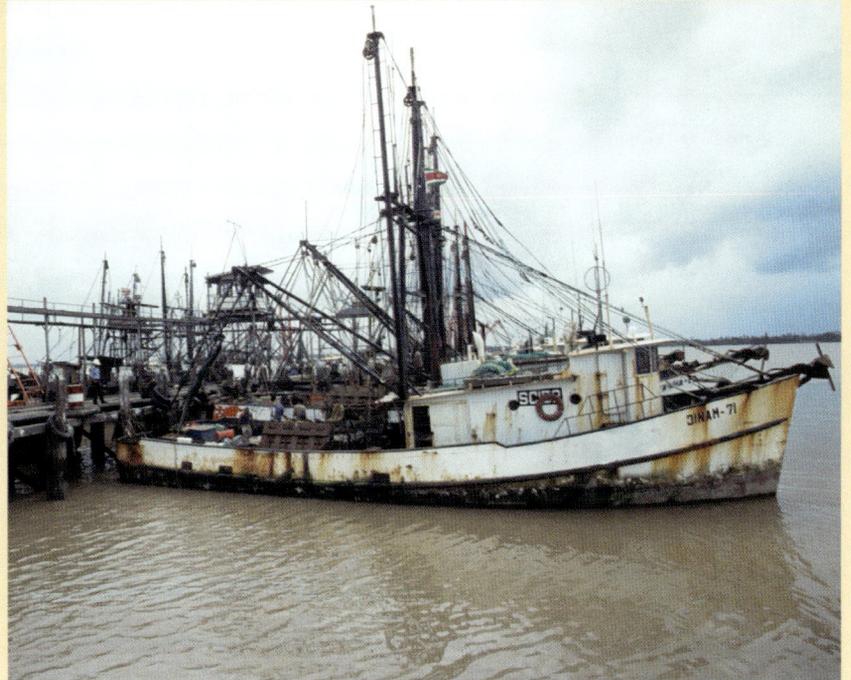

117

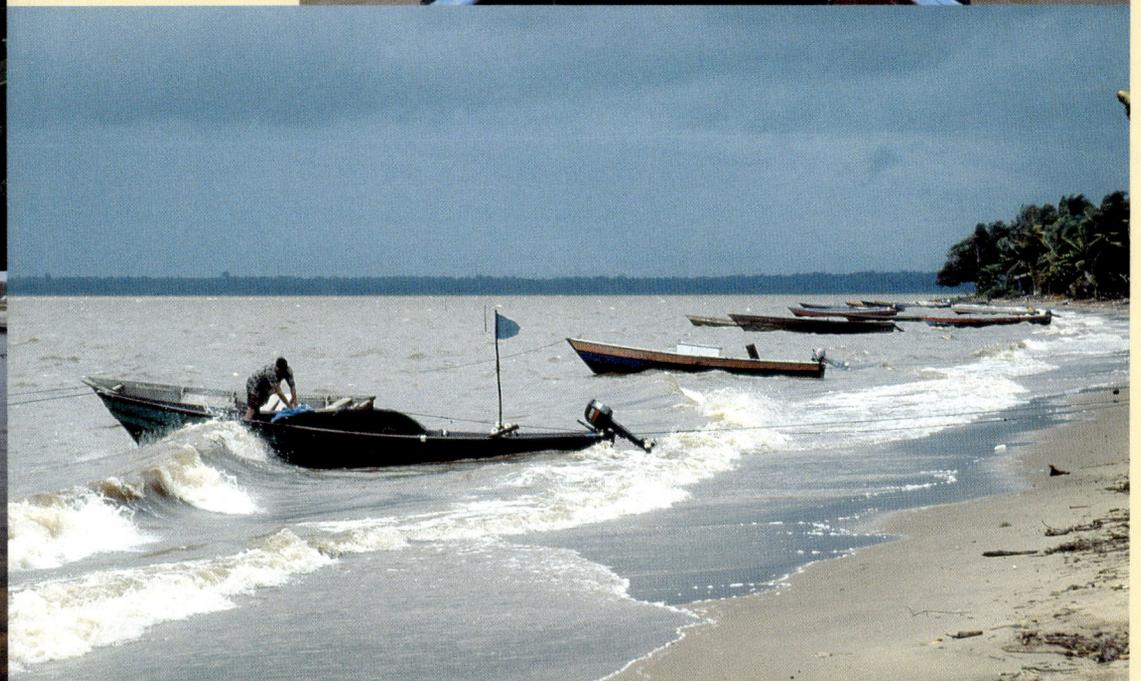

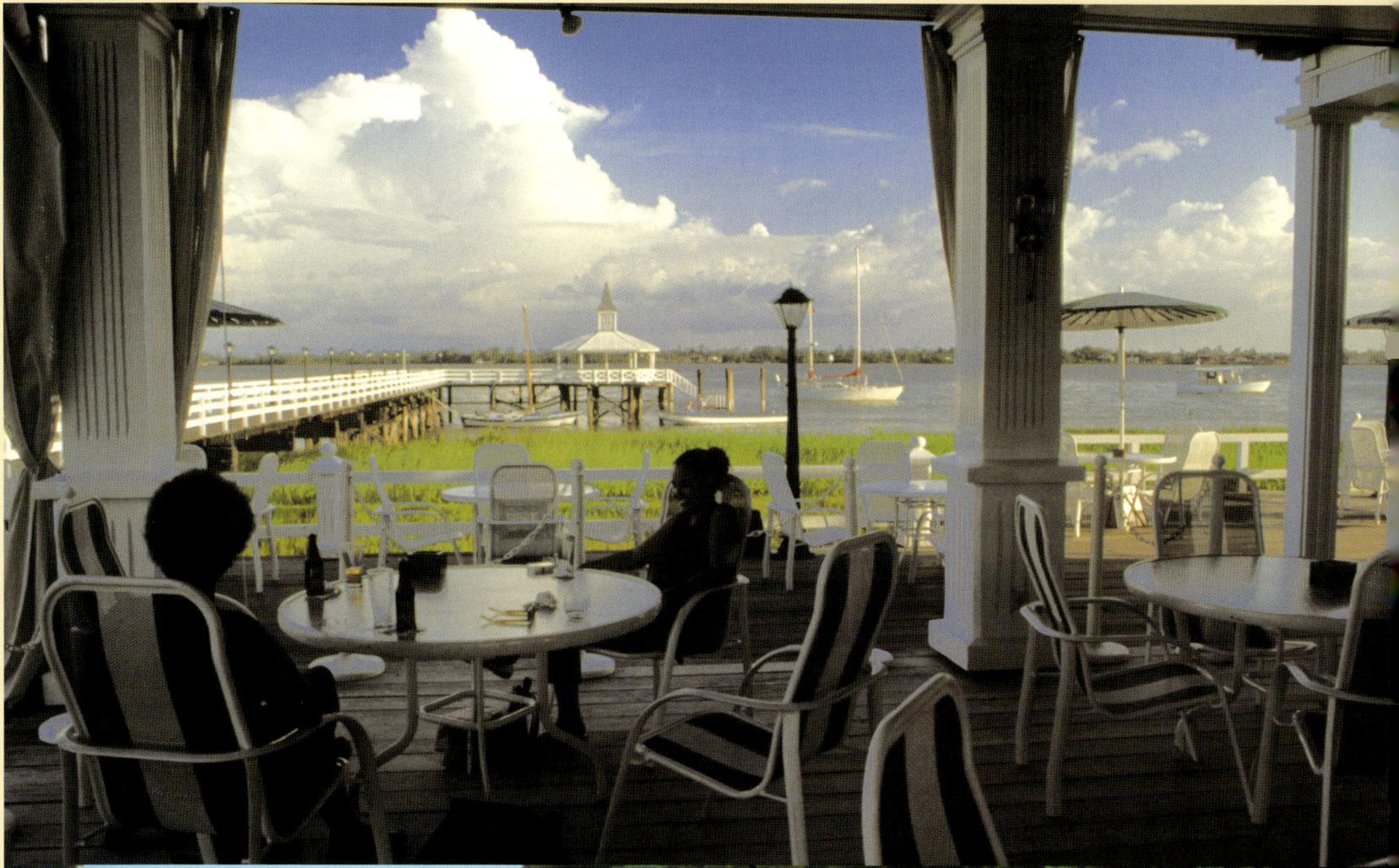

PAGE 118
Terras Torarica on the Suriname River.
TOON FEY
Eco-tourism in Awarradan.
KARIN ANEMA
PAGE 119
Maroon helmsman.
TOON FEY
In a bus to Brownsweg.
WILLEM KOLVOORT
Noha ('Little Nut') paddling near Awarradan.
KARIN ANEMA
In front of the blackboard, Jacobskondre.
TOON FEY

Fishing

Fish is a popular food in Surinam. Enough fish are caught in rivers, river mouths, swamps and estuaries to provide for the local needs. Simple methods are used, such as trawling, floating nets and line fishing. Hoop (or double) nets are used to catch shrimp in the river mouths between tides. Long, open boats with powerful outboard engines are mainly used. Foreign companies dominate the export industry. Fish processing factories have been established in Paramaribo.

Aquaculture has recently been introduced with some success. Fish and shrimp are bred in ponds, relieving some of the pressure on natural stocks.

Tourism

The coast of Surinam, with its lack of beaches and its many estuaries and mangrove forests is unsuited to large-scale tourism. The gradual increase in tourism can therefore only be attributed to other factors such as the relaxed lifestyle, the hospitality of the inhabitants and the tropical climate.

Nature holds the biggest potential for tourism. The incredible wealth and significance of the rainforest attracts increasing numbers of visitors. Eco-tourism has become a significant source of income in some countries.

Surinam lags behind as a tourist destination because of the expensive flights. Tickets to Surinam cost as much as a ticket to Australia because of the monopoly held by KLM/SLM on flights to Paramaribo. Lack of competition has the same effect on the prices of internal flights. Ticket prices are kept artificially high by a small group of travel agents. Organisation and accommodation also leave much to be desired.

Nonetheless, eco-tourists rarely leave the country disappointed. A journey inland guarantees a wealth of experiences. There is an added advantage for Dutch visitors: Dutch is spoken in this tropical environment, facilitating communication with the locals.

119

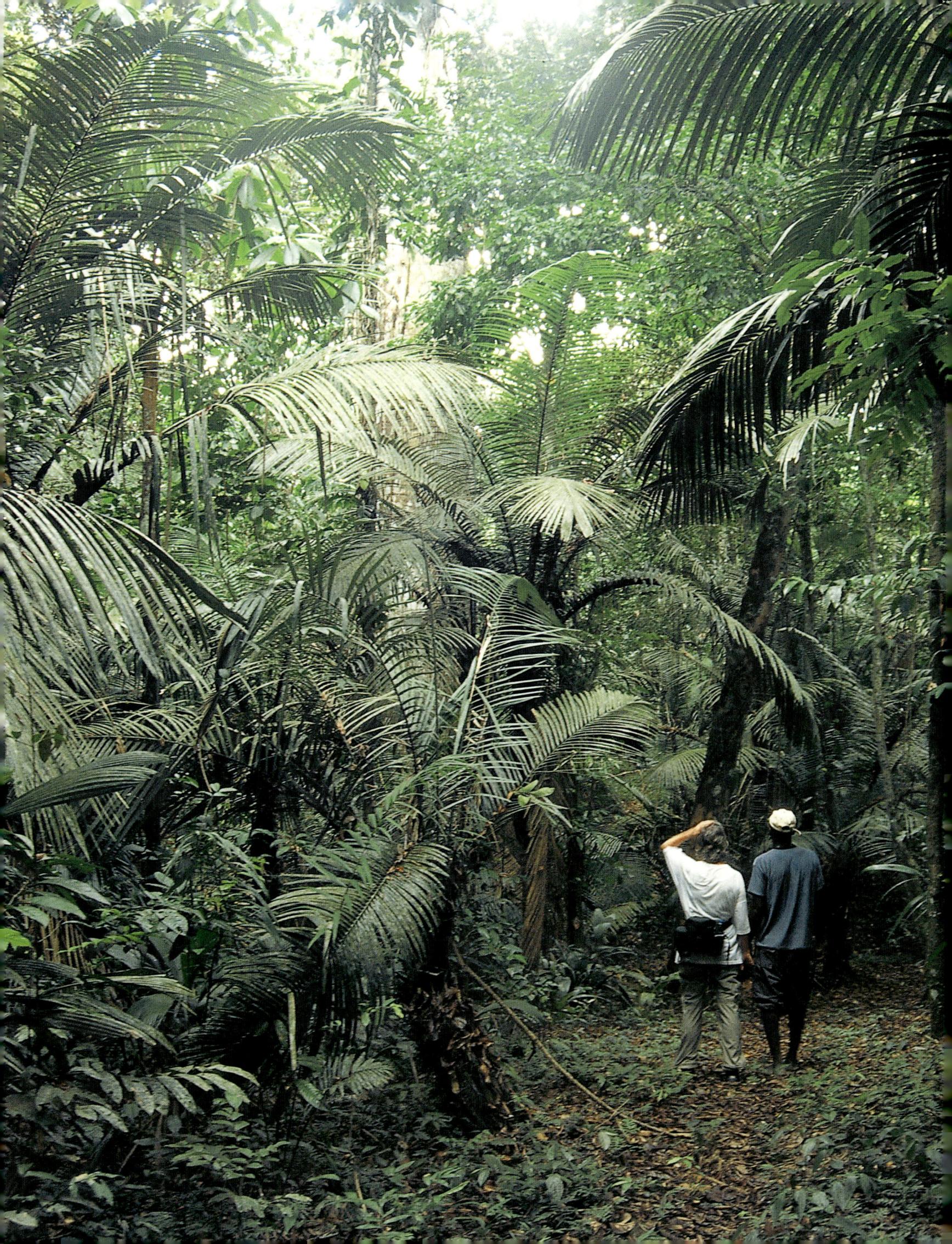

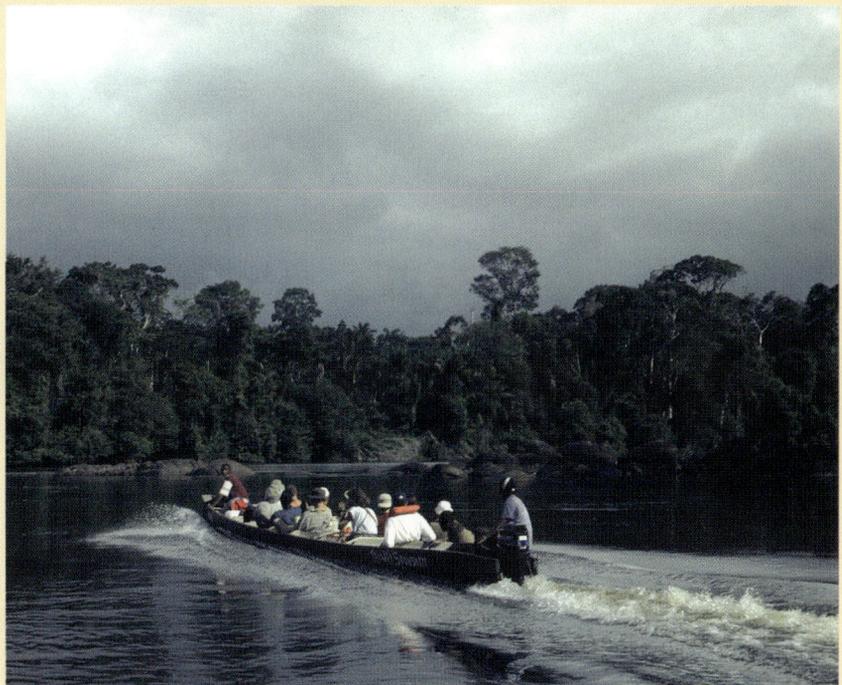

121

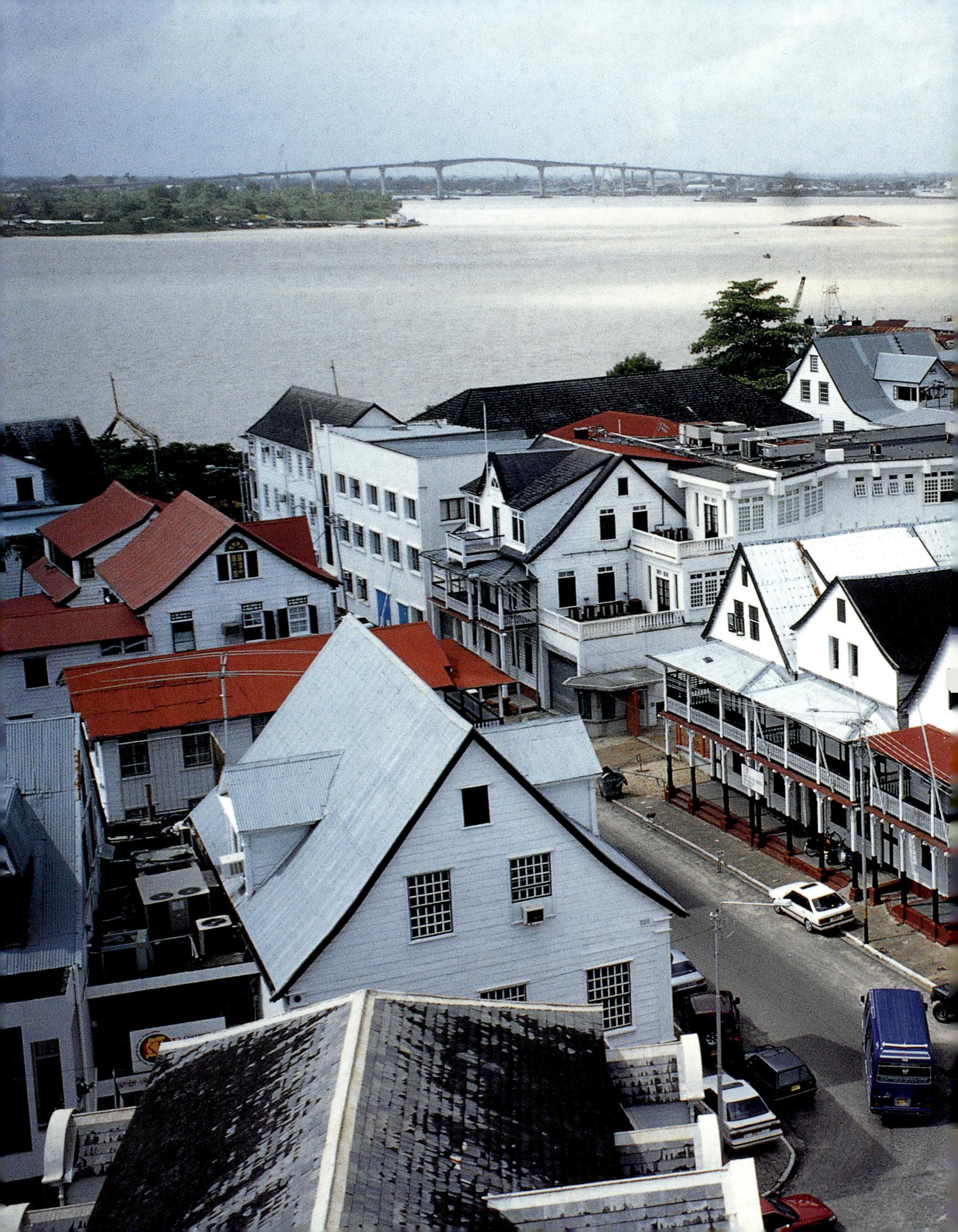

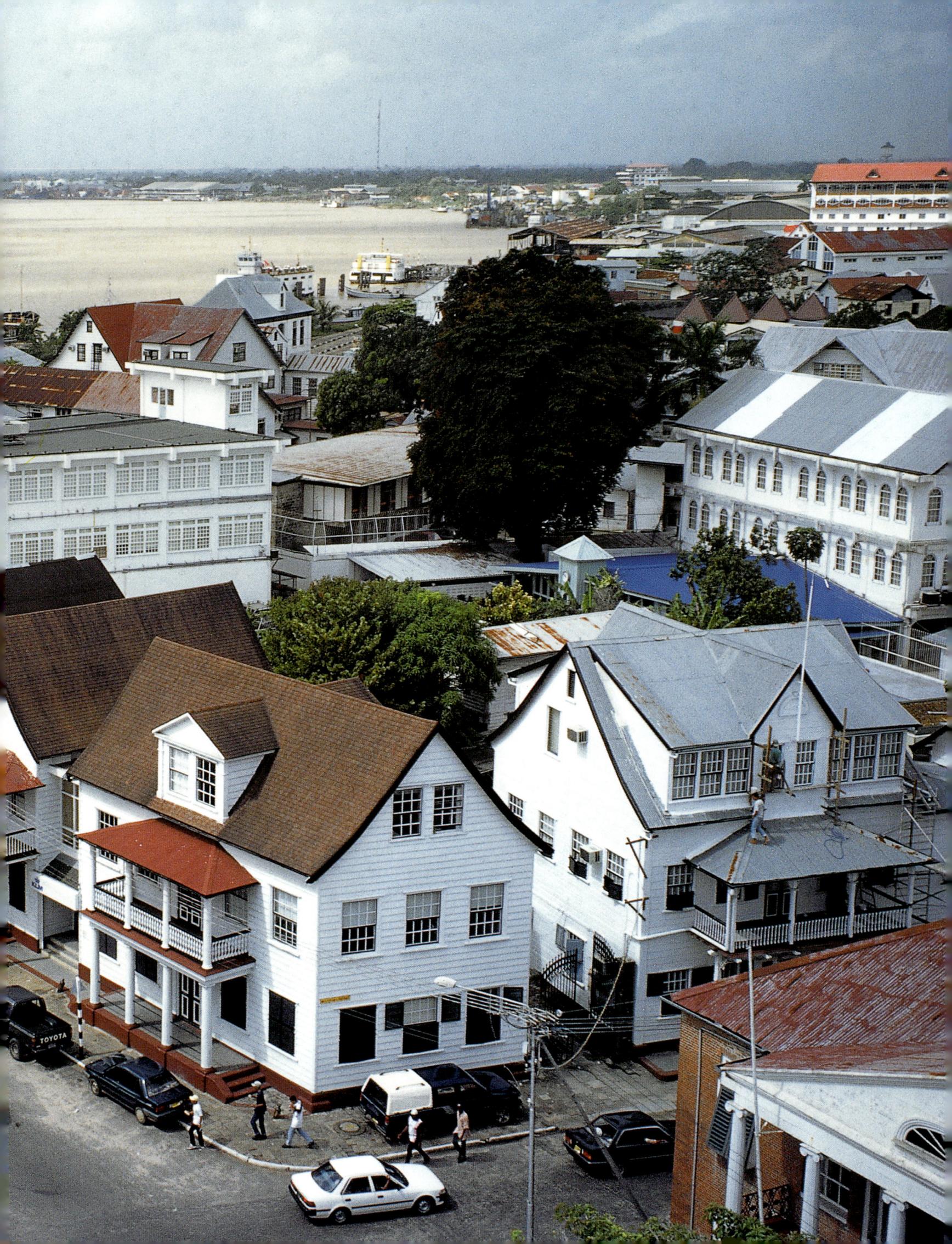

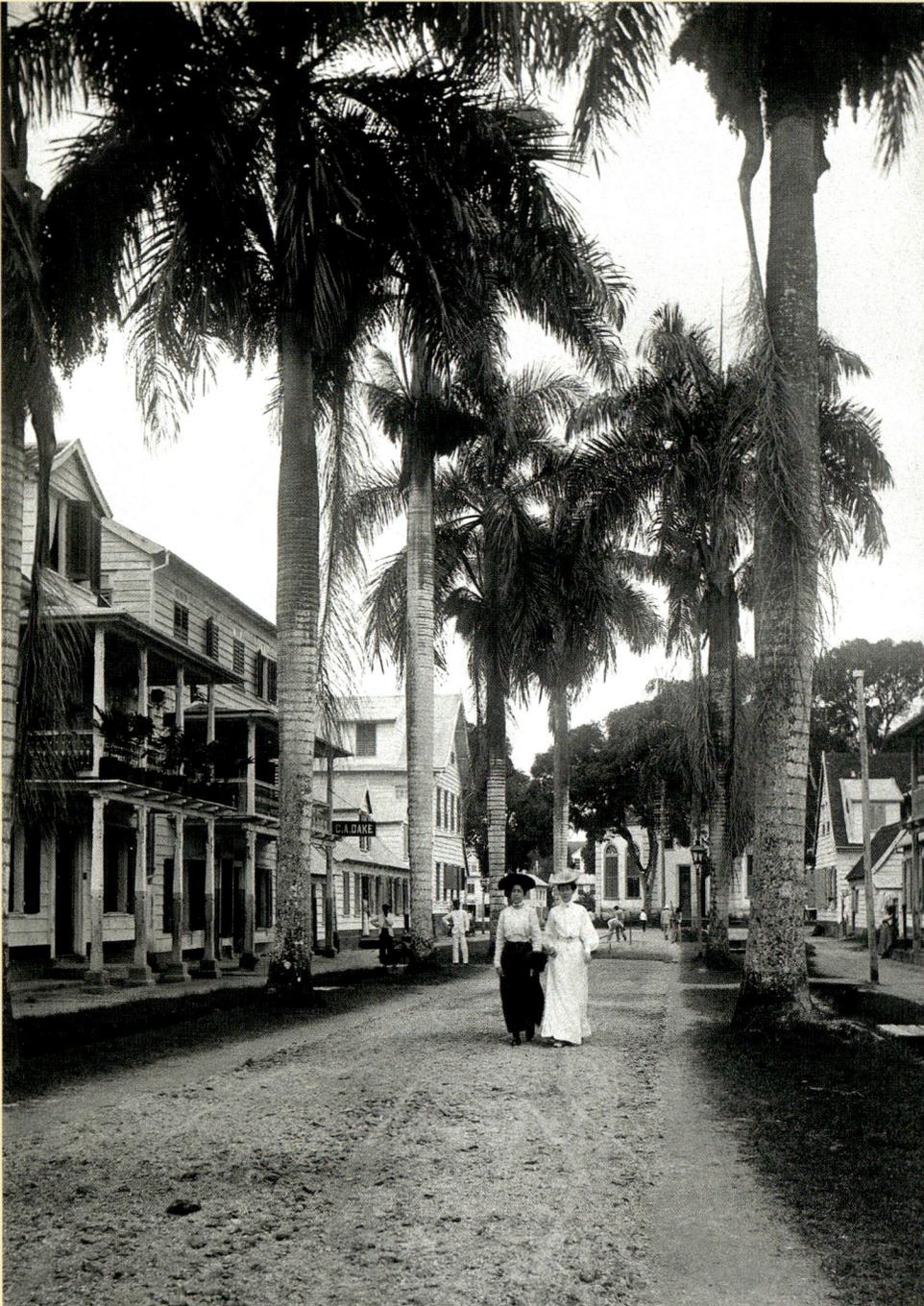

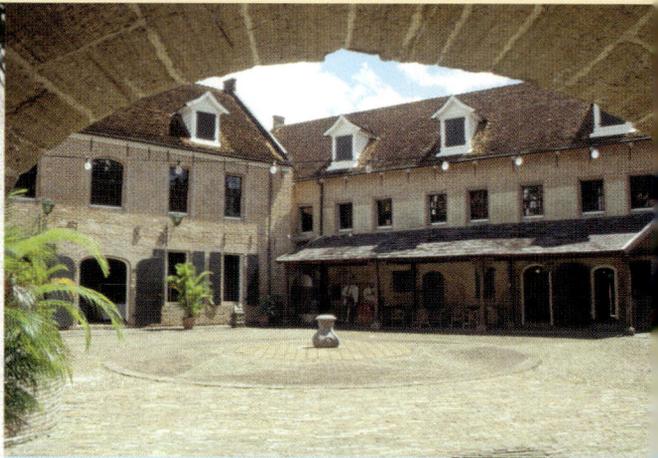

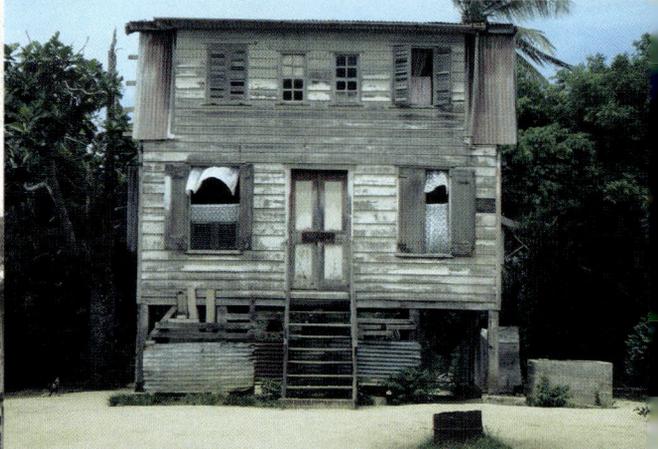

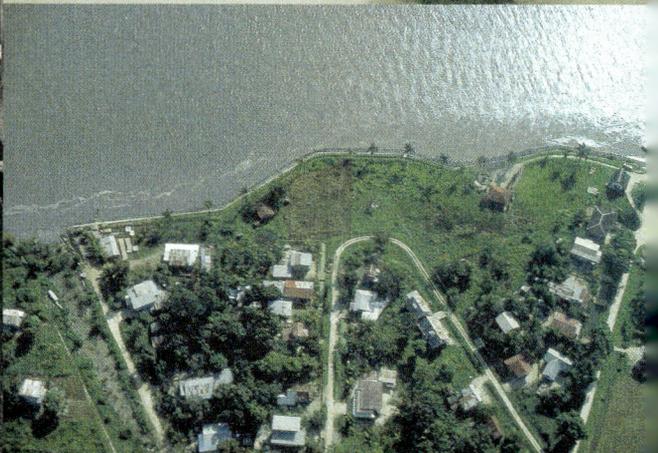

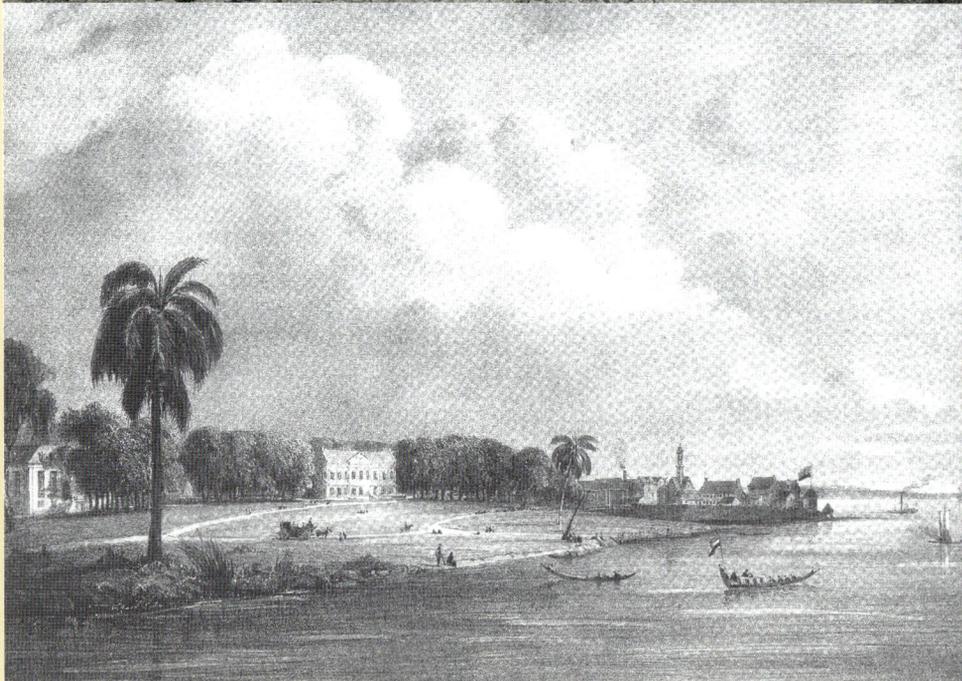

THE *city*

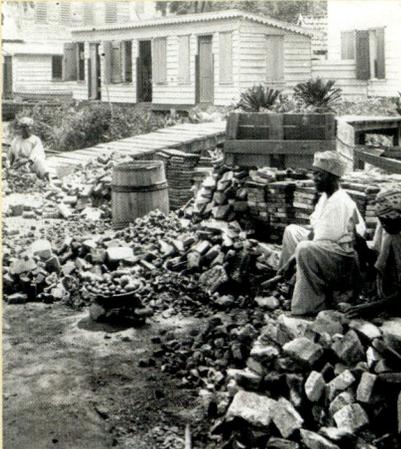

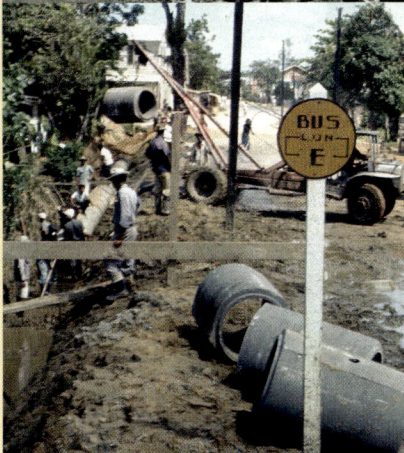

PAGE 122/123
Paramaribo with a
view of the beach and
bridge.
TOON FEY

PAGE 124
Noorderkerk Street,
Paramaribo, *c.* 1920.
KIT

Fort Zeelandia.
TOON FEY

Wooden house on
poles.
TOON FEY

Nieuw Amsterdam
from the air.
HENK LUTCHMAN

Paramaribo, *c.* 1835.
PIERRE BENOIT

Palm grove,
Paramaribo.
TOON FEY

PAGE 125
Women building a
road, Paramaribo,
c. 1925.
KIT

Drains and road
surfacing, Paramaribo.
KIT

Further
education
(physics),
Paramaribo.
FRANS
SCHELLEKENS

When talking about 'the city', one is obviously referring to Paramaribo. Paramaribo is the political, economical, administrative and cultural heart of Surinam. Surinam's only university, the occupational training centres and the most important medical facilities are all in Paramaribo. That Paramaribo was once known as the most beautiful capital of South America is easy to understand. The colonial architecture of white wooden houses and buildings makes the city very photogenic. Admittedly, it is in need of some maintenance. Buildings are in various states of decay or at least need re-painting. Renovations, well-planned house construction and the repairs to the cathedral have fortunately improved this situation and Paramaribo is slowly regaining some of its old glory.

125

From trading post to capital city

Instead of Paramaribo, another town in Surinam, Thorarica (an Indian name), could have become the capital city. When the Dutch conquered the English colony, Thorarica was a sizeable settlement with houses and a church situated some tens of kilometres upstream from Fort Willoughby. The Dutch, or, more precisely, the Zeelanders, did not like the location and decided to develop the existing trading post, 'Parmirbo', near the old English fortress only ten kilometres from the sea. The fortress was named 'Zeelandia' and the settlement 'Nieuw Middelburg'. It was soon renamed 'Paramaribo'. The old shell reefs were used as street foundations when extending the city, and work started on draining the marshy ground between these 'ridges'. Sommelsdijckse Creek, Steenbakkersgracht and Drambrandersgracht are just a few of the names still remind us of this reclamation.

Early Paramaribo had a Dutch look: the neatly laid-out, straight streets were flanked by rows of trees and swept nearly every day. Only a few of the original wooden houses have survived the frequent fires. The largest fire burned down more than

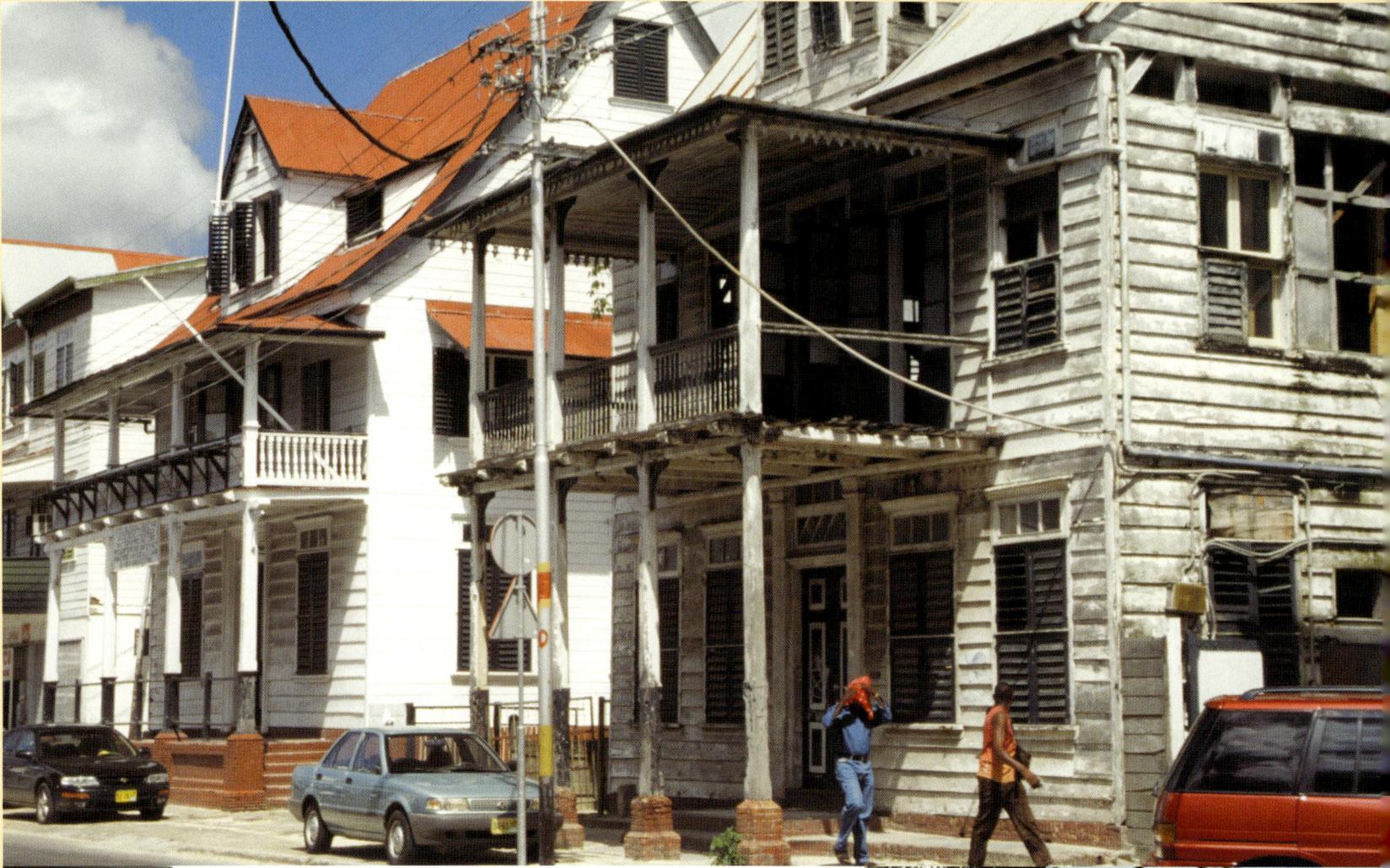

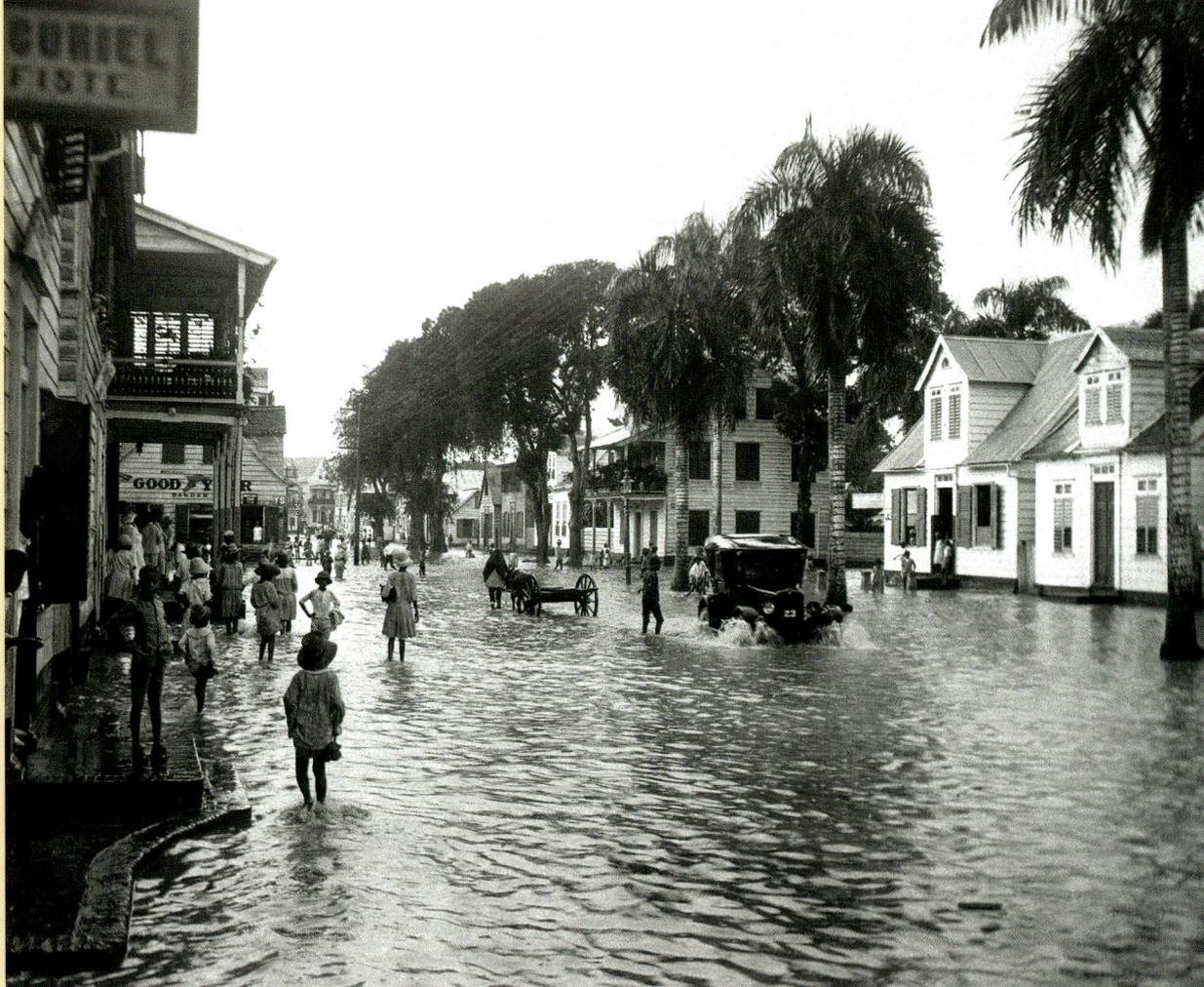

PAGE 126

400 homes and buildings as well as some churches in 1821.

Paramaribo has many streets with names that can also be found in Amsterdam, indicating that trade was mainly centred on Amsterdam. The population increased dramatically after the Second World War and farmland surrounding the city was turned into suburbs with names like Tammenga and Brussel. Former plantations north of the city were subdivided and urbanised. Suburbs with names like Rainville and Ma-Retraite reflect this history.

Architecture

The influence of Western European architecture on Paramaribo is evident, even to the untrained eye. The wooden houses, their balconies replete with iron railings typical of the southeastern part of the United States, also betray American influences. Despite the many foreign influences, a typical Surinam style developed with a clear passion for symmetry.

As in many (sub)tropical countries, highly reflective white was the prevailing colour used to paint the buildings. As a building material, wood allows for the attachment of ornaments to balconies, galleries, entrances, staircases and awnings. Stone foundations were the norm and the wooden structures often had gabled roofs. In some buildings, the first layer was made of brick; older buildings made entirely of brick are rare.

The use of more modern materials and techniques changed this characteristic way of building. New structures are almost devoid of Surinamese influence. Some new houses are still traditionally built on poles with a garage or storage space on the ground level and a living area on the first storey. This has several advantages: more wind, less vermin and better views. Modern suburban houses are made of concrete with small windows and air-conditioning.

Most of the houses are invisible from the street. Housing estates are hidden from view and the inhabitants of these one- or two-room units often share facilities.

127

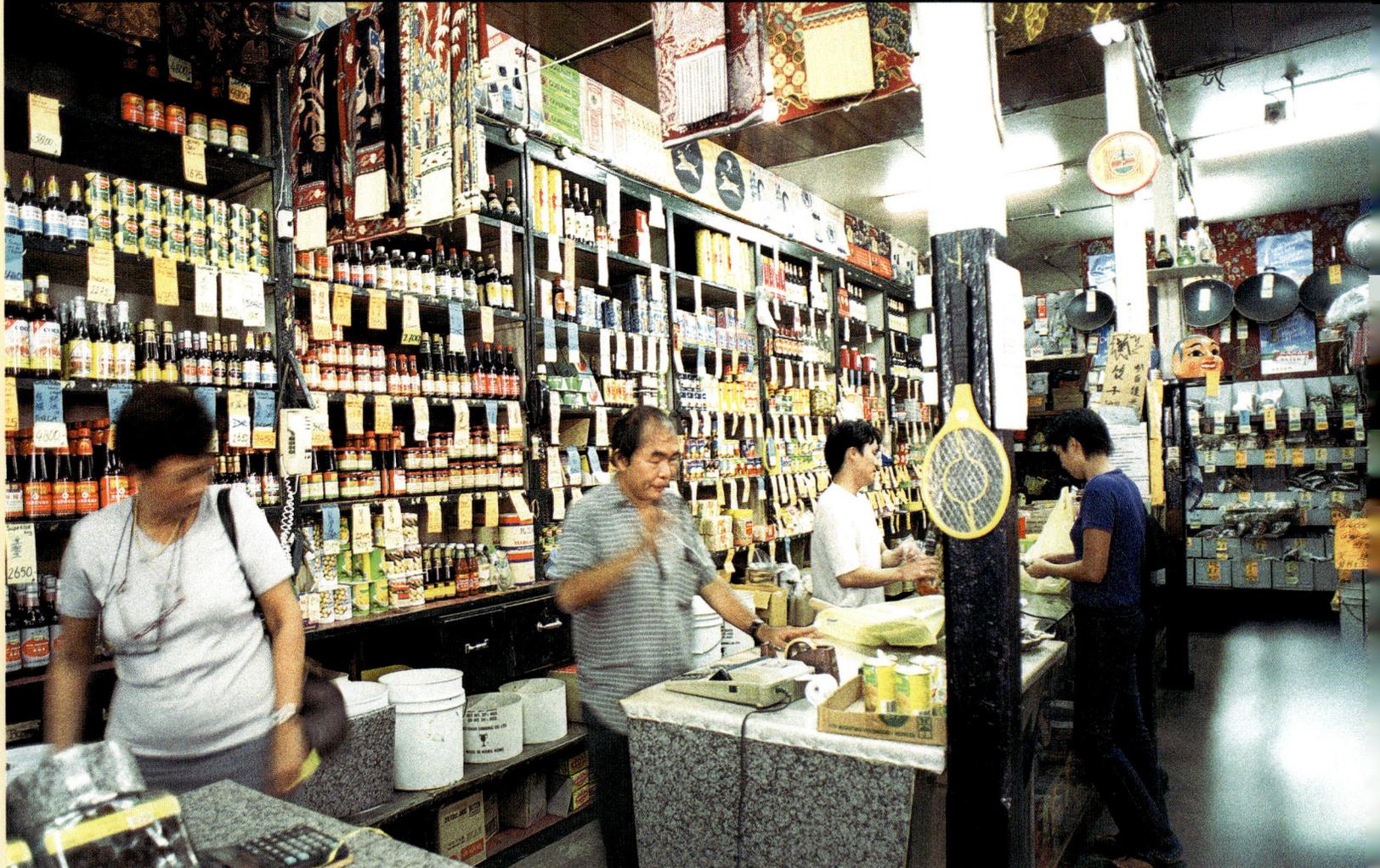

Schaafijs (shaved ice with coconut milk and syrup) cars.
TOON FEY
FRANS SCHELLEKENS
KIT
Attendant at an exhibition in Fort Zeelandia.
TOON FEY

The inhabitants

A stroll through Paramaribo offers a variety of cultures and activity. Chinese and Hindus own many of the shops and Javanese vendors offer their merchandise on the markets. It is not always immediately apparent that Creoles are by far in the majority in the city.

The city can be divided into suburbs along ethnic lines. This can be explained historically: after the abolition of slavery many former slaves settled in the city joining the freemen who had already acquired land there. A large number of domestic slaves already lived in the city. Creoles are still the largest population group in Paramaribo. Most of them live in the old city centre.

Later, Hindu immigrants settled on the edge of the small city, followed by the Javanese. Most Javanese and Hindus preferred living as far from the city centre as possible. The Javanese suburb 'Blauwgrond' is a good example of this. It was easier to live in their own community and the Javanese liked city life less than the Creoles who felt at home in the bustle.

Nowadays, most wealthy neighbourhoods have no specific ethnic signature and the population is completely mixed; people live here mainly for comfort and lifestyle.

Fort Zeelandia

Fort Zeelandia is the oldest building in Paramaribo and its history is inextricable from that of Surinam. After conquering the English, the Dutch extended the fortress, adding five bastions and a moat. The fortress resisted the French invasion of 1712 without much trouble, but it could not on its own block access to the Surinam River. A second fortress, 'Fort Nieuw Amsterdam' was built on the opposite side of the river to defend its mouth.

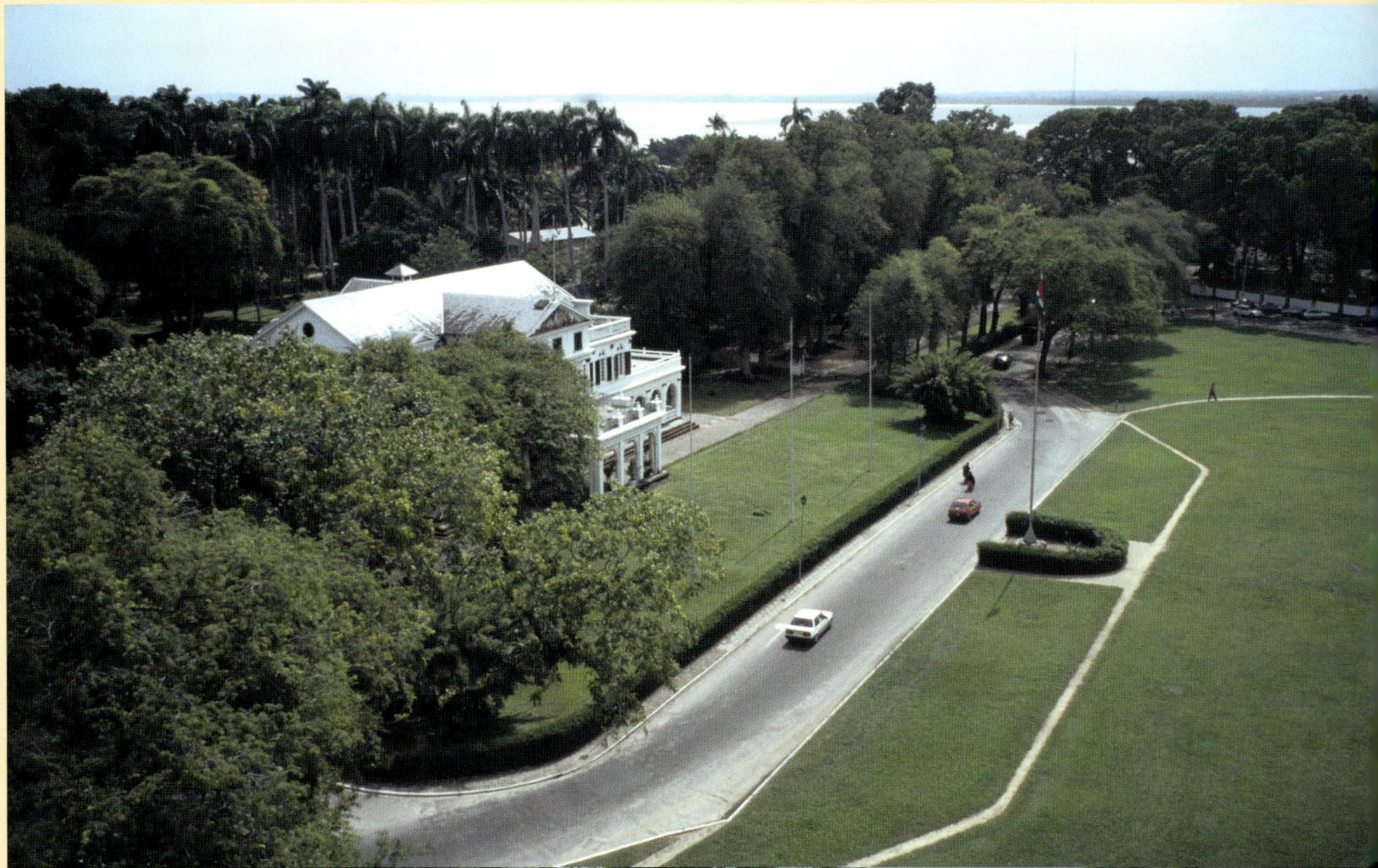

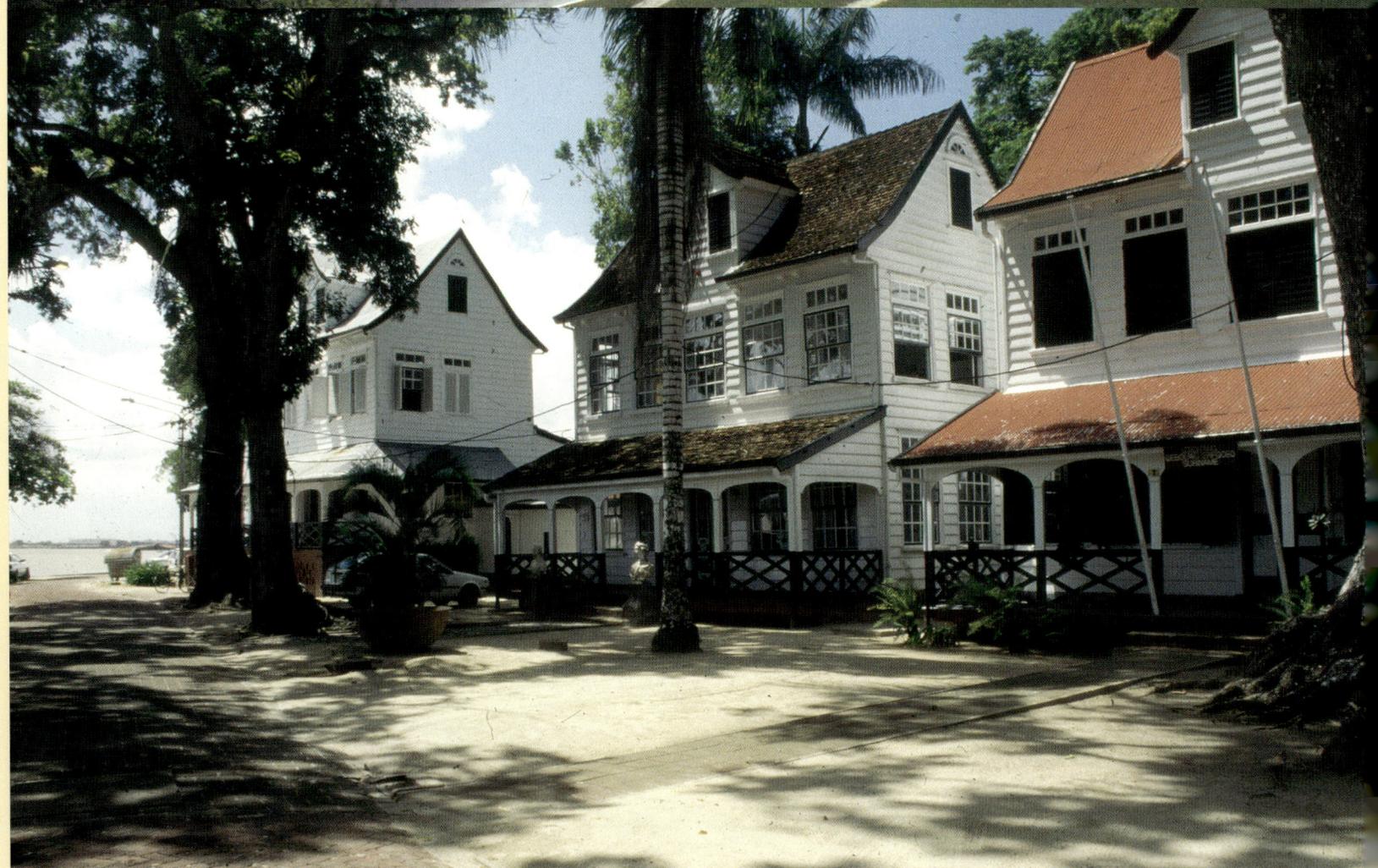

PAGE 130
Presidential palace.
TOON FEY
Zeelandia Road.
TOON FEY
PAGE 131
Palm tree.
TOON FEY
Grote Combé Road, the Palm grove at right.
TOON FEY
Ministry of Finance.
TOON FEY

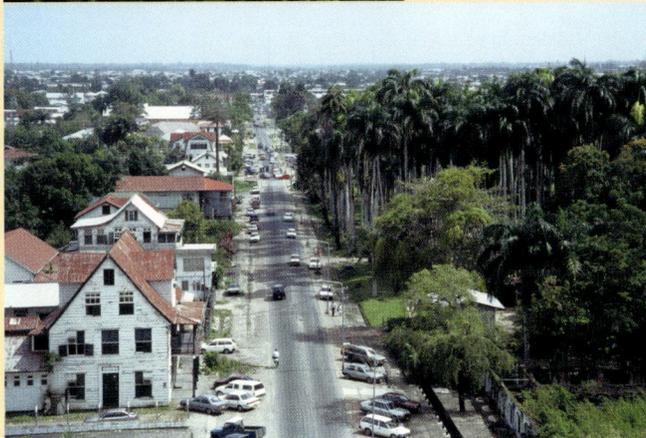

Bricks were valuable building materials that served as ballast in ships coming from The Netherlands. Therefore, two bastions of Fort Zeelandia had to be dismantled to provide sufficient building material for the new fortress. Fort Zeelandia was no longer used for defensive purposes and was converted into barracks, a storage depot and a prison to which plantation managers could send rebellious slaves. The moat was filled in. The names of the three bastions, Zierikzee, Middelburg and Veere testify to the Zeelander origins of their builders.

The fortress' reputation as a notorious prison was underscored twice in the last century. In the Second World War, two suspected collaborators were shot and killed here while 'trying to escape'. In December 1982, fifteen opponents of the military regime were murdered in the fortress. It is now a popular museum with a splendid view of the river.

The area around the Onafhankelijkheidsplein

For strategic reasons, the authorities left an open space between the fortress and the houses. Now called Onafhankelijkheidsplein ('Independence Square'), this large square is the oldest in Surinam and was used as a military parade ground. It is surrounded by a number of striking buildings.

The Ministry of Finance with its characteristic tower and clock is the most eye-catching of the buildings lining the square. It was built as a city hall in 1836 and soon became the seat of the Ministry of Finance. The Court of Justice was built entirely of brick in 1793. The Presidential Palace was formerly the governors' residence. The word 'Palace' is somewhat misleading, as the building has never actually been used as a palace. The nearby palm grove was once part of the palace grounds; now it is public space.

The cathedral

A remarkable building arose in the Gravenstraat between 1883 and 1885: a wooden cathedral built by Frans Harmes. Like the beatified Peerke Donders (who is buried here), he was a member

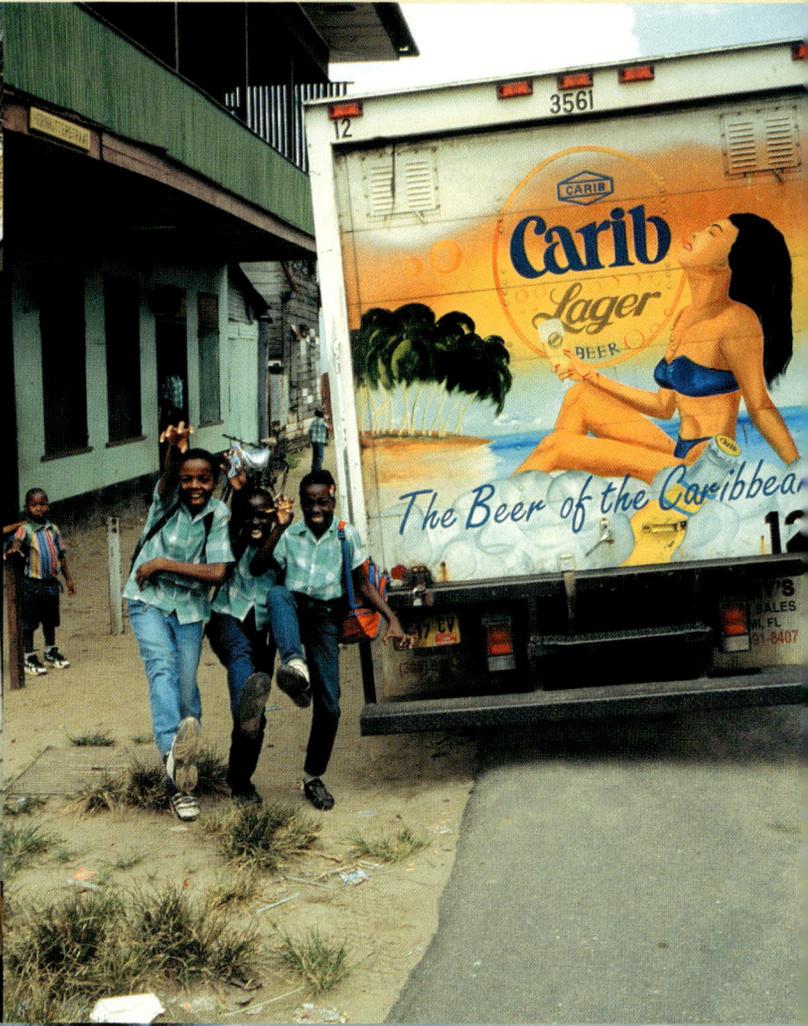

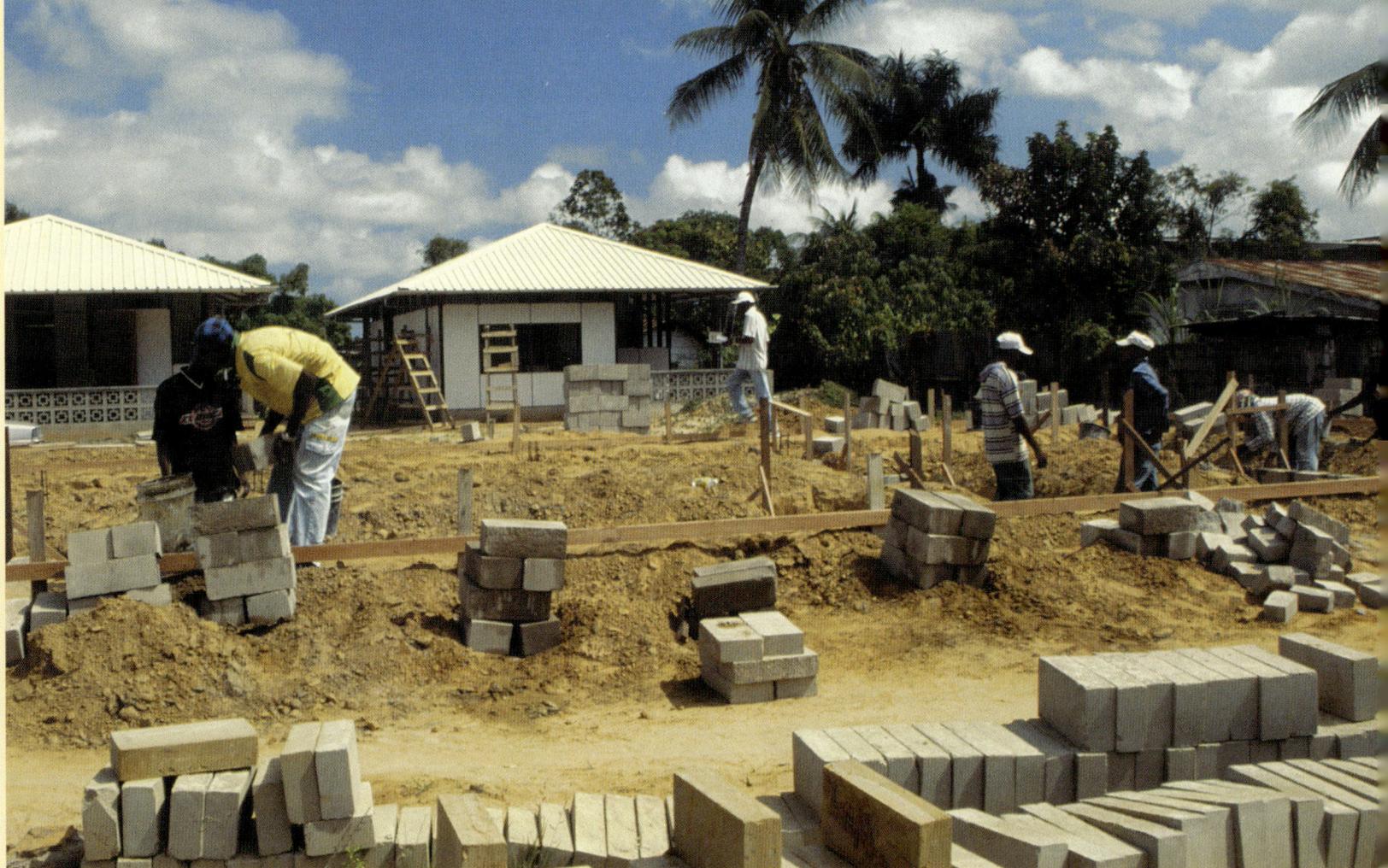

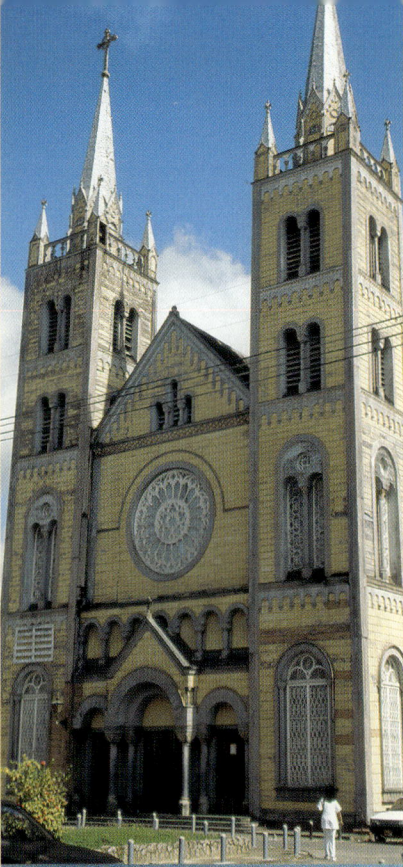

PAGE 132
Painters standing on improvised scaffolding, Paramaribo.
FRANS SCHELLEKENS
School children.
FRANS SCHELLEKENS
Social housing development, Plein Va, Paramaribo.
TOON FEY

PAGE 133
Paramaribo cathedral.
KARIN ANEMA
Wanica Road; the southernmost city expansion is absorbing former farms. The Suriname River in the background.
HENK LUTCHMAN
Completed social housing.
TOON FEY

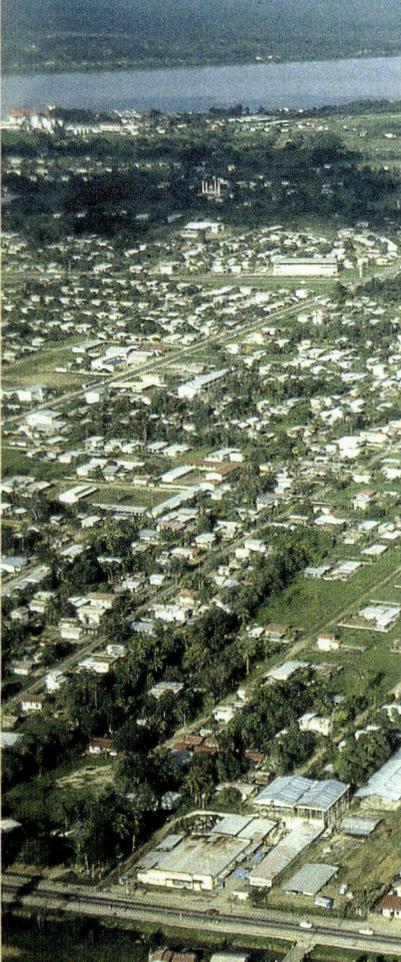

of the Order of the Redemptionists. The cathedral is generally known as the largest wooden building in South America although this has been disputed by Cayenne (French Guyana). Nevertheless, it is one of the largest wooden buildings in the world. The interior has been splendidly finished with cedar.

The cathedral was seriously neglected during the second half of the last century and termites, structural subsidence, leakage and substandard repairs exacerbated its deterioration. A restoration strategy has been developed and subsidies were granted some time ago to restore the monument and create a multi-purpose complex. Apart from its traditional religious function, the building will include spaces for conventions, concerts and other activities.

133

The Central Market

The central market of Paramaribo is a beehive of activity. Activity starts at night when trucks and pick-ups deliver all sorts of vegetables, fruit and other produce from the countryside. Old photographs show how the market once consisted of covered stalls. Most of the market was relocated to a huge shed in later years.

The stalls along the waterfront mainly sell fish. Meat, fruit and vegetables are still the leading merchandise but in fact all sorts of products are traded. These are partly 'dumped goods', such as cheaply imported clothing, shoes or bags rejected by or too outdated for Western markets. The market cannot house all the vendors, which means that some of them, called 'Hosselaars', offer their home grown produce outside of the market area without paying market fees. Moneychangers are also found here.

Wealthy people tend to avoid the hot, bustling market building. They prefer the American/European style supermarkets that obviously have less character and variety.

Urban renewal and housing development

Paramaribo has a considerable shortage of houses. The wooden dwellings are often very dilapidated. There is a great need for

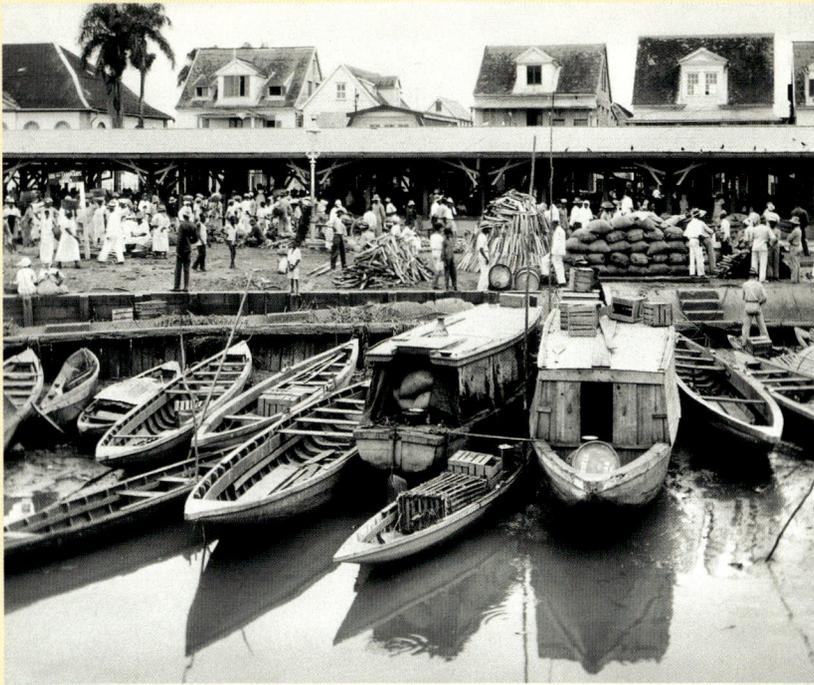
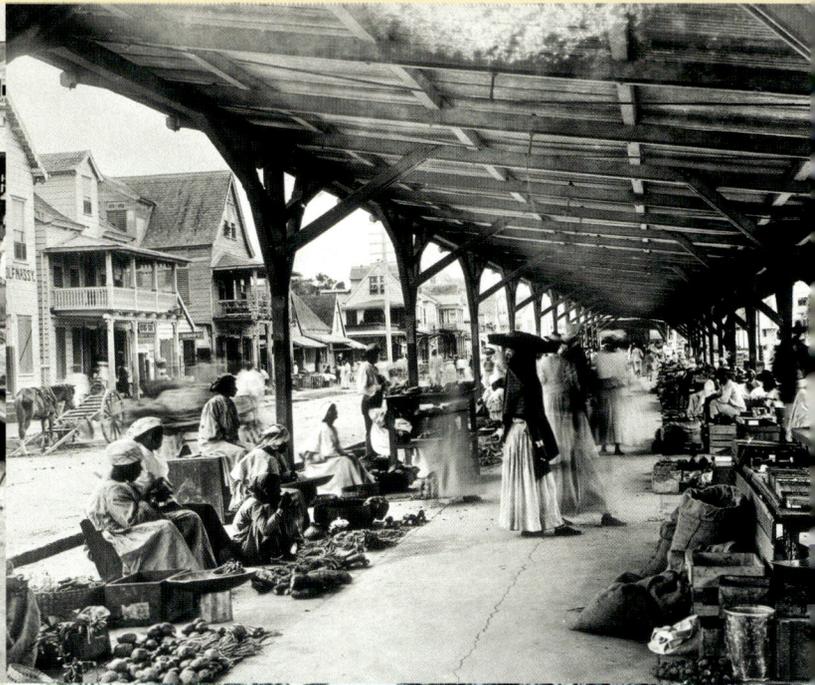
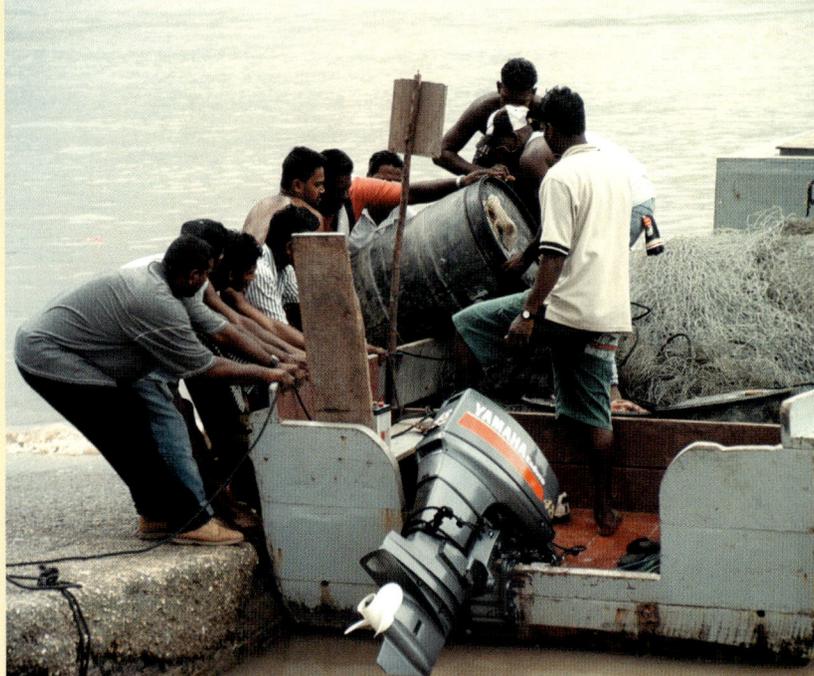
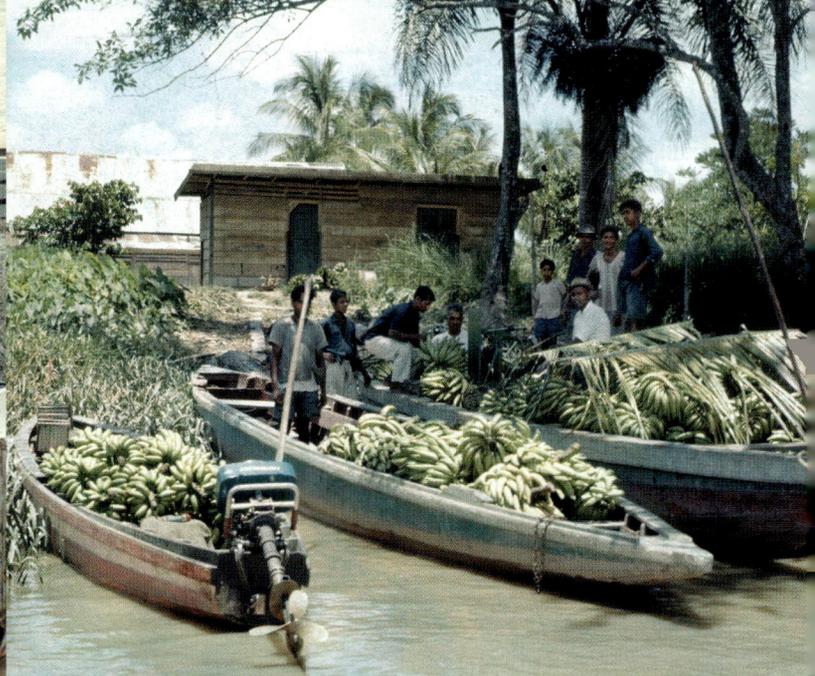

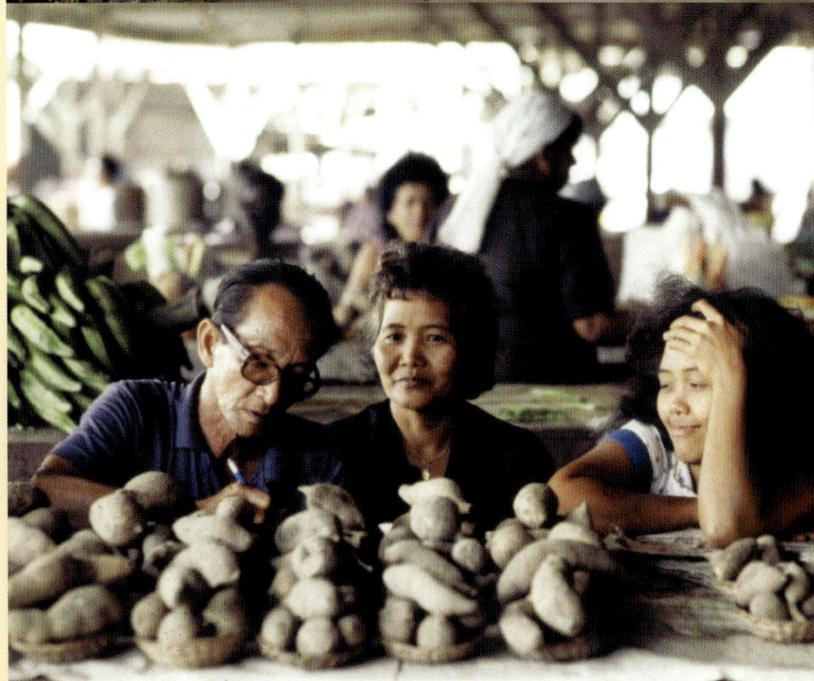
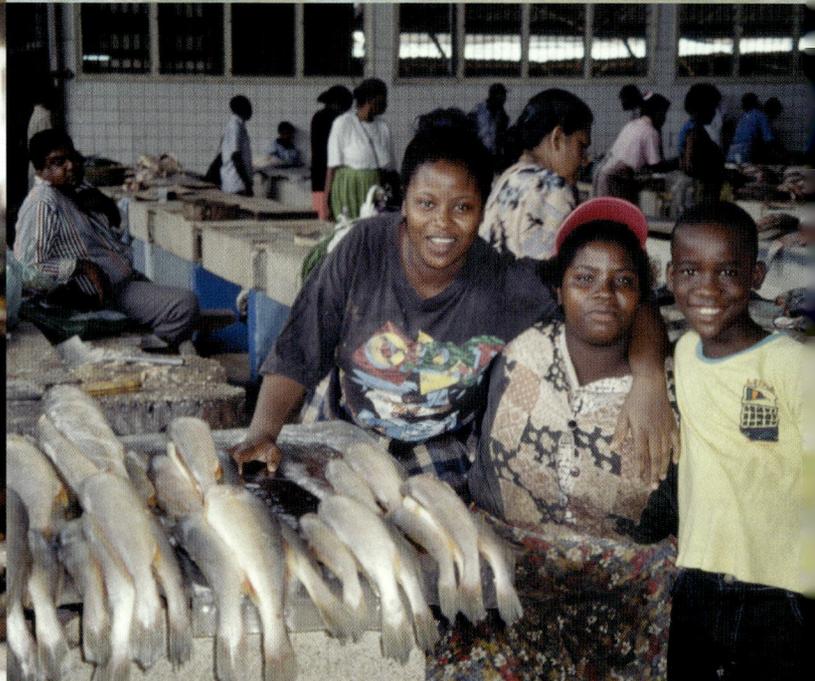

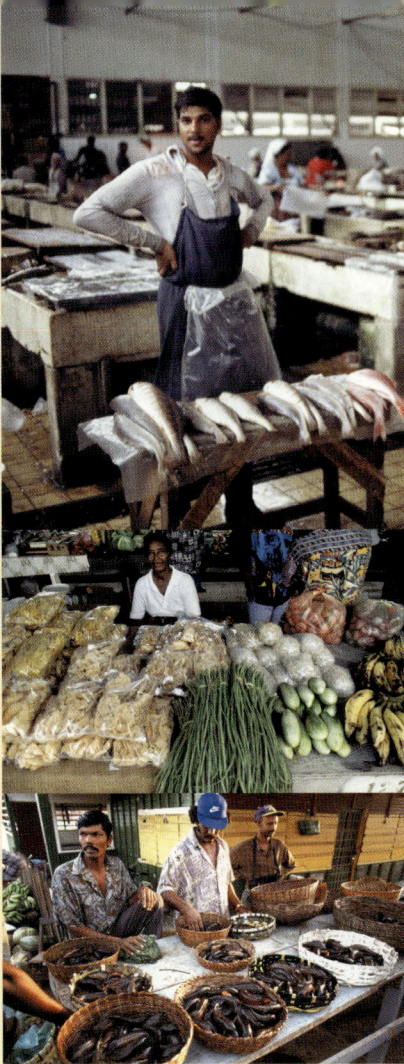

PAGE 134

Paramaribo Market, *c.* 1915. At the time, goods were usually delivered by water.
KIT

Market, *c.* 1925.
KIT

Canals are used to transport goods to market.
FRANS SCHELLEKENS

Javanese market vendors selling yams.
FRANS SCHELLEKENS

Fish stalls at the Central Market.
TOON FEY

PAGE 135

Fishmonger at the market.
FRANS SCHELLEKENS

Fruit and vegetables.
KIT

Sweetwater fish (*kwi kwi*) for sale at the market.
ROY TJIN

Homeward bound.
TOON FEY

Delivering cabbage to market.
KIT

Pickling.
KIT

Plate of warm Surinamese food (l. to r.). banana (*bacove*), *tajerblad*, *antruwa*, okra, tomato, paprika, lettuce, cabbage, madam Jeanette peppers (very hot so used in limited amounts), and chicken with *masusa alesi*.
ROY TJIN

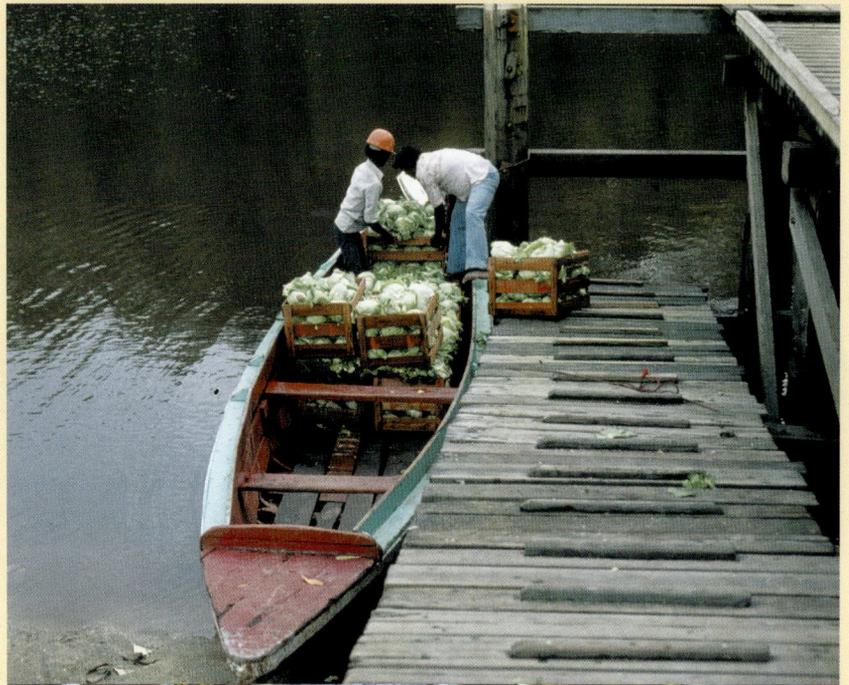

135

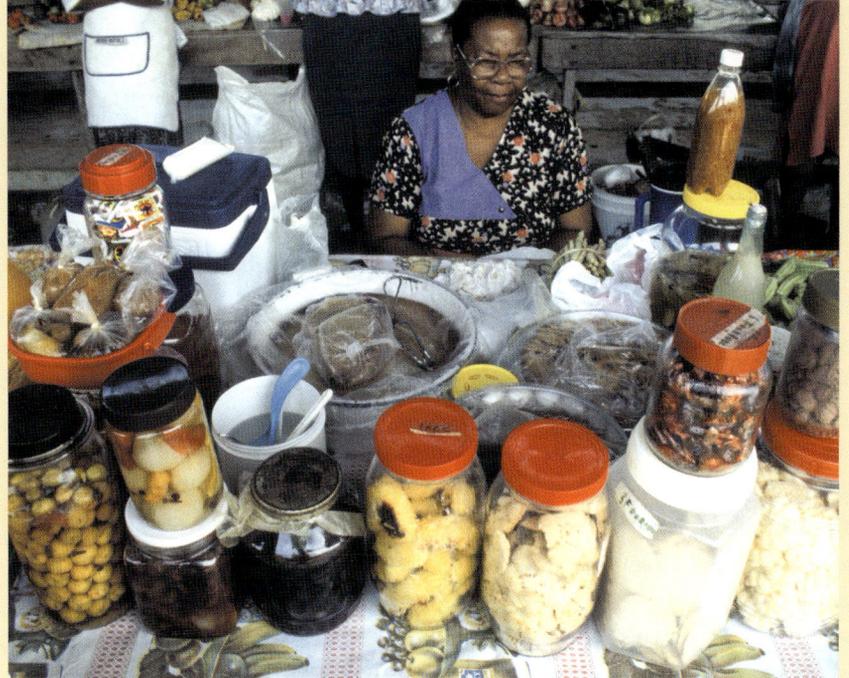

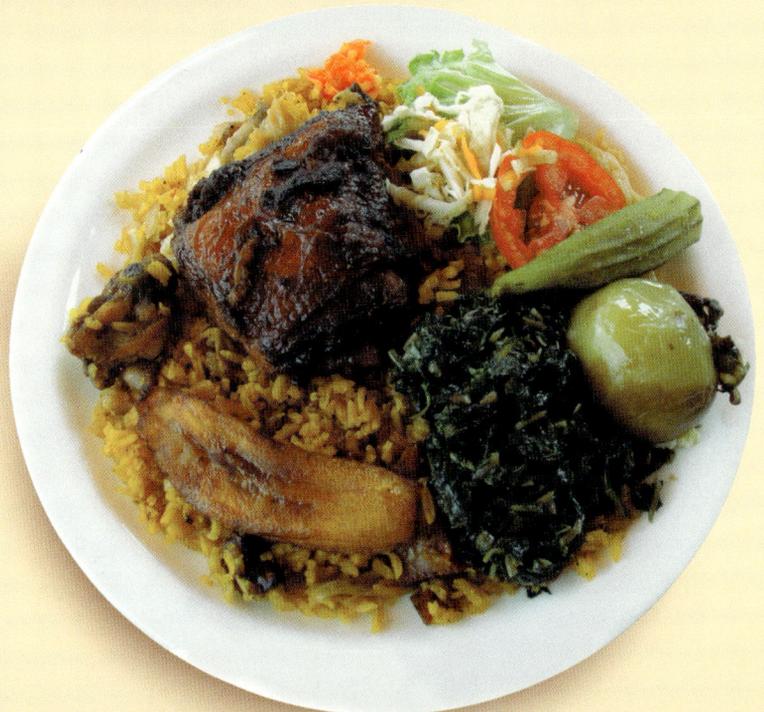

comfortable and affordable housing. Surinam does not have a public housing policy or house construction projects but this situation seems to be changing. The Sekrepatu Foundation builds and manages building projects. It is not common in Surinam to rent a house.

Improving the quality of life is the main focus in Frimangron, a suburb bordering the old city centre. New building projects are not an option because of the historical and architectural value of the neighbourhood. Run-down houses and schools are being renovated. Inhabitants and proprietors are being involved in this process as much as possible.

Relatively simple prefabricated techniques can be used for the construction of comfortable houses. Some of these have been built on 'Plein Va', an area created by combining a number of back yards. A contractor built the first (rental) houses, but citizens are encouraged to take the initiative. By using the often-neglected back yards, the 'Plein Va' project proved that development within city limits is possible. 'Wooncentrum Mariënburg', another housing project where inhabitants can erect their own prefab houses, has been started on the site of a former plantation.

THE CITY AND ITS CULTURE

New art forms are often born of the hybridisation of cultures in capital cities around the world. Paramaribo is certainly no exception and although Surinam does not have a large population, the city has a wealth of cultures. The following overview touches on art forms specific to Surinam. It does not include the traditional art of the Hindus or Javanese, for example.

Music

Kawina is a type of music integral to Surinamese life and can be heard in almost every public place. Kawina probably become popular when Creoles worked on plantations along the river Commewijne in the post-slavery era. It is rhythmic music with African influences: the instruments are mainly drums of different sizes that produce a variety of sounds. Complex variations on basic rhythms are played on smaller drums. The rhythm section can be extended with rhythm sticks, a referee's whistle or shakers. A lead singer and a choir provide the vocals.

Kawina is played in every neighbourhood in spite of being originally Creole music and has become popular with other ethnic groups. There are even Hindu Kawina bands.

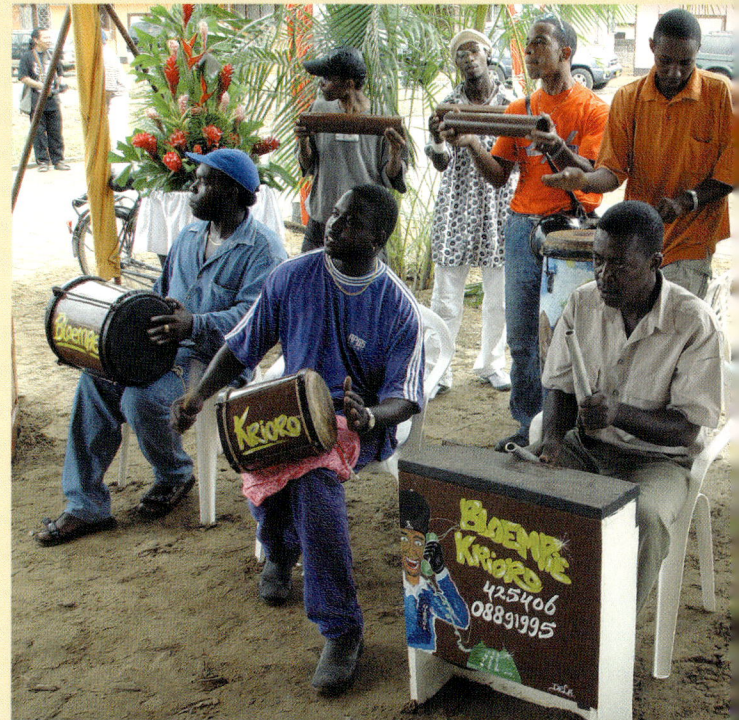

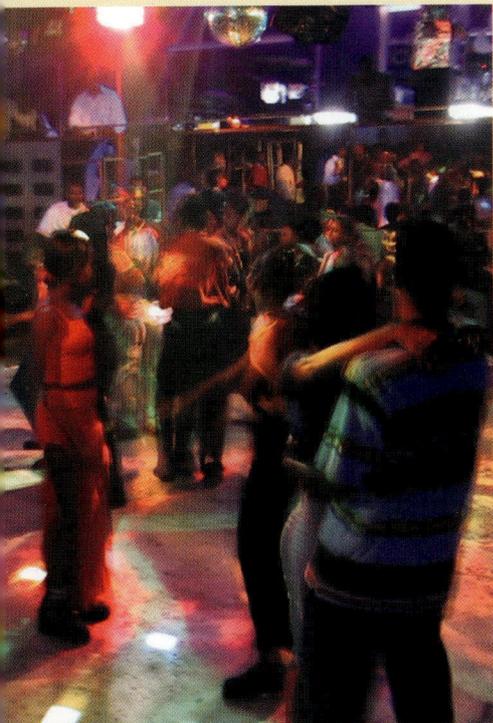

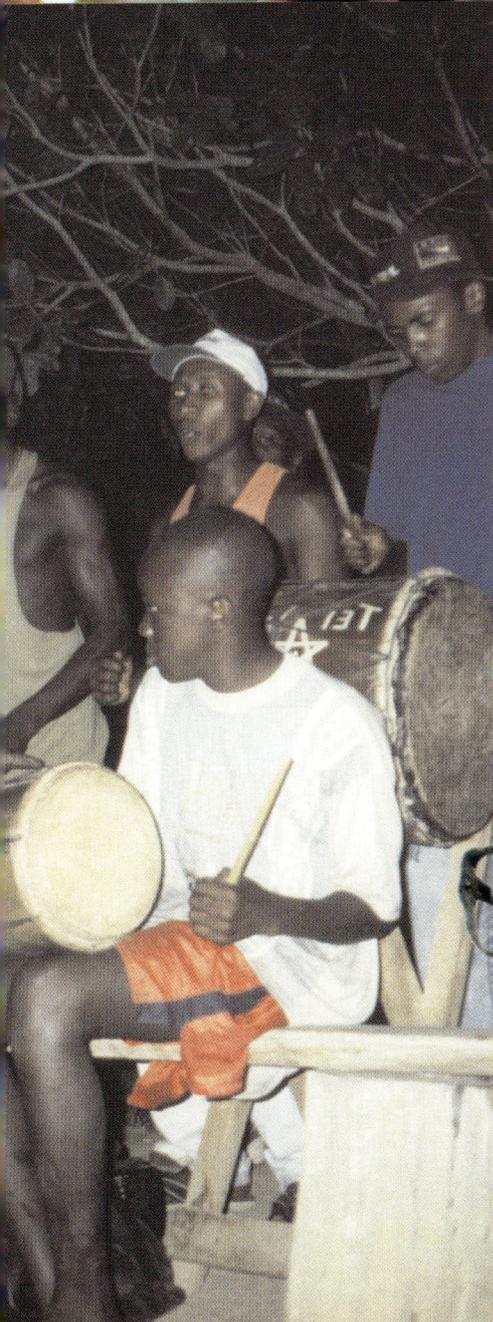

PAGE 136/137
Kaseko band
'Bloempie'.
ROY TJIN
Discotheque in
Paramaribo. The
music differs from
Western dance music
and has deep roots in
Caribbean music.
FRANS SCHELLEKENS
Kawina band
performing inland by
night.
TOON FEY
Bust of Eddy Snijders,
a composer of
contemporary
Surinamese music.
ERIK SOK

Its popularity is easy to explain: Kawina is passionate music that can be played anywhere on cheap instruments.

Kaseko is the music of the urban Creoles. It is not as old as Kawina. It became enormously popular after the Second World War. Kaseko, very catchy dance music, came into being by mixing traditional Maroon music with Kawina and popular Latin American and Caribbean dance music such as the rumba and calypso. A Kaseko band has drums, percussion instruments such as the cowbell, guiro or maracas, electric bass and lead guitars and a wind instrument section. Several Kaseko styles have developed by incorporating new rhythms such as reggae. Both Kaseko and Kawina experience renewal and variation in times of cultural crossover. Aleke, a modern form of Kaseko, is an example.

Hindu music is much more calm and sentimental than Creole music. Baithak Gana music is very sweet and often heard in the soundtracks of romantic Indian movies.

Javanese music is strongly influenced by Western music as can be heard in the performances by Pop Jawa bands. Traditional Gamelan music is only popular with older people.

Western classical music is not very popular in Surinam. Classical instruments are taught at the Surinam Folk Music School but there are limited career possibilities. There is no professional classical orchestra in Surinam. Classical piano and guitar are reasonably popular, possibly because both instruments can be played solo. The really talented students are obliged to attend foreign conservatoires.

Western choral music is derived from Christianity and is reasonably popular. Some choirs have gone in a more modern direction and perform music by Surinamese composers. This leaves the military and police brass bands, which offer good musical training for young musicians

137

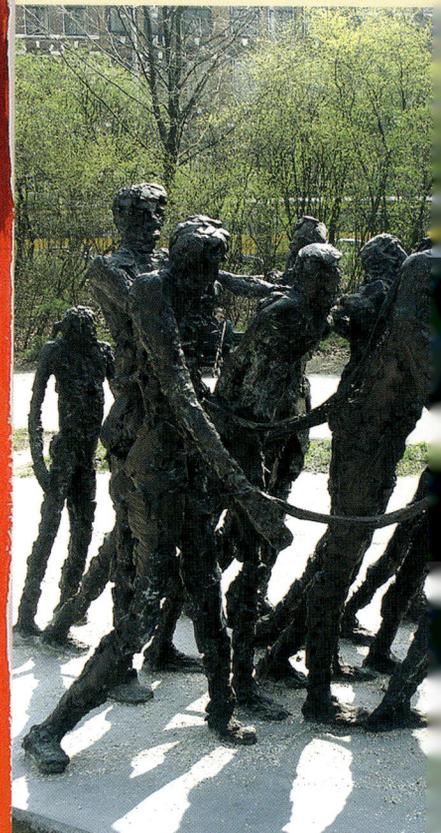

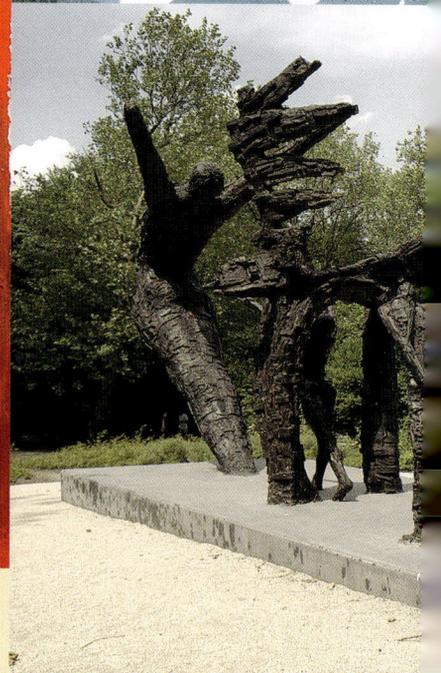

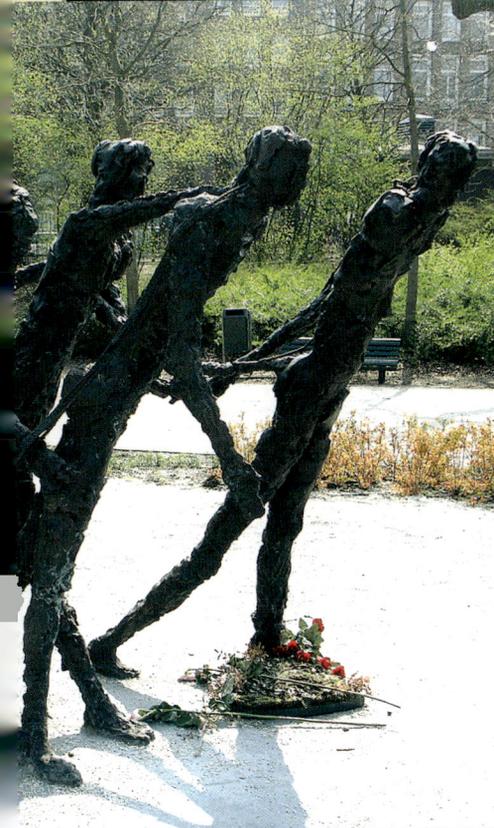

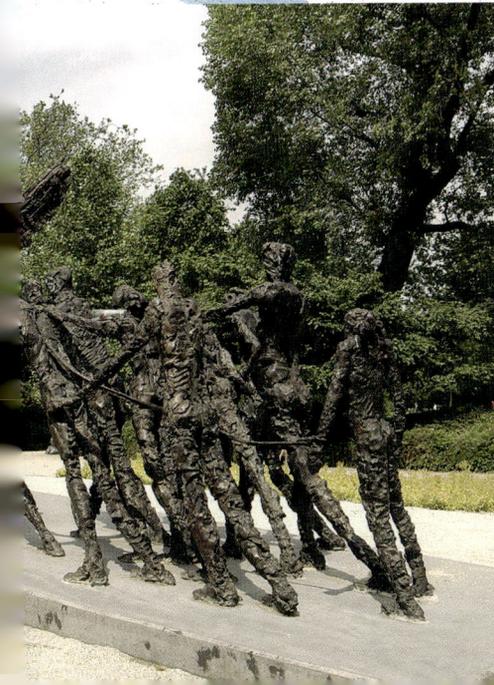

Theatre

Traditional theatre is popular in Surinam and performances are often based on social themes. Establishing a tradition is difficult as there are no professional theatre groups, no continuity and insufficient funding.

Folk theatre draws a lot of attention in Surinam. These mostly amateur plays are so popular that they are often performed several times a night to full houses. The plays are based on current affairs and are full of exaggeration and effects.

Creole performances are the most popular of all, largely because they are spoken in Sranantongo, which lends them an authentic Surinam character. Hindu folk plays are often delivered in Sarnami, while Javanese performances are in Surinam Javanese. The impact of folk theatre is not attributable to the artistic level of the performance but to the way themes taken from real-life are illuminated through theatre.

Visual arts

The life of a visual artist in Surinam is not easy. Surinam has no subsidies or benefit funds. The level of education leaves much to be desired and materials can be hard to come by. The geographical position of Surinam is furthermore not beneficial to the exchange of ideas. The Nola Hatterman Institute relieves some of this burden by educating young artists and introducing visual arts to young children. The institute is managed by established artists and is based in one of the officers' residences of Fort Zeelandia.

Nonetheless, Surinam art is thriving and is starting to attract international attention. Many Surinam artists have been educated at foreign art academies, especially in Amsterdam, Rotterdam and The Hague. There is no lack of styles and influences. Nearly all movements in painting can be recognised in the work of

Surinam artists, from Impressionism to Expressionism, Cubism to Pop Art, Abstract Art to Photorealism.

While a Surinamese movement has yet to evolve, a lively, inspiring collective of styles and views can be recognised. Besides Western and Caribbean influences, ethnic influences, including Creole, Javanese, Hindu, indigenous and Maroon, are clearly evident. Artists are aware that an ethnic background is not sufficient for making art and therefore cannot be the sole inspiration of an artist.

This could lead to the conclusion that Surinam visual art is not unique. This is definitely not the case. The reappearance of figurative and realistic elements, possibly inspired by the tropical environment with its spectacular nature, its splendid palette of colours, the bright light, the skin colour and the colourful clothing, is very striking. These very vivid circumstances, rather than a visual or intellectual approach, seem to influence artists.

A common theme can be found in the subject matter: the human condition, local inhabitants and nature. The question of whether art copies the world or if the world copies art is a philosophical question and one that will preoccupy a young nation such as Surinam in the years ahead.

Literature

Literature matured in Surinam long before visual arts. Writing, after all, requires only a pen and paper. The Dutch and other Europeans were the only people who wrote about Surinam in the first centuries of its existence. Slaves were not allowed to write. The first writings were usually travel journals about inland expeditions or life on the plantations. Slavery was sometimes fiercely criticised, although from a colonial perspective. Matawai Johannes King was the first, and for many years the only, black writer.

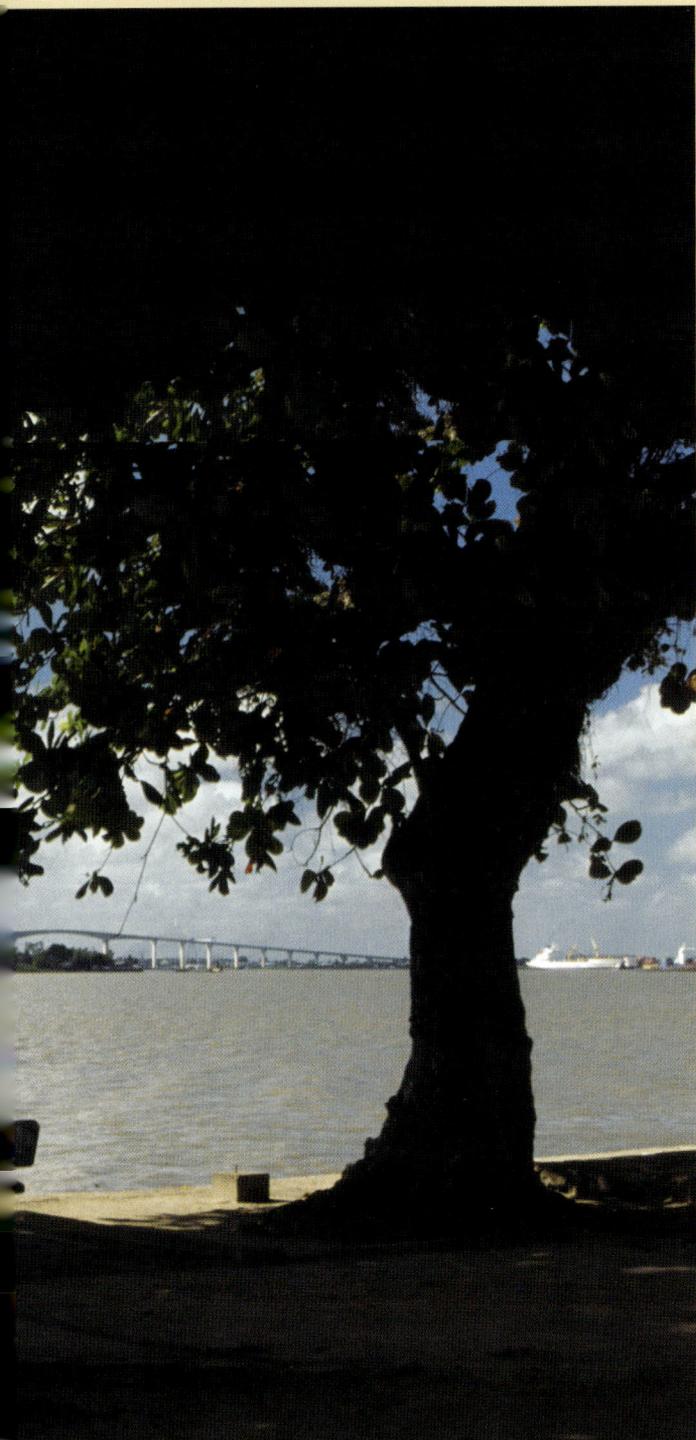

As mentioned previously, missionaries from the Evangelic Brotherhood, the 'Hernhutters', learned the language of the slaves, it being vital to their work. They were able to translate Bible passages into Sranantongo. King's book, titled *Skrekibuku* ('Book of Horrors'), contains episodes from his own life combined with biblical imagery of hell and condemnation

Two writers are generally considered to be the fathers of Surinam literature: Albert Helman and Anton de Kom. Both authors lived in The Netherlands and wrote passionately about the country they had left behind. The longing for their country of birth and the feeling of total isolation apparently inspired them to write such powerful stories about Surinam.

Those wishing to continue their education after a good basic schooling usually had to move to The Netherlands, which was also the place where writers could develop their skills. It was almost impossible to make a living as a writer in Surinam. As it was once the colonising power, unconditional love for The Netherlands was hard to find among the intellectuals that had moved there. Their stay in The Netherlands changed their opinions of their country of birth, which could not sustain or keep its talented people. This paradox is a recurring theme in Surinam literature. Michael Slory and Dorus Vrede are the only two significant writers that have remained in Surinam. The way they live leaves much to be desired. A shift can be seen in the literature of the last few years. Outspoken Surinamese topics have replaced life between worlds as the main theme. The historical novels of Cynthia McLeod and Clark Accord are examples of this.

By comparison, poetry is often written in native languages such as Sarnamian, Javanese, Saramaccan and Acadian. Sranantongo has long been a popular language with Surinam poets. Some poets write in Sranantongo as well as in Dutch. Shrinivasi (a pseudonym for M. Lutchman) was the most famous poet to write in Dutch.

141

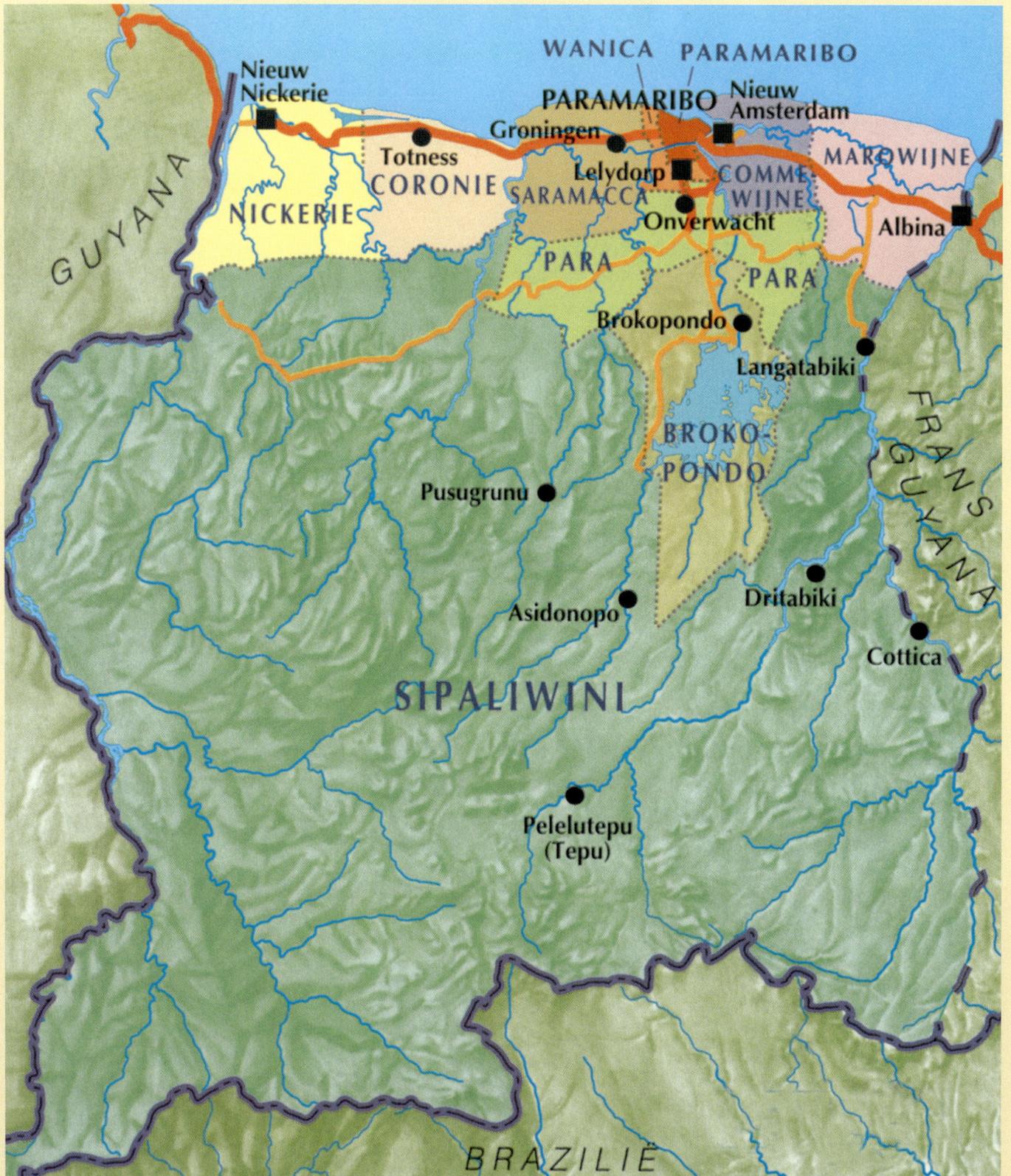

GUYANA

Nieuw
Nickerie

WANICA PARAMARIBO

PARAMARIBO

Nieuw
Amsterdam

Groningen

MAROWIJNE

Totness

CORONIE

NICKERIE

Lelydorp

COMME-
WIJNE

SARAMACCA

Onverwacht

Albina

PARA

PARA

Brokopondo

Langatabiki

BROKO-
PONDO

FRANS
GUYANA

Pusugrunu

Asidonopo

Dritabiki

Cottica

SIPALIWINI

Pelelutepu
(Tepu)

BRAZILIË

THE *ten* DISTRICTS

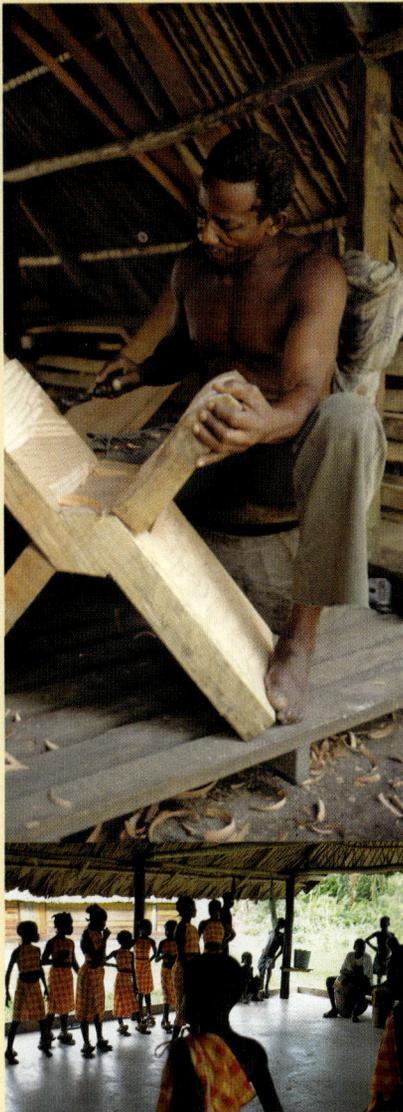

The Surinam territory is divided into ten districts, which are in turn sub-divided into jurisdictions. The district-commissioner is the head of the district administration. Each district is represented in the National Assembly by a proportional number of elected members of parliament. Paramaribo is a separate district that has been described elsewhere in this book and therefore will not be discussed the following summary.

Wanica

Wanica is one of the smallest districts, but it has the second highest population (more than 76,000) after Greater Paramaribo. The district includes much of the capital city and has a relatively high number of arterial roads, such as the busy Indira Ghandhi Road to the Johan Adolf Pengel Airport, the official name of the airport at Zanderij. The road also runs to Lelydorp, the district's most important town.

Lelydorp has grown into a bustling town and is the gateway to Paramaribo: fuel and provisions are bought here before travelling inland and those living in the interior buy their tools and supplies here. Kwatta Road (which turns into Garizoens Path) is the arterial road to Coronia and Nickerie and is an important supply-route to the city for a variety of agricultural produce. One of the best-known side-roads is the Weg naar Zee ('Road to the Sea'), which ends at an open-air crematorium used by Hindus.

Many small farms line the roads in Wanica but increasingly more businesses and commuters are settling here. The swampy area west of Lelydorp, which stretches to the Saramacca River, is the least populated region of Wanica. The Maroon village Santigron near the Saramacca River is a popular tourist destination for those wishing to acquaint themselves with Maroon culture.

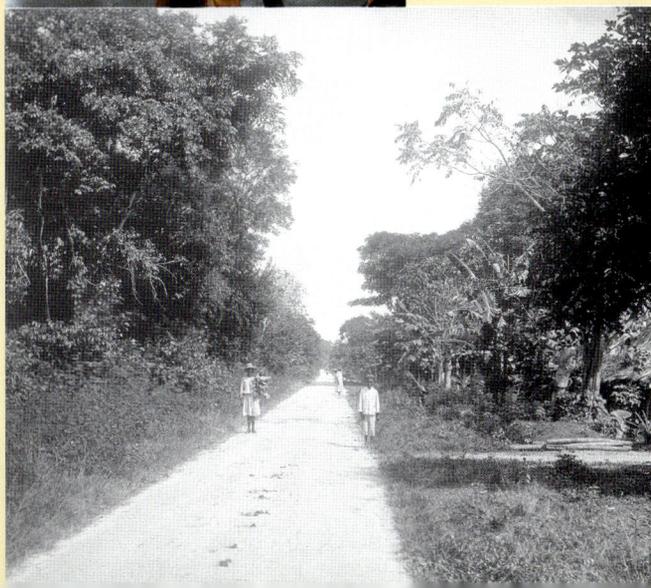

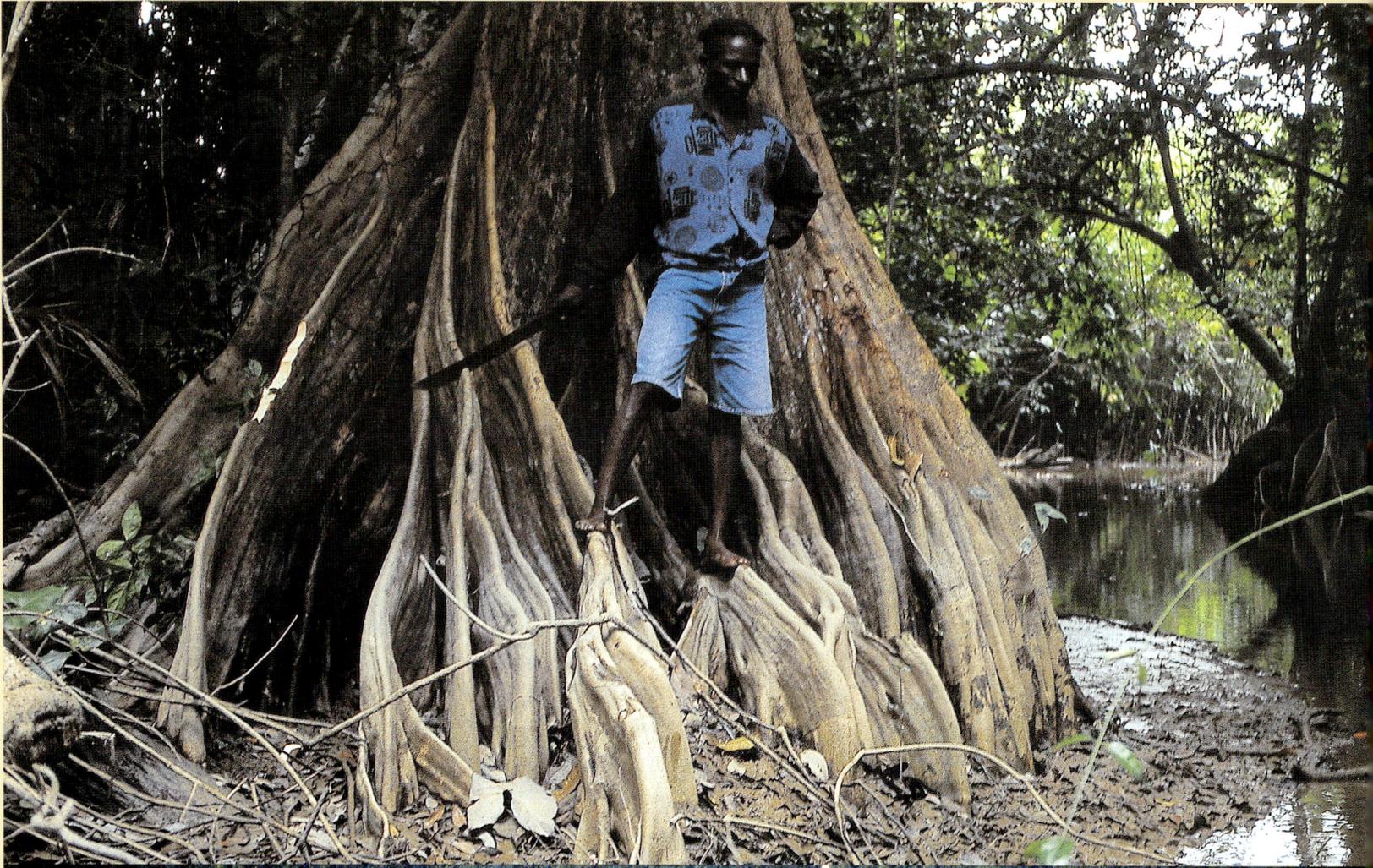

Horticulture, Saramacca.
HENK LUTCHMAN
Coconuts, typical of the district Coronie.
TOON FEY

Saramacca

The Saramacca district with only 13,000 inhabitants is rather sparsely populated. No more than several thousand people inhabit the most important towns including the district capital, Groningen. Around 80 percent of the district is barely inhabited. Saramacca used to be a thriving plantation district. The plantations, run by former slaves and their descendants, were booming businesses even after the abolition of slavery. Cacao farming dominated but the plantation culture completely collapsed after a devastating disease ravaged the crops in 1896. The workers were forced to switch to small-scale farming or seek employment elsewhere.

Agriculture is still the main industry in Saramacca. In the 1980s, Staatsolie attempted to exploit the oilfields that were located on the east-west route. This was successful and the fields have been expanded as far as the sea and even into the sea in the north. Most of the oil is processed in the Tout Lui Faut refinery. The rest is exported or sold to the Suralco bauxite company.

Saramacca has long been accessible only by water. For this reason, the Saramacca Canal, connecting the district to Paramaribo, was dug over two centuries ago. This meant that the produce from the plantations could be transported directly instead of on the Saramacca River and along the coast.

Saramacca's population is similar to the whole country. The district has two important nature reserves, Copenamemonding and Boven-Coesewijne.

Coronie

The district Coronie with its main town Totness also has a modest-sized population of around 3500, and nearly all these inhabitants can be found along the east-west route. The largest part of the district is very marshy and is uninhabited. The many English names in this district are redolent of the brief period of English rule when many English built and owned plantations here.

147

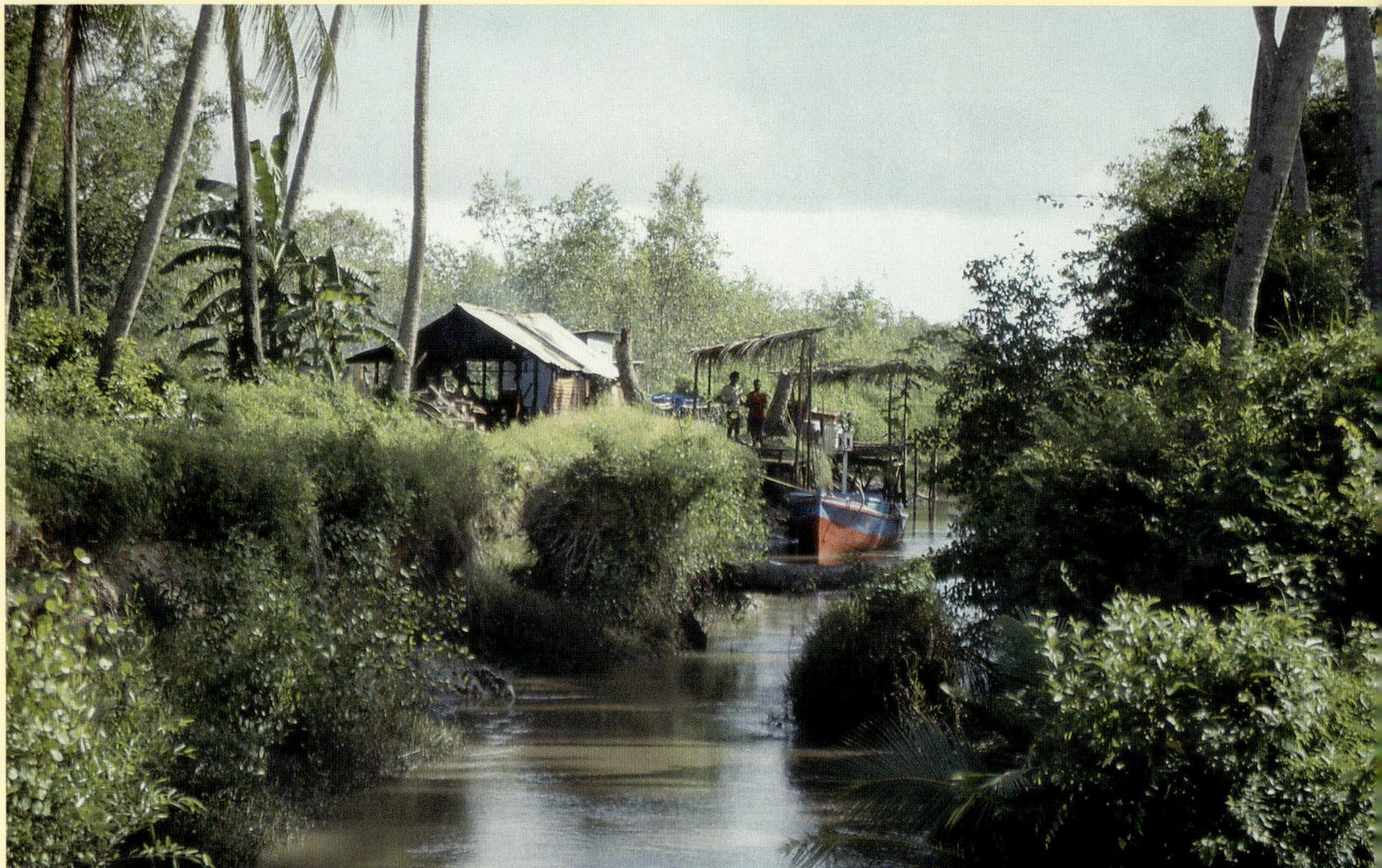

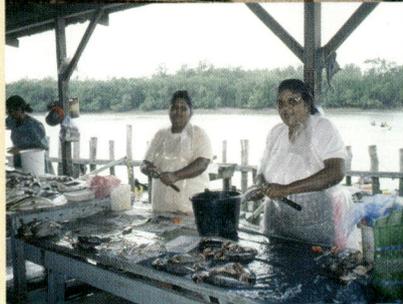

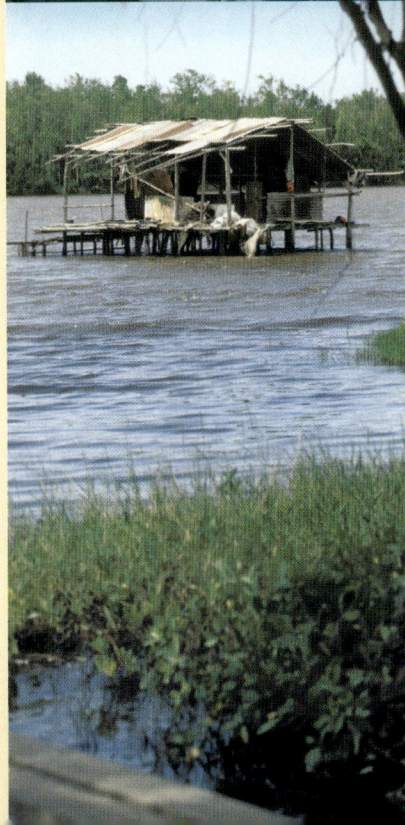

Coronie was known in earlier centuries as the 'Sea coast', as some of the plantations were located along the coast instead of along the rivers, as usual. The district was very isolated until the end of the last century, forming an 'island' between the sea in the north and the swamps down south. The link with Paramaribo was by sea and larger ships had to steer clear of the coast and anchor at a distance because of the shallow waters. Smaller boats were used to ferry people and goods ashore.

Most cotton plantations were given to the former slaves in lieu of salaries after the abolition of slavery. They introduced the coconut farms that resulted in Coronie becoming known as the 'coconut-district'. Oil was pressed from the coconuts and sold. The waste was fed to pigs that were sold in Paramaribo. The largely Creole population of this district reflects its history.

Halfway through the last century the coconut culture was struck by a serious disease that diminished production. Rice cultivation was introduced recently. Fishing along the coast and in the swamps provides a reasonable source of income for the inhabitants. Located near the sea, this area suffers occasional drainage problems and the soil tends to become brackish. The Peruvia Nature Reserve is situated in Coronie and is vital to the blue and yellow macaws.

Nickerie

Nickerie is the district furthest from Paramaribo. This remoteness has had a noticeable influence on the history of the district, which was called 'New Colony' for a long time. The 'Old Colony' was much more influenced by Paramaribo.

Nickerie's development lagged behind the other districts by about a century and a half. The first plantation was built here in 1797 and just after this, Surinam became an English possession for a brief period. The first settlers were mainly English and Scottish, and many English surnames can still be found here. This together with the distance to Paramaribo might explain the slightly different culture in Nickerie.

149

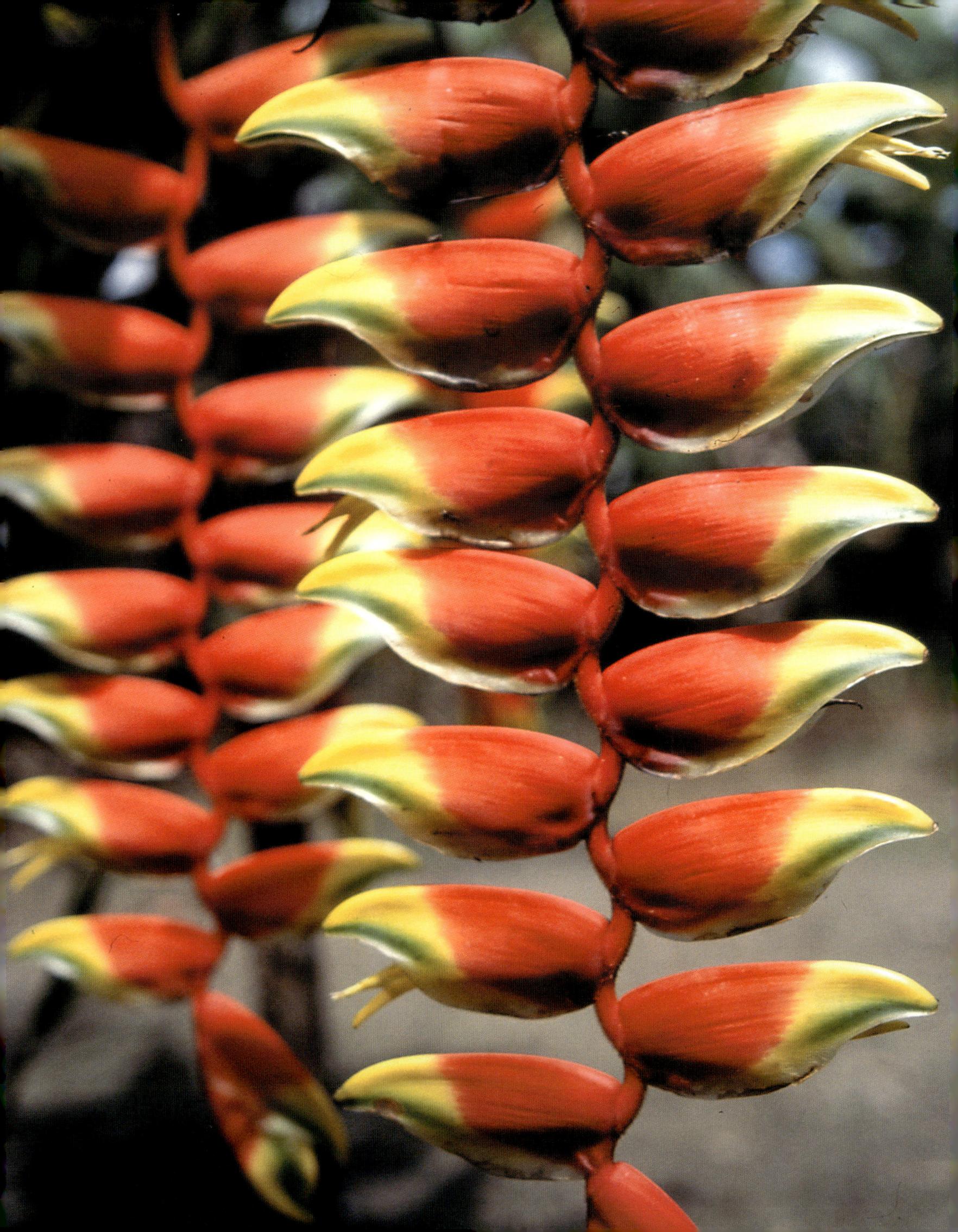

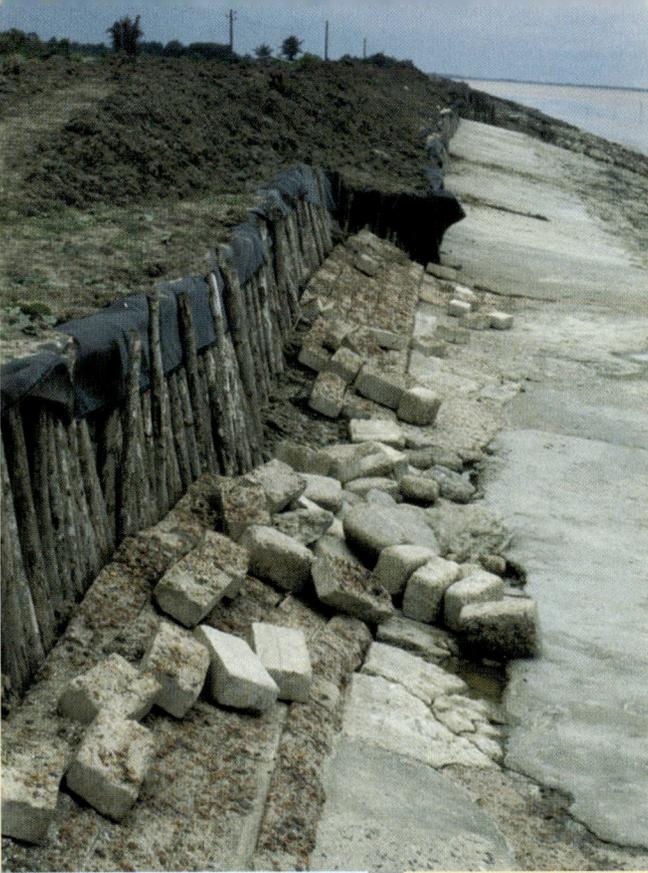

The plantation owners were more involved in management here than in the Old Colony where managers ran the plantations. Under English rule produce was exported straight to Europe; this was forbidden after the colony passed into Dutch hands. The plantations were in trouble even before slavery was abolished. Many slaves escaped to neighbouring British Guyana where slavery had already been abolished. They were replaced by Hindu and Javanese contract workers, nearly all of whom went into family-structured rice-cultivating businesses after their contracts expired.

Nickerie accounted for a considerable share of the balata production at the start of the last century. The tappers were nearly all Creole and remained in the woods for months. They left the district after the balata market collapsed. The population today comprises largely Hindu and Javanese who cultivate rice and bananas and catch fish in the swamps.

The coast of Nickerie has been drastically eroded by the sea: the main township New Rotterdam was reclaimed by the sea first, followed by 'de Nieuwe Wijk'. At the end of the 19th century a new settlement, now known as New Nickerie, was established further inland.

More than a quarter of the district's current population of 41,000 lives in New Nickerie. The symmetrical layout of the town clearly indicates a project-based approach instead of organic expansion. New Nickerie has an indoor market much like that in Paramaribo. The lively atmosphere is partly due to the intense contacts with neighbouring Guyana. Fast boats cross the river mouth continuously, transporting passengers and goods.

Some parts of Nickerie have a typically agricultural landscape with extensive polders, cows and rice fields. The district is only partly populated, however. The Hertenrits Nature Reserve includes a significant archaeological site and the BigiPan swamp stretches over the northwestern coastal area. Migratory birds stop here to feed on the abundance of insects, small fish and crustaceans that live in the mudflats.

151

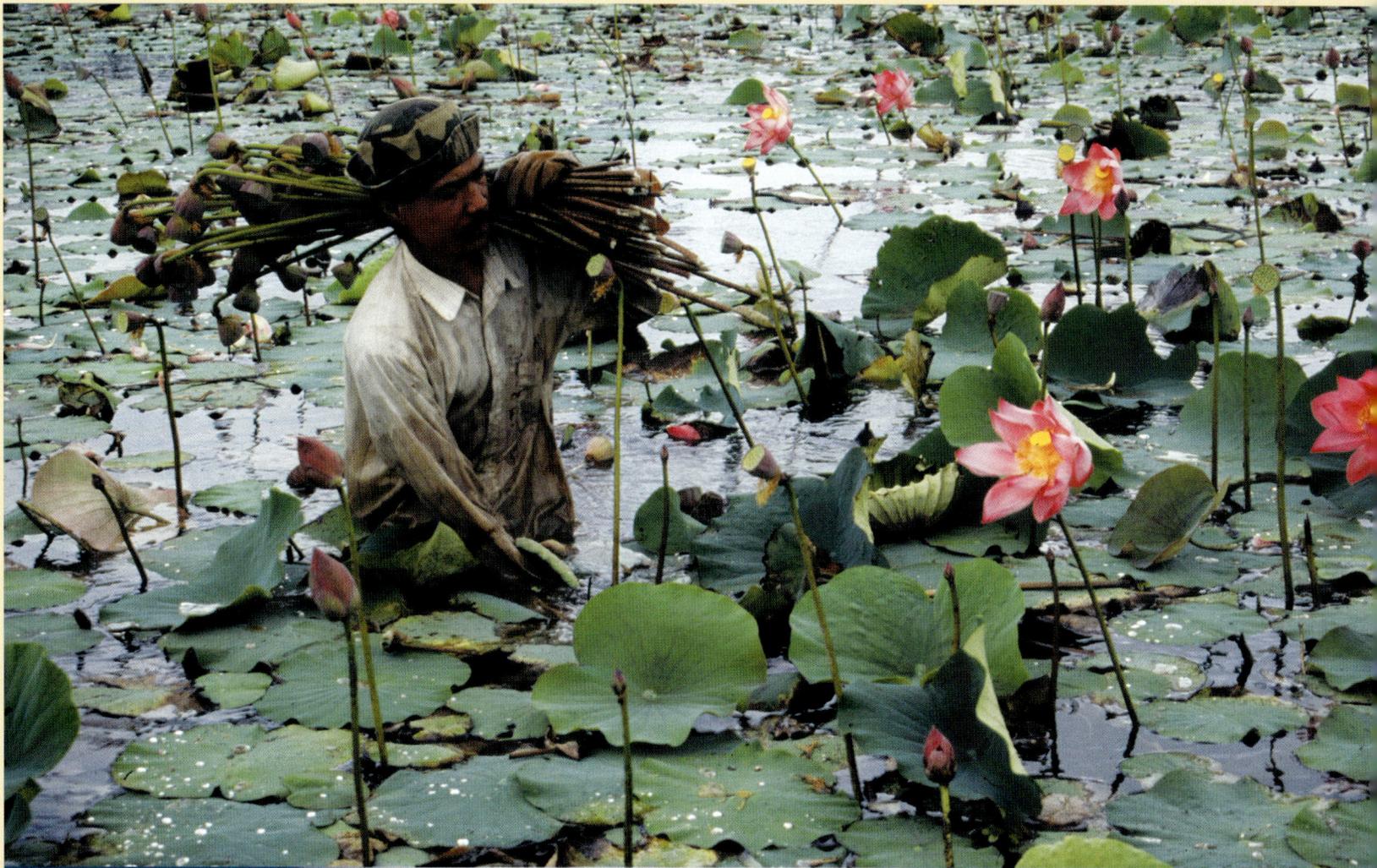

PAGE 152
Harvesting lotus flowers in the old water tanks on the Mariënburg plantation. The dried pistils are exported for use in decorative flower arrangements.
TOON FEY
Braamspunt.
TOON FEY
PAGE 153
Shack on Braamspunt.
TOON FEY
Biotechnology company cultivating orchids and palms on the former plantation, 'La Solitude'.
WILLEM KOLVOORT
Dilapidated house, Alkmaar.
TOON FEY
Flowering lotus: the seeds develop in the yellow pistil.
KIT

Commewijne

This district was one of the main plantation regions of Surinam for many years. The young, fertile coastal plains were a perfect location for extensive plantations, and the distance to Paramaribo was relatively small. Commewijne therefore had the largest number of plantations.

The history of these plantations is inseparable from the Maroons, who continuously looted the plantations for supplies, women or for revenge. These runaways hid in the coastal swamps, where the legendary Maroon leader Boni built the remote Maroon fortress, Buku.

The plantation culture in Commewijne lasted longer than in the other districts. The best-known plantation, Mariënburg, was kept operational by subsidies until the end of the last century. A housing project has now been established on the site. Not much is left of the plantation culture, with the exception of the Peperpot plantation. There is still some small-scale production of coffee, cacao, bananas and other fruit. The former plantations along the east-west route are now divided into small farms.

As the other coastal districts, the increasingly brackish soil is a problem. Fishing in the swamps and in the Surinam River mouth accounts for a large part of the earnings in the district. Large-scale aquaculture with fish and shrimp is a fast-growing business.

New Amsterdam is the main town of Commewijne and has a population of 25,000. The fortress has been turned into a museum. A large sandy plain called Braamspunt covers the north-westernmost area of the district.

153

Marowijne

Like Commewijne, Marowijne has never been an important plantation region. Only the areas along the Cottica River were cultivated. Most of the current inhabitants are descended

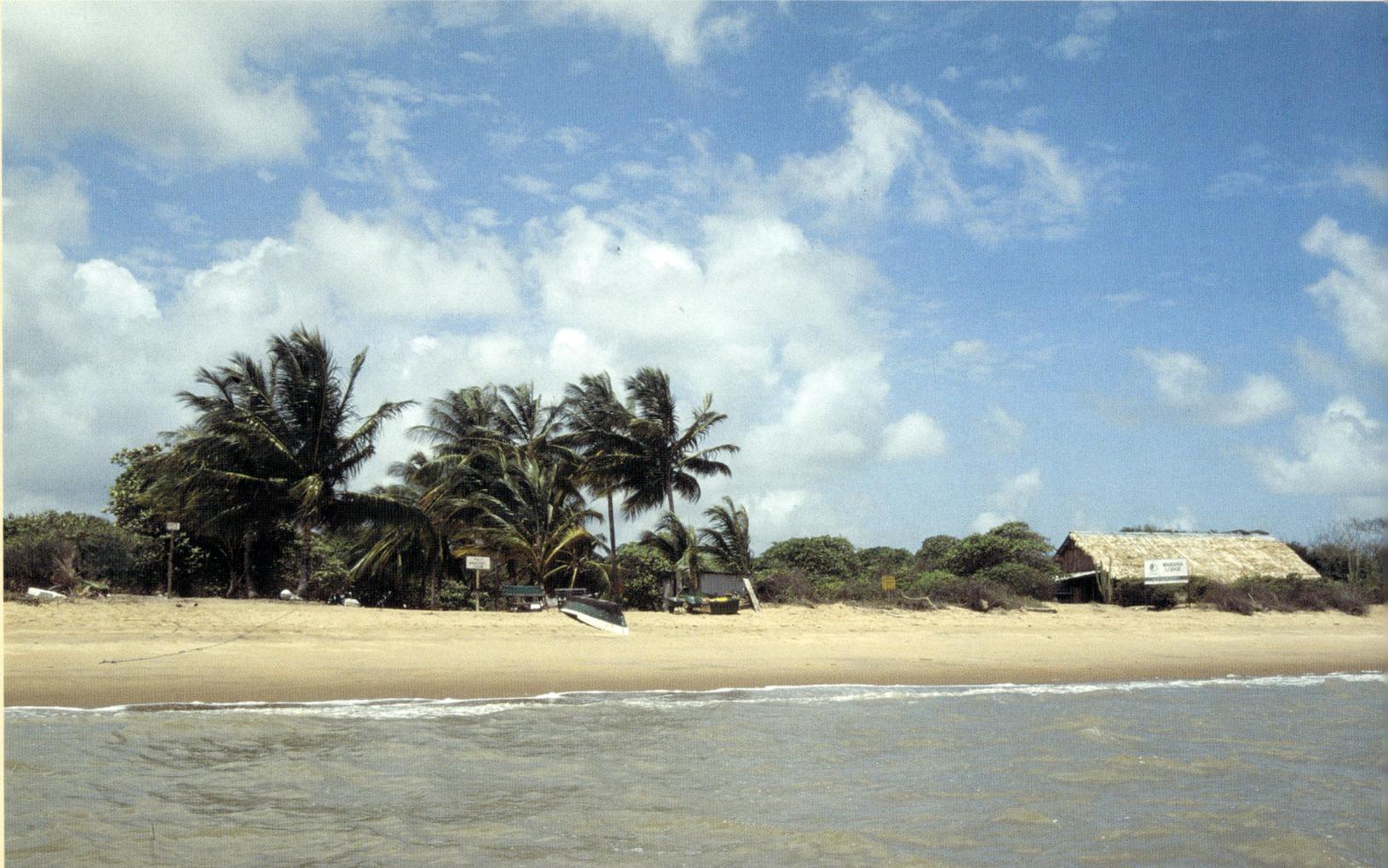

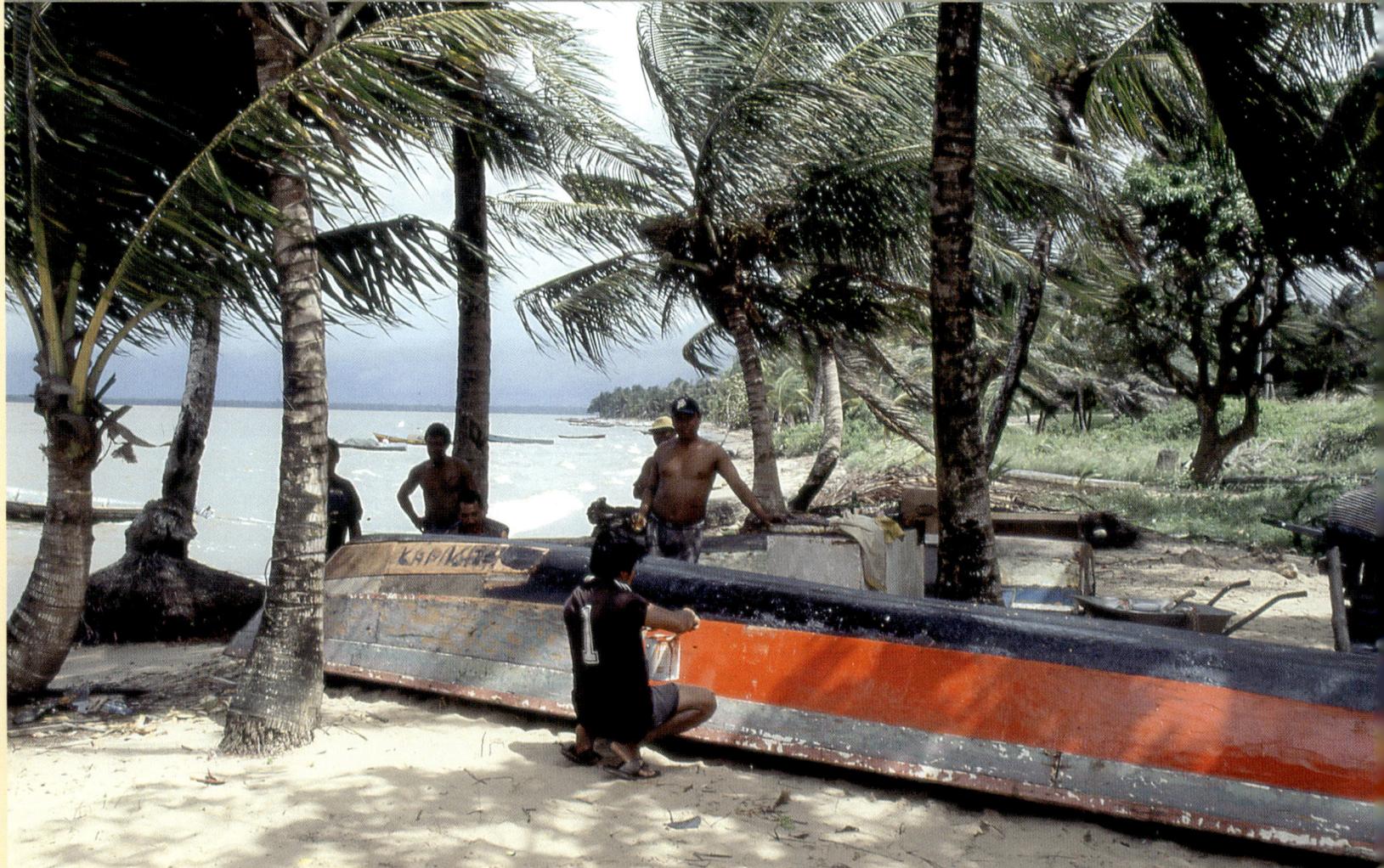

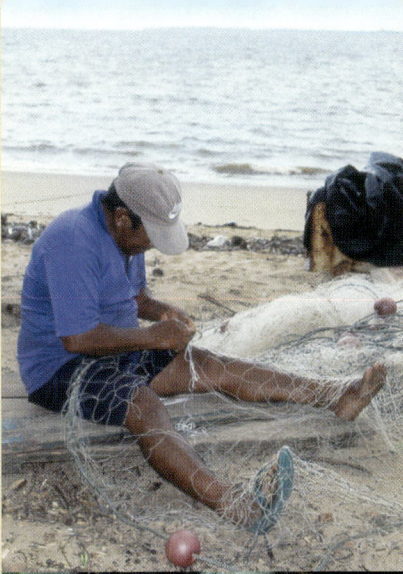

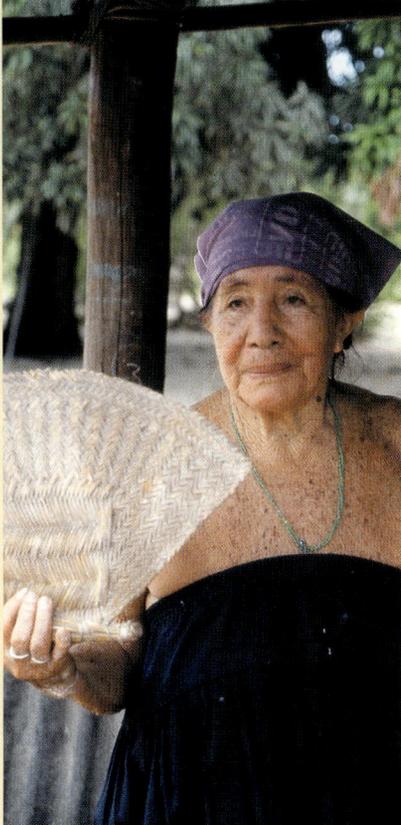

from plantation workers. The main town of Albina was founded by the German August Kappler, who named it after his wife. Albina profits from its location: the French town of St. Laurent was located on the opposite bank of the Marowijne River. Albina was the obvious stopping place for gold prospectors travelling to and from the interior. Paramaribo was only accessible by sea for many years, when a boat made the round trip only once every two weeks.

Bauxite production was a major influence throughout the last century. The township of Mungo was founded along the Cottica River. Large ocean-going vessels could be loaded here because the narrow river was sufficiently deep. Basins were dug to enable the ships to turn. The infrastructure in the district improved as a result of this activity. When the east-west route was completed in 1964, Albina became a popular destination for daytrips from Paramaribo.

The civil war of 1986 in which the military regime caused carnage in some Maroon villages is a black chapter in the history of this district. Many inhabitants fled inland or to French Guyana. Albina and Mungo sustained great damage and many roads were destroyed. Albina has largely been rebuilt and tourism is on the rise. Mungo is in a worse state because the bauxite mines have been relocated and bauxite is transported to Paranam by tug-pushed barges. The Suralco buildings have been dismantled.

Marowijne has about 20,000 inhabitants, most of whom are Creoles and Maroons. Two fair-sized Indian villages lie near the mouth of the Marowijne River, Christiaankondre and Langamankondre; the inhabitants (Caribbean) live mainly from fishing. The Galibi Nature Reserve, famous for its sea turtles, is close to these villages.

Para

The district of Para (population 15,000) lies south of Paramaribo and is easily accessible from the city. Para is

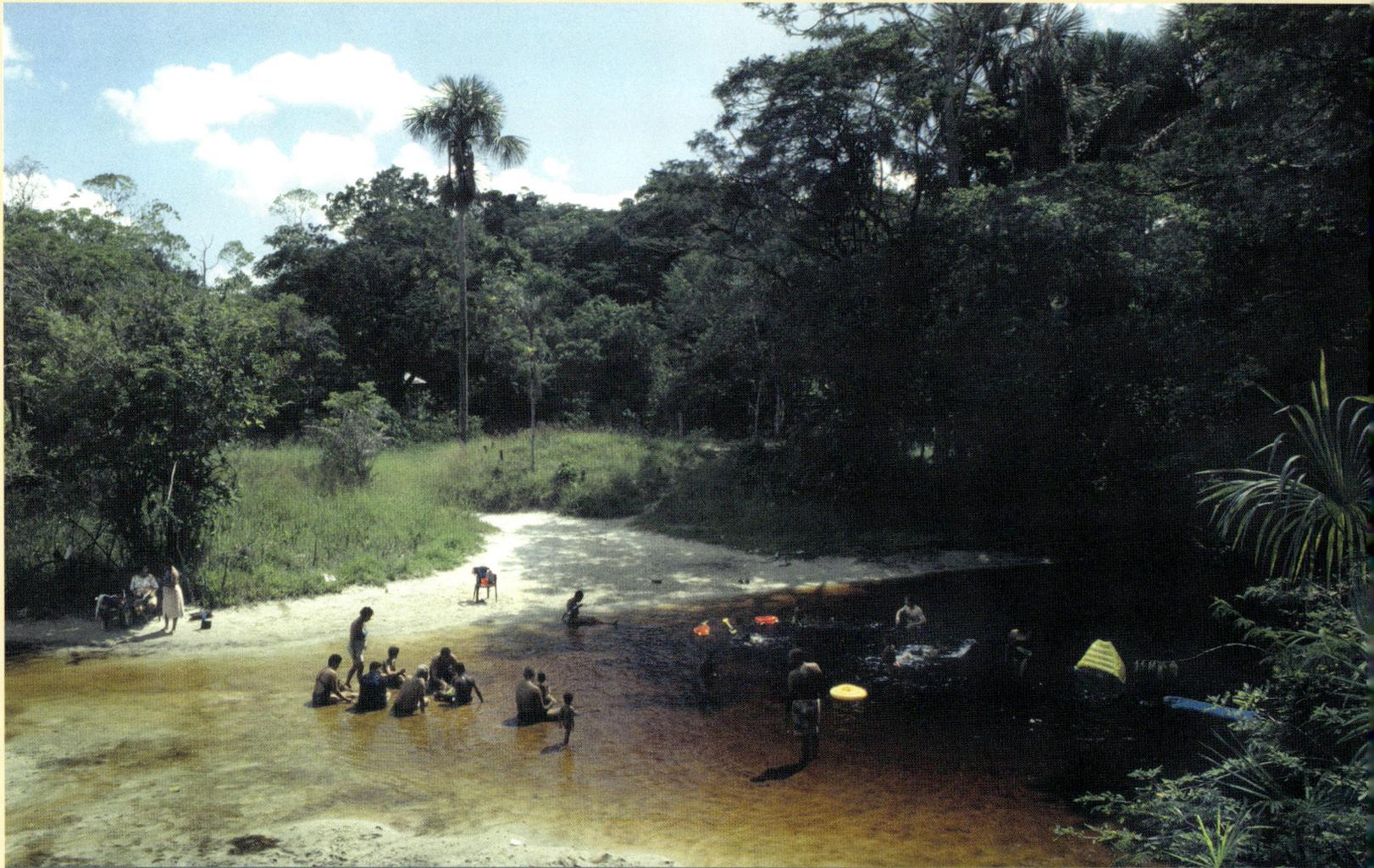

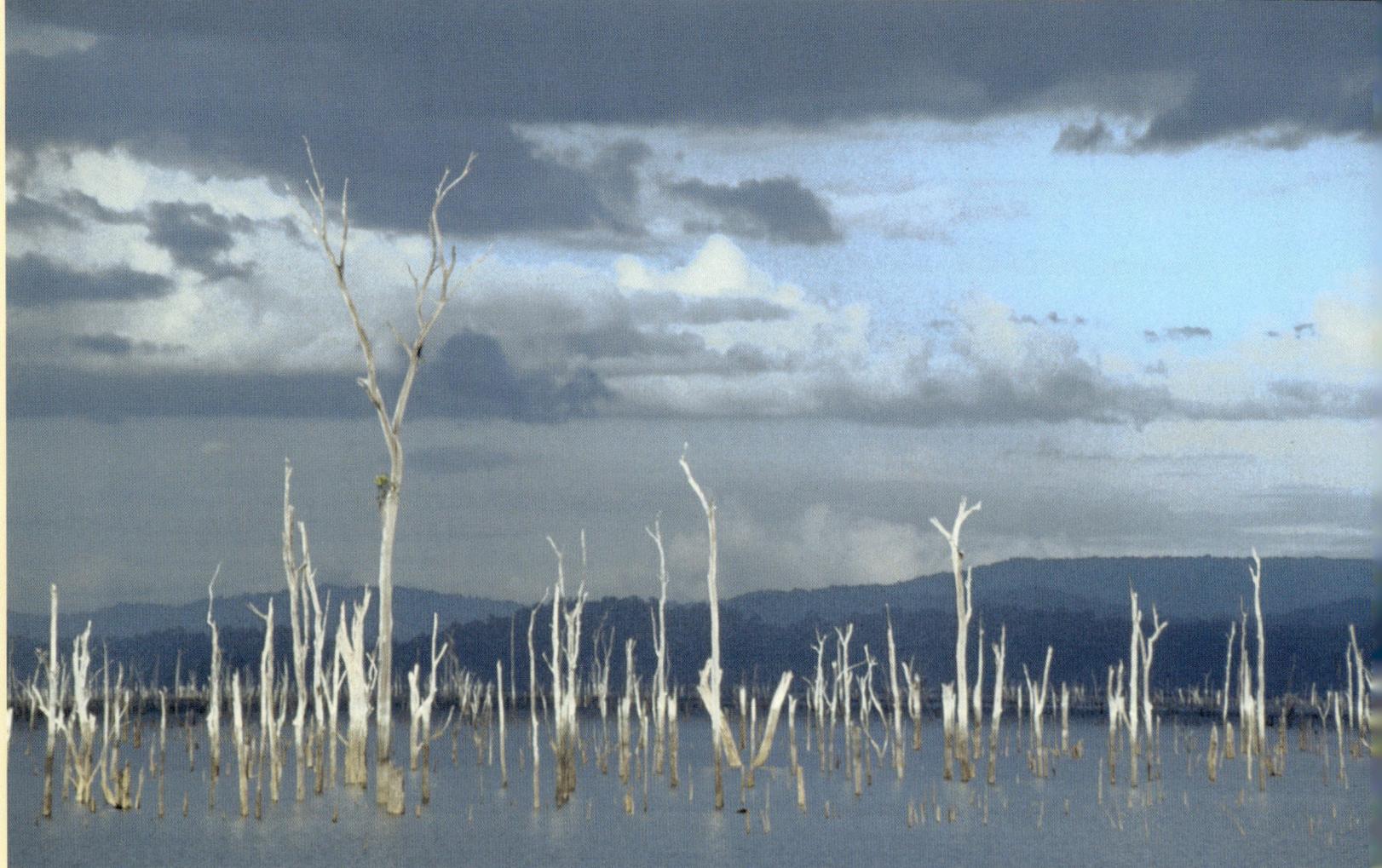

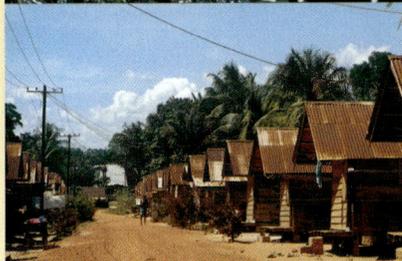

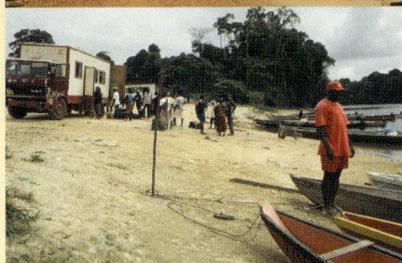

one of Surinam's oldest farming regions: the first colonists grew sugar and tobacco here. Slaves working in the important timber industry were relatively free and independent; bad treatment would only provoke escape. This somewhat 'privileged' position enabled slaves to maintain African culture, and traces of it can still be found despite Christianisation.

Bauxite mining is the most important industry in Para and thus the district has a substantial road network connecting it to Paranam and Billiton. The road to and from Zanderij Airport can be very busy at times. Para is also Paramaribo's backyard and offers many recreational opportunities. Cola Creek, Bosbivak, Republiek and Bersaba are popular holiday resorts. Many weekend visitors swim in the Coropina Creek that runs through Bersaba. Blakawatra is the former countryhouse of the legendary Prime Minister Pengel. Jodensavanne is another well-known destination.

Most inhabitants of the district farm land or livestock. The Javanese are in the majority, with Creole and Hindus coming second and third. Pokawa is the most famous Indian village in Surinam.

Brokopondo

The construction of the Afobaka reservoir in 1985 was a massive project requiring considerable administration and the Brokopondo district was established to this end. The dam is 54 metres high almost 2 kilometres wide. The local Maroon population numbering at least 5000 had to be relocated before construction could begin.

They were resettled in various areas. Some established new settlements north of the reservoir while others moved to newly built villages to the south. Part of the population chose to settle along the Surinam River or near the new road to Paranam (the Afobaka Road) that was built to transport building materials for the dam. One hundred and fifty eight power pylons were placed along the road to carry the electricity to Paranam.

A palm oil factory was built to provide work for the relocated population and was profitable for years until plant disease crippled production. Timber production and gold prospecting occur south of the reservoir. Livestock farms and road-metalling businesses have been established along the Afobaka road. The Brownsberg Nature Reserve with its

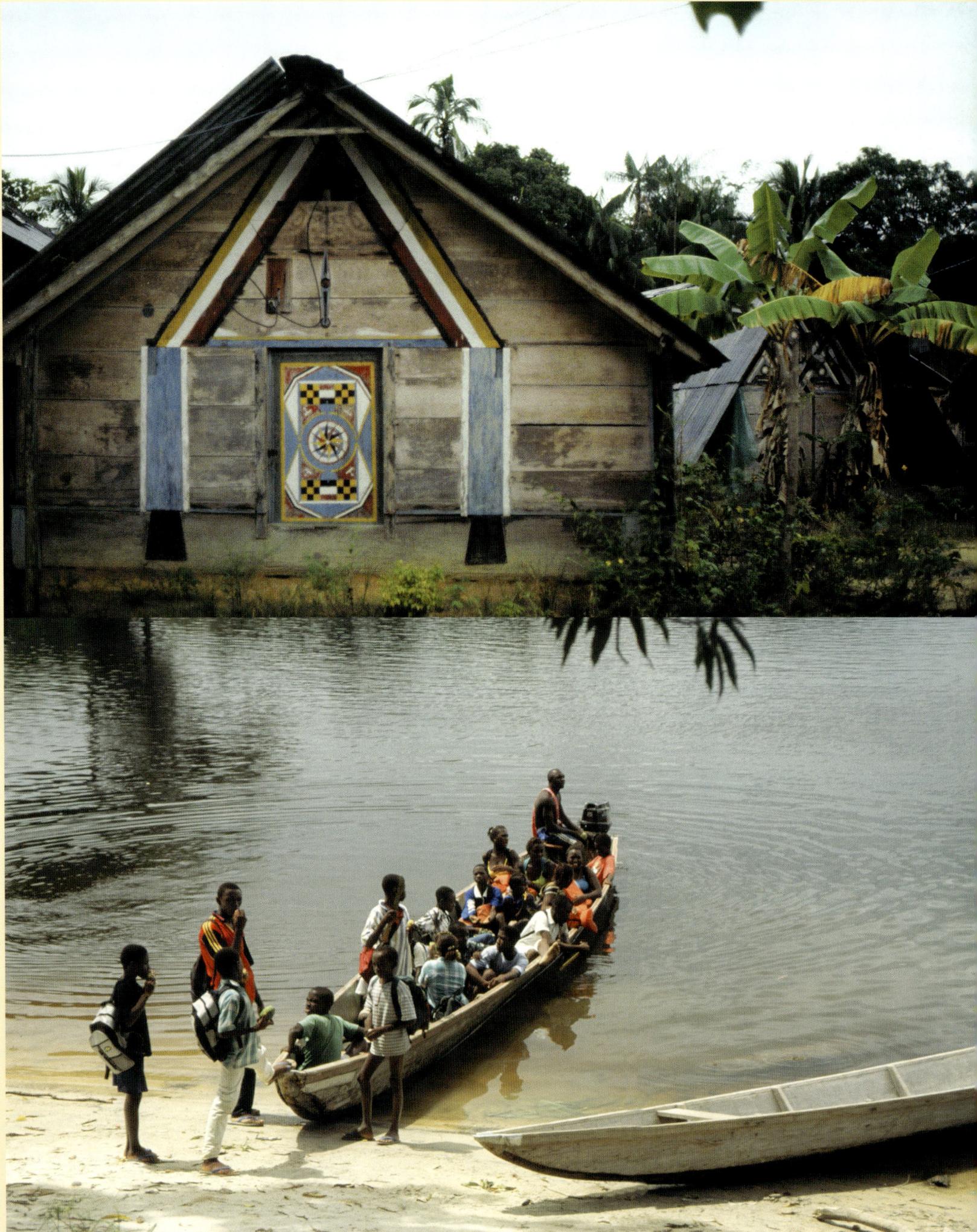

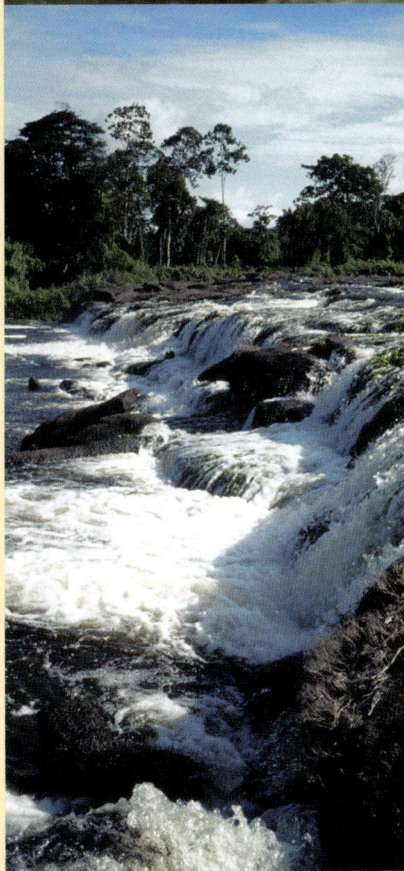

views over the reservoir is a popular recreational destination. The district's 8000 inhabitants are nearly all Maroon.

Sipaliwini

Sipaliwini is by far the largest district. Measuring 130,000 square kilometres it accounts for 80 percent of Surinam and is largely unpopulated. Villages and settlements can be found along the rivers, but there are no large towns. This vast district has a population of only 30,000 people.

The geographical layout of Sipaliwini is also very different to the other districts: most of it is hilly and mountainous and is blanketed by tropical rainforests. The only exception is the Sipaliwini savannah. The southern border of the district is also the border with Brazil and is formed by the river deltas.

Most of the Indians and Maroons live in tribes along the rivers. The Trio, Wajana and Akurio live along the rivers Tapanahony, Lawa, Palumeu, Sipaliwini and Ulemari. The largest Maroon tribes are the Saramaccan (along the Surinam River), the Aukaners (Ndjuka) tribe (along the rivers Tapanahony, Upper-Marowijne, Cotica and the Sara Creek) and the Paramaccan (along the Marowijne River). These bush tribes live from slash-and-burn agriculture, fishing and hunting.

The almost virgin rainforest with its rivers, *sulas* and waterfalls is a paradise for eco-tourists. Two travel resorts can be reached via the Bosontsluitings Road to Apura: the Raleigh Falls and Blanche Marie Falls. The Voltzberg can be reached by foot from the Raleigh Falls. There are some simple resorts along the Surinam River such as Dyumu. Visitors can travel quite far inland in motorised dugout vessels to places like Langatabiki, Dritabiki and Stoelmans Island. The Bosontsluitings Road is the only road in Sipaliwini. Everything is transported by river or by air: there are almost 20 airstrips in the district.

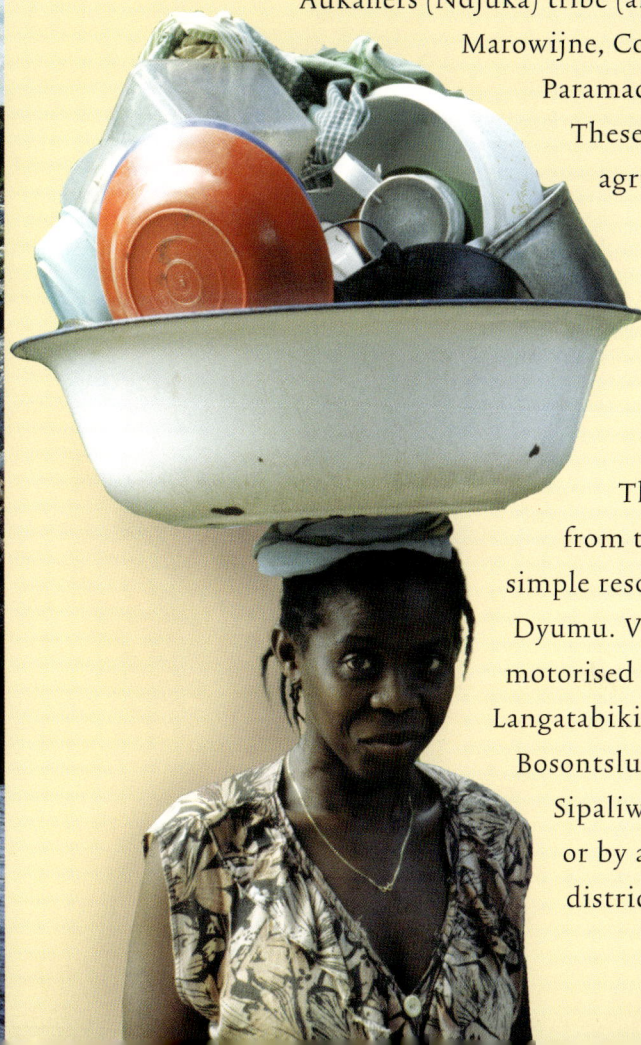

159

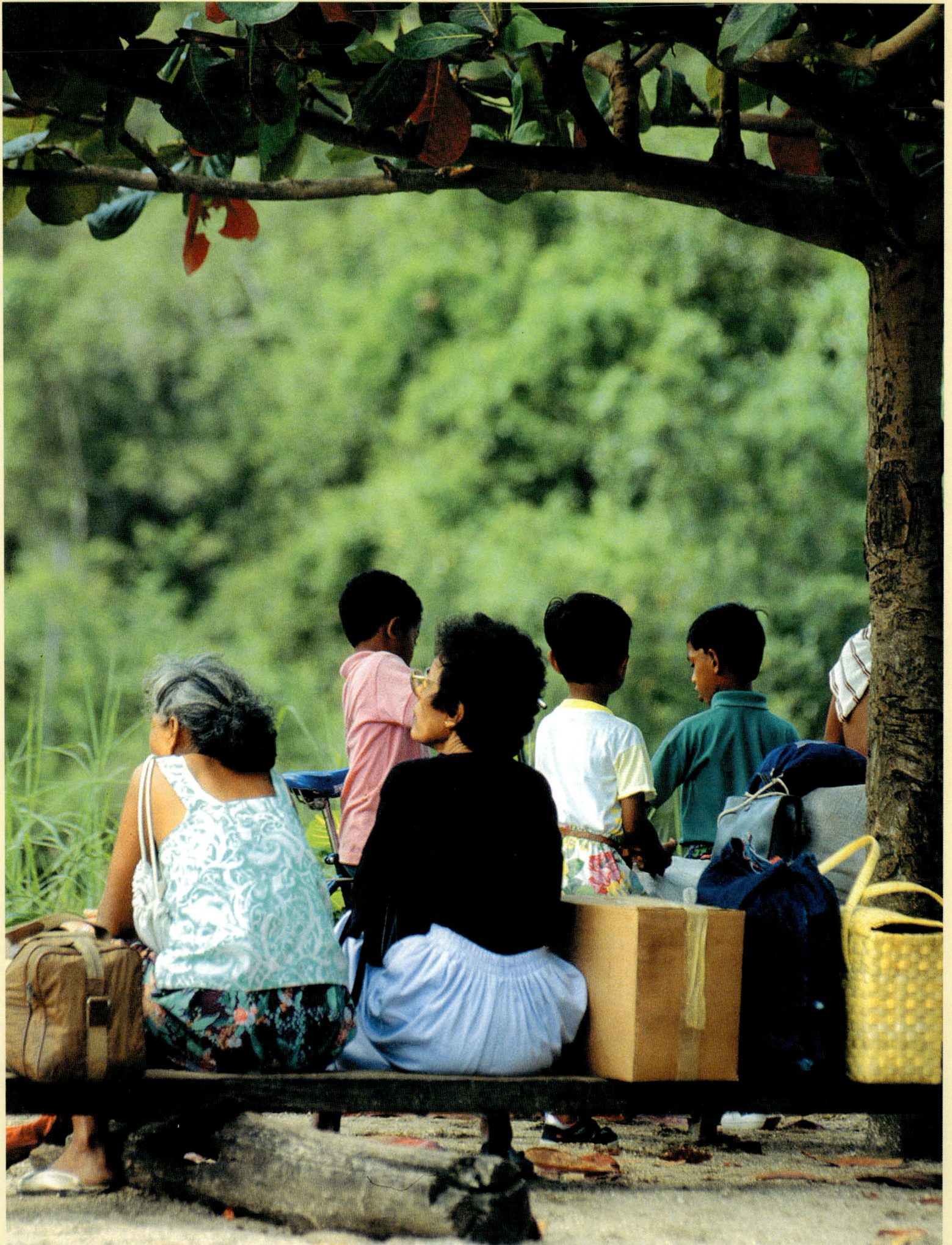